Man Ray

PHOTOGRAPHS

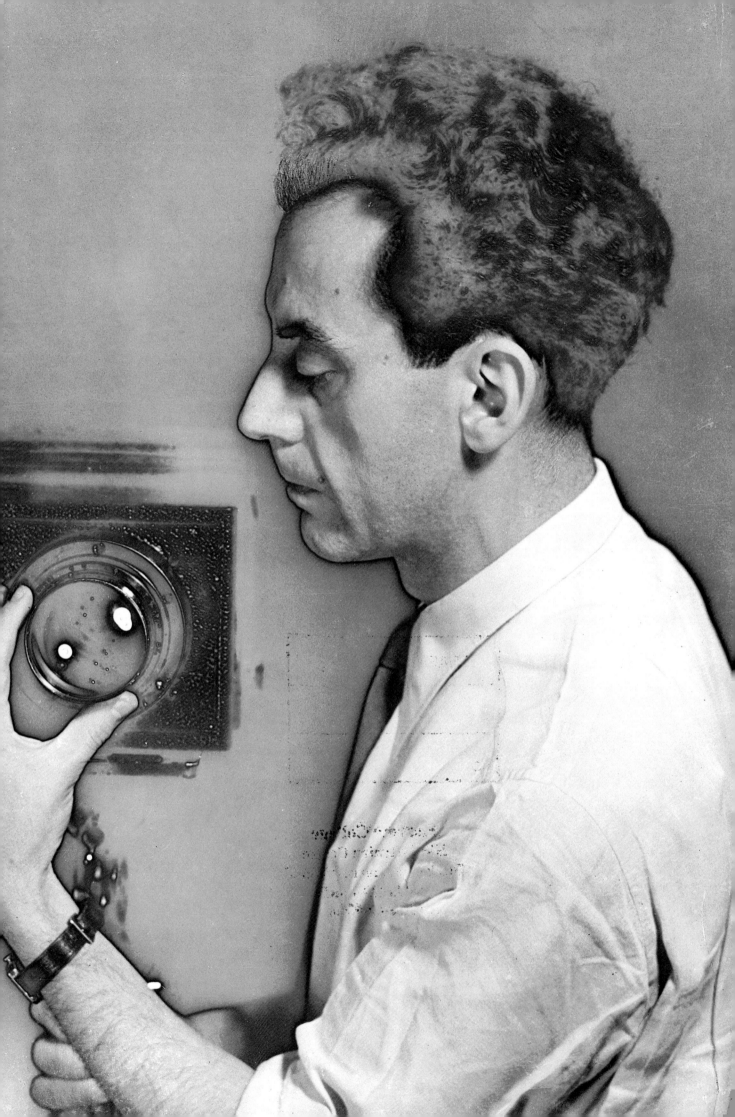

Man Ray

PHOTOGRAPHS

WITH 347 DUOTONE PLATES

INTRODUCTION BY
Jean-Hubert Martin

WITH THREE TEXTS BY
Man Ray

Harrow College
HW Learning Centre
Brookshill, Harrow Weald
Middx HA3 6RR
020 8909 6248

Thames & Hudson

Frontispiece 1 Self Portrait, 1932

Translated from the French *Man Ray Photographe* by Carolyn Breakspear

The original hardback edition of this book was published to conincide with the
exhibition of Man Ray photographs held at the Centre National d'Art et de Culture
Georges Pompidou, Paris, December 1981 - April 1982

First published in hardback in the United Kingdom in 1982 by
Thames & Hudson Ltd,181A High Holborn, London WC1V 7QX

www.thameshudson.com

First published in hardback in the United States of America in 1982 by
Thames & Hudson Inc., 500 Fifth Avenue, New York, New York 10110

thamesandhudsonusa.com

First paperback edition 1987
Reprinted 1990, 1997, 1999, 2001

British Library Cataloguing-in-Publication Data
A catalogue record for this book is available from the British Library

Library of Congress Catalog card number 81-53058

ISBN 0-500-27473-8

Printed and bound in Italy

Contents

Introduction

Jean-Hubert Martin

On 14 July 1921, Bastille Day, a little man, with harsh features set on an ungraceful face and an asymmetrical expression heightened by short-sightedness, disembarked at Le Havre. The festivities were in full swing. Fascinated by the giddy rounds of the dances, which had been a favourite theme in his paintings, he marvelled at the firework displays and was soon to freeze their phosphorescence in his photographs.

In New York he had moved in literary and artistic avant-garde circles. He had lived with Adon Lacroix, a Belgian-born writer, and had been a patron of the photographer Stieglitz's 291 Gallery. He had mixed with the circle of Walter Conrad Arensberg, a writer and art collector who possessed some of the finest Picassos and Braques. He had met Picabia as well as Duchamp, with whom he became friends. He was radical and ambitious, and had swapped his own name, which revealed his Russian-Jewish origins, for a pseudonym made up of two short and striking syllables: man, on the one hand, and ray of light, or of the sun (man, an individual alone in the midst of universal humanity), on the other. At just twenty-three years of age he had charted his course. The same year - 1913 - he married Adon Lacroix and signed his newly acquired name in the marriage register. He could hardly put two words together in French, but, since the artistic circles close to Dada in New York were francophile and the Dada group in Berlin were fascinated by America - Grosz, Heartfield and Hausmann giving English titles to their works - Man Ray gave French titles to his works.

He was met in Paris by Duchamp and, after spending three weeks in a hotel, he went to stay with a friend of his who lived in the rue de la Condamine. He was on familiar ground, as his hostess was the wife of Jean Crotti, another Dada painter he had known in New York.

In his luggage Man Ray brought with him his best works: cubo-futurist and abstract paintings, aerographs - which were very uncommon - and a medley of strange objects. At the customs he had had some trouble in explaining that they were works of art. When he arrived, Paris was seething with excitement over Dada, and Man Ray, a newcomer from glamorous America, was welcomed with open arms. By December he had had his first exhibition at Mick Soupault's Librairie Six. The catalogue, a small folded sheet of paper, included messages of welcome from the most illustrious leaders of the Dada movement as well as a list of thirty-five works. Some of these remain, but most of them have disappeared or are hard to identify, for Man Ray frequently changed the titles of his works.

This exhibition did not include photographs, but, needless to say, Man Ray had brought some with him from New York. Among them was a 38 × 29 cm. print of a mechanical egg-beater and its shadow. Signed and dated 'New York, 1920', it is entitled *La femme* (**9**) [1]. The size of the print, its title and signature indicate that the author considered it to be a fully fledged work of art. In 1917, he had already made a cliché-verre of an *Egg-beater* which recorded its successive movements. In the photograph, the beater, seen from below, can hardly be distinguished from its shadow. At first sight, the shadow appears to form part of the beater itself, for it is quite clearly defined. The light falls from above, so the shadow cast is longer than the egg-beater.

For several years Man Ray had been very interested in shadows. He described his painting *The Rope Dancer Accompanies Herself with Her Shadows*, 1916,[2] as an attempt to transfer both the light from the spotlights and the shadows cast by the advancing rope dancer onto large coloured surfaces. He followed the same lines of research for the collage *Revolving Doors*, 1916-17, to produce a formal equivalent to the object (subject in the picture) without being bound by naturalistic imitation. Cubo-futurism, which he had discovered at the Armory show in 1913, had served as a trigger for this. His title reminds us not only of the personality of Duchamp but also of his *Nu descendant l'escalier* which, like the sequence of coloured planes in *The Rope Dancer*, offers a synthetic vision of the different stages in movement. Both in his painting and in his photography, Man Ray sought reality's plastic equivalent, not its literal copy. He was especially interested in the cast shadow, for it represented the object's legible outline and, at the same time, was extremely varied in form. In short, he was trying to find a new means of portraying reality; a means which took the model into account but which avoided the dangers of abstraction and of its gratuitousness. The Cubist solution had been to fragment the model, so that its facets could be apprehended from various angles, and then to reassemble them. The model then became a combination of 'signs' which revealed sifted fragments of reality. For his part, Man Ray wanted to create images that would restore the model's outline or imprint and that would add to the object's initial form. The object can project an infinity of virtual forms around itself according to the angle at which it is hit by the light. These shadows belong to the object; they reveal it and yet they are elusive, for they are in continual movement as they follow the course of the sun. A fuller mastery of these effects had been achieved only recently with the invention of electric light.

Another photograph of similar composition to the *Egg-beater*, taken the same year, reveals his continued interest in these problems. Whereas the beater is a 'readymade', an object 'by itself', [3] portrayed in its entirety without transformation, *Integration of Shadows* (**221**), [4] also enti-

tled *La femme*, brings together a lamp reflector and six clothes pegs attached to a sheet of glass. Here Man Ray consciously cultivates our confusion of the forms of objects and their shadows. The surface reels, the perspective is upset, and we are forced to choose between several possible interpretations before we are able to restore to each thing its proper value.

Constantly seeking a technical process that would allow him to capture the image of the object as well as its imprint without the direct intervention of the artist's brush, he learned the technique of aerography while working for an advertising company. He became proficient in this technique, which involved using an air-brush to spray paint or ink onto a sheet of paper. He placed objects or overlays on the paper and these acted as stencils so that, when he sprayed on the paint and then removed the objects, their blank shapes remained. If the object stood out from the paper's surface or did not adhere to it completely, a small amount of paint penetrated the hollow areas, thus emphasizing the volume of the object.

In 1921, Man Ray 'invented' his first rayographs or rayograms (which met with Tzara's immediate enthusiasm), only after a long period of research. He explained this in a letter to Katherine Dreier:[5] 'I'm trying to make my photography automatic - to use my camera as I would a typewriter - in time I shall attain this and still avoid the irrelevant, for which scientific instruments have such a strong penchant. I'm working for the truth - one is apt to get too much of it, or get it a bit exaggerated'.

The controversy around Man Ray's 'invention' of the photogram (rayograph) is irrelevant (it is true that others had used this technique before him, such as Schad and Coburn or, at the same time as Man Ray, Moholy-Nagy). What is important is that for many years Man Ray had been trying to produce an image that would preserve the ambiguity of objects exposed to the light by including their shadows. This ambiguity arises from the fact that the light, necessary for our perception of the object, also necessarily casts the object's shadow - its twin. What marked the difference between Man Ray and his predecessors in the use of the photogram was the extraordinary way in which he took advantage of what the technique offered. It was the long thought process, which had finally led him to the (re) discovery of this technique, that enabled him to do this. The photogram offered several important advantages. Execution was automatic (no camera) and instantaneous, and both the imprint of the object and its shadow remained. Lastly, each photogram was unique. The traces left by the object's contact with the paper give the result an almost tactile quality. The play of greys and blacks reveals the presence of the light and the creation of a space. Each photogram is unique because there is no negative and we are faced with a fixed, non-renewable time lapse.

The objects that appear in Man Ray's rayographs form part of his microcosmic world. They stem partly from themes that had interested him long before he started using this technique. The more or less regular spirals (springs and such like) are adjacent to the paper at a fixed point and they unfold in infinite curves that oscillate from geometrical regularity to distortion, from order to disorder. He had already dealt with this phenomenon in *Lampshade* (an opened-out lampshade which was suspended from one end) as well as in his photographs of opened shells. He had also dealt with the theme of permanency, with his revolving gyroscope balanced on a string (which reminds us of another magnificent image capturing movement, *The Rope Dancer*). More emotionally charged are the photographs where a human presence is revealed. *Man Kissing Kiki*, in 1922, was taken in the dark and captured in a few seconds of exposure to the light; *Kiki Drinking* (**155**) is another example, as are his handprints, where he brings us back to the origins of painting, and which he had already used in his *Self Portrait* of 1916. Returning to the photograph *La femme*, we could perceive it as vaguely anthropomorphic. The handle could be seen as a head, the large cog-wheel as a body and the whisk as the legs or - why not? - even as a crinoline, which had already appeared in *La volière* ('The Aviary', or, in slang, 'The Brothel'), an aerograph of 1919. This leads us to consider Man Ray's titles and their relationship with his works.

Picabia had been the first artist to incorporate the machine, which he invested with a strong sexual symbolism, into human undertakings. He excelled in this vein, combining mechanical elements with some Latin expression or other which he found in the pink pages (devoted to Latin phrases and their translations) of the Larousse dictionary. Thus, with a 'slight' shift in meaning, *Ecce Homo* became *Voilà la femme* ('Behold the Woman'). Man Ray had seen these works as early as 1915 in Stieglitz's 291 Gallery, in New York. Man Ray bathed his objects in strange isolation, and this strangeness became poetic on account of the discrepancy between the object and its title. The importance he attached to this over any formal equivalence between the object and its naming is confirmed by a second known print of *La femme*, of 1918, which he had entitled *L'homme*.[6] It had not been without presumption that the author had adopted the pseudonym of *Man Ray*, and he was very fond of self portraits, which were sometimes in the form of a rebus.[7] *L'homme*, in this case, could very well have been referring to Man Ray himself. Far from being any attempt at analogy, the title is there to set off an association of ideas to divert us from anything reminiscent of the object's familiar contexts. In some cases, only the title provides a clue to the infinity of possible paths we could follow. Chance is no stranger to his inventions, and with certain objects it can occur as a play on words or as an expression taken literally. Here the situation is reversed, and it is the words, on the contrary, that are being put into pictures in an incongruous or ingenuous fashion, to highlight one of their possible meanings. Sometimes Man Ray's creation of a work was sparked off by a title he already had in mind. He spoke no French, so it is not surprising that he took words at their face value. It is striking to observe how many artists, after spending many years in a country where they know nothing of the language, never really learn it properly. It is as if the absence of verbal communication stimulates them, or makes them more receptive to all kinds of other perceptions.

Le violon d'Ingres is another work which can be read in several ways. The back view of the outline of Kiki's bust and hips, in a similar pose to that of Ingres's *Baigneuse de Valpinçon*,[8] is a somewhat humorous revival of Picasso's and Braque's recurrent themes of the violin or guitar. The extreme erotic refinement of many of Ingres's works suggests that *his* real pastime was, in fact, women.[9] Man Ray makes this inference quite clear by adding the two sound-holes, and the work becomes a masterpiece. Surprisingly, this is one of the few works to which he

added graphic elements. He only rarely made use of collage, photomontage or superimposition. It is quite amazing that Man Ray, who is considered to be one of the greatest creative photographers of the twentieth century, did not exercise more freedom in the taking of his photographs. He photographed reality and a certain mystery and was not interested in trick photography as such. His rayographs indicate how attached he was to cameraless and negativeless photography. The techniques of solarization and ruled half-tone screening also allowed him to achieve graphic effects without having to intervene manually. His artistry was based not on the tracing of outlines by hand, but rather on the length of exposure time which was often subject to chance. But he was never systematic, and some of the prints he made in the twenties were highlighted with white gouache strokes which were probably added by his assistants. Because of his attachment to photography, with its immediate and often unpredictable results, he left aside a vast field of research in the areas of painting, drawing and collage/assemblage. In 1928, he spoke of his 'resolution to devote a certain amount of time to painting again,' adding 'and now that my curiosity about photography has been satisfied, I shall be interested to see what influence it will have on my work.' [10]

It still remains that, when set in motion, *La femme* begins to dance. Whether male or female, it is nevertheless a sexual being for whom the dance is a ritual overture to love. There is nothing more mechanical than a dance rhythm, and this explains why the dance appears as one of the recurrent Dada themes. This is particularly true for Picabia as well as for the Delaunays and Severini. *The Rope Dancer* is a good example of this as well as *Sequidilla*, an aerograph of 1919, which revives the Spanish dance of the same name. Another example is *L'impossibilité*, 1920, which is a painting on glass that combines the wheels of a machine and the word *Dancer* or *Danger* in such a way that we are unable to distinguish which is the correct word. In matters of love, once you have set the machine in motion...

Freud was the first to adopt a more pragmatic and mechanistic approach to sexual phenomena, breaking with views that hitherto had been totally spiritualist and mystical. Walter Conrad Arensberg's small circle of friends knew of Freud's theories and discussed them. Proof of this lies in the fact that in 1919, when Duchamp and Man Ray published their sole issue of *TNT*, they included in it a play by Nicolaï Evreinof, called *The Theatre of the Soul*. The prologue explicitly refers to Freud. 'As you know,' says the professor and narrator, 'it has been conclusively proven by Wundt, Freud and Théophile Ribot and others that the human soul is not indivisible but is, on the contrary, composed of several selfs.' The rational, emotional and subliminal psychic entities and the concepts to which they give rise are embodied by the actors who confront each other in dramatized conflict situations. Man Ray illustrated the play with an aerograph of a mechanical nature, entitled *My First-born*. Moreover, from the notes he left in his archives we can see that both *The Rope Dancer* and *Suicide* (dedicated to Evreinof in 1917) were inspired by *The Theatre of the Soul*, as were many other works of his. *Suicide* is entitled 'an illustration for a play by Evreinof. The dramatic situation on the professor's blackboard' (the professor is narrating the prologue). On the card in his file on *The Rope Dancer*, Man Ray wrote underneath the photograph: 'The Theatre of the Soul. Dans sa cervelle la danseuse dance' ('In her brain, the dancer dances'), which he later crossed out. Thus, the fact that Man Ray entitled his egg-beaters both *L'homme* and *La femme* stemmed more from his knowledge of Freudian concepts of the psyche than from an attempt at humour on his part. The two titles form two sexual counterparts; the beater symbolizes the human being as possessing the characteristics of her/his opposite sex in embryonic form. *Dual Portrait*, a painting he did in 1913, adds weight to this interpretation. It represented two faces with their profiles superimposed. The two models were Man Ray and his wife Adon Lacroix united in loving osmosis. Only one of the two portraits remains, cut from the original canvas.

Finally, after having repeatedly referred to Man Ray's egg-beaters, one of which became *La femme*, we cannot avoid considering the egg itself. Its purity fascinated Man Ray, and he included it in many of his pictorial and graphic works. Under the photograph of an ostrich egg [11] he wrote: 'Of course, nature provides all the elements for creative inventiveness, including anal techniques.'

We have seen how impossible it is to isolate a particular technique in Man Ray's works, or to give one prominence over another. They all merge and proceed from Man Ray's conception of things, which he does not retain at their face value but goes on to interpret. The controversy as to the respective values of his painting and photography and the pre-eminence of one over the other is therefore most surprising. Man Ray spent so much energy defending photography (though not without limitations), yet this question is still being argued to this day. We may well ask if it will never end. One is reminded of the interminable seventeenth-century discussions about the superiority of poetry over painting or of one art over another. But each technique has its own specificity and its own characteristics. What predominates and dictates the end result is the idea. The form is but a means of expressing it. Sometimes it fits the idea perfectly. The resulting work then becomes, as in the case of Man Ray's rayographs, perfectly appropriate; the quest for a new means of expression merges with the discovery of a new technique. Man Ray used all sorts of materials and techniques to express ideas which revolved around a few major themes. Photography and painting are only two facets of his art. Nevertheless, except in his souvenir photographs, Man Ray endowed his subjects with a graphic quality that only an accomplished manipulator of signs and symbols could achieve. His thoughts on the Renaissance masters are revealing: 'I had considered myself fortunate to be living in an age that put the camera at my disposal. Leonardo and Dürer had racked their brains to produce an optical instrument, if only as an aid to their drawing.[12]

Man Ray's situation as an artist appears to have been quite clear cut and coherent at the beginning of the 1920s. The hard fact remained, however, that he had to earn a living. There was a small circle of middle-class Parisians who were very enthusiastic about the young American and who admired him and held him in high esteem, but Dada lovers and collectors were few and far between. Photography therefore seemed the obvious money-earning solution. He already knew how to handle a camera and how to use a dark room, having worked in advertising in New York, so he started work as a photographer, but in a spirit of irreverence, always refusing to consider it a profession. In only a few years his

photographs and portraits brought him fame and financial stability and he no longer had to rely on a chance sale to survive. Moreover, his success was assured as a young American photographer who had close ties with the Parisian avant-garde and who moved in the cosmopolitan world of Montparnasse; his new environment also stimulated him to try out new techniques. The portraits he made of his artist friends brought him success and fame. 'I made lots of friends…, among them Picasso and Braque who always worked a great deal and who were very successful. My new role as a "photographer" allowed me to go everywhere and to become well-known. I say "photographer" because it removes me from the fierce competition that exists here amongst painters. I have something unique, as Jean Cocteau says, "I have delivered painting".' [13] All the Surrealists and a great number of English writers came to his studio. The portraits he made of them with the small means he had at his disposal are sober and inspired. They are in no way artificial and avoid the dangers of the bizarre and of facile humour. The images are concentrated on the facial expressions of the subjects, which generally stand out against a simple backdrop. When he included an object in the picture it rarely had any special significance; it was almost always a work of Man Ray's or one of his household objects, which revealed (to those who knew him) the author of the photograph. His subjects had to pose for a long time. We now know that, for every famous portrait that has been reproduced many times, he made at least half-a-dozen exposures. Some of these are presented in this book. The framings varied from one exposure to the next but, as a general rule, Man Ray framed his subjects tightly - they appear to burst out of the photograph. Sometimes he would isolate a detail and would use it to make an entire picture. For example, he would blow up someone's hand from a group photograph. The prints, nearly always made by assistants or laboratories, varied greatly from one to the other and from one period to the next. At the beginning of the 1920s and 1930s he was very fond of blurred effects, but he later abandoned them. Besides his portraits of the intelligentsia, which established his reputation and to which he devoted all his energies and talents, he also undertook commissions for hundreds of other portraits. It is hardly surprising that they are disarmingly banal: he had to earn money as quickly as possible so as to be able to devote himself to his other, far more fascinating, activities. It comes as a shock, however, to find that, alongside the eloquent sobriety of the portraits he made of his friends, he also indulged in gaudy stereotypes such as a picture he made of a woman against a background of water-lilies.

The handful of views of Paris that were included in the album *L'âge de la lumière*, 1920-34, have often been reproduced. Taken at night, they were obtained by the simple but powerful effects of electric light. But Man Ray also hunted out the strange and the unusual, scenes which he mirrored in the many pictures he took of Paris streets. As a foreigner, newly arrived, he expressed his wonderment at picturesque Paris. This is why he strongly identified with Atget's inventories of the old quarters of Paris. Man Ray was one of the first in the artistic circle to proclaim the merits and the value of Atget's work. He sometimes adopted the same approach in his photographs of the entrance halls and the interior courtyards of Paris buildings. The severe and regular rhythm of certain façades, empty of passers-by, gives them a dream-like

appearance reminiscent of de Chirico, or even of Magritte. Mystery mingles with the bizarre in a photograph of a large tarpaulin hung over objects on the banks of the Seine that bring to mind *L'énigme d'Isidore Ducasse* (**149**), as well as in another photograph where the pavements are preyed over by the giant claws of freshly pruned trees (**236**). The plastic force of the gable-ends of demolished houses did not escape his notice, neither did they escape that of Raoul Hausmann and others. We can see a new urban sensitivity, characteristic of the twentieth century, developing in these images of city decor where advertisements, torn posters, shop signs and windows combine. Some of these photographs had a more literary vocation and were destined to be used as book illustrations. Surrealism fed on the strangeness of everyday occurrences; nothing could track them down and fix them better than photography could.

In the vast field of Man Ray's photographs there was also room for critical appraisal, which could take a particularly acute turn. In 1924, he included in *391* a photograph of two statuettes of female divinities which he placed in the centre of a page of iconoclastic aphorisms. One of them was African, the other Greco-Roman: two aesthetic canons, two visions of the world confronting each other, summing up the artistic quarrel. The total simplicity of the image has its corollary in the transparency of the title, which also qualifies the photographic technique: *Black and White*. The word play and picture play becomes even less innocent if we recall that Man Ray was American. The racial problem had not been erased by the Civil War.

Man Ray takes up the same theme in more elaborate form in his famous photograph of Kiki's face beside an African mask. In this *Noire et blanche* (**109**) [14] (which he prized above all, and of which he left a negative version (**110**), his intentions appear to have been more complex. Here again, several different poses exist. One of them, a vertical pose (**111**), is published in this book for the first time. It does not have the same limpidity, however, as the famous version which opposes the vertical position of the mask to the horizontal one of the face.

Man Ray was a tireless traveller in the unbounded field of creation. His creative peregrinations led him to tackle all kinds of domains with the utmost freedom. In photography he explored every avenue, from the most orthodox to the most inventive, never allowing himself to be hemmed in by social convention. His work is immense and has yet to be fully appreciated - for his was a mind in perpetual motion and photography was only one of the many aspects of his art. True to the ideas of his youth and to Dada, he explored all techniques and all subjects. For him no domain was reserved for specialists alone; he entered freely into each new activity. Each problem would provide its own solution for he who knew where to look for it. Dada created not craftsmen, but excellent jacks-of-all-trades. The multimedia objects that Man Ray made out of bits and pieces acted as intellectual stimuli. This same need to dominate matter was equally visible in his immediate environment. Everything had its place in his apparently disorderly studio; he left his mark on every household object. He adapted everything with the most obvious simplicity so that it could be used with maximum efficiency. To be one's own master implies that one be master of one's own immediate environment. He ruled over his living space and over everything it held, in both the making and the placing of his objects. In this we are

reminded of Brancusi (a friend of his), a fanatic lover of objects. During the 1930s, he had designed the furniture for his studio in the rue du Val-de-Grâce, and subsequently always oversaw the furnishing of his studios. In California, he also designed houses. For Man Ray, his own studios were moulds that he reshaped in order to preserve his sense of freedom. When, at the age of eighty-three, he lived in what used to be a garage in the rue Férou (although he could easily have lived in comfort) he insisted on filling his oilstove himself. Among a thousand unforgettable details was the cigar box, attached to a mobile arm, upon which he placed his bedside telephone; or the partition in his dark-room which was made out of planks from an old crate with the inscription 'Fragile - Museum of Modern Art'.

Man Ray succeeded in mastering his environment and in piercing some of the mystery of matter and of reality by manipulating light and shadows. This dialectic necessarily brings us back to Plato and his cave: humankind does not see reality, only shadows. To consider objects in themselves is to consider them at face value. To be interested in the shadows of these objects, thereby taking the sun, essential creator of all things, as reference, is to pierce their truth a little. The sun gives us light and is in constant movement. Man Ray knew how to face the sun without being blinded by its rays.

1. *Paris, Musée National d'Art Moderne, gift of Madame Arp, 1973.*
2. *New York, Museum of Modern Art.*
3. *Term used by Man Ray to define two 'sculpture-assemblages' of 1918.*
4. *Milan, Studio Marconi.*
5. *20 February 1921. Yale University Library. Beinecke Rare Books and Manuscripts Library.*
6. *Milan, Arturo Schwarz Collection.*
7. *Francis Naumann, 'Cryptography and the Arensberg Circle', Arts Magazine, May 1977, p. 131.*
8. *Paris, Musée du Louvre.*
9. *Ingres was well known for playing the violin as well as painting. The expression 'violon d'Ingres' is now used to refer to 'a hobby exercised with passion'.*
10. *Letter to Katherine Dreier, 22 October 1928. Yale University Library. Beinecke Rare Books and Manuscripts Library.*
11. *1944, Paris, private collection.*
12. *'Photography Is Not Art', View, December 1943.*
13. *Letter to Howald, 28 May 1922. Ohio State University, Department of Photography and Cinema.*
14. *Variétés, I, No. 3, 15 July 1928.*

2 Man Ray 3 Untitled

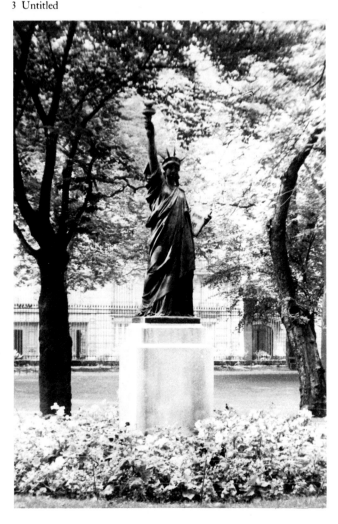

'New York is sweet but cold. Paris is bitter but warm.' (Letter from Man Ray to Howald, 28 May 1922).

Man Ray and the avant-garde

Philippe Sers

Man Ray told us everything we need to know about him; and his work, full of wisdom, also spoke for itself. But despite all he said and wrote, he left us few clues to the meaning of his art. He talked instead of the details of his everyday life, his encounters, personal experiences and intuitions, as well as his extraordinary appetites. His savouring of a tasty sandwich or of a wine, his making of furniture out of planks or soap boxes, his dyeing of his curtains with a tea mixture and his continuous and joyful struggle to obtain women, food and warm clothes all intermingled with his activities as a painter and photographer simply because all these were his pleasures.

If theoretical discussions arose, he would challenge basic assumptions, those obvious questions most often overlooked, or he would avoid empty discussions entirely by wittily sidestepping the debate. In this, as in so many other things, he relished his position as an outsider. It provided him, for example, with an excellent excuse for not signing the manifestos that were brought to him by his friends. He was captivated by the mystery of French words and, ignoring their accepted meanings, he would subvert them for his personal fantasy world. Once, in New York, he suggested that Katherine Dreier and Marcel Duchamp call their foundation 'Société Anonyme'. Duchamp laughingly replied that this was the French equivalent for 'Incorporated' in American, and Man Ray liked the idea even better.

He managed to remain a foreigner all his life, both in America, where he was born, and in France, where he died. He was extremely comfortable in this role. Yet even he was surprised that he and Tzara could communicate without sharing a common language, a puzzlement which led him to reflect on the peculiarities of language and meaning throughout his life. He often wrote on the subject. Perceiving that Duchamp's painting *Nu descendant l'escalier* would have gone unnoticed were it not for its title, Man Ray began to consider the importance of titles, their ability to offer a semantic counterpoint. They could at times be merely disconcerting, at other times severely schocking to the spectator.

Man Ray's own name is perhaps his best invented title. After choosing a new name for himself - almost as a banner - Man Ray set out to make his art with the eagerness of a child discovering the world. In his painting entitled *Man Ray*, 1914, he clearly stated the new life he had chosen: he used his new name not only as its signature, but also as its subject. From that time on he discarded anything that did not work towards enriching his singular adventure. For Man Ray there were few uncertainties. He methodically assimilated his daily revelations and the traces of past encounters. Patiently,

Man Ray worked his alchemy, drawing his personal vocabulary from a boundless stock of ideas and objects and, along the way, investing them with his own secret meaning, our Ariadne's clew to his creations - all the while offering them to us with a somewhat mocking humour and with the utmost discretion.

'I feel embarrassed about exhibiting my pictures; I get the impression that my closest-guarded secrets are being revealed in public. I'd rather walk around totally naked in the middle of a crowd of well-dressed people. The presence of other naked people would reassure me, would give me the feeling that I was normal and that my incognito was being preserved, as happens when I exhibit with other artists. Nevertheless, my secret is violated, and any satisfaction it would have given me is lost.'

Man Ray did not care whether he stepped on forbidden artistic ground; he used all kinds of materials and techniques in his art. When he first used a camera, he did so with simplicity. He was enchanted by the machine. Man Ray did not conceive of one art form as being more noble than any other; nor did he indulge in such 'refined' cultural discourse. He set out as a pioneer, aware that his adventure was a solitary one, wanting to break new ground at all costs. The result was that, in photography, for example, he invented and reinvented everything. This was the self-educated man's sin but the artist's privilege. Making good use of all the means at his disposal, he turned his weaknesses into strengths. Like a Zen master, he accepted the unexpected and 'danced with life'. Man Ray's approach also recalls that of the Beat Generation, of that of the Americans in Paris who, in their writings, were ever conscious of the moment yet tirelessly struggling towards the future. A photographic error opened the doors of Parisian high society to Man Ray. He photographed the fiery-eyed Marquise de Casati under poor lighting conditions, and three pairs of eyes appeared on the plate. He had made the 'portrait of her soul'. He then started taking photographs deliberately out of focus. Later, he even turned his own legendary near-sightedness to advantage. Having forgotten his camera lens one day, he used his own glasses for the beautiful portrait he made of Matisse (**277**); the whole photograph was blurred, but the important elements stood out very clearly.

Lack of focus has a definite role in photography. We are drawn to consider the play of light, as the composition is laid bare. The subject, divested of its material aspects, shares the rhythm of its surroundings and merges with them in a symbiotic relationship. Only the main elements of the whole emerge. In the portrait of Matisse, the painter, model, easel and mural design are all perceived in essential harmony, enabling us to interpret the whole.

For Man Ray, photography was, above all, the recording of light. It was the basic material with which he

worked. In his art, he played with the transitions from white to black as well as with their dynamic oppositions. Hence the importance he attached to the different shades of grey and to the gradations of light. His rayographs represent a kind of quintessence of the photographic process, recording the passage of light through translucent objects or the shadows of solid ones. Only the formal structure of the object in relation to the light that falls upon it appears. The object is seen in a new way and is as 'immaterial' as it is in the blurred photographs. The object is perceived only insofar as it arrests the rays of the oncoming light; we perceive the object's illusion in the Platonic sense, that is, it exists only in relation to the source of light.

When Man Ray invented this technique, almost by chance, he was taken with it, and rayography became one of his favourite themes. He saw this as a great step towards the future and he presented his rayographs to the public as often as he could. 'Ray for ray of light', as André Breton called Man Ray, adding, 'Man Ray is listening for light.' And Man Ray really did listen for light, both in his rayographs and in his solarizations, offering us some of light's unexpected possibilities, irresistibly reminding us of its traditional philosophical role as a picture of knowledge. His photographic œuvre minutely explores the world around us and the light upon which our knowledge, our picture of the world according to Plato, is based. Thus Man Ray marked the passage from an aesthetic of substance to something more fleeting, that of light, characteristic of our time.

Man Ray was not a photographer. He was an avant-garde artist who used photography as a means of research. Like his peers, László Moholy-Nagy or Raoul Hausmann - and perhaps even more so than they - Man Ray explored the camera's possibilities, confident in the renewal of aesthetic values.

Another, and perhaps the most spectacular, of Man Ray's themes was his play on dimensions, as in *La voie lactée* ('The Milky Way') (**222**), or in the famous *Elevage de poussière* ('Dust Breeding' (**10**), which he called for a time *Vue prise d'un aéroplane par Man Ray*. We are drawn into a world of different dimensions so that we are led to read the photograph in a different way. The title often helps set us on the right track, but sometimes the photograph is self-evident, like that of the enlarged insulator which becomes a knight's helmet (**181**), or that of the neck thrown backwards which, when isolated from its context, becomes a phallus (**182**).

Man Ray made the photographic space his own. Hence his superimpositions: Duchamp's hands on the back of a chair (**176**) or the portrait of a suicidal Tzara beside a woman who is naked from the waist up (**6**); or the different ways he played with the imaginary space surrounding the African fetish photographed against a lunar landscape (**218**); or again, Kiki's three faces (**107**), a 'Cubist' image which sets off our imagination. We stand before a new space, that of artistic creation. The photograph no longer simply records light; it reveals Man Ray's mastery of his art.

Temporal relationships are another strong point of Man Ray's photographic work. Photography belongs to the domain of the instantaneous; the photographer immortalizes the moment and, at the press of a button, he fixes situations on celluloid. As the shutter closes, time is frozen forever. For Man Ray, the decisive moment always took place before or after the event. Everything was

suggested, nothing was clearly stated. This is where our dreams and fantasy take over. Man Ray rarely presented stark reality, and certainly never one-to-one relationships in his art. Narrative elements lay primarily in the recording of often trivial events, such as the rubbish in *Transatlantic* (**219**) or the traces of milk in *La voie lactée*, but also in more spectacular events such as his firework display (**220**) or the car race, where the wavey picture of a car in motion recurs two or three times in the photograph, in the manner of a futurist painting (**173**). Here, as in the pictures called *Space Writing* (**153, 154**), where a light was moved in front of the lens, inscribing a series of luminous lines on the plate, his photographs record the actual traces of a time lapse.

These, however, are relatively rare examples. Man Ray was more given to suggestion, like in *Erotique voilée* ('Veiled Nude') and its variants (**49, 53**), where the event (which event?) never takes place. He shows us Meret Oppenheim, her forearm stained with ink. Or else, he shows her writhing on a press in the grip of Louis Marcoussis who is wearing a false beard. Or yet again, we see Louis Marcoussis (still wearing a false beard) delicately wiping her hand as she casually leans against a wardrobe, very much a society woman yet completely naked. The atmosphere in these photographs is evocative of some unknown event, the meaning of which we are unable to grasp. And the ambiguous title gives free rein to our imagination. A crowd gathers for some unknown reason on an Orléans bridge (**237**). Nor do we know what is happening in the Surrealist gallery in the rue Jacques Callot where four individuals - a cyclist astride his bicycle, a workman wearing a cap, a *bourgeois* and a man in livery - are lost in contemplation of the shop window while the glass door in the centre invites us to enter into the mystery (**347**). A broken chair and a ballet slipper, over which floats the polyhedron that appears in several of his compositions (**142**); a mannequin in a sumptuous dress, perched on the first step of a staircase it will never climb (**286**); the studio's stove and coal bucket (**261**); these are quick glances at the many outside worlds that his photographs bring to mind. Man Ray travelled his fantasy world which he delightedly engraved in the fragile marble of photography.

For Man Ray, the new method implied 'a way of looking at things as well as of doing them'. Photography's role was that of doing what the eye could not do. Painting circumscribes our vision of things; the painter draws his subjects from the material world, interprets them and, in the act of painting, places them in his own pictorial world outside reality. The photographer, however, focuses on reality itself: he mechanically records the visible world of places, objects and people that are his direct subject-matter. No longer choosing to isolate fiction from its surrounding reality, the photographer opens up a window on the world and centres on one of its particular facets through his photographic lens. But while photography offers us reality's true likeness, it also has space for revealing some of its unexpected aspects. This is the case, for example, when the entire photograph is taken up by a simple detail that would not usually be isolated from its context and which normally would escape our attention. Hence the utmost importance of the role played by the photographer himself, for it is he who determines which of his subject's aspects he is going to centre upon. This requires the utmost precision and, to achieve it, Man Ray was often obliged to make enlargements and in so doing

was led to explore the photograph's inner layers, its inner reality, with the appearance of the photograph's 'grain', its pigmentary structure. Here a relationship can be established between photography and classical art techniques such as drawing and engraving.

Man Ray played with the photographic space in a marvellous way and with very simple means, in order to disconcert the viewer in his perceptions. First of all, he would concentrate on secondary details or on objects that would normally go unnoticed. Isolating them, he would allow them to take on their full meaning and would offer them as a subject for aesthetic, erotic or vital meditation. In his *Self Portrait* (1), he stressed the importance of detail in a woman's face. He provided some excellent examples in his photographs of lips and of tear-studded eyes. Hands also fascinated him; he presented them in all manners of ways, either bare or gloved, holding objects or empty. Nature's details enchanted him: he photographed the curled ends of a dead leaf (223), or spiky Catalan rocks suggesting the head of a bird of prey (228). Even his many assemblages of apparently heterogeneous objects he carefully prepared to live an adventure all of their own, to be recorded in numerous photographs. His attention to detail is superbly illustrated in *Transatlantic*, where the most commonplace objects - a few cigarette ends, burnt matches and torn paper, refuse of no importance - are assembled in a composition that Kurt Schwitters would not have disowned.

Another of Man Ray's themes was his study of light effects, as in his photograph of a torso striped by shadows cast by a curtain in *Retour à la raison* ('Return to Reason') (95) or in his photograph *Moving Sculpture* (174), which shows the white shapes of linen hung on a line. Or again, in *Boulevard Edgar Quinet, à minuit* (249), where car headlamps pierce the night, or in the unexpected structure of *Saddle* (187). Here the effects of black and white - the very climate in which, every night, our dream activity occurs - were particularly precious. By stripping light of its accidentals of colour, he would unify the subject's various aspects so as to focus attention on its texture. Thus Man Ray drew us to perceive light in all its richness.

Man Ray's self-portraits show him as mischievous or pensive, but always precise and painstaking in his work. Lee Miller reported that 'no movement he made was superfluous'. He was so very particular in everything he did and such a great discoverer of new processes that we should have expected him to have interested himself in sophisticated techniques or to have possessed highly complicated equipment. But this was not the case. And here, perhaps, lies our key to his character, to his greatness. Man Ray always employed very simple means. More often than not, his camera was a 'modest Kodak'. If he had no spotlights, he would use an ordinary electric light bulb (with which, for example, he made *Elevage de poussière*). Man Ray told us himself that, having been deprived of his dark room for some time, he had developed his photographs at night. His entire photographic work, so dazzling in its achievement, was achieved with the most makeshift of devices. He was no more given to technical overstatement than he was to philosophical debate. 'It is useless to rack our brains for the solution, we must live as if there were no problems, and as if there were no solutions to be obtained. This is the final art demanding no effort but that of living and waiting'. Such an attitude springs from his utmost attention to his own experiences. Given the high quality of Man Ray's œuvre, and particularly that of his photographic works which harboured so few weaknesses, we may well be tempted to ask ourselves what his method was. And the answer lies here, in his art of living. Man Ray spoke of this himself:

'What interests *me* is an object that does not look like a work of art; something that is part of our lives, that we all collect, whether it is useful or not. Sometimes I choose a ready-made object and sometimes I bring together several objects that I make into one whole, or else I throw them away. The most intriguing objects for me were those that I kept for a very short time and that I threw away or destroyed afterwards. But I always recorded them, either by photographing them or by painting them. For me this was real sculpture, it became part of life. You did not have to go to a gallery or museum to see them, they were within arm's reach.'

Man Ray, like many others - though perhaps even more so than they - offers us insights into the meaning of avant-garde art, by the quality of his vision and the amazing simplicity of his means ('I have always envied those for whom a work of art is a mystery'). First of all because he is deeply rooted in Dada. And what was Dada, if not the oldest and most rigorous of methods of research and renewal; that of the clean sweep and of authenticity? Man Ray began his life as an artist by a complete rebirth, and through his art he engaged in the most genuine of meditations on life. He was Dada by instinct, and it was instinctively that he swept the board clear of artistic influences. What interested him was the future. That is what he meant when he pronounced his famous, 'I have never made a recent painting.'

The Dadaists adopted a rigorous and cautious method in order to uncover primary truths underlying the creative act. Their approach can be likened to that fixed point which Archimedes conceived of as supporting the world, or that clear and distinct idea sought by Descartes which led him to the *Cogito*, that single and absolute certitude, since the 'I think', the moment it is stated, marks the indisputable coincidence of the idea and its object.

For Dadaists, this certitude lay in the coincidence of the act and its justification as embodied in creative spontaneity. No Dadaist would have accepted any reference to established cultural values which they considered to be obscure and confused; nor would they have accepted as valid anything outside the spontaneity of the moment. Schwitters summarized this in his, 'art is everything that the artist spits out'. Art becomes not an ideal, a criterion to which we refer, but the product of the artist's labours. No Dadaist would have bowed to any criterion or ideal other than that of the spontaneous act of a given individual at a given moment. Thus, all discursive cultural justification outside the creative act, as well as, by definition, all reference to the past, is eliminated.

This is why Dada has often been considered negative in its outlook. But this negativism is only superficial. All the Dadaists, who were considered as art destroyers, were in reality - and Man Ray is a prime example - overflowing with creative life and activity. The lesson they left us was, in fact, that of a positive outlook and of confidence in life.

From this, we may understand better Man Ray's vital and creative wisdom. He was close to Surrealism but stressed in his *Self Portrait* his 'Dada integrity'. He always tried to free himself of all constraints so as to be able to

concentrate on being aware of the moment; for the moment encompasses the true realities of the creative act: chance occurences, accidents, and various impulses like Man Ray's shooting of a film by starting up the camera and then throwing it thirty feet in the air before catching it again. These various elements all allowed him to take stock of the many possibilities which his inventive mind revealed to him.

And so Man Ray proclaimed that throughout his life he had only ever had two goals: the pursuit of both freedom and pleasure. These were the only shields he had to ward off the commonplace and routine aspects of life.

Throughout his long life as an artist, Man Ray was often surprising and sometimes shocking. He always turned up where he was least expected. He looked on his art as both a superior game and as a pleasure 'the same as eating and drinking'. His love of solitude brought him to reflect that he could very well have been a hermit; and indeed he probably was one, within the four walls of his studio which he only rarely, and reluctantly, left. And his 'plastic' meditation of our conscious and unconscious worlds, especially in his photographic œuvre, greatly expands the bounds of human perception, offering the present the most bewitching of his 'Vanities'. ∎

Photography as consolation

Herbert Molderings

In 1854 Blanquart-Evrard published a book of photographs by John E. Greene which showed landscapes and monuments along the Nile valley; it was given the subtitle *Explorations photographiques*. This also serves as a description of the first period in the history of photography - which began around 1840 with its invention and ended during the decade preceding the outbreak of the First World War.

This period witnessed the growth of bourgeois society in Europe and in the United States and was a time of colonial expansion when world markets were developed. Military, commercial and scientific expeditions set out for hitherto unknown regions, paving the way for the major countries' capitalist economies. This would not have been possible without a revolution in transport. The central role played by the railways in this revolution had its counterpart in the role played by photography in the no less revolutionary developments that were taking place in the field of intellectual communication. *Explorations photographiques* aimed to give those who stayed at home a glimpse of the exotic landscapes, men, animals and monuments that they were unable to see for themselves. On the home front, other 'expeditions' were being directed towards family or personal histories (private photography); towards social events (newspaper photography); towards those parts of nature which, up to then, for physiological reasons, had remained inaccessible to the human eye (scientific photography).

When Man Ray came to photography around 1920, these photographic explorations had already drawn to their close; the world had been photographed from end to end, so to speak.

As early as 1841, the Swiss painter Rodolphe Toepffer, in a text entitled *De la plaque Daguerre, à propos des excursions daguériennes*, described how people's perceptions and imagination had been affected by the unbridled profusion of pictorial information that photography had produced: 'People delighted in the idea that their entire universe would soon be captured and reflected onto metal plates. Towns, cathedrals and empires would exchange striking likenesses with each other. Monuments and ruins, stripped of the mystery that their remoteness, isolation and inaccessibility had engendered, would become everyday sights'.

Photography between the Wars reacted against this bland presentation of reality, against its demystification. Its mass reproduction had deprived reality of its heroism and magnificence. Man Ray and his contemporaries sought to recapture this mystery in the familiar, everyday occurrences that had hitherto been considered too ordinary to merit contemplation: the prow of a ship, a dead leaf, a flower, a heap of stones, an egg-beater.

In 1920, Man Ray photographed Duchamp's work, *La mariée mise à nu par ses célibataires, même*, a sort of industrial drawing on a sheet of glass (also known as *Large Glass*) which had been lying for years, unheeded by the artist, on his studio floor. This photograph is representative of all Man Ray's subsequent photographic works. Because of the studio's dim lighting, the exposure had to last about an hour. The resulting image - a detail of the *Large Glass* - resembled a photograph of a mysterious landscape, taken from an aeroplane. The dust that had gathered over several years, and the traces of cotton wool (cotton) that had been used to clean the glass in parts, gave the impression of a vast sandy stretch seen through clouds. Later, Duchamp was to call this photograph *Elevage de poussière* ('Dust Breeding') (**10**).

By isolating details and robbing them of their familiar context, by making enlargements and choosing unusual angles, the new generation of photographers that sprung up after the First World War tried to bring a sense of wonder back into the now humdrum world. Pierre Bost

describes this process in the Preface to his anthology, *Photographies modernes*, which was published in Paris in 1930. For Bost, 'the problem consists in finding a new meaning for each object, to invest it with some miraculous power. The photographer, in order to discover the unknown in everyday objects, chooses the most unexpected, which is also, as so often, the simplest means: separating the object from the world, he considers only the object itself. This is the true role of photography: to isolate things, so as to render that which is familiar, strange.' The images thus produced showed objects as they were in isolation, but seen through the camera lens. The 'realm of wonders' that the nineteenth-century expeditions had encountered was now to be found only on the inanimate surface of the photographic image.

Unlike most of the photographers in Europe and the United States between the Wars, Man Ray only rarely concerned himself with the decorative side of objects or with the photographic demonstration of their structural regularity or the tactile qualities of their matter. His photographs stemmed from his poetic vision of reality. He concentrated on the fugitive aspects oscillating from light to shadow, creating more of a dream world than a constructive one. From this world stems the associative power of his photographs which often inspired the Surrealist writers.

In Man Ray's pictures things appear to presage something that is not visible but which is accessible to our imagination only. His early Dada photographs, of around 1920, are particularly good examples of this. They show objects that were so familiar - cigar smoke, a wrapped object, the contents of an ashtray - that they were devoid of any voyeuristic appeal. Only through their titles did these reproductions become images. The titles, like the captions on Duchamp's readymades, introduced the viewer to the objects in a roundabout manner: *Transatlantic*, *L'inquiétude*, *Le violon d'Ingres*, *L'énigme d'Isidore Ducasse*, among others.

Thus, photography not only serves our desire to recognize or simply to look at things, it becomes an operational element in visual-literary constructions which seek to appeal to our thought as well as to our imagination. This is why these Dada images appear to us today as the most modern of Man Ray's photographs. With the exception of a few rare works, Man Ray did not use this technique again until *La photographie n'est pas l'art*, a collection of photographs which was published in Paris in 1937. Two pictures, one of a peasant girl and another of a skyscraper, were brought together by a play on words that opposed a *Plein-air artistique* and a *Vide-air Utilitaire*. [1] Underneath another photograph, turned on its side and showing a wooden parapet and its shadow, is written, *Passage entre deux prises de vues* (Literally 'Passage between two shots'). The title *Photo de mode, 'Collection d'hiver'* ('Fashion photograph, "Winter Collection"') adds an ironic element to the image of a pear tree on which the fruit is covered with paper bags.

Man Ray came to photography via painting. He formulated his ideas of these two artistic genres and their relationship in an article entitled *Photography is not Art*, which was published in 1943 in the American magazine *View*, as well as in an essay he wrote in 1960 called *Art is not Photography*. In both these texts he expressed a point of view that Cubist circles, in particular, had developed

before the First World War. Thus, the 'liberation of painting' by photography freed artists from 'the drudgery of reproducing the proportions and the anatomy of those subjects that served them as a vehicle to their full expression' (1943)... 'In other words, painting has been liberated from its purely anecdotal and functional role, and, thanks to photography, it has never been so creative as during the last two generations. At the same time, photography, which was initially considered as a scientific and documentary medium, is also liberated from its strictly "utilitarian" function' (1960), and this gave birth to what Man Ray called 'creative photography'.

It would be a mistake to conclude that, for Man Ray, the latest developments in the historical evolution of photography were to exclude previous ones. On the contrary, in his creative activity, Man Ray did not draw an absolute dividing line between documentary, or 'utilitarian', photography on the one hand, and 'creative photography' on the other. He took documentary photographs of Duchamp's and Picabia's paintings and objects as well as those of other artists. He worked as a fashion photographer for Paul Poiret to satisfy the latter's desire to have 'some original pictures of his mannequins and gowns... giving more human qualities to the pictures' (*Self portrait*, London, 1963). At the same time, he made portraits in his studio according to the individual demands of members of the aristocracy, the *grande bourgeoisie* and the bohemian world of painters and writers who came there to acquire portraits that reflected their various self-images. Along with these commissioned works, to which Man Ray attached a purely documentary value, he also created other works which, from a purely economic standpoint, were not so easily exploitable. Only rarely was he able to place them on the graphics market as he had done with his first rayographs in 1922, when he had them published in forty copies of a portfolio *Champs délicieux*. For the most part, he used them to illustrate art and literature magazines (*La révolution surréaliste*, *Le surréalisme au service de la révolution*, *Variétés*, *Transition*, *Discontinuité*, *Minotaure*, *Cahiers d'art*, *Le phare de Neuilly* and others), or the books of his writer friends. In avant-garde circles Man Ray became the most sought-after illustrator of his time.

The year 1934 saw the publication of *Man Ray Photographs 1920-34 Paris*, a book of 104 selected photographs. In the Preface, 'The Age of Light', Man Ray describes these as autobiographical evidence: 'It is in the spirit of an experience and not of experiment that the following autobiographical images are presented. Seized in moments of visual detachment during periods of emotional contact, these images are oxidized residues, fixed by light and chemical elements, of living organisms'. He then goes on to compare them to the works of a painter who, 'working directly with light and chemistry, so deforms the subject as almost to hide the identity of the original, and creates a new form'.

This description of the photographic process was in line with the avant-garde photographic aesthetics of his time, whether expressed as Constructivism, New Objectivity or Surrealism. Whereas photography had originally offered a fictitious means of overcoming distances, it was now trying to create distances in a fictitious way. This lies at the heart of the aesthetics of 'creative photography'. In the early years, photography had played a part in demystifying the outside world, whereas, in the 1920s, it tended to remystify it.

1. *There is no direct English equivalent of this French pun.*

Notes on the plates

*Brigitte Hermann and
Jean-Hubert Martin*

PLATES 1-10

1. Self portrait, 1932.
There are two known versions of this picture. One of them, reproduced here, shows Man Ray in profile; the other is a three-quarters version. They have been variously dated, between 1930 and 1943. Man Ray himself, however, wrote '1932' on a print belonging to the Crane Collection.

2. Man Ray.
This photograph was taken when Man Ray arrived in Paris. It bears the stamp of Photo-Studios, 18, rue de la Gaîté, Paris, 1921.

3. Untitled.
Luxembourg Gardens, Paris.

4. *Le violon d'Ingres*, 1924.
First published in *Littérature* (No. 13, June 1924), this is undoubtedly one of Man Ray's most famous photographs. Kiki's pose, seated and wearing an oriental turban, recalls that of *La grande baigneuse* in the painting by Ingres.

5. *Coat-stand*, 1920.
Originally published in *Dada New York* in 1921, bearing the title *Dadaphoto*, this picture subsequently appeared in Hans Arp's and El Lissitzsky's *Les ismes de l'art* (Zürich, Munich, Leipzig, 1925, p. 19) under the title *Model*.

6. Tristan Tzara, 1921.
The photograph of a naked woman which Man Ray used as a background for this portrait of Tzara was probably taken by him in New York in 1920. The negative still exists.

7. *Primat de la matière sur la pensée*, 1931.
This appeared in *Le surréalisme au service de la révolution* (No. 3, December 1931).

8. Mina Loy, 1918.
Mina Loy, a painter and poet, was the wife of Arthur Cravan, one of the most outrageous Pre-Dadaists. She frequented the New York avant-garde (she contributed to *The Blind Man* of April-May 1917). This photograph is sometimes entitled *Portrait*. The inclusion of a thermometer echoes a work that he dedicated to Katherine Dreier, *Catherine Barometer* (1920).

9. *La femme*, 1920.
Man Ray called another version of this photograph of an egg-beater *L'homme* (Milan, Vera and Arturo Schwarz Collection). He had already made a cliché-verre entitled *Egg-beater*.

10. *Elevage de poussière*, 1921.
Traditionally dated 1920, this photograph was first published in *Littérature* (15 October 1922, p. 10) in a version using a larger area of the negative. The date 1921 was added to the title, *Vue prise en aéroplane par Man Ray*, with the following inscription:
Voici le domaine de Rrose Sélavy
Comme il est aride. Comme il est fertile
Comme il est joyeux. Comme il est triste!
(This is the domain of Rrose Sélavy/How arid it is. How fertile it is/How happy it is. How sad it is!)
Man Ray thus describes his first encounter with the *Large Glass*, which was lying on Marcel Duchamp's studio floor in New York: 'I suggested to Duchamp that I pick up my camera, which I had never taken out of my place, and photograph his glass as I had offered to do on my first visit to him. ... As I had already noticed, there was only a single unshaded bulb hanging over his work... Looking down on the work as I focused the camera, it appeared like some strange landscape from a bird's-eye view. There was dust on the work and bits of tissue and cotton wadding that had been used to clean up the finished parts, adding to the mystery. This, I thought, was indeed the domain of Duchamp. Later he titled the photograph: *Elevage de Poussière* - 'Bringing up Dust' or 'Dust Breeding'. Since it was to be a long exposure, I opened the shutter and we went out to eat something, returning about an hour later, when I closed the shutter. I hurried back to my basement and developed the plate - I always did my developing at night, not having a darkroom. The negative was perfect.' (*Self Portrait*, pp. 90-91.) On the negative, the instruments that were used to make the *Large Glass* appear in the foreground.

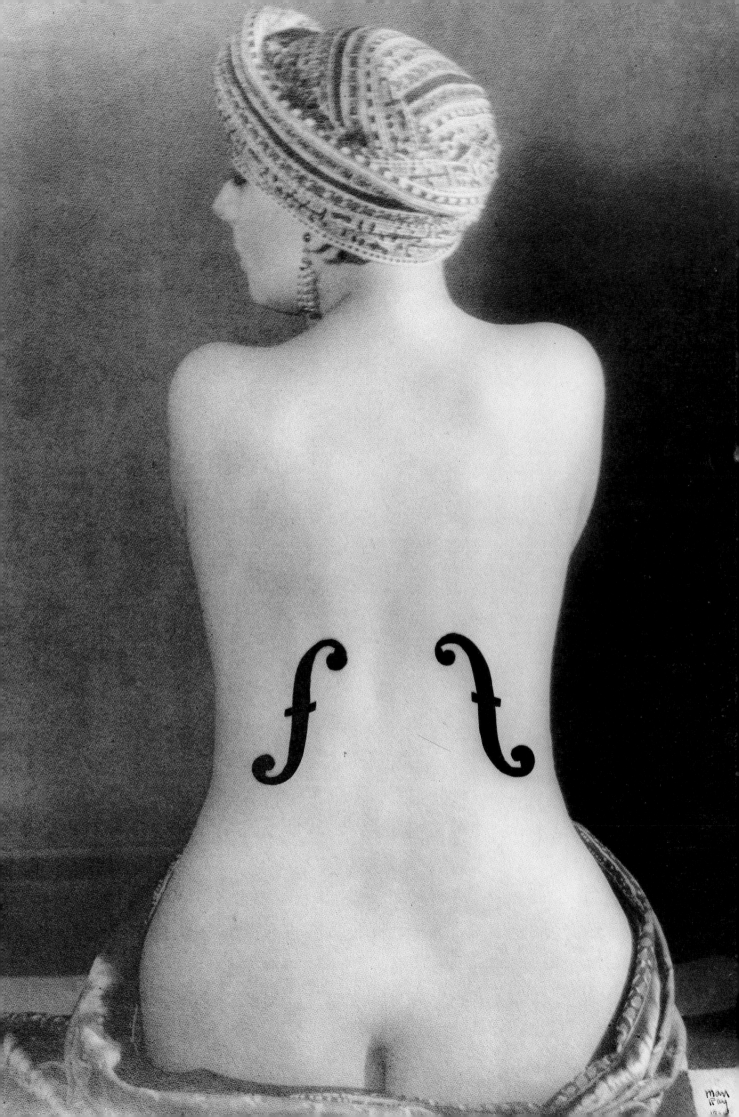

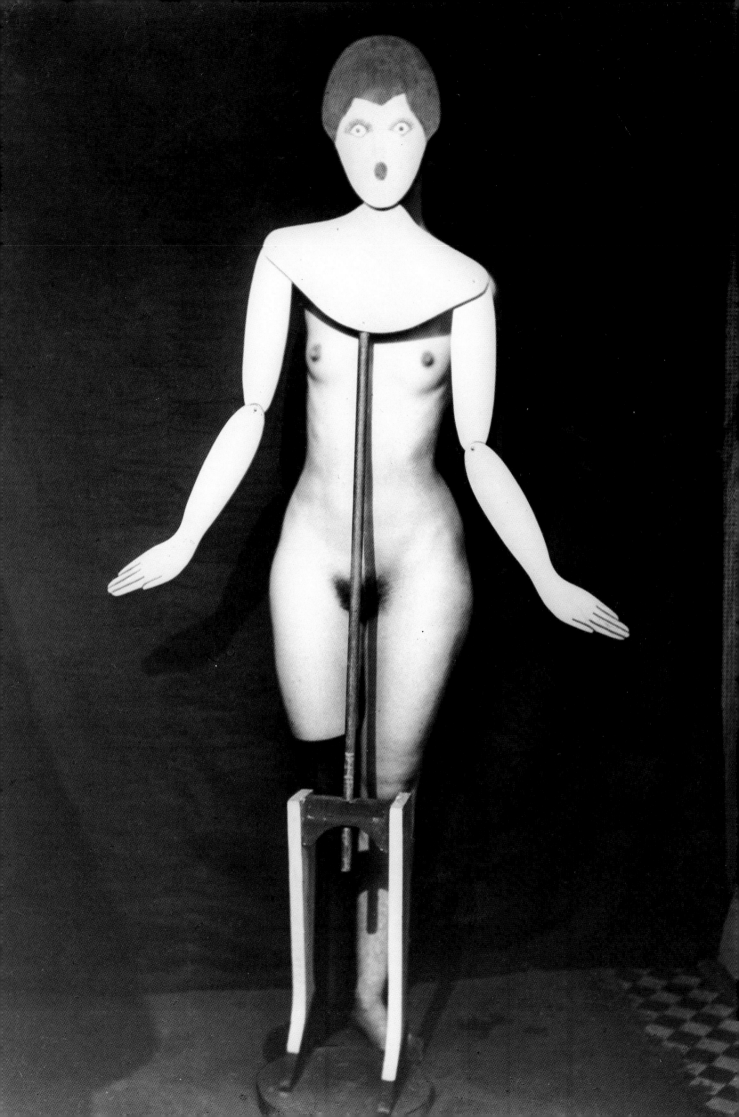

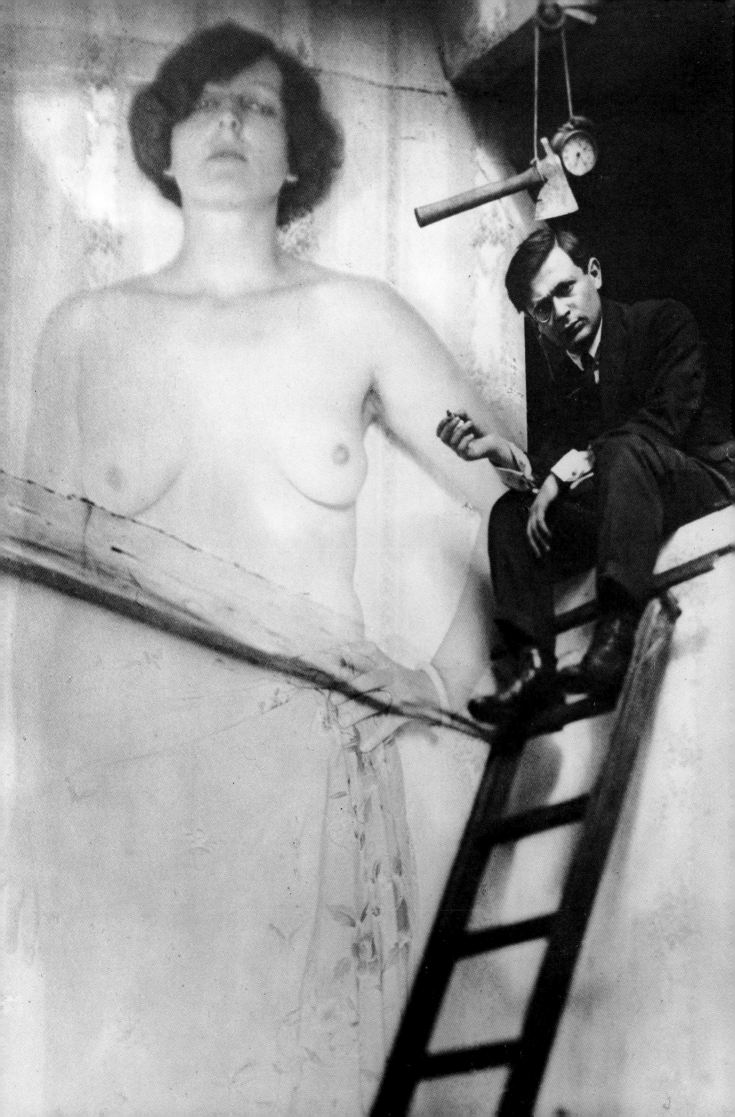

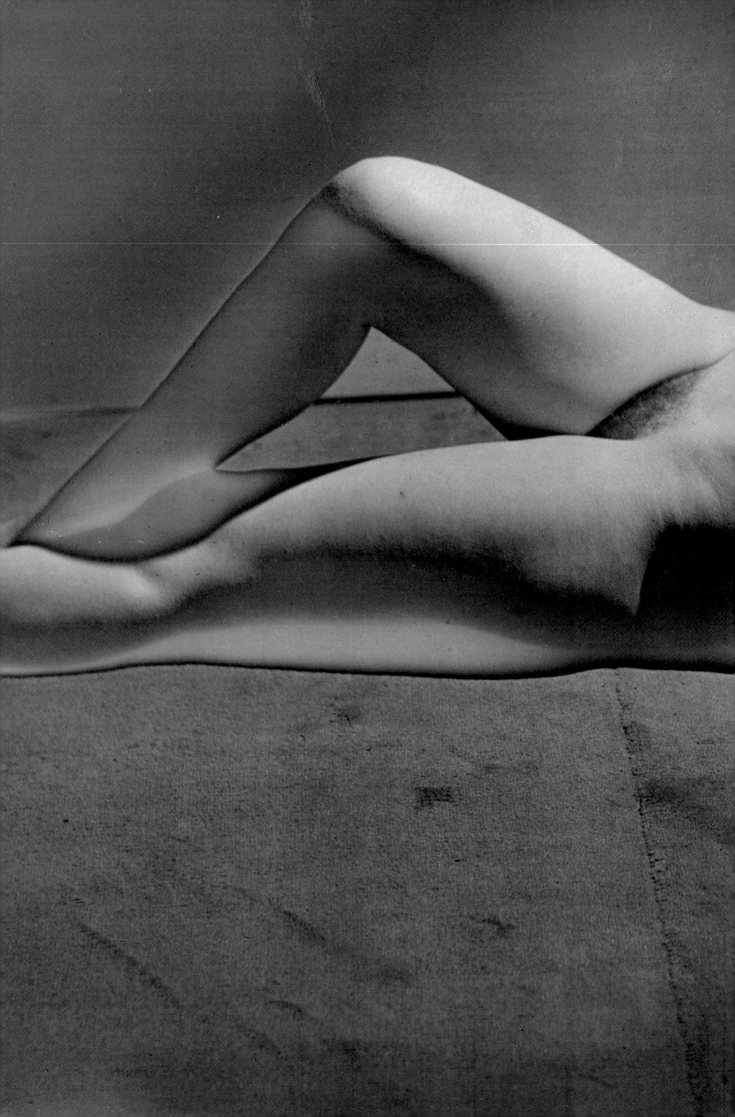

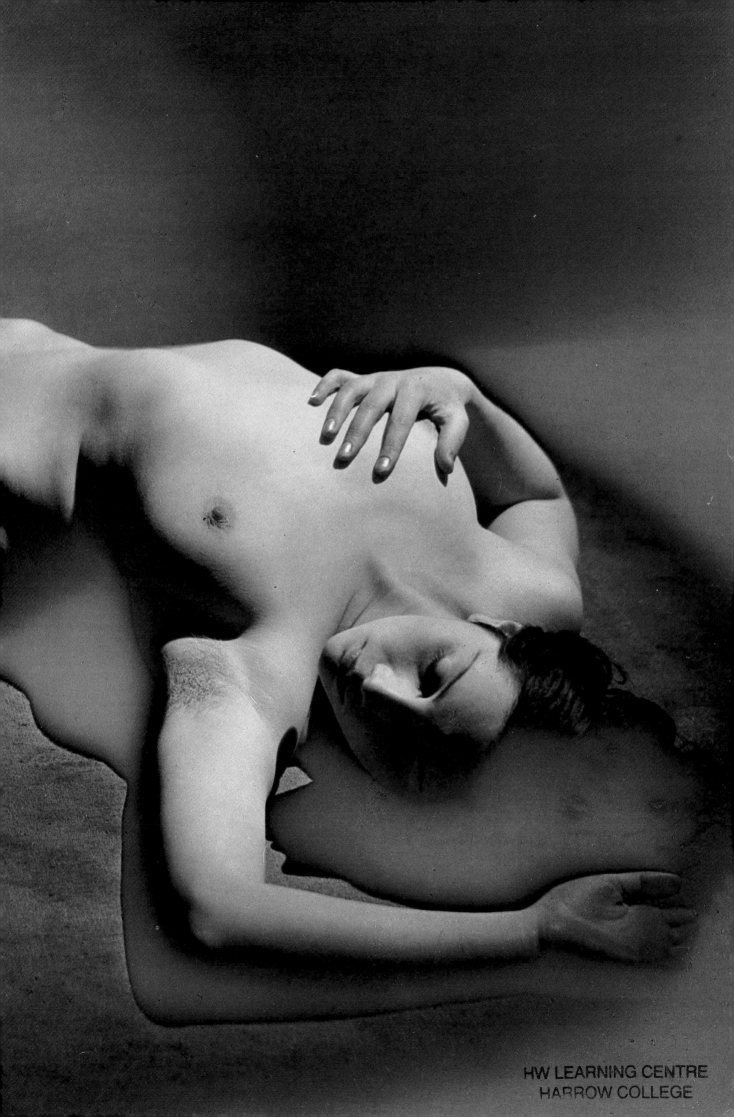

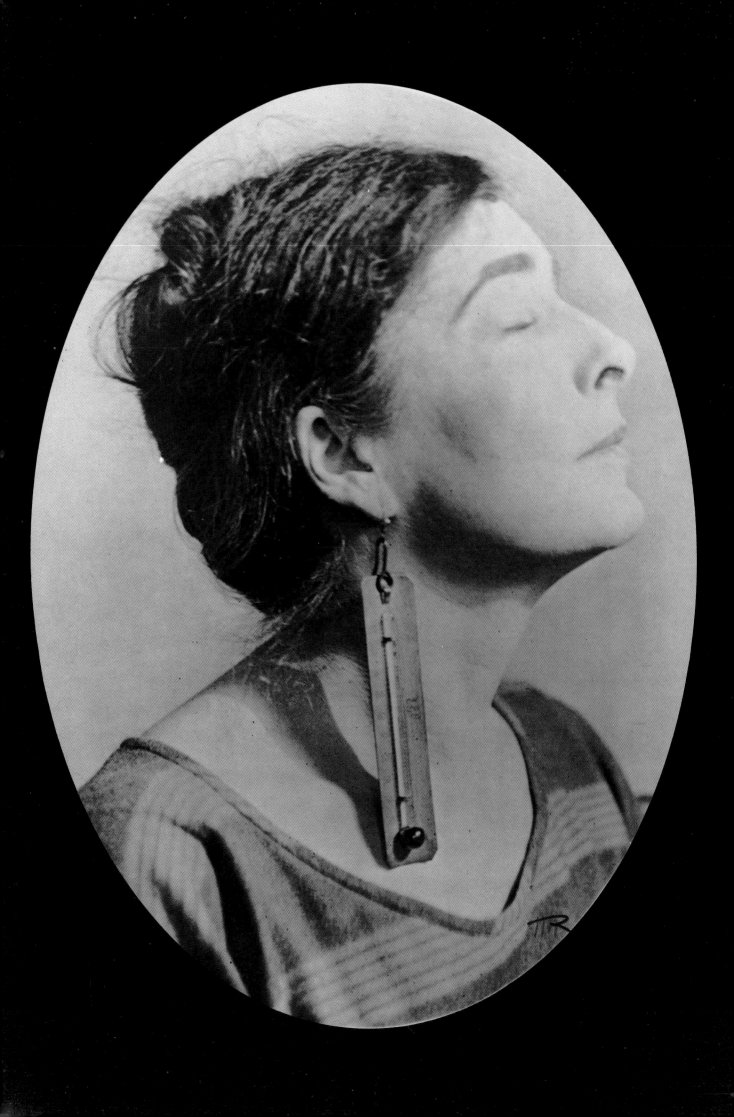

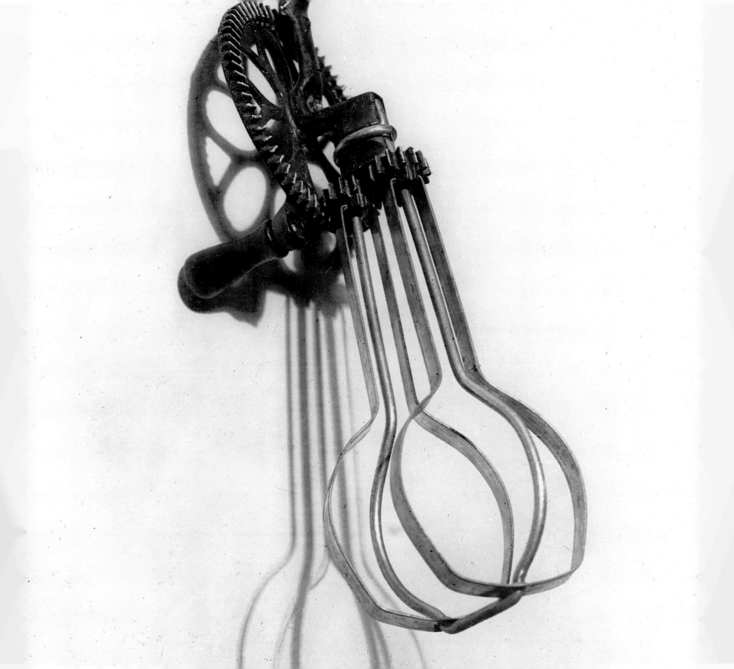

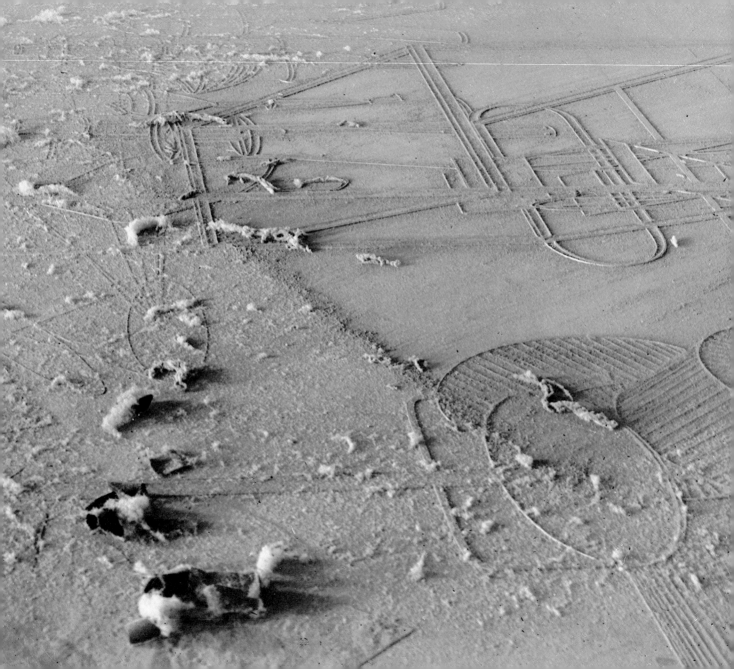

Man Ray expressed this most directly with his rayographs, by fixing the shadowy imprints of commonplace objects: matches, funnels, bottle-openers, feathers, buttons, string, pencils, and so on. He did not invent, but rather rediscovered the 'photogenic drawing' process that William Henry Fox Talbot (one of the inventors of the negative-positive method) had already used in the 1830s. This pre-industrial photographic technique conferred on familiar objects some of the mystery and wonder palpable in the still part-alchemical 'photogenic drawings'.

In 1931 Man Ray combined the rayograph method with photomontage to produce pictures of electrical appliances in a portfolio for the Parisian electricity company, CPDE. Pierre Bost, in the Preface, pointed out that the objects in Man Ray's pictures looked like idols. He considered that this alienating fetishism was inevitable, since the social division of labour excluded the majority of people from any scientific knowledge of the technical products they handled daily. 'We do not understand the wireless, the gramophone or the electric light bulb', he wrote, 'any more than the first man understood sunrise, shooting stars, rainbows or lightning... we have entrusted a body of engineer-preachers with the mission of exploring and interpreting these secrets, and we trust them even though they are not (and cannot be) accountable to anyone.'

Whereas the role of the 'photographic explorations' in the nineteenth century had been to bring people closer to strange and faraway things, their mission in the twentieth century was to remove them from what was close and familiar. It is questionable whether this estrangement of people from their environment was as beneficial as Walter Benjamin stated in his *A Short History of Photography*. In 1938, just as the social and economic crisis between the two Wars was reaching its climax, Man Ray, in a short article for the magazine *XXe siècle* entitled 'La photographie qui console', made the following remark on the critical state of photography: 'If we are to make good use of the complicated machines that we build, we must approach them calmly. Ever since our love of them has replaced the love we had of our fellow beings, one catastrophe follows another'.

In Man Ray's century

Janus

Which was the real Man Ray? Was it the painter, the photographer, the layout artist, the draughtsman, the film-maker, the sculptor, or the inventor of objects? Or was it the writer, the author of hundreds of pages of reflections, stories, critical essays and even a novel? These different aspects of his immense output form part of an indivisible whole and to isolate any one of them risks grave errors of interpretation. As soon as we start to consider Man Ray's photography we find it tending towards painting: if we try to consider his painting exclusively, we are immediately led to consider his photography. His drawings become sculptures (*Les mains libres*, for example), his paintings become objects and his objects are transformed into paintings. There is a constant interplay between the genres, a constant displacement of forms and materials which ultimately converge towards the same goal.

Far removed from Duchamps's esotericism and from Picabia's improvizations, Man Ray's approach was totally rational. He was an intellectual artist who tried to construct one of the many possible worlds that the mind inhabits. Whatever technique he adopted, he worked towards the same project; his works were pieces on a giant chess board. He made no concessions to established aesthetic or spiritual values. With minute care, he aimed at transposing his dreams and thought processes into the realm of mechanics. His creations always stemmed from an idea. He was never drawn to esoteric, illusory or mythological worlds. He conceived of a universe made up of atoms and machines. Not that mystery never attracted him: quite the contrary. But for Man Ray the mysterious and the unknown were of an extremely concrete and clearly defined nature. This reveals one aspect of his philosophical attitude towards that elusive world whose true - or possible - outlines artists seek to reconstruct.

During his early years in New York, Man Ray was quickly attracted to avant-garde circles, and these were influential in the formation of his artistic outlook. He was particularly influenced by Stieglitz and his sophisticated friends. In 1915 he met Duchamp, with whom he formed a mutually stimulating friendship. Perhaps of still more importance was his contact with Francisco Ferrer's anarchist circle. (Ferrer was a Spanish revolutionary who was executed by a firing squad.) Man Ray took life-drawing classes in New York, and during that time he formulated his most original ideas about society. He found kindred spirits in the students and teachers there, and later they put their revolutionary ideas into practice by founding an anarchist colony in Ridgefield, New Jersey, then an almost uninhabited rural spot not far from New York. It was in Ridgefield that Man Ray designed and published (on 31 March 1915) his first artistic-anarchist review, *The Ridgefield Gazook*. Its programme was ironic (though not exclusively so), a rack of bombs set to explode against society. Man Ray always remained true to this form of aggressive and enterprising social criticism, whether in the form of spiking a household iron with nails, turning it into an instrument more menacing than a weapon, or when he admitted in his later years that, if he had not been so lazy, he would sooner have become a gangster than an artist.

During this time in New York he published another review, in collaboration with the anarchist sculptor Adolf Wolf, who had been in prison several times. It came out in March 1919, with the hardly reassuring title of *TNT*. But Man Ray was always a harmless terrorist, confining his subversion to the realm of art; he was a revolutionary of the mind. Nevertheless, behind the creative machinery of his art there was also a concern for society (although he never allowed this to appear openly), which originated in his early contacts with the Ferrer circle. From the start he was dissatisfied with academic and traditional values, and looked for anything which, in however confused a manner, might act against the old bourgeois society. His first exhibition was organized at the Ferrer Center in 1912.

When Man Ray, with Duchamp and Katherine Dreier, founded the first American museum to decide against having fixed premises and to send exhibitions all over the world, he suggested they call the new institution 'Société Anonyme', a name drawn not from the world of art but from the world of industry and commerce.

As we look at these various aspects of Man Ray's thought and work it becomes more and more apparent that for him the artistic problem was, from the beginning, a scientific problem. For Man Ray, art was a mechanism that had to be continually dismantled and reassembled: it was a complicated system where techniques and materials were all-important and where ideas were driven back into a corner as a ridiculous survival of the past. Man Ray appears to be more a scientist than an artist, a scientist analysing culture's contradictions. His work suggests that in order to become an artist today one must go through science.

The Object

The various aspects of Man Ray's work point directly to the heart of the problem: that of transforming, from the inside, our picture not of aesthetics but of science, our picture of the technical world and of society - in short, our picture of knowledge. He constructed a city in which mannequins, shadows both false and real, and objects all dictated their own specific laws. If we glimpse an overall view of the world of the 'objects of his affection', we are

immediately immersed in a universe which we never tire of exploring, whose limits are extended not only according to the constructor's will but also according to the particular viewpoint of the spectator, who is gradually drawn in and captured. Man Ray's world is a world of infinite dimensions where nothing is in its right place, but is constantly sliding out of its shell and undergoing a total change in appearance. Even the names Man Ray gave to his works contribute to their displacement in space. They are snatched out of their bourgeois reality and inserted into a world with a different mental framework, in a way which is intended not only to provoke but also to stimulate.

What is the meaning of these objects that attempt to weigh the weightlessness of a feather? What are these steel balls enclosed in an olive jar? What are these objects that make an infinity of absurd combinations out of little bits of wood, metal or cloth? No doubt they are there to reawaken our sense of wonderment. Perhaps they are there to schock those who cannot accept any shift in the traditional image. But they also have a far more ambitious goal. They aim at displacing the bourgeois self-image with an alternative, far removed from the normally tranquil, prudent and virtuous bourgeoisie. Man Ray did not like this kind of virtue. Who could deny that such bourgeois virtues are, in their own way, charged with horror? The 'objects of Man Ray's affection' were a form of punishment that he sadistically inflicted on the bourgeoisie. He punished them for always having viewed their objects through the same eyes, for having regarded them so blindly, from their own point of view. He punished them for never conceiving that other mirrors and other visions existed. His art was a series of whiplashes; the equivalent of the flagellations to which Sade's characters so often subjected themselves with such voluptuous pleasure. This is the philosophical interpretation that allows us to enter the labyrinth of Man Ray's objects, and to contemplate them stripped bare, sharp instruments designed to winkle out all the ideas of reality that tradition, habit, morality, or the intellectual laziness of people presumptuous enough to believe they have attained wisdom, make us take for granted. All his life Man Ray demonstrated through his works exactly the opposite; that the bourgeoisie is neither wise nor virtuous, that it is certainly not the guardian of the truth, not even of the faithful representation of images.

Man Ray's objects are a statement of coherence in the midst of highly paradoxical and disconcerting propositions. They are not objects (or not only objects), but finely honed weapons that could be lethal in the hands of someone with a piercing mind like his. He used them to wreak havoc in the ranks of the enemy as well as to affirm his own truths and to claim his right to a different outlook on life. Man Ray's objects can be obstinate, resolute and serious in the midst of an apparent desacralization of form and traditional usage. In their way, these objects offer their own life syntax, their own proletarian ethic. They are simple, and immediate, but also vital. They can only be produced by a poor, humble and oppressed society. When it becomes richer and acquires more power, the objects are no longer adapted to the myths of a world that demands an absolute obedience, both from the people that serve it and from the objects at its disposal. The affluent classes need perfectly recognizable objects, objects they can use without danger, whether they be magnificent amphoras or jewels, paintings that they can

confine within their frames and place with precision on the wall, elegant furniture, tapestries and carpets, weapons both efficient and finely ornamented, welcoming armchairs, fine decoration and high-quality tableware. The 'objects of Man Ray's affection' - one might prefer to call them 'non-natural objects' - are the opposite of all that; they are not recognizable, they are not destined for use and they can even be dangerous, threatening to the mind at least. Yet they are not a radical negation, in the sense that Duchamp's objects were continually on the brink of a void. Man Ray needed to formulate a discourse, he needed to give meaning to his forms. Duchamp, in each of his readymades, even excluded thought itself.

Man Ray must be defined, not as a painter, nor as a photographer, nor as a film-maker, but rather as a 'master painter' or 'painter of ideas'. It is impossible to tell which of Man Ray's objects is the most beautiful or the most suggestive, primarily because it is not their aim to be either. They do not aim at being masterpieces. Their goal is simplicity of expression. It seems that their didactic and scientific goals take precedence over all other considerations. They belong to a kind of semantic chain whose purpose is usefulness, an attempt to provide a definition of an attainable mankind of the future.

Man Ray presented us with irons spiked with nails - of which he made several versions (*repetita juvant* also applies to art) - metronomes, with or without inviting eyes, bronzed or blue-coloured bread, plaster pipes topped with glass bulbs, stringless musical instruments, mannequins that are always available for sex education demonstrations (here again we find the same ironic didactic goal), lampshades and coat-stands that are neither lampshades nor coat-stands, and innumerable other irreverent transpositions of matter (that is, of morality); all contribute to the plot of a long narrative that has something of the *roman philosophique* and something of the *commedia dell'arte*.

Man Ray's objects are, in fact, transparent. They allow us to go beyond the object, to go below the surface of things, they allow us to enter into a more complex form of reasoning on the ambiguity of meaning. They are like Alice's jam-jar, caught in mid air in the White Rabbit's burrow. They are like the food and drink that made Alice smaller or bigger at will. Man Ray's objects (as well as his photographs) continually stress the idea that forms either stretch out physically in space or else they disappear.

The Object is a Machine

In the past there were fewer objects, not only because there was no industry capable of spilling out mass produced objects onto the market, but also because people had far less need for surrounding themselves with fetishes, with material goods. People had less need for objects in which to see themselves, for objects they could use. Without doubt, their needs were more limited. This was before our wasteful epoch, in which people need, and at the same time burn, everything they lay their hands on. Art, therefore, although divided into major and minor arts, did not need so many objects to include in its museum, save the traditional objects (including everyday utensils) that had been passed down through the ages. No one imagined that, one day, objects would be multiplied to such an extent, and especially not in such unexpected areas. Art discovered that it was even possible to entertain the idea of uselessness, of cast-offs, of debris, that it could retrieve things that had been over-hastily thrown into a

corner or destroyed. Man Ray's objects occupied the empty space that lay waiting to be filled. His objects were never arbitrary, they were never fortuitous. They were constructed with the precise goal of furthering our intellectual awareness. They belong to a kind of art factory and they are proud of taking part in the civilization of their time. Like perfect thinking machines, they are aware of being indispensable cogs in life's machinery.

Man Ray's 'object' is like a machine, it is yet another instrument with which we may ask ourselves what the world's destiny will be. It is a key fitting many locks, but no lock in particular. This applies equally to his pre-Dadaist objects, to the 'objects of his affection', and to his 'mathematical objects'. On the one hand his objects are solitary presences, on the other hand they are like a thundering crowd. They are totally individualistic, yet at the same time they have a collective force by virtue of the fact that they can multiply and be regenerated *ad infinitum* according to yet another of Man Ray's tendencies, which was to consider them, at the time of their creation, as unique and unrepeatable forms (especially from other people's point of view), and then, immediately afterwards, to desire their continued propagation, their unlimited production. This was the only way the object could hope to survive in a society which destroys everything it uses and everything it lays its eyes on. From a philosophical point of view, the object is even more important than a painting. A painting has nothing to defend itself against the destroying hand of time, nor can it act against the destructibility that stems from its inherent structure. Man Ray went even further. He considered that the reproduction of a painting in a catalogue was of far more significance than the painting itself. Through this kind of transposition, the painting became absolutely useless, or alternatively it simply became a product, a piece of merchandise bearing no relation to Art. Its faithful reproduction was the only pure work of art. It was free from any commercial or economic contamination. Man Ray declared this very explicitly in his autobiography. Speaking about one of his most famous paintings, *A l'heure de l'observatoire - Les amoureux*, he said 'I won't be satisfied until I have seen it reproduced in two-page colour in a book on Surrealism. Only then will I be sure of its permanence. The preservation of the original worries me far less.'

Photography

It is clear, therefore, how Man Ray's objects became photographs. Photography provides all the necessary connotations that the above-mentioned philosophical concept requires: speedy execution, synthesis, the impossibility of harking back to an illusory original model (no unique work is left, the negative can be multiplied), the image can be reproduced *ad infinitum*, and, at the same time, a similar richness of variation and transformation can be obtained from the negative in the laboratory. A photograph, therefore, is the mind's most perfect creation. It is always true to itself, however diverse. The space separating the external and the internal image is far smaller and far more immediate than that which exists between a painting and its reproduction on the pages of a book. A painting can very well die and disappear. The model that existed at the outset, as a configuration, ceases to exist as soon as it has been seized by the camera. If an

original is to be found, it lies in the country or mountain landscape upon which the photographer focuses, it lies around the house that attracted his lens, in the well-known or unknown personality who posed in front of his camera. In short, the original is the model. Duchamp, Tristan Tzara, Virginia Woolf and Sinclair Lewis, of whom Man Ray made portraits, were all dead and buried long before their time, before their real death, along with many of the other protagonists of modern culture. They died at the very moment when they decided to comply with the photographer's will, when, in an instant, they were dissolved into space, when they became unreal, when they were turned into phantoms. What was left of the life each had yet to live had nothing to do with the destiny of the photographic print it had produced: it was already something different, no longer bearing any resemblance to the photograph. The *reductio ad absurdum* of this position is that if someone wants to commercialize photographic works, he or she should sell, not the photograph, but its model, whether a landscape, a still life, or a flesh-and-blood personality. This explains why Man Ray often photographed things that he invented and built for the occasion. And even in these cases there is no distinction between the photograph of an object and the photograph of a living person.

In practice Man Ray succeeded in accomplishing a revolutionary operation, that of always photographing the photograph, which is quite different from photographing objects that have nothing to do with the photograph. This attitude is quite unique and has no parallel in either the traditional or the non-traditional photographic canon. Man Ray was not only the photographer, but also the subject of his own photographs. The camera always has its shadow before it, is always at a slight distance from the image. It is always multiplying itself, as if there were an infinity of cameras between the artist using it and the reality it portrays, as if it were always mindful of its eventual destruction. With Man Ray there is no longer a model in the way, but rather he photographed what he wanted or desired to see, what he imagined he saw and what he wanted to imagine. The imaginary model escapes our grasp. We are left with the ideal model: the photograph viewing the photograph, the photograph reproducing the photograph, the photograph photographing the photograph in its renewed destruction and in its renewed eternity.

The camera

We are in the process of creating a new photographic genealogy, where every detail of the world's history is recorded for a posterity which already waits to receive it with stupor and anguish. Man Ray is at the heart of this revolution, between the object-object, that reproduces a fantasy world, and the object-photograph, which reproduces the hypothesis of the image; on the one hand we have the 'non-natural object', or the philosophical object, and on the other we have the proletarian object, the collective object, reaching out to infinity before our very eyes. We have the portrait without a portrait, the landscape without a landscape, the composition which dissolves as soon as the photograph has been taken and the photograph which ressembles a mask. At this point, the image eludes even the camera (in the collage, the rayograph, the solarization and so on, where we see Man Ray's mind evolving with the same intellectual vigour),

and the artistic circle is complete. For the camera without photography is the artistic paradox *par excellence*. We have perfection without the need for action, thought no longer needing to think, the Divine Machine that from now on creates everything, the machine in its own image. The camera's function is no longer that of photographing, but that of existing in itself, for itself, higher than humanity. In that absolute solitude which has become its own, the machine is human.

Man Ray's camera, therefore, has a twofold value: it attracts the image, but also repels it; it pierces reality; but is also outside reality; it embraces the world's boundaries but is also excluded from them; it is both of the greatest necessity and of the utmost uselessness. The camera already belongs to a dying race. It is an instrument of truth but, above all, it is an instrument of death. Its task is that of killing, in the instant it comes face to face with reality. Its primary task is that of destruction: the image that comes out of it is like a corpse on a dissecting table. The artist-photographer alone tries to bring it back to life single-handed, so as to bequeath it to the future. Man Ray was an exorcist wandering among the world's sepulchres, evoking what life unceasingly passes over; he was even willing to kill the camera when he realized that it had, above all, become an obstacle. To come to photography without making use of such a headstrong mechanical or electronic presence implies constantly overturning the parameters, stripping the camera of part of its power as well as of part of its fiction. The power and arrogance that the camera unquestionably possesses have to be resisted, as does its implacable inner cruelty.

The rayograph, for example, thus takes on an extra-ordinary significance. It belongs to two quite distinct areas of knowledge, that of humankind and that of the machine, and both of these pinpoint the basic question of man's identity. The rayograph is a social indicator. It indirectly describes our time far better than any illustra-tive means and far better than any analytic framework. The rayograph upsets the image so that it may be observed from the inside. Dialectically, it passes from an often illusory proximity to an often more objective *rapprochement*, and its great polemic force lies in its oscillation between these two moments, both of which are of prime importance. From the first to the last, Man Ray's photographs should be viewed and judged from this angle. They all have something in common with the rayograph, even when the technique is different: it is as if the slightly heretical and absurd elements of the rayo-graph insinuate themselves into the gaps in his photo-graphs. I am not referring exclusively to the old cliché-verre of the early American period, or even to the classic and archetypal *Elevage de poussière*, which is worth a book to itself. I am thinking more particularly of the *Voie lactées*, the later photographs that were traditionally composed with a camera but no longer betray the camera's presence.

Photography continually mixes with the camera and its negation. The machine, however, is always elsewhere, it is in its creator's eye, under Man Ray's skin, in his look and in his hands, it is inside his body. His camera is his brain. And so it becomes obvious how he was often able to do without his camera, how he often tired of it, how he even ended up despising it and how he preferred anonymous old cameras to the sophisticated and perfected detail of electronics. To the students who brought their prints to him in America, he would disdainfully reply 'You didn't do these, Mister Kodak did.' Man Ray was always above the camera.

Painting

We have examined two fundamental aspects of Man Ray's 'objects'. The first kind has been referred to as 'non-natural object', or 'artificial object', and the second kind as in effect photography in its function as object. Painting is the third aspect of his work that plays an important role. Here again, his paintings are, above all, objects, both from the technical point of view and from that of content. As far as technique was concerned, Man Ray was always open to any system that would allow him to do away with the paint brush, that would allow him to go beyond it, notwithstanding the fact that he continued to make good use of that noble and ancient instrument. One of his most characteristic creations was the aerograph. He introduced it into his painting around 1917. With the aerograph, he had the exhilarating sensation of painting with his mind. Many other painters subsequently used this very speedy technique, but at the time Man Ray used it in his painting (between 1917 and 1919), it still retained all its revolution-ary force. The spray-gun is a psychological machine that only half belongs to painting. The other half belongs to science. Thus it is one of the collectively used instruments of which Man Ray was so fond.

Man Ray's object-painting was soon afterwards enriched with another technical invention which emerged from his original use of paper cuttings. The ten works that resulted, entitled *Revolving Doors*, are particularly exquisite; they are technically refined constructions that sail through painting like the prow of a ship through stormy waters. Basically collages, obtained by the superimposition of transparent paper which produced a chromatic blend, they were hung, not on the wall, but in the air, back to back in twos (so that they turned like the elements of a mobile). They were like ever-open and ever-closed doors in space, like tiny windows on the unknown. Man Ray later made lithographs from them, either because their function was that of being multiplied like any other object, or because their form and chromatic composition made them similar to photography. They are painting's rayographs.

Later, his alchemy produced his *Shakespearean Equa-tions*, paintings that are again direct descendants of the machine. They began as a series of photographs of mathematical objects representing algebraic equations preserved in the Institut Poincaré in Paris. Later he made them more stylized and produced the object-paintings with the same title, which mark one of the most fascinating high points of Man Ray's production. They are so well known that it would be pointless to speak further of them here. But I should mention his 'natural paintings', which were obtained by pressing together two surfaces spread with colour and then abruptly separating them, so that the result was partly subject to chance and partly determined by the initial pattern.

When he once more took up the patient paintbrush, Man Ray also obtained stunning results, half mechanical and half human. The giant lips in the famous *A l'heure de l'observatoire - Les amoureux* are a gigantic machine floating in space, a spaceship coming from the other end of the galaxy. Another timeless masterpiece, *Le beau temps*, 1939, is a description of a series of dreams (if we analyse it deeply enough), as well as being an intricate piece of

machinery. Here, the painting is also a 'marvellous, object'.

Man Ray's pictorial works are generally harsher than his photographs, even though the colour does help to soften them a little. But foreign elements always seem to creep into their structure and deeply disrupt it. A flower bends forward threateningly, mannequins appear from some other dimension, pawns seem to move on the chess board of their own volition, a shadow pursues a fleeing man, stones become portraits, portraits seem to spring out of the camera. There are whole series of ambiguous and conflicting presences that arise both from the technique Man Ray adopted and from the unremittingly coherent meaning he gave his works. His paintings are some of the most subtly charming of our time. And this is not only because they always remain a little apart from painting, whatever the technique, not only because of their strange and arduous beauty, but also because, as I have already said, they are of a twofold nature. They are part painting and part science. They are material objects. They are sustained by their author's polyvalence and by his immense talent, both of which allowed him the greatest virtuosity. In the depths of art's incandescent matter, we can discover another truth about Man Ray: he was also a true painter.

Machines become paintings, but paintings eat everything alive. ∎

Photography is not art

Man Ray

'*I wish I could change my sex as I change my shirt.*'
ANDRÉ BRETON

Ask me, if you like, to choose what I consider the ten best photographs I have produced until now, and here is my reply:

1. An accidental snap-shot of a shadow between two other carefully posed pictures of a girl in a bathing suit.

2. A close-up of an ant colony transported to the laboratory, and illuminated by a flash.

3. A twilight picture of the Empire State building completely emptied of its tenants.

4. A girl in negligee attire, calling for help or merely attracting attention.

5. A black and white print obtained by placing a funnel into the tray of developing liquid, and turning the light onto the submerged paper.

6. A dying leaf, its curled ends desperately clawing the air.

7. Close-up of an eye with the lashes well made up, a glass tear resting on the cheek.

8. Frozen fireworks on the night of a 14th of July in Paris.

9. Photograph of a painting called, 'The rope dancer accompanies herself with her shadows. Man Ray 1916.'

10. Photograph of a broken chair carried home from Griffith Park, Hollywood, at one of its broken legs the slippers of Anna Pavlova.

Do you doubt my sincerity? Really, if you imagine that I value your opinion enough to waste two minutes of my precious time trying to convince you, you are entirely mistaken.

Let me digress for a moment. Some time ago, in the course of a conversation, Paul Eluard proclaimed very simply, 'I detest the horse.' And yet the horse in Art... from Uccello to Chirico, the horse reappears again and again as a dream motive and as a symbol of woman. Its popularity is universal, from the most vulgar chromo of the racing fan to the painting full of implications by the psychologist. One of the reasons we have to thank abstract art is that it has freed us from this obsession. One would have thought that a single picture of the horse would have been sufficient once and for all to dispose of this preoccupation, and that never again would an Artist have resorted to the same motive. Noble animal! The horse a noble animal? Then are we by comparison nothing but dogs, good or bad, as the case may be. The dog's attachment to man is not the result of any similarity that may exist in physiognomy between him and man, nor even of odor. What attaches the dog is his own capacity for loving. The dog is such a complete lover. The horse, however, like the cat, is content with *being* loved. But *we* are not such good lovers, we humor the horse for his hoofs as we cater to the cat for her guts, and our affection and caresses are calculated to exploit their attributes. And so we kid the dog along for his doggedness. So agree; the dog is the only animal that knows what real love is. With his set expression, but unlike that of his determined master, he has no hope, no ambition, he has only the desire for the regular caress and the bone. Take the following example. It is a one-sided but true story of man's perfidy:

For fifteen years this woman has been raising dogs. Now she is twenty-four years old, and wishes to retire. She wants to sell her dogs, fifty-seven of them, all pedigreed, sell them so that she may retire and devote the rest of her life to writing poetry. She speaks,

Yesterday was a cocoon
Tomorrow will be a butterfly
Tonight as I sit and gaze at the moon
I wonder and mutter 'WHY ?'

Speaking of horses, personally, I admit I have never been able to draw a horse, nor for that matter, photograph one. But that is merely a question of habit like so many other of our prized accomplishments. When I was called out to do a portrait of the Maharaja's favorite racing nag, I had considered myself fortunate to be living in an age that put the camera at my disposal. Leonardo and Dürer had racked their brains to produce an optical instrument, if only as an aid to their drawing. It was not their fault (nor very much to their credit) that they were unable to perfect a device that might have freed them entirely from the drudgery of reproducing the proportions and the anatomy of those subjects that served them as a vehicle to their full expression, vehicles that so many of us still admire and emulate. We, some of us, still repeat them, and with them we admire the drudgery that they involve. 'What,' do you say, 'should we do today; draw autos and planes ? This involves just as much drudgery, if we do not use the camera, which after all is not a sensitive instrument like the hand.' I wish to point out here that the horse has one advantage over modern vehicles, and that advantage has confused the Artist down to the present time. The horse does not have to be built, he already exists. Whereas the automobile or the airplane must be drawn again and again to bring them to the state of perfection attained long ago by the horse. Once that perfection attained, the camera will come into its own, to record the perfected new vehicle. Yes, with all the variations of proportion, distortion, light and shade that have been applied to the interpretation of the horse. The camera waits for the human hand to catch up with it.

But why was I unable to photograph the horse, that already perfected animal ? Let me explain. I took him full-face, three-quarters, profile. I caught the white star on his forehead, his liquid eyes, his beautiful glossy skin with its nervous veins, the quivering nostrils, (I'm sorry, the camera was too fast for that, but we know horses' nostrils quiver). However, when I showed the results to the trainer, his face assumed a worried look. 'Ah, but you haven't got his soul.' I ask you, now, how was I to know the animal had a soul like we humans. I have been told so often in my portraits of men and women that I have caught their soul. I do not wish to apologize, I simply conclude that I have no feeling whatsoever for the horse. I admit it, and from now on I shall loudly proclaim it, before any one else can accuse me of lack of feeling or imagination. In short, I detest the horse, and you shall hear no more about the noble animal !

Dear gentle but ruthless reader, if I seem to cover a great deal of ground in too short a space (of time), remember that I am a product of my times and proud of it. I travel in modern vehicles and avoid circumlocution. I have the choice of the means of locomotion. Nevertheless, I consent to stop again by the wayside for an instant, and introduce you to one of my oldest friends, THE ARTIFICIAL FLORIST. Realizing long ago that the perfect crime does not exist, any more than perfect love can exist, and if these existed, we would not call them either crime or love; realizing a state of things that opens the way to repeated effort, he cast about for an object capable of improvement, or of modification, in that it

lacked at least one desirable quality. We all love flowers, that goes without saying, but I wish to state it, although others expect of me so many things without saying so. The flower, in all its perfection, lacks one quality, that of permanence. This has been one of the chief concerns in art for centuries, both material and esthetic. Of course, nature has found a substitute for permanence, in repetition, but that is not an admitted human function. Anyhow, when man turns to imitating the processes of nature, he invariably tries to substitute permanence for repetition, just as he tries to reproduce all the various lever movements in nature with the principle of the wheel, which does not exist in nature. In the same manner, he carries the confusion even into such comparative human activities as painting and photography, to the extent of imagining that he is making a good drawing, when he is simply making a poor photograph, or that he is making a work of art with the camera when he makes a good automatic drawing with it. Here may I ask you, reader, to read this foregoing statement several times to get my meaning. You see I ask you now to slow down your pace, just as you asked me to do previously, except that my trajectory enters into the realm of the permanent while you in the role of reader must practice the art of repetition at this time.

To return to my ARTIFICIAL FLORIST; loving flowers as he did, and being more human than nature-loving, he wished to assure himself of the permanence of certain blooms. The choice of two courses lay open to him, either to paint them, or to make the actual artificial flower, and he made his decision in the following manner: Looking one day at a painting that meant nothing to him he asked me to explain what there was beautiful about it. I replied that I would, after he had explained to me what there was beautiful about a painting of flowers. 'One can

then still have them in winter time', he answered. Thus we both skillfully parried the question of beauty. But his mind was made up from then on; he would make actual flowers, instead of painting them, flowers that would not fade, but be permanent, like painted flowers. The question of odor did not enter into the project, since no one had ever demanded of painted flowers that they smell. ARTIFICIAL FLORIST became very expert in the making of permanent flowers, so that at a short distance they were easily mistaken for nature's work. One day I came around with my camera and photographed the permanent flowers. I took them against the sky, I added drops of water to simulate the dew, and I even put a bee in the chalice of one them. However, when I showed the results to FLORIST, his face fell. 'Ah, but you haven't got their souls.' Once again I had failed. Now I ask you, how can we ever get together on the question of beauty?

This dilemma, fortunately no longer troubles a self-respecting Artist. In fact, to him the word beauty has become a red rag, and with reason. I am not being sarcastic, but mean it in all sincerity, when I say that the Artist even when copying another, works under the illusion that he is covering ground which he imagines no one has covered before him. He is then necessarily discovering a new beauty which only he can appreciate, to begin with. (In this respect he really returns to nature, because he employs her time-honored mode of repetition, unconsciously. Only the desire to make a permanent work is conscious.) Aside from this, *the success with which the Artist is able to conceal the source of his inspiration, is the measure of his originality.* The final defense is, of course, 'I paint what I like,' meaning he paints what he likes most, or he paints that which he fears, or which is beyond his attainments, in the hope of mastering it.

Happily, most of the pioneers of the past two generations have freed themselves from these obsessions and the rot of past performances. A few are still walking ahead with their heads completely turned around, looking backwards as they advance, in an impossible anatomical position in spite of their respect for the old masters. Then there are the few pessimists and disillusioned ones, bewildered and discouraged, who say, 'What is the use, in medical parlance, whether the stool is easy and abundant or difficult and meagre, the anus is equally soiled.' As for the practical ones who are always ready with their wash-rag, soap and water, they can take care of themselves. But it is useless to deny the future, and especially the present...

Have you ever tried looking at a Veronese or a Vermeer through a red glass? They become as modern as a black and white photograph. And how often has a painter, upon seeing a black and white reproduction of his work, had a secret feeling that it was better than the original. The reason is that the image thus becomes an *optical* image. In the last few generations our eyes and brains have become *optically* conscious, not merely plastically conscious. Turner and the impressionists were the first painters to develop this optical nerve in color. It was a mere hazard that photography began with the black and white image, perhaps it was even fortunate for the possibilities of a new art, or that a new art might become possible. The violent attacks by painters on photography were mitigated by its lack of color, of which they still had the monopoly, and they could afford a certain indulgence. Just as in writing, 'l'humeur noir' had been considered the bastard child, a new black and white graphic medium

could never be feared as a serious competitor. But, if this humor should assume all the colored facets of a serious form, like the present discourse, or if a photograph should break out into all the colored growths accessible to the painter, then the situation would indeed become serious for the exclusive painter. Then the danger of photography becoming a succeeding art, instead of simply another art would be imminent. Or rather, the danger of photography becoming simply Art instead of remaining AN art. To complete this result, a little research and some determination could prove that whatever was possible in the plastic domain, was equally feasible in the optical domain. The trained human eye, guiding one of glass, could capture as wide a field as had been controlled by a more or less trained hand guided by a half-closed eye.

It is the photographer himself who is to blame for his lack of standing amongst art dealers accredited by their supporters, and self-accredited critics. Until now he has relied too implicitly on the short-sighted scientists who have furnished him the materials of his medium. His concern with *how* the thing is to be done, instead of *what* is to be done, is a repetition of the spirit that held in the early days of painting, when painters went about smelling each other's oils. Of course, painting dates back 10,000 years, while photography is barely a century old, and there is hope for it. The photographer has pulled his little Jack Horner, has pulled the chestnuts out of the fire for the scientists and the manufacturers, and it is time he kick over the bucket and put out the fire. Wet chestnuts are better than singed fingers, a drop in the bucket cannot compete with a plum out of a pie, but even so, the greatest thrill can be obtained only by throwing the whole pie into the face of those who have arrogated to themselves the monopoly of intelligence, perception and knowledge. Proverbs are at their best when they are reversed, as practised by our most revered poets, who also have announced that poetry should be practised by all. I remember one poet, especially, in the course of a talk, accused of irrelevance, and requested to stick to the subject of poetry, replying, 'Damn it, this is poetry!' In another instance, the poet spits in the face of those who are charmed with the form of his writing and politely ignore the too inflammatory content. We can no longer be satisfied with the ivory tower of quality, but that does not mean we shall make a point of setting up our artistic headquarters in a steel skyscraper, which would be equally evasive. A cry or a song emanating from a palace or a prison, if they are loud enough, can stop us dead in our tracks. I do not think the architecture has anything to do with the message, with human functioning, any more than a sunset is motivated by esthetic considerations on the part of nature.

We can only see, hear, feel what we have been in the habit of seeing, hearing and feeling, or if it is a new and unfamiliar world, we must be prepared in advance and disposed for its reception. The optimistic subject that comes into my studio with the concentrated idea of having a successful photographic portrait of himself, does not even see the for him weird and abstract canvases on the walls. The colored houseboy who comes in to clean up the place, still throbbing from a night's dancing to his favorite swing, is spell-bound by the colors and forms on the walls. The least he can do to express his enthusiasm is to offer to buy a painting, which, of course, I sell him in that same spirit of make-believe that children play store and trade with each other. But, a strange transformation

has occurred in the house-boy, he becomes a full-fledged artist in his own right, a poet of the dust, which he disturbs with the greatest precautions, and only for a consideration, just as I condescend to interest myself in someone's physiognomy only for a consideration. He, the house-boy, assumes an air of efficiency and mock-usefulness, confident that the thin layers of precious and indestructible atoms will return to their accustomed places, and thus assure him the future with its day-dreaming, and its occasional discoveries. And as he dusts, he composes his poem in silence:

DUST TO DUST

For years these objects lie motionless
Though some are articulated for action
Performing satisfactorily
The function they were destined for —
Entailing no wear or tear
No supervision or directing
To which more living matter is subject —
Accumulating dust
Which is also an object
Of an amorous nature
That seeks its soul-mate
Everywhere and forever
And never will surrender
To our prosaic gestures. ...

It will return to its accustomed place.

* * *

I said for a consideration, but there are two considerations in these cases, one of them secret. For, in the end, the object or the subject will play the final role and will determine the validity of the result. Therefore, the intentions of the self-appointed chronicler will be of little importance. The inventor is the tragic figure, he who adapts and improves is the lucky guy. The inventors have developed the means merely to show the way, to be improved upon and turned against them with a hundred-fold power.

This thing called time, beautiful, automatic dimension that relentlessly measures our steps, neither hastening them nor retarding, however short or long they may be, time will resolve all our problems. It is useless to rack our brains for the solution, we must live as if there were no problems, and as if there were no solution to be obtained. This is the final automatism, demanding no effort but

that of living and waiting. To all this you will agree or disagree according to whether you have felt in a similar way, or not felt at all. I said living and waiting, and do not we perform all our necessary physical functions while awaiting the most desired results? Thoughtless wishing, you may say, but see into what blind alleys of action the contrary, wishful thinking, has led us.

And now, patient reader, it is time for me to meditate, to reassemble my memories, put my house in order, without further disturbance of the dust of past experiences, except for this stereotype, or photograph:

TIME IS

It was not a long walk
From the Place de la Concorde to the Champs de Mars
Not any longer than the transition
From white to black from peace to war
From water to blood

Cleopatra's Needle stood nakedly straight and white
In the night's projectors of the Concorde
Eiffel's Folly concaved black to a point
In the dimmed regions of Mars
Flashing its own light from minute to minute
Visible time inaudible

White shaft black shaft
With the eternal patience of inanimate objects
Wait for their transport transformation
And for their destruction
It is all one they have made their point

The supine Pont du Jour has already less time to travel
It has reversed the process of erection
Experienced by the obelisk recorded on its very base
Indeed there will be records of all transformations
A record will never equal the accomplished fact of an erection
Can never replace it
Will always be an obituary.

* * *

To conclude, nothing is sadder than an old photograph, nothing so full of that nostalgia so prized by many of our best painters, and nothing so capable of inspiring us with that desire for a true Art, as we understand it in painting. When photography will have lost that sourness, and when it will age like Art or alcohol, only then will it become Art and not remain simply AN art as it is today. ∎

Photography can be art

Man Ray

There are purists in all forms of expression. There are photographers who maintain that their medium has no relation to painting. There are painters who despise photography, although many in the last century have been inspired by it and used it. There are architects who refuse to hang a painting in their buildings maintaining that their own work is a complete expression.

In the same spirit, when the automobile arrived, there were those that declared the horse to be the most perfect form of locomotion.

All these attitudes result from a fear that the one will replace the other. Nothing of the kind has happened. We have simply increased our range, our vocabulary. I see no one trying to abolish the automobile because we have the airplane.

I was very fortunate in starting my career as a painter. When first confronted whith a camera, I was very much intimidated. So I decided to investigate. But I maintained the approach of a painter to such a degree that I have been accused of trying to make a photograph look like a painting. I did not have to try, it just turned out that way because of my background and training. Many years ago I had conceived the idea of making a painting look like a photograph! There was a valid reason for this. I wished to distract the attention from any manual dexterity, so that the basic idea stood out. Of course there will always be those who look at works with a magnifying glass and try to see 'how', instead of using their brains and figure out 'why'.

A book was once published of twenty photographs by twenty photographers, of the same model. They were as different as twenty paintings of the same model. Which was proof, once and for all, of the flexibility of the camera and its validity as an instrument of expression. There are many paintings and buildings that are not works of art. It is the man behind whatever instrument who determines the work of art.

Some of the most complete and satisfying works of art have been produced when their authors had no idea of creating a work of art, but were concerned with the expression of an idea.

Nature does not create works of art. It is we, and the faculty of interpretation peculiar to the human mind, that see art. ■

Interview with Man Ray

Why did you take up photography?

I was a painter many years before I was a photographer. I got a camera one day because I didn't like professional photographers' reproductions of my work. At just about that time the first panchromatic plates came out and you could photograph in black and white preserving the values of the colours. I studied very thoroughly and after a few months I became the most expert photographer for reproducing things! What interested me mostly were people, particularly their faces. Instead of painting I began to photograph people and I didn't want to paint portraits anymore. Or, if I painted a portrait I wasn't interested in making a likeness, or even a dramatic thing. I finally decided that there was no comparison between the two, photography and painting. I paint what cannot be photographed, something from the imagination, or a dream, or a subconscious impulse. I photograph the things that I don't want to paint, things that are already in existence. I got tired of painting, in fact as I've often said : 'To master a medium you've got to despise it a bit too'. That means that you've got to be so expert and sure of yourself in that medium that it is no longer amusing or interesting to you — it becomes a chore. So I began to paint without using brushes, or canvas, or palettes. I started painting with air brushes, an air gun and compressed air. It was a wonderful relief to paint a picture without touching the canvas. I painted practically in three dimensions because with the air gun if I wanted a thin line I'd approach closely to the surface and then if I wanted to model a shade, I went moving into a third dimension. That was a marvellous thing at the time; it relieved my depression about painting, especially as I was being so much attacked for doing abstract painting. So it became another medium, and when I satisfied my curiosity, or just satisfied myself on that, I would stop and maybe went back to painting for a while. But I continued to make photographs — reproducing my work and doing my portraits of people that came into the studio. I hoped one day that I would be able to make a living out of it. All pupils ask the classical question : 'How do you become successful and famous?'. I've talked to thousands of pupils and there's one in ten thousand that will probably come through, and that requires simply time and persistence, and a certain passion — a certain mania.

What has been your passion? What has been your mania? Somehow it seems like play is a very important part.

Well, its all play. The motive? What am I after? The pursuit of liberty first. When they said I was ahead of my times I said, 'No I'm not, I'm of my time, *you* are behind the times'.

Anyhow I continued. I jumped from one to the other, or did them both simultaneously. I had my hands full and that was enough to keep me going. Then when I came to France I immediately met all the young revolutionary crowd, Dadaists and so forth. I brought a certain number of works and they thought it was absolutely in line with what they were advocating. So I collaborated with them and we published magazines and we gave exhibitions. I was always invited to those manifestations but now those things are historical. I tell the youngsters now, 'You are all going back 40 or 50 years. Why don't you create a new movement of your own. Find a new title for it, that's what you should do, not go back to the past'. I'm not a historian, I was always the lowest in the history class. I was a disgrace to my instructor. He kept me in school one day after the examination which I had failed miserably. He gave me a list of questions, told me to look them up and write down the answers. He passed me to save his own skin.

Did you feel isolated in America because of the sort of work you were doing?

Practically. I began to paint and exhibit a bit around 1912. My first big show was in 1915 in a gallery on Fifth Avenue that was devoted to young American painters, but they just didn't know what I was driving at.

What was the name of that Gallery?

Daniel's. Daniel was a prosperous man who had a big saloon and he had a lot of money, and a friend of mine — a poet — persuaded him to open an Art Gallery. He said that that was the coming thing. The whole New York School were involved in that. They were all very nice people, but I was on an entirely different track. When I got out of school and started reasoning with it, I decided that I must do the things that you're *not* supposed to do. And that was my slogan.

I was invited to the Armory show in 1913, but at that time I didn't have anything I thought was important enough to put up, and I was glad when I saw the Armory show that I hadn't sent anything there. There were all the Cubist paintings of Picasso and Picabia. Enormous Picabia paintings, and Duchamp's work, and all the riots that the 'Nude Descending the Staircase' had created. I said to Duchamp one day, 'You know if you hadn't put the title on the canvas, "Nude Descending a Staircase", that picture would have passed unnoticed like the Picabias did'. So that gave me a hint, and I've always attached titles to my objects. They do not explain the work but add what you might call a literary element to it that sets the mind going. It doesn't do it to everybody, but the few people that I expect to respond to it, do.

Did you at that time show your work to Alfred Stieglitz?

Oh yes, I used to go to Stieglitz's gallery of course. He had his gallery a few blocks away from the technical publishing house where I made my living as a draughtsman. At noon I'd rush up to his gallery whenever he had a new exhibition. It was very interesting because here was this marvellous photographer who opened an art gallery. He didn't show photographs, but he showed Modern Art. Around 1912 when I rushed up there, there was an exhibition of Picasso's collages, you know, a few charcoal lines with a few pieces of newspaper painted on it. Another time there was an exhibition of Cézanne's water colours, where the whole sheet was not painted, just a few touches of colour. The white seemed to be part of the painting, it had been done in such an artful way. I came around quite often and we got to know each other. We talked for a bit, but I was very young then, and very timid too, and hadn't gotten anywhere yet with my work; the way I hoped to some day. He had invited me to have a show there. I said would, when I had enough things, but I never did. I was just then getting interested in photography too and I began to reproduce my paintings. I wondered why Stieglitz was so interested in Modern Art — showing abstract things — Brancusi sculptures, Rodin's quick watercolours. I thought: it was because he was a photographer and photography does not compete with modern painting. I never was profound enough to discuss it to that degree with him, but I felt that he wanted to give the value to photography that it deserved. He was a secessionist from other photographers and the idea of seceeding, or revolting, always appealed to me. I was a revolutionary. And so I went on more and more determined to do all the things that I was *not* supposed to do. I was told I should stick to painting when I came to Paris. Stieglitz told me to apply to some collector, a rich coal baron, who bought one or two of my paintings at the exhibition — 'ask him to help you'. And this man was very nice, and immediately he gave me a cheque and said he'd be in Paris the next year to see what I'd done. I offered him some paintings. 'No, I want to see your new work and I'll take it out of that'. When he came the next year and saw that I was head over heels on photography and making hundreds and thousands of dollars, he said, 'Oh no, you're an American. You must go back to America. You mustn't stay in Paris, and you mustn't give up your painting.' 'I'm not giving it up, I have lots of time for painting too.' I only work two hours a day at photography, and that's enough.' Although I used to work sometimes ten hours in the dark-room, because when I started I was so fascinated by optics and chemistry, and I did everything myself. People ask : 'What camera do you use ?' I say : 'You don't ask an artist what paints and what brushes he uses. You don't ask a writer what typewriter he uses.' Anyway, I regard the camera as an aid in a way. Many painters, especially nowadays, use a camera to start with. Like Warhol; or even Ingres who painted all his nudes secretly; he was making lots of Daguerreotypes from which he drew his nudes. All the 19th century painters were against photography because they were afraid it would take their bread and butter away from them. Ingres was asked, 'Well, what do you think about photography ?' 'Oh,' he said, 'I think its wonderful — but you mustn't say so'.

You say that you were revolutionary even with your family. Was there any art background in your family at all?

None at all. The fact was I wanted to paint. It was a passion. I was mad about painting. I don't know where I inherited it, or how I got the contagion. It seems like a disease, the smell of turpentine and oil would intoxicate me as alcohol intoxicated others. And then, of course, like all bourgeois families the idea of being a painter was not acceptable. So finally I had to get away from home. I got myself a little shack out in New Jersey, went to my work in this draughting office, and came back there and painted. I arranged, finally, so that I would only have to go into town three times a week. The other half of the week I could paint. I didn't care about money or anything, I just wanted to paint.

Did you pay much attention at this time to what was happening in photography at the Photo-Secession Gallery, for instance?

I didn't see all the things. I knew Steichen, of course, who was a painter to begin with. Well, sort of a decorator painter. He wanted to be a society painter as I did too. I thought I'd become a society painter and do all beautiful ladies like Singer Sargent. I wasn't really interested in photography, I never was, as an artist. And when I was attacked here in the 30's, I published, through my literary friends, a little booklet called 'Photography is not Art'. Of course, everybody was trying to prove that photography was art and Stieglitz worked in that direction too. That was his theme, and they're still at it now you see. Since then my old photographs have been collected and they have had exhibitions all over the world. And they have gotten medals and parchments in Europe. They ask me 'Well, do you still think that photography is not art ?'. 'Oh', I say, 'I don't know what Art is myself. I think the Old Masters weren't artists, they were good photographers before the camera was invented'. Now I say : 'Art is not photography'. Well, that's still more confusing.

Do you find yourself making Art *now, but using your photographic past?*

Everything is art. I don't discuss those things anymore. All this anti-art business is nonsense, they're all doing it. If we must have a word for it, lets call it Art. And if it's different from anything else, that is the real revolution. The mere fact of calling it a negative thing is not sufficient to destroy it — if they want to destroy art. The Futurists of 1911 advocated burning down all the museums, and I agreed with them too. Although I loved the old masters. To me they were more than painters, they were blacksmiths by the way they painted, they were a force, Goya or Uccello, or even Manet later on. Why, those men used a brush like a blacksmith would handle a hammer.

Is there anything at all that's related to photography in the work you are doing now?

Everything is related to photography because it all has to be photographed finally. There are half a dozen books and catalogues of mine with colour reproductions and they have put everything into it. They put in the rayographs, photographs, black and white rayographs, and colour reproductions.

What work are you doing presently?

Well, it's a secret. Because I don't like to show the things I do immediately — I wait years sometimes. There

are now big exhibitions of all my graphic work, lithographs and etchings, but this is a sort of panorama from my early work. They accept everything I do here, you know. There is no hesitation at all. But some of the American publishers want to change things, or they want to take this out, or put something else in. I say 'This is my work, if you want to do something different, sign it with your name, create something — don't try and change my work'. I consider all these things self portraits.

I never touch a camera myself any more than a movie director does. People say : 'Do you take the photographs yourself ?'. Always. Even if somebody else pushes the button, I take it. You don't ask an architect whether he built the building himself, you don't ask a composer whether he plays the whole piece himself. I am enjoying the last years since I don't want to produce any more original work. Well, I do some, but it's not really for publication. The things I exhibit, the things I reproduce, are things that have been going on for the last 60 years, they have no date. Some of the French critics are very intelligent. One critic said that all the things I've been showing, all the exhibitions and so forth, reproductions, publications, some of which were done 40-50 years ago, could have been done today; and whatever I do today were made 40-50 years ago too !

There is no date in my career. I have several mediums at my finger-tips. Photography was just as incidental as say painting was, or writing, or making sculptures, or just talking. I wrote a book which was published, called 'Self Portrait'. I wrote the book in 1963 with the instigation of an editor in New York. He said I should write a book about the 20's and 30's and so forth. I said : 'Well, I started long before that and I finished long after that. I'm still around you see, so you can't really fix it. I'd have to start from the very beginning and go to the very end'. So it starts with my so called, or accidental, birth, and ends with my return to Paris in 1951 after having spent 10 years in California from 1940-1951.

Where in California ?

I lived right on Vine Street in Hollywood. I had a beautiful studio there, in a courtyard with palm trees, and humming birds, and flowers. I forgot that I was in America at the time, just as I forget that I am in France now. I live within my own four walls, it's my own life. I don't attach any importance to the public. I think that a few people is all one needs to sympathise with you or to accept you. I want people to show me the same confidence as I show to most people when I meet them, although we are entirely different individuals.

'What are you doing now ?' Well, it is the same thing that I have been doing all my life. When I have a show people ask : 'Is this your recent work ?'. So I shouted one day : 'I have never in my life painted a recent picture'. My show was done probably many years ago. By living this way I have been able to develop my own personality, no, not develop it, but emphasize it. I consider individuality the most important thing. In a preface for an exhibition in a museum, I wrote : 'This exhibition is not for the public, it's only for one person — it is for you who are here.' Well, at first they thought that was a little bit tough. Anyhow they got it, they understood it, so it went through.

I can only deal with one or two people at a time. I never think of the public, of pleasing them, or arousing their interests. I despise them, just as much as they have despised me through the years — for the things I've done.

They have accused me of being a joker.

But the most successful act involves humour, the joke. In America for instance, a lot of Dadaist activity is like the comics in the paper; it's provincial humour, acceptable only to the people immediately around them. It hasn't got that universal quality which the movements in Europe had at the time.

I was closely attached to the Dadaists and Surrealists because the things that I was doing were absolutely in line with what they were propounding.

Why did you return to Paris ?

Well, after all I spent 20 years in Paris before the War, but I couldn't stay with the Germans all around me, it got impossible. Fortunately, I went to America, otherwise I'd have ended up in a prison camp, if I had stayed until 1941. I couldn't take it any more. I talked to some of the Germans, some of the officers, they were in the know about lots of things. 'You stay here with us, we'll give you lots of work'. I said : 'I have commitments, I have to go back to the States'. So they let me go, after looking at my passport very carefully to see that I wasn't involved with any of the political activities here. I escaped practically.

In California, I had a wonderful time. I did a lot of photography and a lot of painting. I no longer worked for anybody but myself, and that was the final ideal that I had attained. You see, I did all the paintings that I had planned for years before, 10 or 20 years before. Paintings I had never realized, some of them from photographs even; of abstract subjects like mathematical objects, which I photographed in the colleges here, in old showcases. I used them as a subject matter for paintings, because they were man-made objects, they were *not* from nature.

That in itself is a rather revolutionary thing isn't it ?

Absolutely. Well, all those paintings are gone now. I did about sixteen paintings one year of those mathematical objects and then when I'd finished with that there was a long rest again. I came to Paris in 1951 and found this studio by chance. I settled down and I started all over again — a sort of a second life — and painted like mad from 1950-1960.

Did you become disenchanted with America ?

Oh no, it's got nothing to do with that. I thought Hollywood was a wonderful place. In fact, when I got back to America in 1940, I stopped in New York, and they set up a big studio for me in Vogue or Harpers Bazaar. I was doing all their fashion work, and celebrities, theatrical and movie people. I said, 'Well, I've been through this terrible war, I've been through it since the September before (this was in October) and I've got to have a little vacation now'. I was really on my way to Hawaii and Tahiti — I was going to disappear. I left the studio with everything in it, like here, not knowing whether I'd ever see the things again. A lot of my paintings were hidden away in a cellar. I found them 7 years later when I came back to collect them.

It's just that I feel freer here, that's all. There's a proverb about a prophet in his own country. I didn't want

to get known or anything, I just wanted to be comfortable and have enough to live on and to do the work; especially the things that one shouldn't do.

I lectured a lot there. I had pupils in California, the wives of movie producers who had nothing to do and wanted to learn photography or painting. I even had a waitress who would come in her spare time for lessons in painting. She became a good painter and then she became a professor in a University, I heard afterwards, on Art. So I was very successful as a teacher, but I wouldn't teach. The Art Centre in California gave an exhibition. They tried to get me to teach. I said : 'I'm against education'. I could teach just a few people, one at a time. I've always had one or two students in my studio in Paris to learn photography. I had individual pupils and I'd charge them 50 dollars a lesson, or something like that.

Bill Brandt came to you didn't he ?

He was my pupil. He came to my studio and asked if he could study with me. I said, 'I can't teach you anything. You watch me, and you help me too'. He puddled around a bit and he finally became a photographer, like Berenice Abbot did. I had three or four others and they all are great, famous photographers now. One of them has all photographic archives in the Amsterdam museum, you know. Another one, Madame Lindquist, is a Royal photographer in the court of Denmark.

Did any other photographers come to see you, people like Cartier-Bresson and Brassai ?

There is a snapshot by Cartier-Bresson of me and Duchamp before Duchamp died. We were sitting here going over a game of chess and he took a snapshot and sent it to me when I had my last exhibition saying : 'Maybe if you need a photograph for publicity, you can use mine'. I had plenty of photographs. I'm very seldom behind the camera now, but I'm in front of the camera a great deal now — I've been promoted !

Can you explain your relationship with Atget ?

I discovered him ! But, I don't consider that a merit. Atget lived a few doors from my studio in Paris in the 20's. He had albums on printing out paper which he printed in a little frame putting it outside his window in the backyard in the sun; and as soon as he had these prints he put them in a book. You could go up to him and buy a print for 5 francs which is about one dollar, or 50 cents, and then he'd replace it. He printed a new print by daylight. They were all the French size which is 18 × 24 cm. I begged him once : 'Lend me some of your plates and I'll make some prints on the modern paper'. 'Oh no. That's not permanent'. His prints all faded if you exposed them to the light because they were washed in salt water to fix them. They were the kind of prints that photographers made as proofs for their sitters so that they wouldn't be kept as permanent things. They disappear after a while. Anyway I would drop in once in a while and pick up a few prints. He had thousands of prints; he had photographed so much stuff in his life-time. But he said he was making documents for painters (he was a

painter himself; he painted landscapes). These prints were documents, and most of them were uninteresting, but I finally acquired about 30 or 40 and I gave them to Beaumont Newhall. He has them. They're the ones that have been the most reproduced, because they have a little Dada or Surrealist quality about them.

He was a very simple man, he was almost naive, like a Sunday painter, you might say. He worked every day. I had a couple of his things reproduced in the 20's in a surrealist magazine — a crowd standing on a bridge looking at the sky, at an eclipse. He said : 'Don't put my name on it'. He didn't want any publicity. 'These are simply documents I make'.

Did he explain why he didn't want any publicity ? He was living in very poor circumstances.

Very poor. He had no money. He had been an actor once on a travelling presentation, I think. I was away from my studio for a few weeks on a trip down South when he died. At that time Berenice Abbott was my assistant. I knew her in New York as a young girl of 18, she was a sculptress. She'd come to Paris a month or two before me. She was starving, and I asked her to come and help me, because I was loaded with work. All the painters came rushing around to me to photograph their paintings — Picasso, Braque, Matisse, all the painters. I had an awful lot of work, so I took her up. When Atget died she went around there with her brother and they got the collection of negatives. She was able to go ahead and have a book published in France first. She was very enthusiastic about it. She became a very good photographer after a couple of years with me and then went off on her own.

I don't want to make any mystery out of Atget at all. He was a simple man and he was using the material that was available to him when he started around 1900. An old rickety camera with a brass lens on it and a cap. He'd just take the cap off and put it back.

I've taken photographs that way too, when the cameras broke down. I've even taken photographs without a lens on it. Once I had to photograph a painter. I arrived with my studio camera and tripod and everything. I started to set up, but I'd forgotten the lens. My lens I knew because I prescribed my own glasses; I knew optics so well. I knew that my lens had a 12 inch focal length, but I knew it would give a very fuzzy picture. I had a roll of tape and taped it on to the opening in my camera and just let the black cloth down, with a little hole in it, to diaphragm it. I just opened the cloth and let it down, and I got the portrait of Matisse. A beautiful soft focus photograph with all the details visible in it too.

Do you feel it is a burden to be a historical figure in the Art World ?

It's a nuisance. It's an absolute nuisance. They drag me on television and on radio, and there are newspaper and magazine interviews. I discourage them as much as I can, of course, but it's inevitable for any creative work. You have to rely on publicity because otherwise you can't have exhibitions.

I gave up photography professionally 20 years ago, although when I feel like doing a portrait, I do a portrait. Yes, I make some prints, but I don't even make them myself now, I have two or three laboratories here in Paris;

they do wonderful work for me. There's been so much progress in printing and the mechanics of photography, but there's no progress in the creative side of it.

There are two or three collectors who have a couple of hundred of my prints and the Modern Museum has about 150 prints, so they made an exhibition at the Metropolitan. I wasn't there for it but they sent me photographs of the exhibitions; one in Pasadena, San Francisco, one in Washington. I get all these catalogues of the exhibitions, and sometimes the collector is a bit of a photographer himself, so he slips in some of his own photographs, to see if he can get some notice with it. I tell them : 'That's very bad policy; never show your work with that of a master — it makes it worse'. I never show my works with painters who are considered greater masters than I am. I want one man exhibitions, just as I want a one man audience !

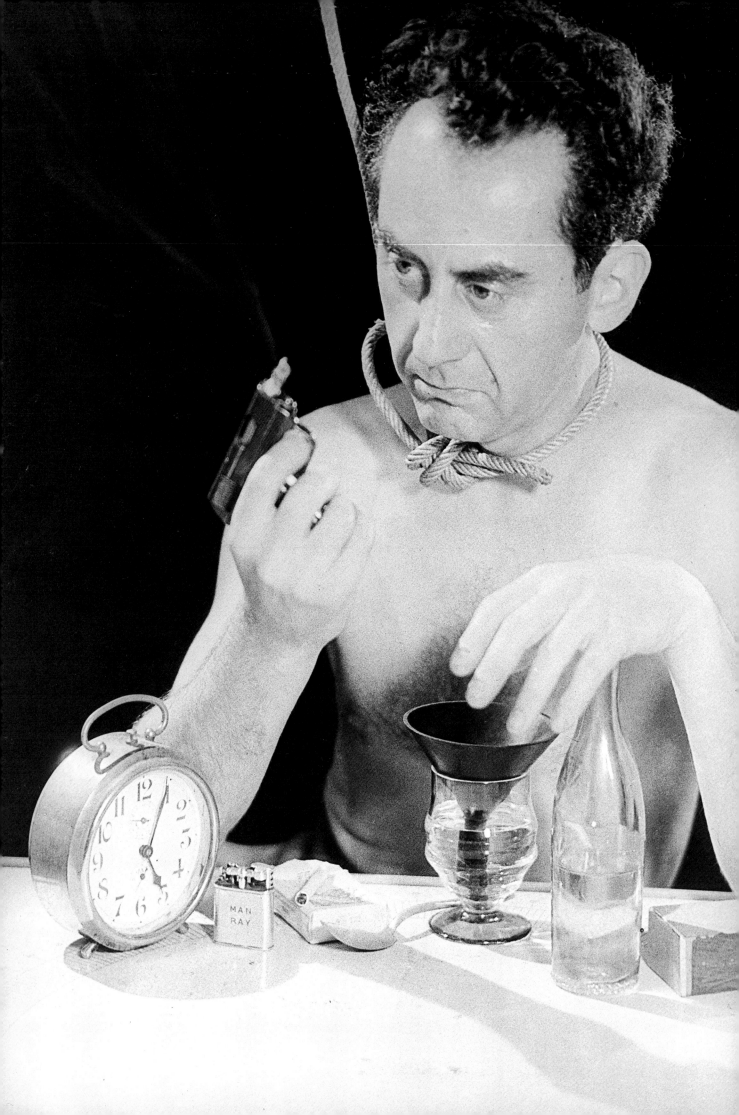

Dada
and Surrealism

Who made Dada ? Nobody and everybody. I made Dada when I was a baby and I was roundly spanked by my mother. Now everyone claims to be the author of Dada. For the past thirty years. In Zurich, in Cologne, in Paris, in London, in Tokyo, in San Francisco, in New York. I might claim to be the author of Dada in New York. In 1912 before Dada. In 1919, with the permission and with the approval of other Dadaists I legalized Dada in New York. Just once. That was enough. The times did not deserve more. That was a Dadadate. The one issue of New York Dada did not even bear the names of the authors. How unusual for Dada. Of course, there were a certain number of collaborators. Both willing and unwilling. Both trusting and suspicious. What did it matter ? Only one issue. Forgotten — not even seen by most Dadaists or anti-Dadaists. Now we are trying to revive Dada. Why ? Who cares ? Who does not care ? Dada is dead. Or is Dada still alive ? We cannot revive something that is alive just as we cannot revive anything that is dead.
Is Dadadead ? Is Dadalive ? Dada is. Dadaism.

11. Self portrait.

The theme of suicide - which obsessed Man Ray for some time, according to *Self Portrait* (p. 249) - recurs several times in his works. Suicide fascinated the Surrealists, and several members of the group killed themselves. This photograph is published here for the first time.

12. *A l'heure de l'observatoire - Les amoureux, 1935-38.*

This large canvas used to hang over Man Ray's bed in his studio at 8 rue du Val-de-Grace. He worked on it for two years. He was eager to make the painting as famous as possible and made numerous reproductions of it, using many different techniques, including several photographs, which included such objects as a chess board, a nude, a cast, a mannequin and a self portrait. The theme of the lips is a souvenir of Kiki: 'On one occasion, I dressed for an important dinner with some prospective sitters. She helped me, putting the cuff links in my shirt, and admired my appearance in my dinner clothes, put her arms about me and kissed me tenderly, telling me not to come home too late. The dinner was in one of the most fashionable restaurants, and we then went on to a night club. I asked the wife of my host to dance; she told me first to go to the washroom and arrange my clothes. I looked at her in surprise; felt my bow tie, pulled down my waistcoat, all seemed in order. When I looked in the mirror in the washroom, there was a perfect imprint of a beautiful pair of red lips on my collar.' (*Self Portrait*, p. 150.)

A text of Man Ray's accompanied a reproduction of the painting in *Les cahiers d'art* (1935, pp. 126-27): 'It is seven in the morning, before satisfying an imaginary hunger - the sun not yet decided whether to rise or to set - that your mouth comes to replace all these indecisions. The only reality, the thing that gives importance to dreams, reluctant to wake up, your mouth is suspended in the void between two bodies... Lips of the sun, you ceaselessly attract me, and, in the instant before I wake up, when I detach myself from my body - I am weightless - I meet you in the neutral light and in the void of space, and, sole reality, I kiss you with everything that is still left in me - my own lips.' In *Self Portrait* (p. 255), Man Ray left another description of this painting he loved so much. He spoke of his further impressions: 'The red lips floated in a bluish gray sky over a twilit landscape with an observatory and its two domes like breasts dimly indicated on the horizon - an impression of my daily walks through the Luxembourg Gardens.'

13. *Suicide, c.* 1926.

The photograph takes its name from the aerograph against which the woman is leaning - *Suicide* (1917).

14. *Rotative plaque de verre (optique de précision)* by Marcel Duchamp, 1920.

This photograph was published in *Les cahiers d'art* (Nos. 1-2, 1936, p. 38). In his *Self Portrait* (p. 69), Man Ray tells the story of how Marcel Duchamp 'was at the time engaged in constructing a strange machine consisting of narrow panels of glass on which were traced parts of a spiral, mounted on an axle supported by bearings and connected to a motor. The idea was that when these panels were made to revolve they completed the spiral (when looked at from in front). The day the machine was ready for the trial I brought round my camera to record the operation. I placed the camera where the spectator was supposed to stand; Duchamp switched on the motor. The thing began to revolve, I made the exposure, but the panels revolved faster and faster and he switched it off quickly. Wanting to see the effect for himself, he stood in the camera position and asked me to stand at the back where the motor was and turn it on. The machine began to turn again, slowly at first, then faster and faster like an airplane propeller. There was a great whining noise and suddenly the belt literally flew off, catching the glass plates like a lasso. There was an explosion, with glass flying in all directions.

Behind the machine, already partly broken up, can be seen the blurred silhouette of Man Ray (or is it Duchamp?). A photograph of the machine in motion, with Marcel Duchamp behind it, appeared in *Les cahiers d'art* (1936, Nos. 1-2, p. 39).

15. Marcel Duchamp, 1916.

Man Ray took several shots of Marcel Duchamp, both with and without his pipe, at a single sitting in New York. They had met each other a year before.

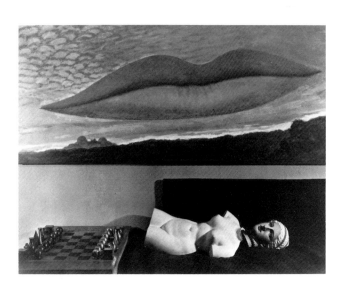

16. *Tonsure.*
Marcel Duchamp's tonsure was done by Georges de Zayas in 1921.

17. *Rrose Sélavy*, 1921.
There are two portraits of Duchamp dressed as a woman. In 1920 he had adopted the pseudonym Rose Sélavy, which he later spelt Rrose. The other photograph was used for a label on the readymade *Belle Haleine, eau de voilette.*

18. Nancy Cunard, Tristan Tzara, 1924.
Tristan Tzara was one of the first people whom Nancy Cunard befriended in Paris. Man Ray had photographed Nancy's mother, Lady Cunard. Here, the young woman is wearing a silver trousersuit, her father's old top hat and a mask, on her way to a ball at the Comte de Beaumont's. Tristan Tzara wrote a play for her (*Mouchoir de nuages*) and introduced her to Dada circles.

19. *Ciné-sketch: Adam, Eve* (Marcel Duchamp, Brogna Perlmutter-Clair), 1924.
On 31 December 1924, Picabia organized a New Year's Eve party during which there was the only performance of *Ciné-sketch*, for which he had written the script. It was directed by René Clair, with whom he had just filmed *Entracte*. Here we see one of the *tableaux vivants* lit for a few seconds, showing a scene that was inspired by Lucas Cranach's *Eve*. Man Ray called this episode a 'ballet' in his *Self Portrait* (p. 238), but was confusing *Ciné-sketch* (where he played a chatterbox) with the ballet *Relâche*: 'one would have liked to see a more prolonged vision of the tableau. I did, however, having photographed the scene at a rehearsal. During the ballet, I sat at one end of the stage like the property man in a Chinese play, but doing nothing, saying nothing, acting out Picabia's name for me: the silent one.'

20. *Le paradis*, a cabaret in the boulevard de Clichy, 1929.
Standing, from left: Hans Arp, Jean Caupenne, Georges Sadoul, André Breton, Pierre Unik, Yves Tanguy. The woman in the centre at the back is Cora, and the man seen from behind with his hand on Cora's breast is André Thirion. To the right of him are René Crevel and Frédéric Mégret (with cigarette and halberd). Seated, from left: Elsa Triolet, Louis Aragon, Camille Goëmans, Madame Goëmans. Suzanne Musard is standing in front of René Crevel. The unidentified figures in costume all worked at the cabaret. This photograph was meant to be reproduced in *Variétés*, but was never used.

21. Back row (left to right): André Breton, Max Morise, Roland Tual. Front row: Simone Collinet-Breton, Louis Aragon, Colette Jerameck-Tual.

22. Back row (from left to right): Paul Chadourne, Tristan Tzara, Philippe Soupault, Serge Charchoune. Front row: Paul Eluard, Jacques Rigaut, Mick Soupault, Georges Ribemont-Dessaignes. One of the rare photographs of the Dada group in Paris, taken *c.* 1922. For the photograph Paul Eluard help up a piece of cardboard, where Man Ray placed a picture of himself.

23. Francis Picabia, 1923.
Man Ray said he was 'good-looking, tall and powerful. He was the most intelligent of the Dadaists.'

24. Philippe Soupault, 1921.

25. 'Waking Dream Séance', 1924.
Back (from left to right): Max Morise, Roger Vitrac, Jacques Boiffard, André Breton, Paul Eluard, Pierre Naville, Giorgio de Chirico, Philippe Soupault. Front: Simone Collinet-Breton, Robert Desnos, Jacques Baron. This photograph was reproduced in vignette form on the cover of *La révolution surréaliste* (1 December 1924). Robert Desnos, the poet, is officiating at the 'centrale surréaliste'. This photograph and the following one were no doubt taken on the same day.

26. 'Centrale surréaliste', 1924.
Back row (from left to right): Jacques Baron, Raymond Queneau, André Breton, Jacques Boiffard, Giorgio de Chirico, Roger Vitrac, Paul Eluard, Philippe Soupault, Robert Desnos, Louis Aragon. Front row: Pierre Naville, Simone Collinet-Breton, Max Morise, Marie-Louise Soupault. This photograph

was also reproduced on the cover of *La revolution surréaliste* (1 December 1924). A painting by Giorgio de Chirico (now in the Tate Gallery, London) can be seen at the back of the room. A detail that could, at one time, be seen above de Chirico's head has been effaced on this print.

27. Jean Cocteau, Tristan Tzara , *c.* 1922.
The two poets, united here by Man Ray's beloved *Lampshade*, were later to fall out. Jean Cocteau, who had met Man Ray at the 'Boeuf sur le toit' cabaret, was instrumental in bringing together many of the artists of his time.

28. Back row, left: Georges Malkine. Front row, centre: Robert Desnos. The other subjects are unidentified.

29. *Échiquier surréaliste* ('Surrealist chess-board'), 1934.
From left to right, top to bottom: André Breton, Max Ernst, Salvador Dali, Hans Arp, Yves Tanguy, René Char, René Crevel, Paul Eluard, Giorgio de Chirico, Alberto Giacometti, Tristan Tzara, Pablo Picasso, René Magritte, Victor Brauner, Benjamin Péret, Gui Rosey, Joan Miró, E.L.T. Mesens, Georges Hugnet, Man Ray. Published in *Petite anthologie poétique du surréalisme* (Paris, 1934).

30-34. Kurt Schwitters, 1936.
Kurt Schwitters made two visits to Paris, in 1927 and again in 1936. Man Ray commented of him that 'he did not smell as badly as people said. He had created the Dada school in Hanover and walked around with a suitcase full of "collages" made out of old scraps of paper, metro tickets and railway tickets, playing cards, and envelopes woven into waste paper baskets. He came to my studio to read his poem.'
In this series of photographs he is said to be declaiming the following lines:
Lanke trr gll
p.p.p.p.
oka oka oka oka
Lanke trr gll
pi pi pi pi
Züka züka züka züka
Lanke trr gll
rmp
ruf
Lanke trr gll
(J.P. Crespelle, *Montparnasse vivant*, p. 257.)

35-39. Antonin Artaud, 1926.
A series of portraits of the poet at the age of thirty, when he was a film actor. The same year, he had two pieces published in *La révolution surréaliste*; he broke with the Surrealist circle a year later with his virulent *A la grande nuit, ou le bluff surréaliste*. These photographs were taken from a distance and then cut down, so as to avoid facial distortions.

40-44. André Breton, *c.* 1930.
André Breton, who led the Surrealist movement, had probably known Man Ray since 1921. Illustrations **41** and **44** show Man Ray's practice of giving his subject a large framing in the exposure, with the intention of cropping it in printing: **44** was probably intended to include only André Breton's face against the white sheet of paper.

45. Paul Eluard, André Breton, 1930.
Paul Eluard and André Breton met through Jean Paulhan. There is also a double portrait of André Breton with Louis Aragon.

46-48. Paul Eluard.
Illustration **46**, showing Paul Eluard bare-chested, also exists in close-up. Man Ray no doubt photographed the poet naked so as to strip him of his social context and get down to basics, an approach which is unusual in male portraits.

49-53. Meret Oppenheim, Louis Marcoussis, 1933.
Man Ray made a series of portraits of Meret Oppenheim, a painter who had been introduced to him by Alberto Giacometti. Here, she is seen near the etching press of the painter Louis Marcoussis, who is wearing a false beard for the occasion. *Érotique voilée* (**51**) was reproduced in *Minotaure* (No. 5, 1934-35, p. 15).

54. Joan Miró, *c.* 1930.
'One of my first impressions of Miró is a visit to his studio in the rue Tourlaque. Many years ago. Two poets were there. They started a little game between them, with Miró as the stake. While one pinioned his arms behind him, the other tried to adjust a noose around his neck. Miró fought furiously, as if in earnest, but the expression on his face was one of fear mingled also with flattery. He would not have foregone this attention centered around him for all the discomfort involved. Sometimes he carried this desire for attention to extremes. He'd put on a pair of boxing gloves and tackle a man much bigger than himself. Or he'd like to come to me and sit for his portrait. Miró has since used a lot of rope in his compositions. Enough rope to hang all his adverse critics, although they would be the last to recognize that it was intended for them.' (Man Ray, 'Juan Gris, Joan Miró, Pablo Picasso', *The Spanish Masters of the Twentieth Century Painting*, San Francisco Museum of Art, 1948, p. 42.)

55. Hans Bellmer.
Hans Bellmer frequented Surrealist circles in Paris, from 1938 onwards. There also exists a solarized portrait of him.

56. Meret Oppenheim, *c.* 1950.

57. Marcel Duchamp, Joseph Stella, 1920.
This photograph was taken in New York and appeared in *The Little Review* (Fall 1922, p. 17). 'Some of my portraits may have looked like caricatures but in his case whatever turned out was a perfect likeness' (*Self Portrait*, p. 93). The Yale University museum has another version of this photograph, entitled *Tree Heads*, in which a small oval collage, showing the silhouette of a girl holding a bunch of flowers, replaces the picture of the woman smoking a cigarette.

58. René Char.
Char was a poet who had close ties with Surrealist circles.

59. Marie-Berthe Aurenche, Max Ernst, Lee Miller, Man Ray.
The two painters appear with their companions of the early 1930s. A later photograph (131) shows them many years later with their then wives.

60. Jacques Rigaut, 1922.
One of the French Dadaists. Other, more conventional portraits exist of him. He committed suicide in 1929.

61. Nancy Cunard, *c.* 1926.
Lying on her back (as the photograph was taken), her head thrown back, she is photographed wearing the ivory African bracelets that she collected. A variant of this photograph appeared in *The Little Review* (No. 12, May 1929, p. 27).

62. Max Ernst, *c.* 1935.
'L'homme oiseau' ('The birdman'), 'Loplop, l'oiseau suprême' ('Loplop, the supreme bird'), was a faithful friend of Man Ray's in France as well as in the United States.

63. Balthus.
'Balthus, slightly precious, on the fringe of Surrealism, with a taste for Lolitas, as his mystical paintings of young girls indicated, reminded one of a Chopin, but his work breathed silence. A series of illustrations he made for Wuthering Heights had a Victorian quality.' (*Self Portrait*, p. 244.)

64. Tristan Tzara.
Photographed many times by Man Ray, he is almost always seen wearing a monocle. The intimate portrait has very rarely been seen.

65. Louis Aragon, 1923.
Man Ray took several photographs of the poet at the same sitting.

66. Benjamin Peret.
Man Ray also took another, more formal photograph of Peret.

67. Georges Ribemont-Dessaignes.
According to André Breton, Georges Ribemont-Dessaignes, with Tzara and Picabia, was one of the 'only real "dadas"'. There is another portrait of this poet and writer, which was probably taken the same day, and in which Man Ray's painting *Homme d'affaires* (1927) can be seen behind him.

68. Erik Satie, March 1924.
Satie was a close friend of Man Ray, who made an object-painting as a tribute to the musician (*La poire d'Erik Satie*, 1972). Together, they made 'my first Dada object in France', *Cadeau* (*Self Portrait*, p. 115). Man Ray adopted Erik Satie's text 'What I am', replacing 'sound' with 'colour' and 'music' with 'painting'. Here Man Ray has caught the twinkle in his eye.

69. Hans Arp.
Arp was a sculptor, painter and poet who was close to the Surrealist group.

70. Roland Penrose.
Sir Roland Penrose, who married Lee Miller, was an old friend of Man Ray. He became one of his biographers.

71. René Crevel.
He was the much loved *enfant terrible* of the Surrealists, who left passionate descriptions of him. A poet and writer, he killed himself in 1935.

72. *Palais de quatre heures,* 1932-33.
The two women behind Giacometti's sculpture *Palais de quatre heures du matin* (now in the Museum of Modern Art, New York) are Kiki (left) and Mélie. The photograph appeared in an article on Giacometti by Christian Zervos, illustrated entirely by Man Ray, in *Les cahiers d'art* (Nos. 8-10, 1932, p. 342).

73. Alberto Giacometti, *c.* 1932.
This portrait is a variant of the one used in the article mentioned above (p. 338).

74. Luis Buñuel, 1929.
Buñuel was a Surrealist film director.

75. Salvador Dali, 1929-31.
The publication of this photograph on the cover of *Time* magazine on 14 December 1936 was the beginning of Dali's conquest of America.

76. Salvador Dali and Gala, 1936.
The photograph was taken in New York.

77. Yves Tanguy, 1936.

78. Alexander Calder.
Affiliated to the Surrealist group, he came to Paris in 1926, and made other visits from 1928 onwards. He made a portrait of Kiki out of wire.

79. Wifredo Lam, 1938-39.
The painter Wifredo Lam had fled from Spain to Paris, where he was taken in by Pablo Picasso and joined the Surrealists.

80. René Crevel, Tristan Tzara, Jacques Baron, 1928.
A photograph taken in Man Ray's studio. Tristan Tzara is holding Man Ray's banjo. Behind them can be seen the drawing for *Trois parasoleils pour dames et cavaliers délicats*.

81. Hans Richter, S.M. Eisenstein, Man Ray, 1929.
Group portrait of the three film directors. Man Ray photographed S.M. Eisenstein alone during the same session (**344**).

82. Giorgio de Chirico, 1925.
Giorgio de Chirico was never really part of the Surrealist group but he influenced many of its artists.

83. Luis Buñuel, 1929.

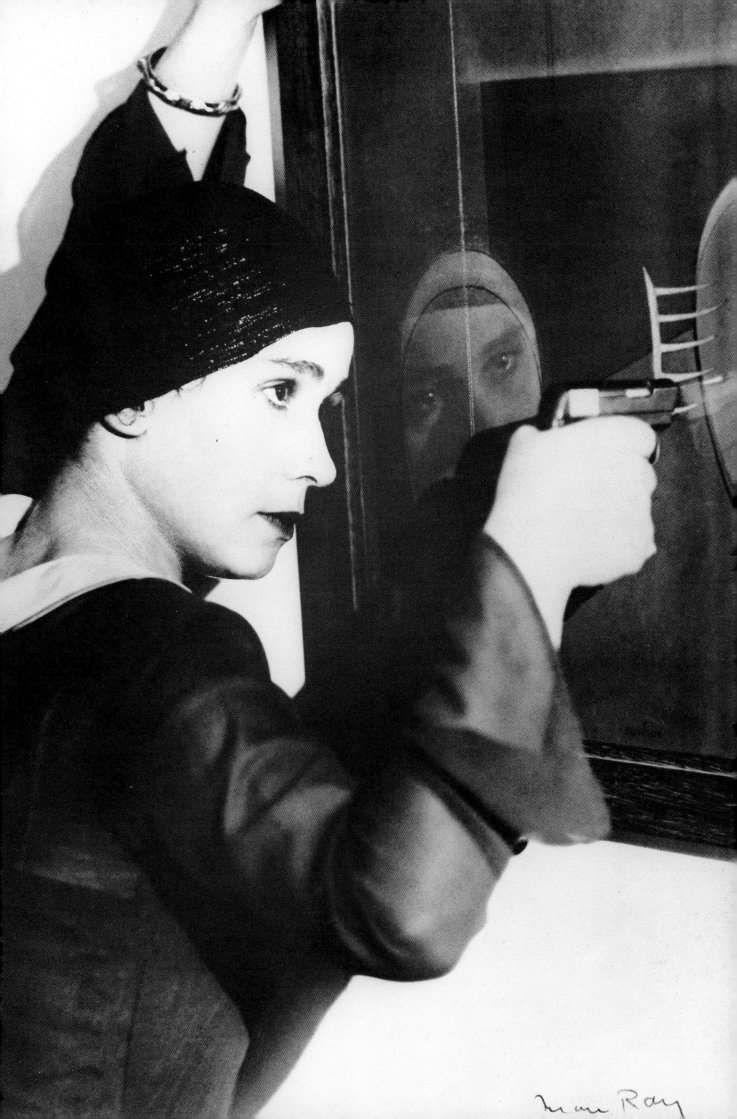

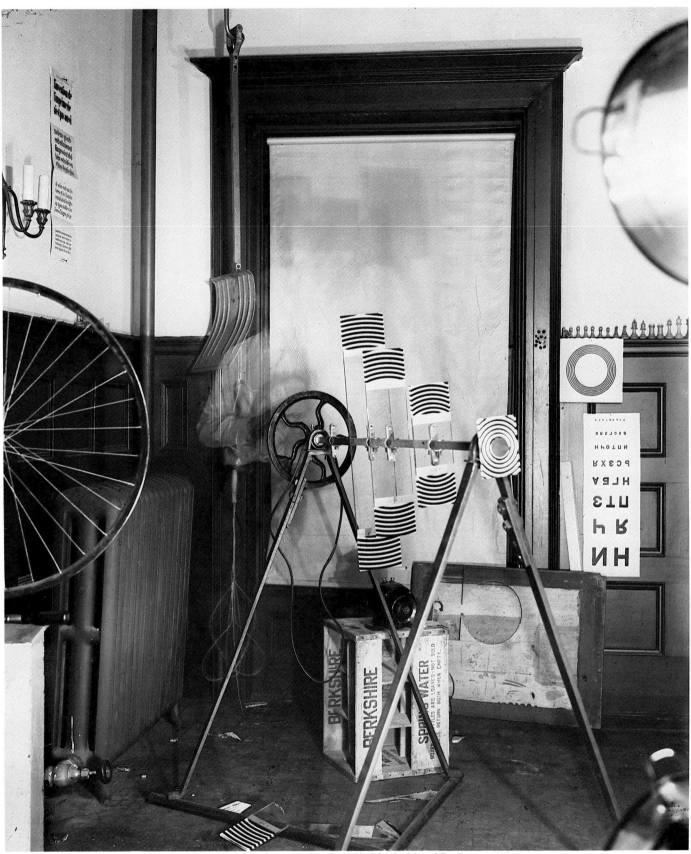

14 *Rotative plaque de verre (optique de précision)* de / by Marcel Duchamp, 1920.

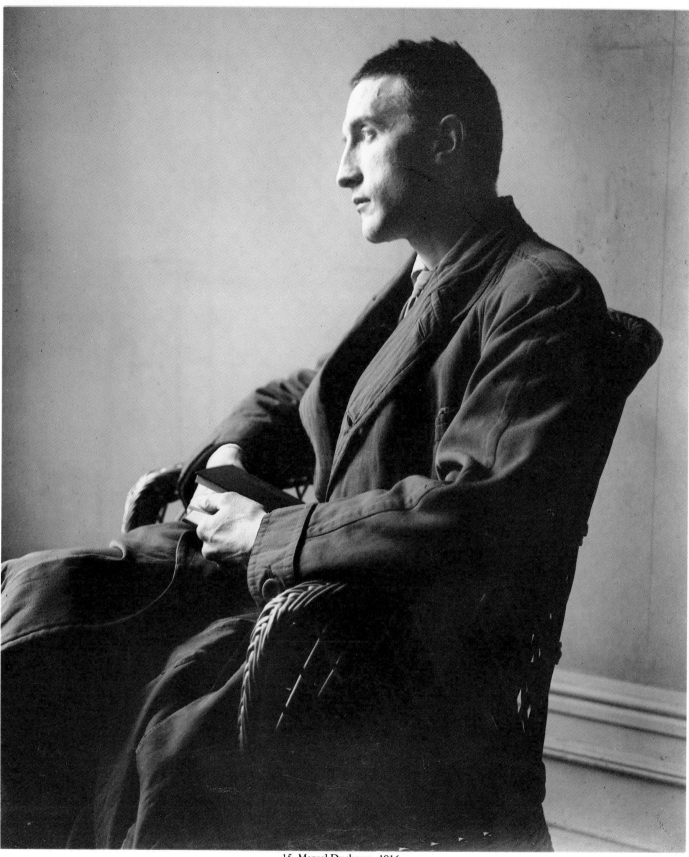

15 Marcel Duchamp, 1916.

16 *Tonsure*, 1921.

17 *Rrose Sélavy*, 1921.

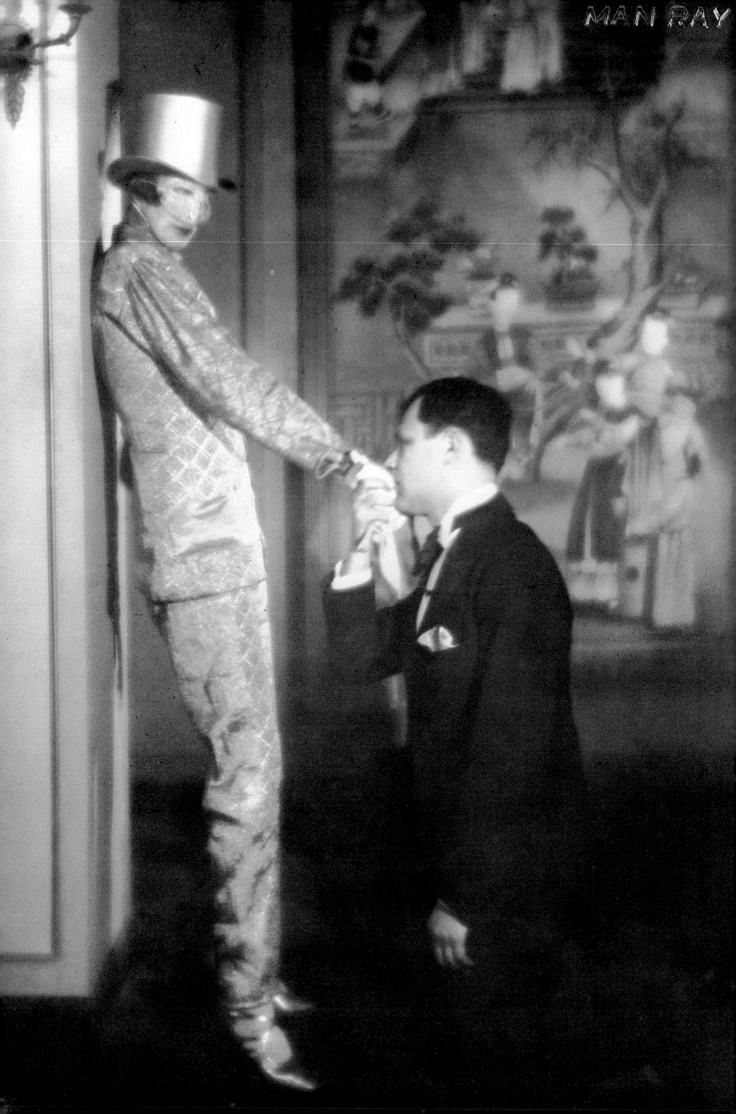

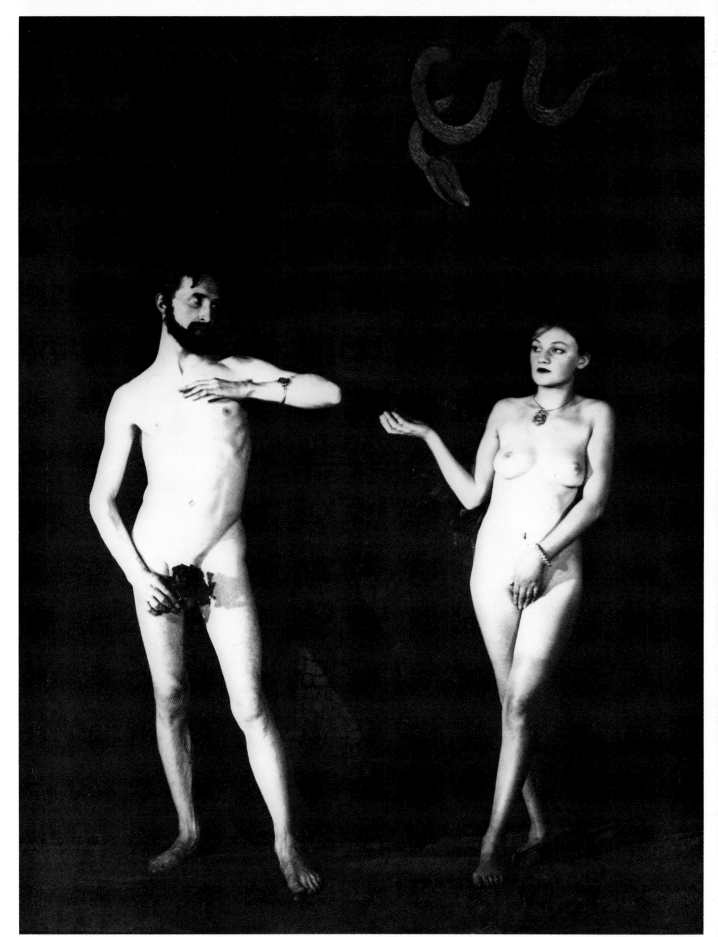

19 *Ciné-sketch : Adam, Ève :* Marcel Duchamp, Brogna Perlmutter-Clair, 1924.

18 Nancy Cunard, Tristan Tzara, 1924.

20

21

52

22 De gauche à droite / From left to right : Paul Chadourne, Tristan Tzara, Philippe Soupault, Serge Charchoune, Man Ray, Paul Eluard, Jacques Rigaut, Mick Soupault, Georges Ribemont-Dessaignes, circa 1922.

20 Cabaret *Le Paradis,* bd de Clichy. En haut, de gauche à droite / Above, from left to right : Hans Arp, Jean Caupenne, Georges Sadoul, André Breton, Pierre Unik, Yves Tanguy, Cora, de dos / seen from the back : André Thirion ; René Crevel, Frédéric Mégret. En bas / Below : Elsa Triolet, Louis Aragon, Camille Goëmans, Madame Goëmans, Suzanne Musard, 1929.

21 De gauche à droite / From left to right : André Breton, Max Morise, Roland Tual, Simone Collinet-Breton, Louis Aragon, Colette Jérameck-Tual.

23 Francis Picabia, 1923.

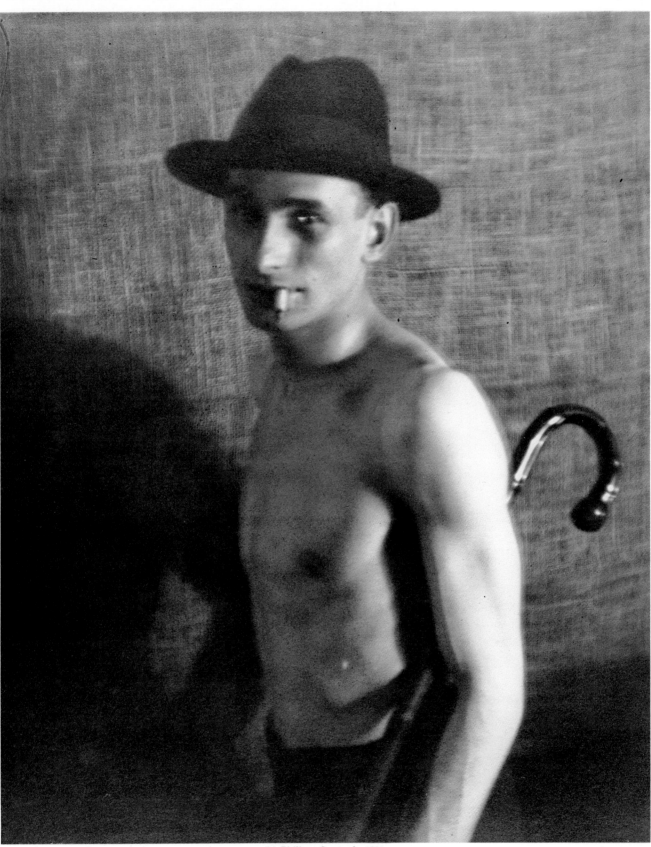

24 Philippe Soupault, 1921.

Page 56 :

25 Séance de rêve éveillé / Waking Dream Séance. De gauche à droite / From left to right : Max Morise, Roger Vitrac, Jacques Boiffard, André Breton, Paul Eluard, Pierre Naville, Giorgio De Chirico, Philippe Soupault. En bas / Below : Simone Collinet-Breton, Robert Desnos, Jacques Baron, 1924.

26 "Centrale surréaliste". De gauche à droite, en haut / Above, from left to right : Jacques Baron, Raymond Queneau, André Breton, Jacques Boiffard, Giorgio De Chirico, Roger Vitrac, Paul Eluard, Philippe Soupault, Robert Desnos, Louis Aragon. En bas / Below : Pierre Naville, Simone Collinet-Breton, Max Morise, Marie-Louise Soupault, 1924.

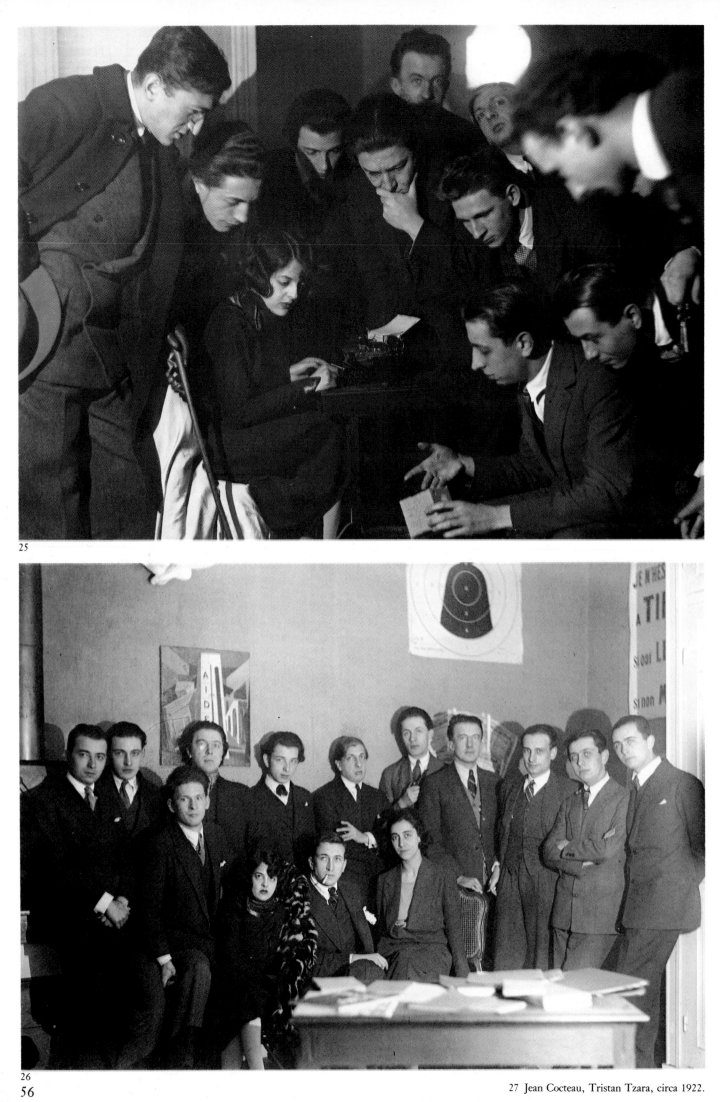

25

26

27 Jean Cocteau, Tristan Tzara, circa 1922.

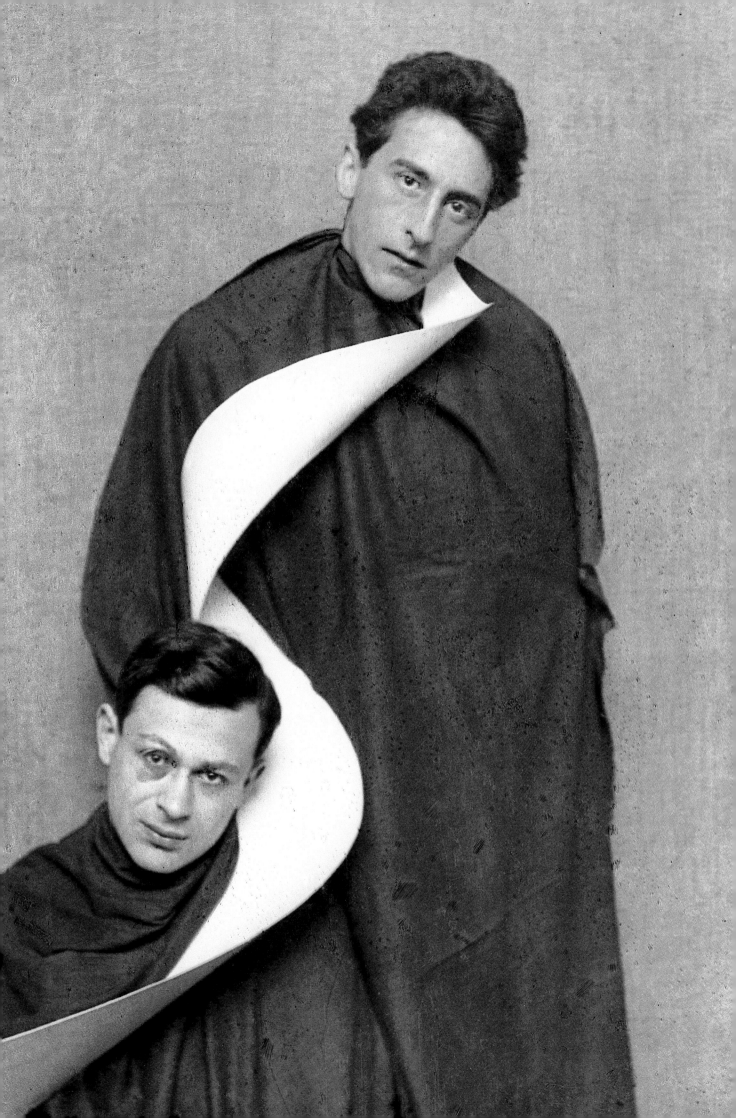

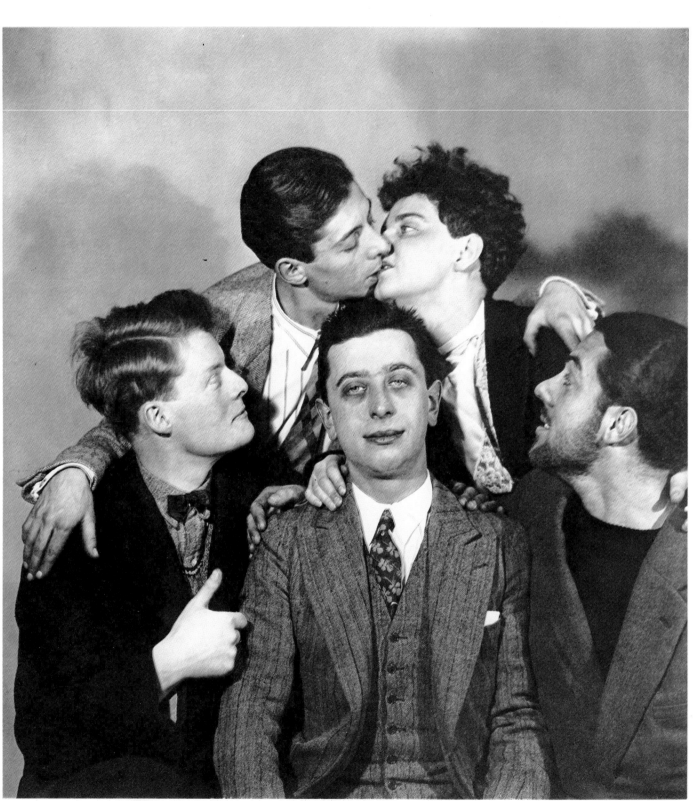

28 En haut à gauche / Above, left : Georges Malkine. En bas, au centre / Below, centre : Robert Desnos.

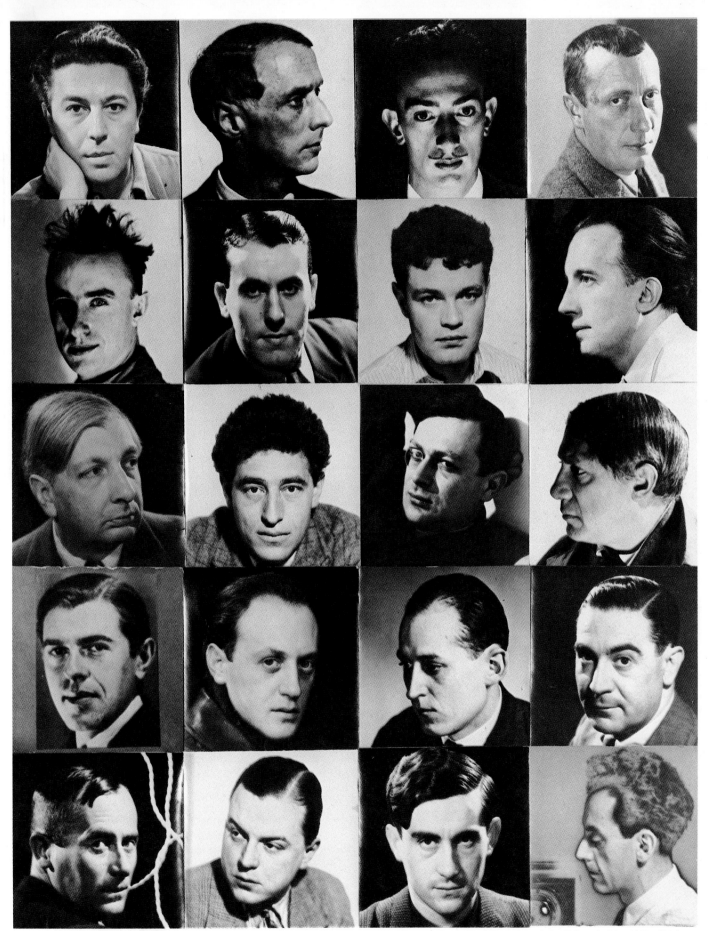

29 *Échiquier surréaliste* : André Breton, Max Ernst, Salvador Dali, Hans Arp, Yves Tanguy, René Char, René Crevel, Paul Eluard, Giorgio De Chirico, Alberto Giacometti, Tristan Tzara, Pablo Picasso, René Magritte, Victor Brauner, Benjamin Péret, Gui Rosey, Joan Miró, E.L.T. Mesens, Georges Hugnet, Man Ray, 1934.

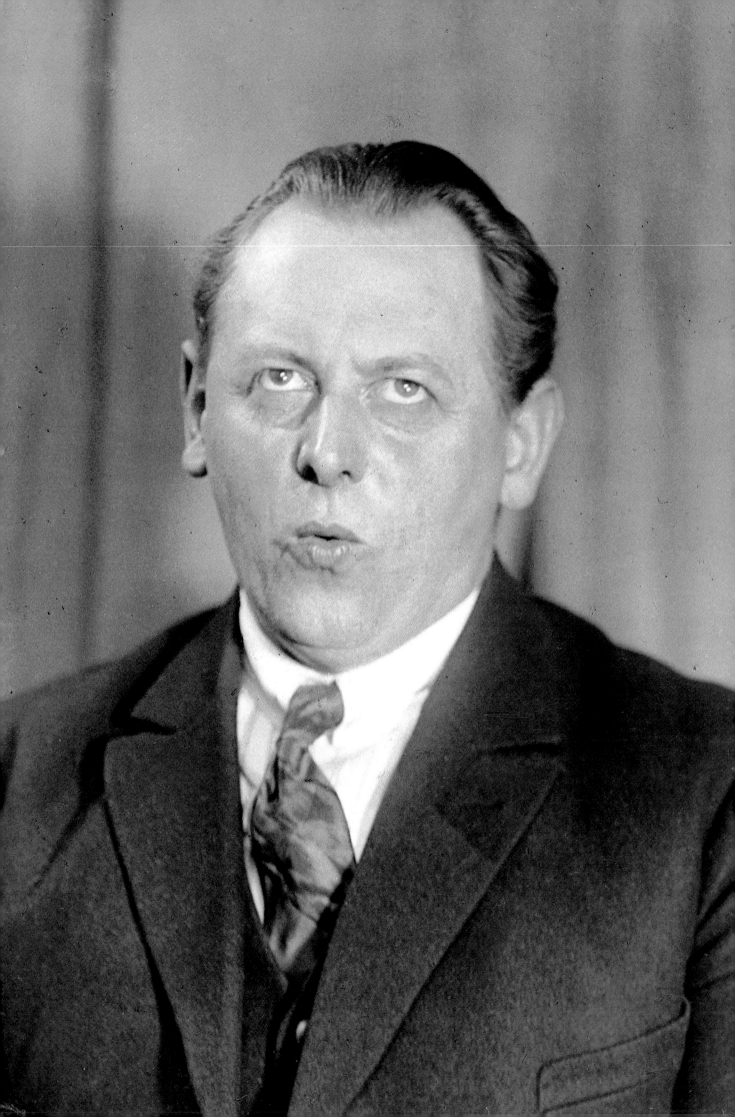

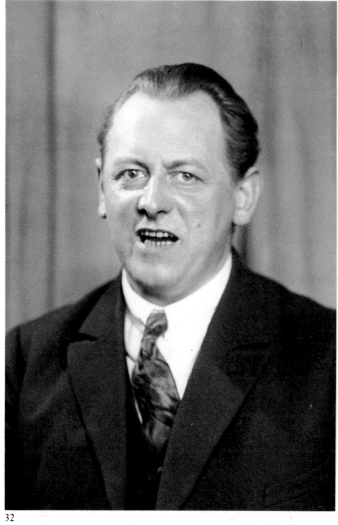

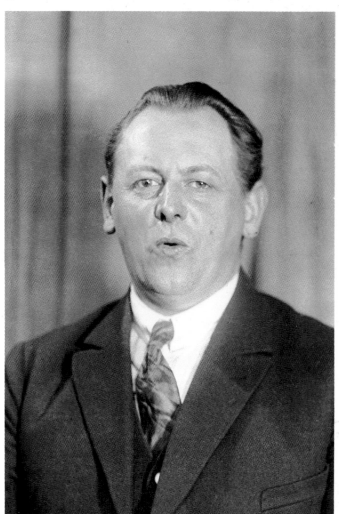

31 32

33 34

30 — 34 Kurt Schwitters, 1936.

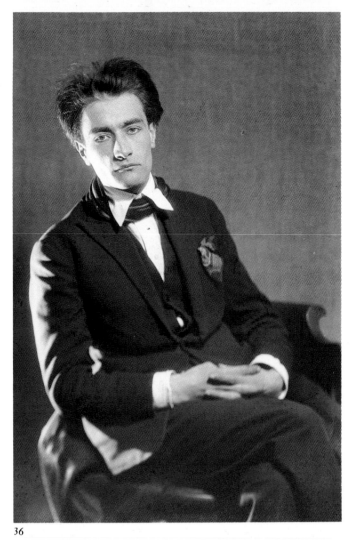

35

36

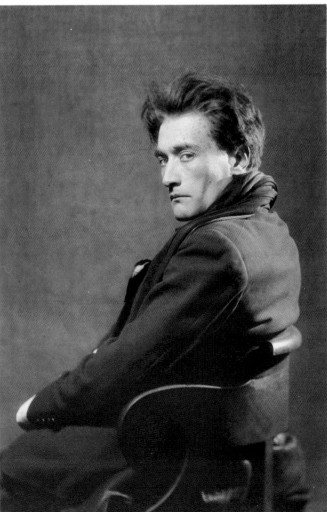

37

38

35 — 39 Antonin Artaud, 1926.

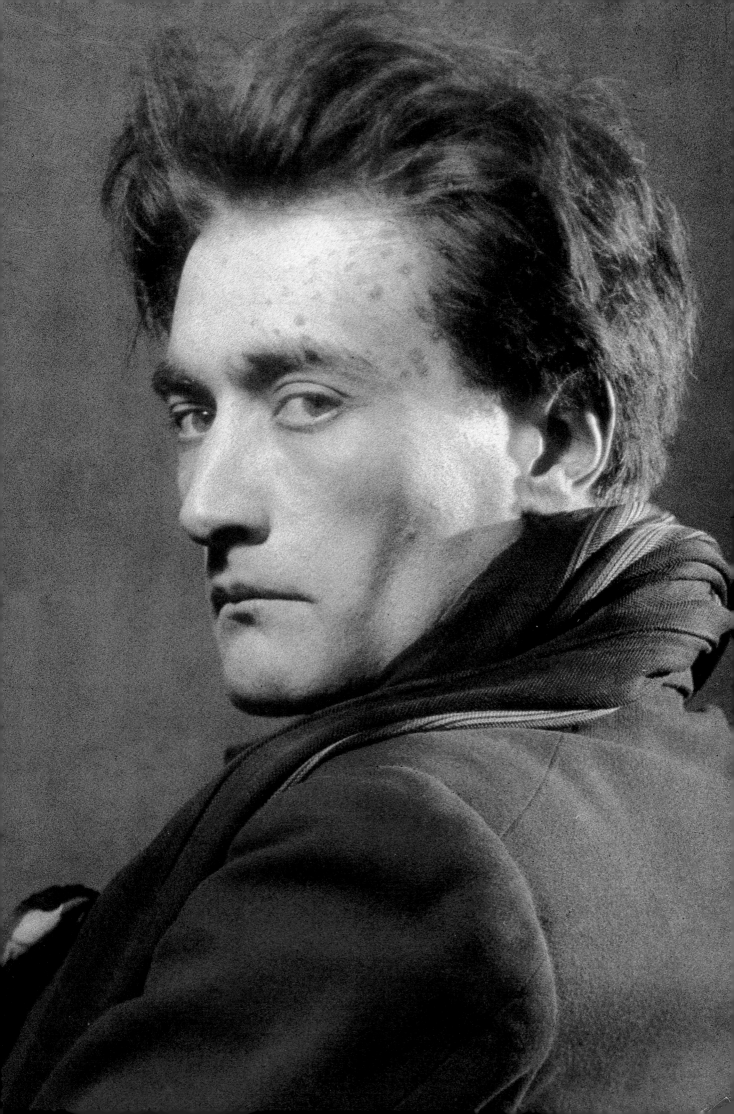

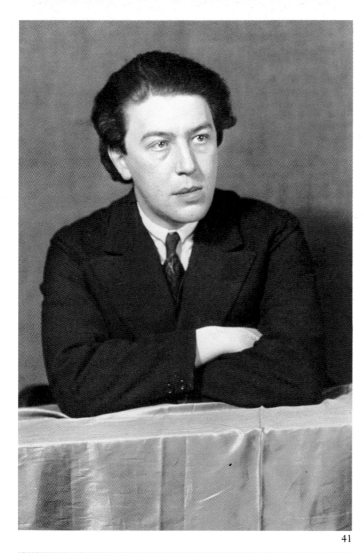

41　42

40 — 44 André Breton, circa 1930.

43　44

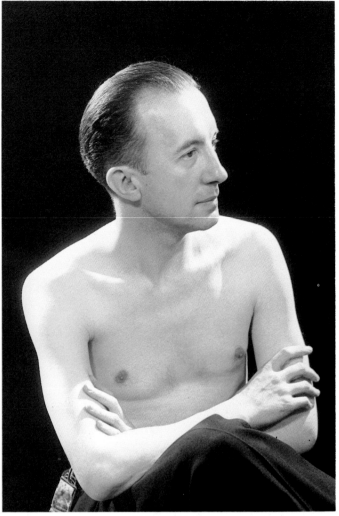

45 Paul Eluard, André Breton, 1930.

46 Paul Eluard.

47 Paul Eluard.

48 Paul Eluard.

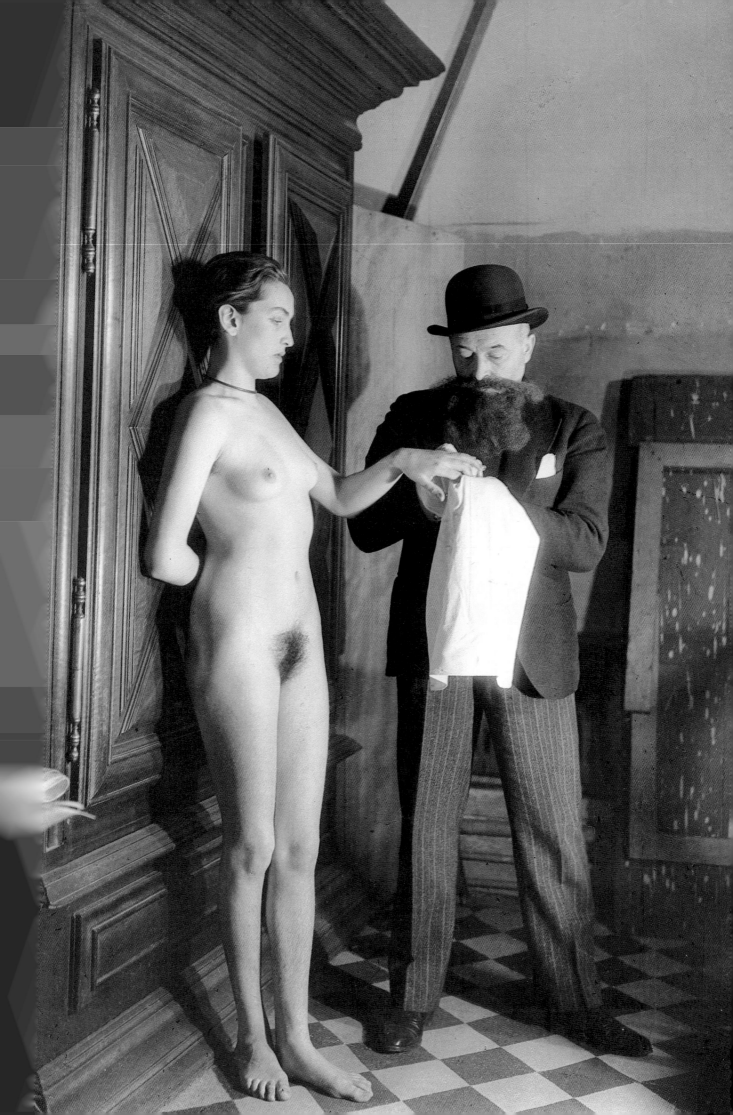

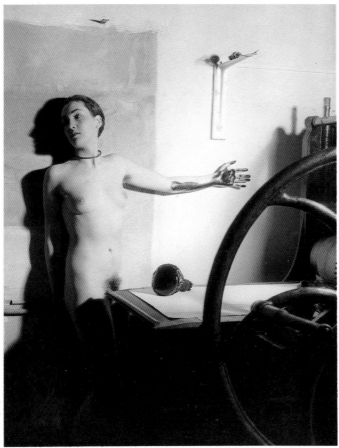

50 Meret Oppenheim, 1933.

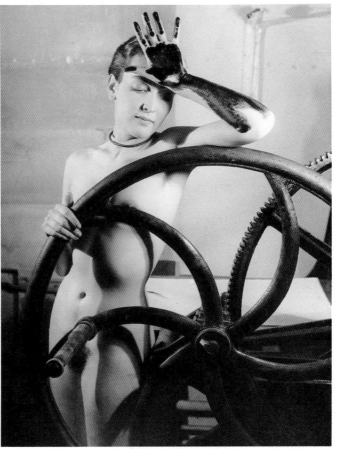

51 *Érotique voilée*, 1933.

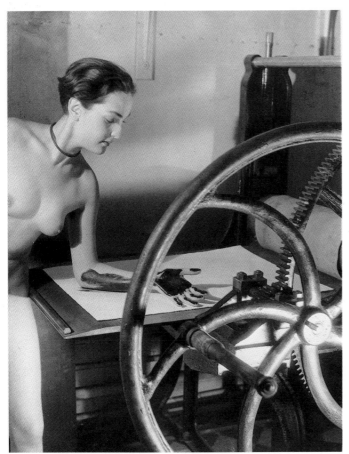

52 Meret Oppenheim, 1933.

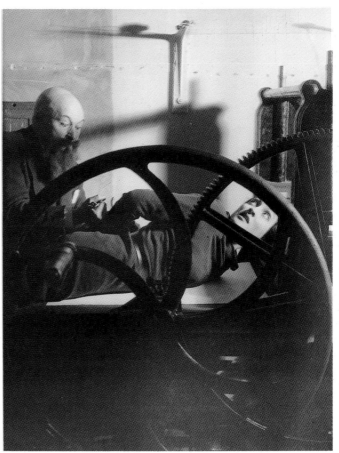

53 Meret Oppenheim, Louis Marcoussis, 1933.

49 Meret Oppenheim, Louis Marcoussis, 1933.

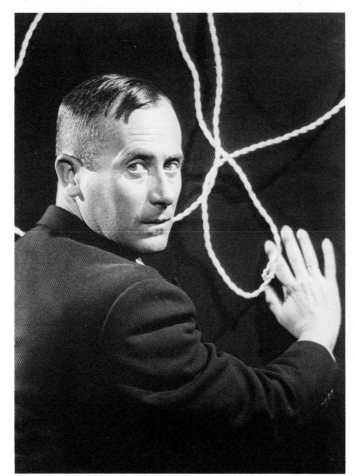

54 Joan Miró, circa 1930.

55 Hans Bellmer.

56 Meret Oppenheim, circa 1950.

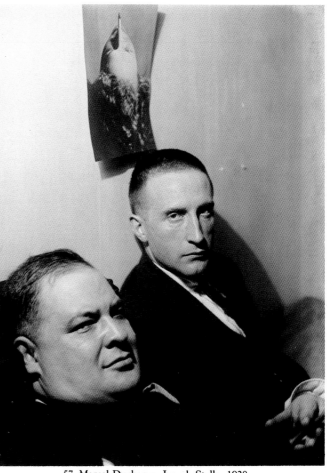

57 Marcel Duchamp, Joseph Stella, 1920.

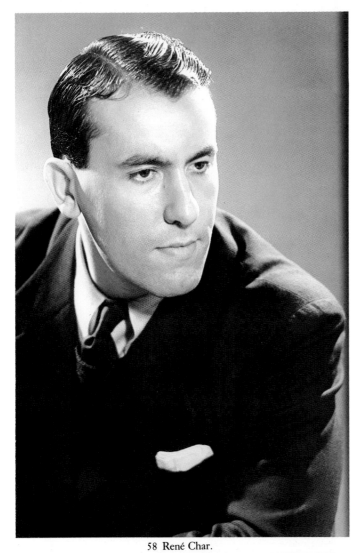

58 René Char.

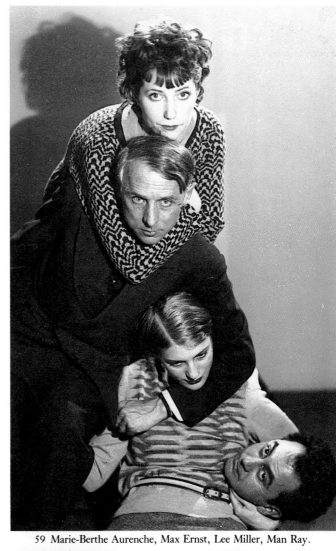

59 Marie-Berthe Aurenche, Max Ernst, Lee Miller, Man Ray.

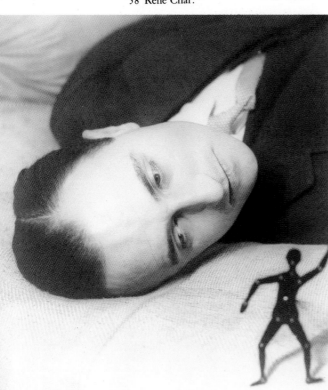

60 Jacques Rigaut, 1922.

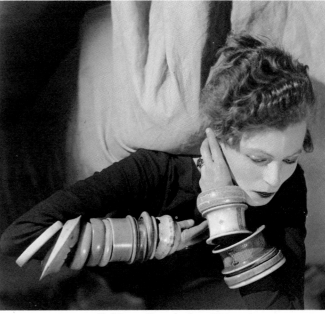

61 Nancy Cunard, circa 1926.

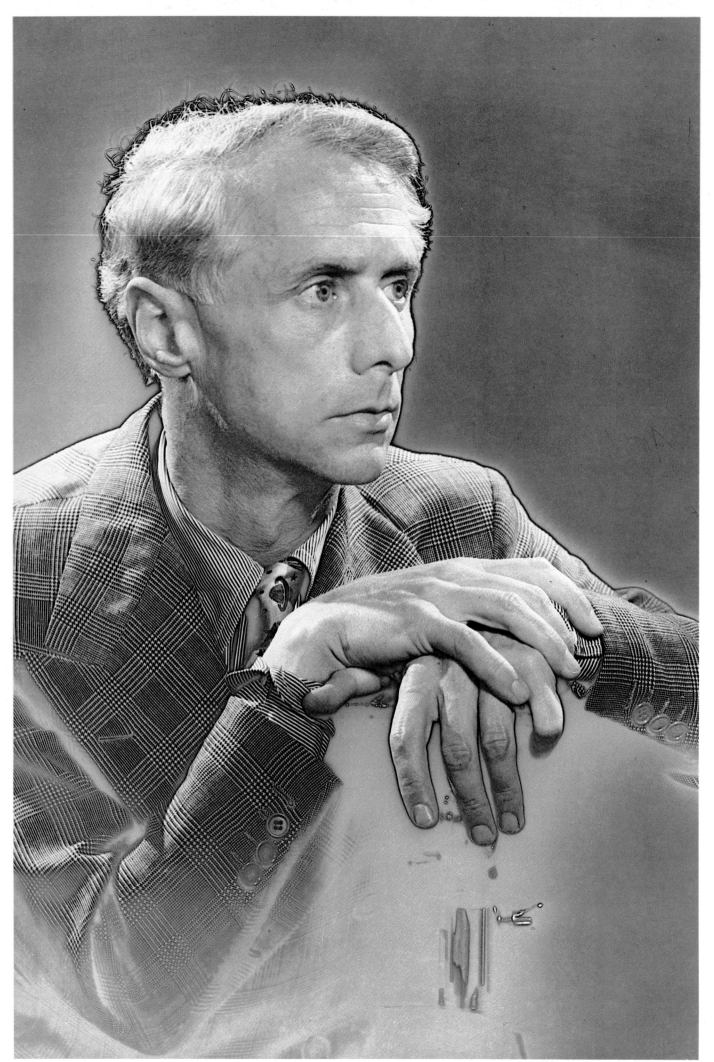

62 Max Ernst, circa 1935.

63 Balthus, 1933.

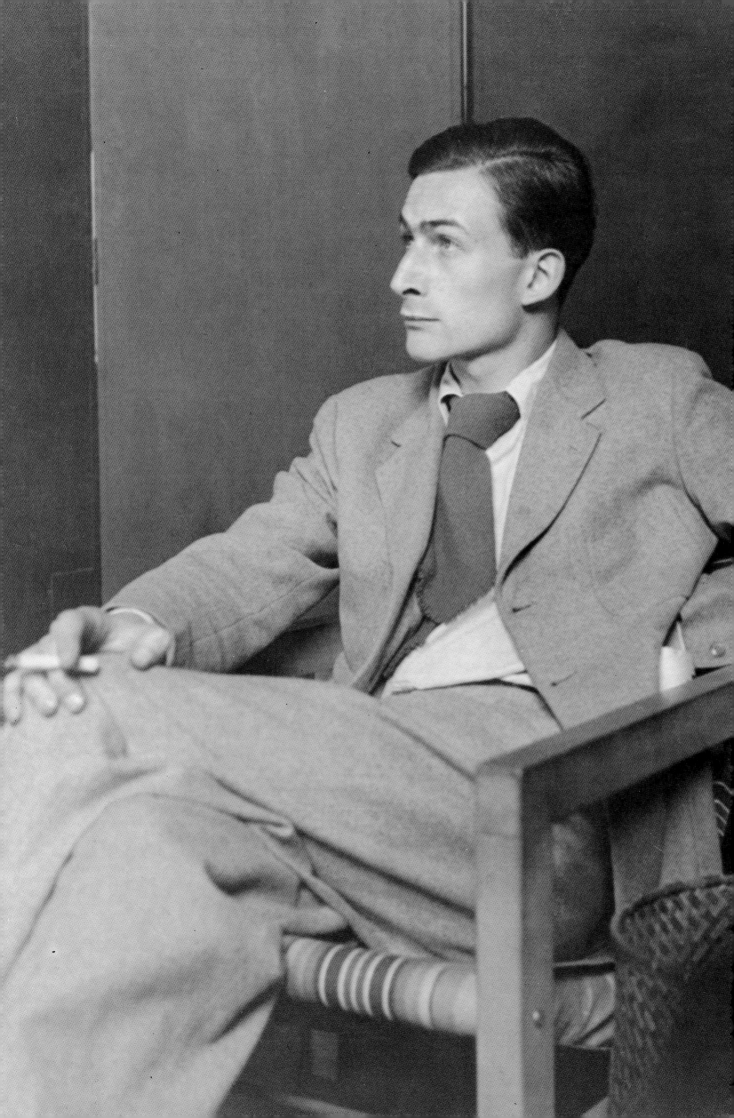

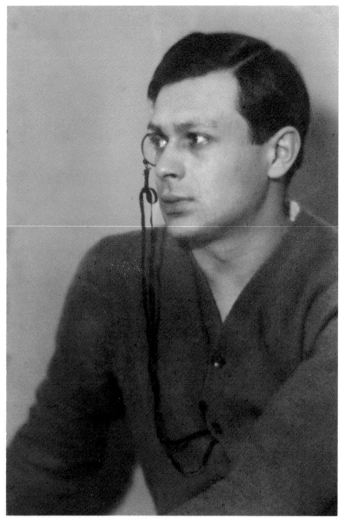

64 Tristan Tzara.

65 Louis Aragon, 1923.

66 Benjamin Péret.

67 Georges Ribemont-Dessaignes.

74

68 Erik Satie, mars 1924.

69 Hans Arp.

70 Roland Penrose.

71 René Crevel.

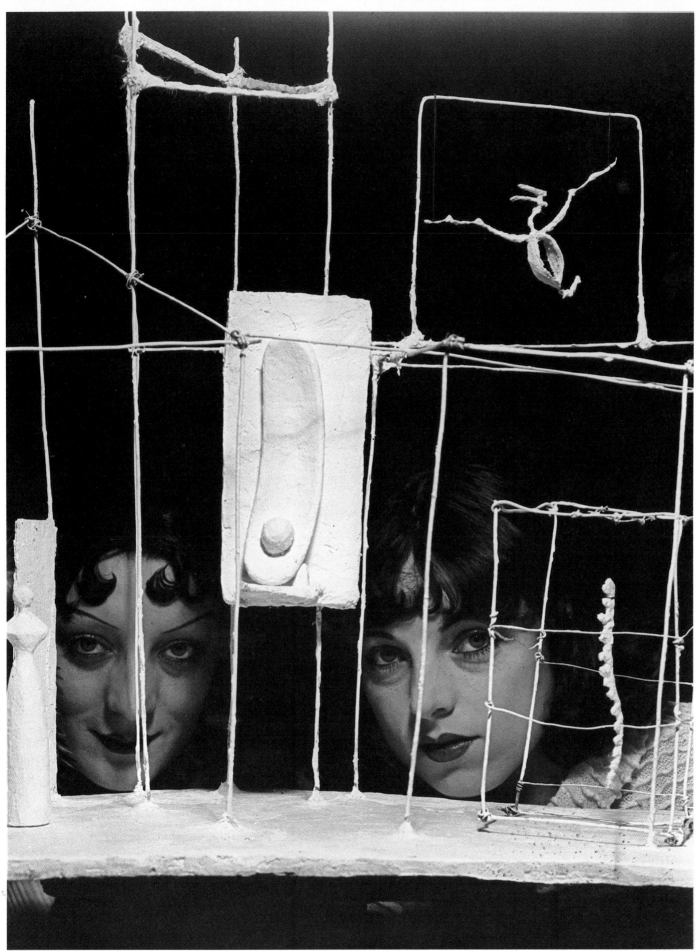

72 *Palais de quatre heures*, 1932-33.

73 Alberto Giacometti, *circa* 1934.

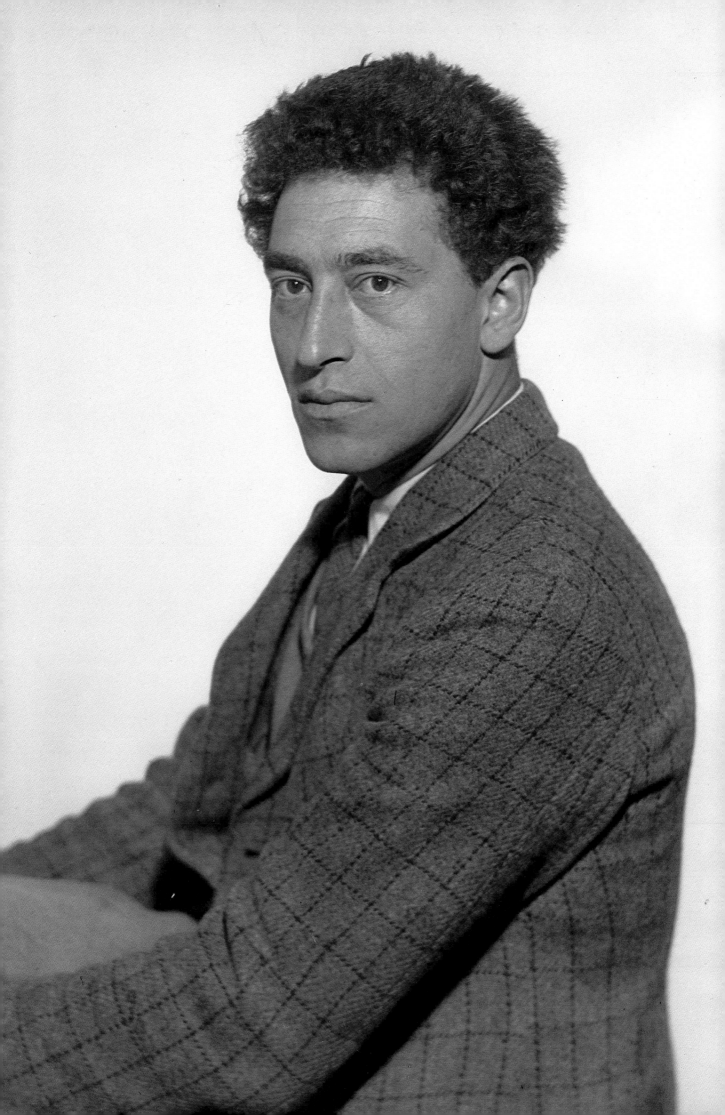

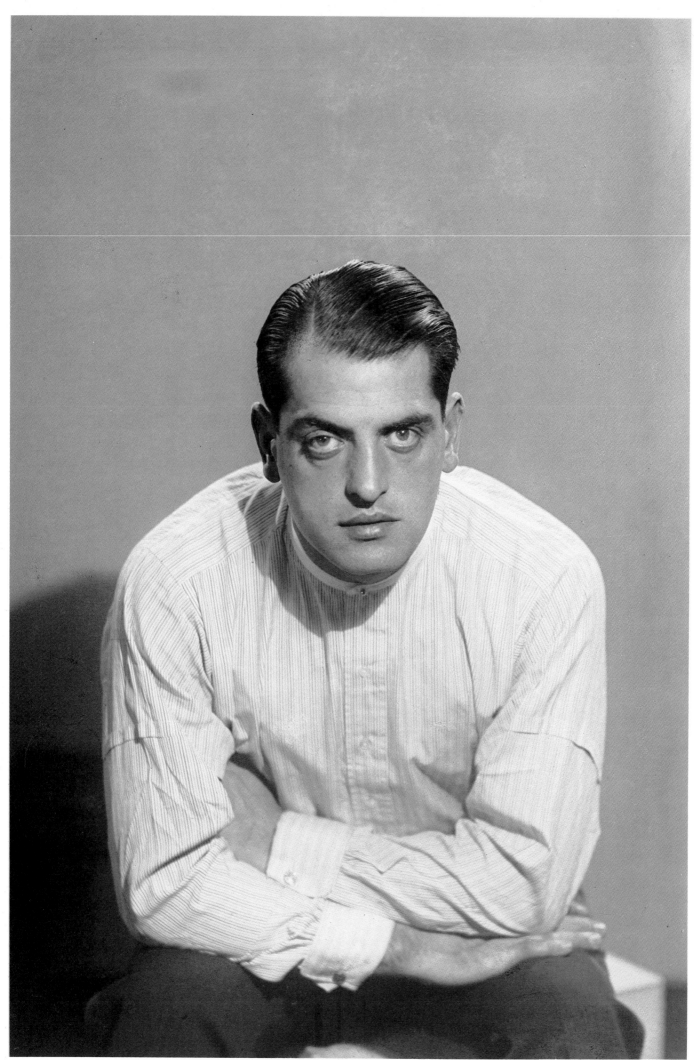

74 Luis Buñuel, 1929.

75 Salvador Dali, 1929-31.

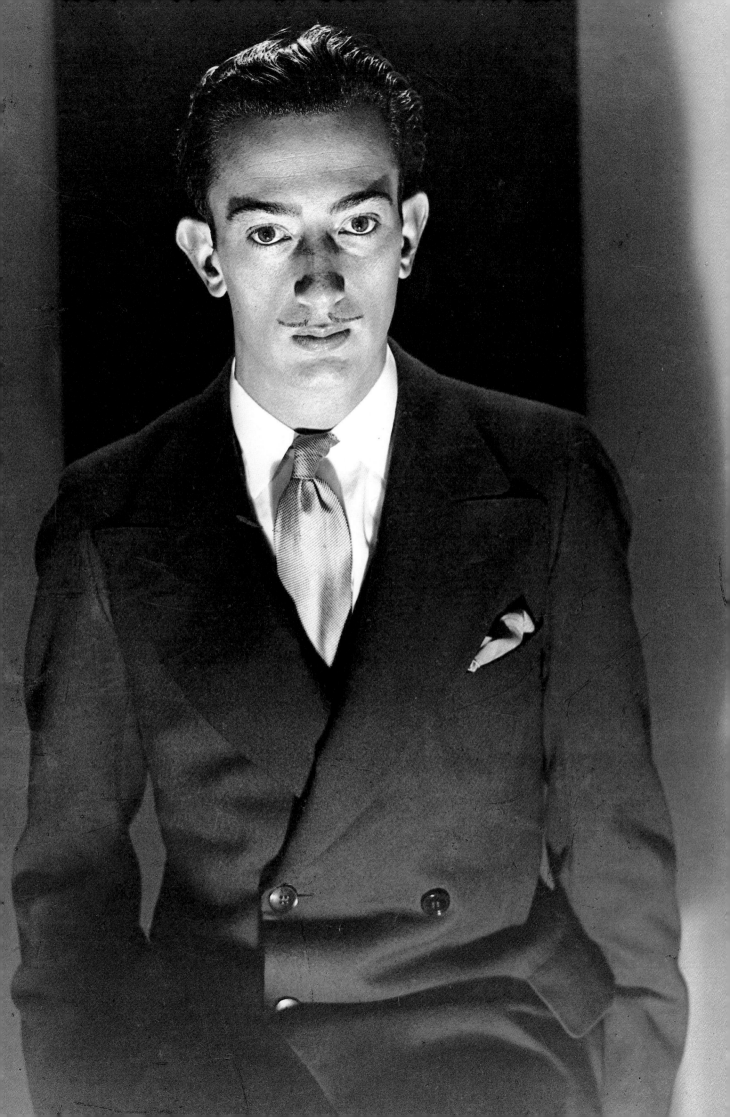

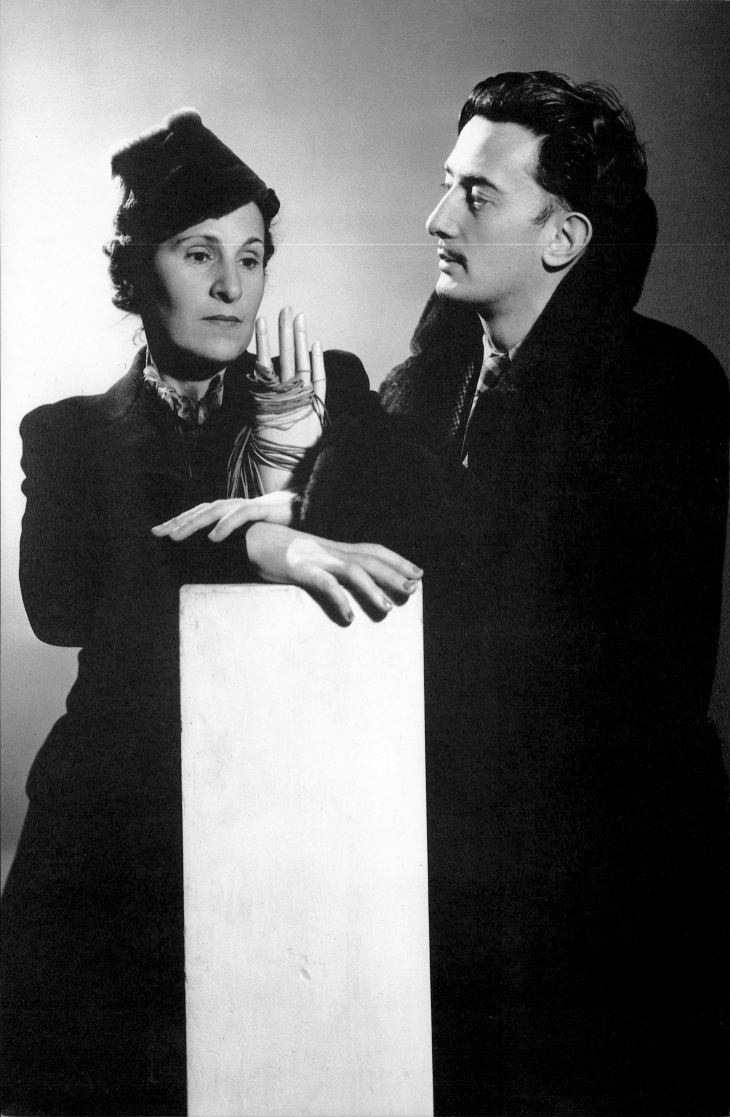

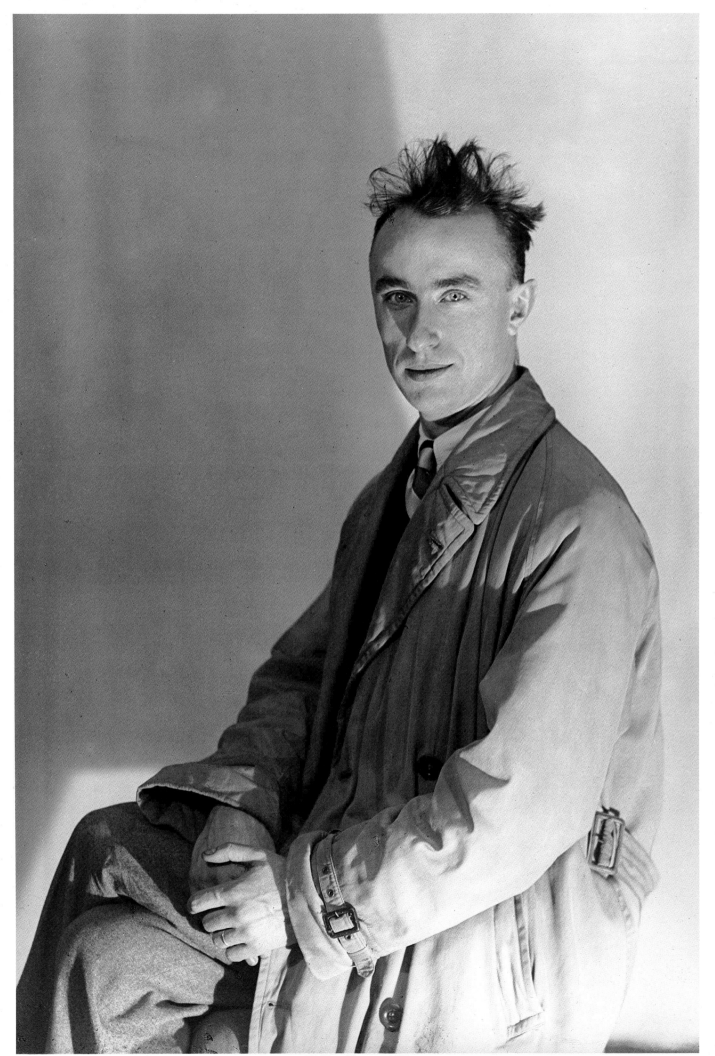

77 Yves Tanguy, 1936.

76 Salvador Dali, Gala, 1936.

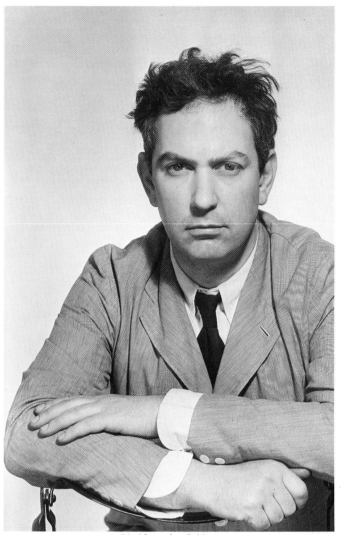

78 Alexander Calder.

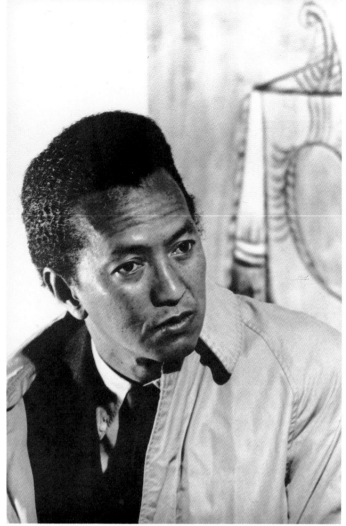

79 Wifredo Lam, 1938-39.

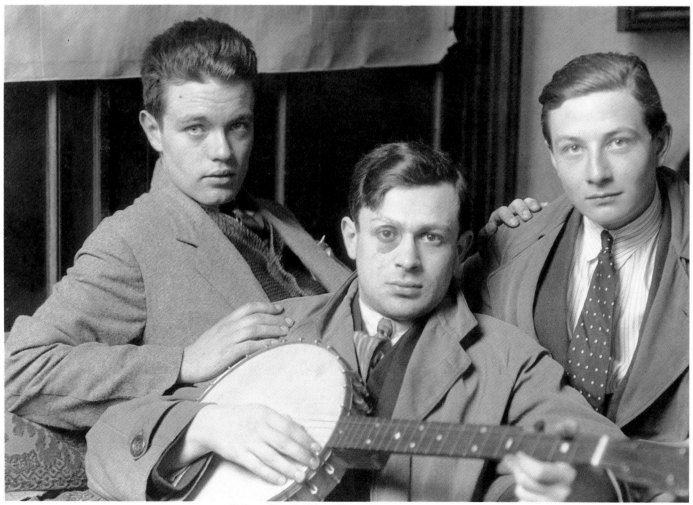

80 René Crevel, Tristan Tzara, Jacques Baron, 1928.

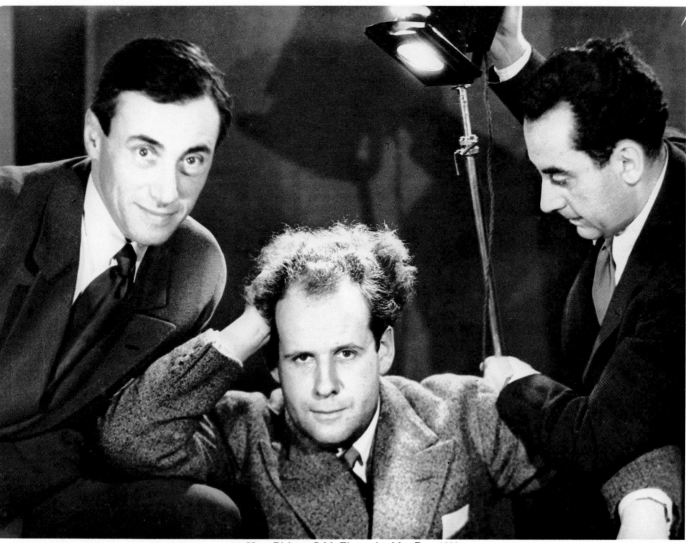

81 Hans Richter, S.M. Eisenstein, Man Ray, 1929.

82 Giorgio De Chirico, 1925.

83 Luis Buñuel, 1929.

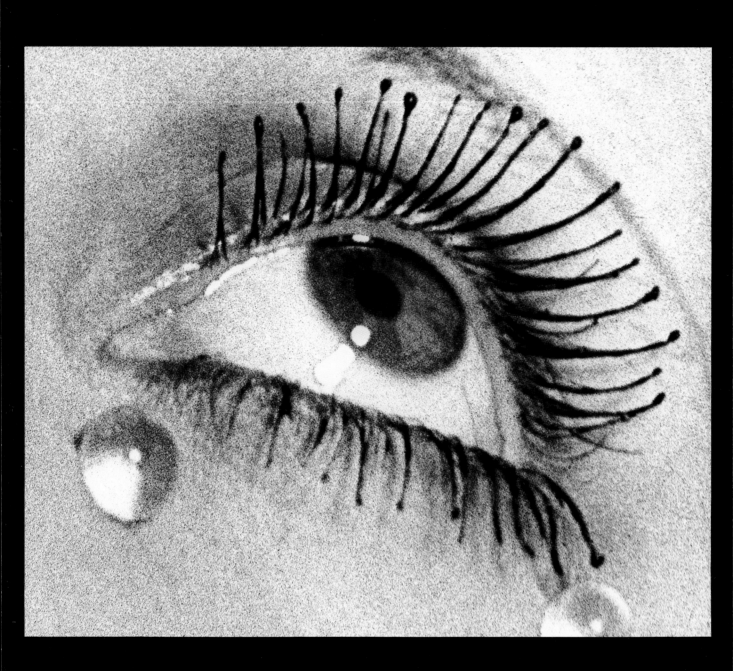

Intimacy
and eroticism

In spite of all restrictions and camouflage, whether for purposes of concealment or merely suggestiveness of her body, most races have unwittingly and fortunately left the head or part of the head of woman naked. Even if it were only to allow the eyes to peep through a veil, our society has committed a breach of its moral code, a laxity for which poets through the ages have been grateful. The more daring poets who have seen in a woman's eyes her sex, have realized that the head contains more orifices than does all of the rest of the body; so many added invitations for poetic, that is, sensual exploration. One may kiss an eye or provoke it to wetness without offending decency. With the complete exposure of the head a veritable orgy is invited. Either in its natural state or with its embellishments of makeup, jewels, and elaborate hairdos, nothing can restrain the imagination from the most riotous speculations.

84. *Larmes, c.* 1930.
'Tears. A dancer's make-up brought forth these (glass) tears that do not express any kind of emotion.' This picture is a detail from a photograph of a French cancan dancer, showing the left eye only; a print which was published in the series *Danses-horizons* in Minotaure (No. 5, 1934) shows that she is sitting on the floor.

85. *A l'heure de l'observatoire - Les amoureux,* 1934-38.
On the back of the print now in the Museum of Modern Art, New York (Soby Collection), dated 1934, was written in French 'The breasts/shoulder-blades pun only became apparent when the image was developed: a perfect Surrealist coincidence.'

86. Self portrait.
The scene may have been a room in the Hotel Istria, rue Campagne Première.

87. Untitled.
The plaster bust of Venus appears often in Man Ray's photographs and was used trussed up with string for an object, *Venus restaurée* (1936), which disappeared after 1971.

88. Meret Oppenheim.
Two other prints are known: one centring on the whole body, the other only on the head.

89. Nusch Eluard, Ady.
Nusch Benz, an actress born in Mulhouse in 1906, met Paul Eluard in 1930 and was his dearly-loved wife until his death in 1946. 'No other photograph could portray so well this woman's charm and sweetness.' Adrienne, called Ady, was a young dancer from Guadeloupe and was Man Ray's companion just before the war.

90. Nusch Eluard, Sonia Mossé, 1936.
The motif of this photograph was taken up in a drawing, *Hommage à Nusch,* which appeared in *Les mains libres,* a book of Paul Eluard's poems (1937).

91. Nusch Eluard, 1935.
This nude was a full page illustration for a poem by Paul Eluard printed on the white background of the photograph, which appeared in *Facile* (1935).

92. Untitled, 1925.
This picture appeared in *La révolution surréaliste* (No. 2, 15 January 1925). The model is Kiki. Man Ray also used it to make a collage, with two smaller nudes in positive in the lower half of the photograph.

93. Nusch Eluard, 1935.
Another illustration from *Facile* (see **91**).

94. Untitled.
This nude portrait of Natacha, who was Man Ray's assistant at the time, was published in black and violet in *Harper's Bazaar* (October 1940).

95. *Retour à la raison,* 1923.
This is a picture of Lee Miller, taken from the film *Retour à la raison.* It appeared for the first time in *La révolution surréaliste* (No. 1, 1 December 1924, p. 4). A horizontal version was reproduced under the title *Torse* in *Art vivant* (No. 103, 1 April 1929, p. 283).

96-97. Untitled, 1927.
These also exist in more close-up versions showing head and torso only, in both positive and negative solarizations.

98. Kiki de Montparnasse, 1924-26.
Kiki (Alice Prin), originally from Burgundy, became a model in Montparnasse, where she posed for Kisling, Friesz, Foujita, Maillol and numerous painters. She was Man Ray's companion from 1922 to 1926.

99. Kiki de Montparnasse, 1924-26.
Photographs of people taken outside the studio are rare. There are only a few photographs of Kiki taken in the street or, as here, in a café.

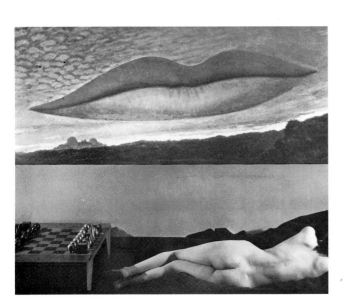

100-08. Kiki de Montparnasse, 1922-26.
106 is a detail from a negative in which there is a full-length portrait of another woman in front of Kiki. **107** is from a film by Fernand Léger, *Ballet mécanique*, which had been started under Man Ray's direction.

109. *Noire et blanche*, 1926.
This photograph, sometimes entitled *Composition*, was published in *Variétés* (No. 3, 15 July 1928). It is one of the photographs Man Ray valued most highly. The negative has been touched up and dated.

110. *Noire et blanche*, 1926.
Negative version of **109**.

111. Noire et blanche, 1926.

112. Untitled.

113. Meret Oppenheim, 1933.
In the background is a painting by Salvador Dali.

114. Untitled.

115. Untitled.

116. Suicide, 1930.
This photograph of Natacha was copied as a drawing for the book of poems *Les mains libres*, where it had the title *La mort inutile*, 1936.

117-18. Untitled.
No doubt the girls were cabaret dancers (of whom Man Ray took many photographs).

119. Suzy Solidor, 1929.
Man Ray photographed her from several different angles. She also had her portrait done by many other artists. A collection of portraits of her is in the museum at Cagnes-sur-Mer.

120. Untitled.

121. Untitled.
This photograph exists in a larger framing, where the model is seen to be kneeling.

122-23. Juliet, *c*. 1945.
Juliet Browner, an American dancer. Man Ray married her in 1946 in California at a double wedding, the other couple being Max Ernst and Dorothea Tanning. The turban and the pose in **122** are slightly reminiscent of Ingres. For **123**, Man Ray used a technique which first became common in California in the forties: placing a piece of transparent paper with a pronounced grain on the paper just before it is printed.

124. Juliet, *c*. 1945.
A superimposition of Juliet's face and the head of a stone statue. Published in *L'âge du cinéma* (Nos. 4-5, August-November, 1951, p. 25.).

125. Juliet, *c*. 1945.
Several versions were taken from different angles at the same sitting in which Juliet holds her hands up to her face. The silk stocking over her head recalls the characters in Man Ray's film *Les mystères du château de Dès*.

126-27. Juliet, *c*. 1945.

128. Juliet, *c*. 1945.
The same technique has been employed as in **123**.

129-30. Juliet, *c*. 1945.
A sadistic Juliet with her sister Selma Browner. **130** is solarized.

131. Max Ernst, Juliet, Dorothea Tanning ?, Man Ray.

132. Man Ray, Juliet.
Man Ray as Walt Whitman, Juliet as a Red Indian.

133. Man Ray, Juliet.
Man Ray as an animal tamer and Juliet as a leopard.

134-35. Self portraits.

136. Self portrait.
Towards the end of his life Man Ray often wore the typically French beret.

137. Self portrait.

138. Self portrait.
Man Ray seems to have filled out somewhat here. No doubt this was taken during the time he was ill (*Self Portrait*, p. 249). The instrument he is playing here and which he demonstrated to a Maharaja and his wife whom he photographed in Cannes 'was a phonograph on an empty valise. On the floor against it was a felted ball worked by a pedal - the kind that goes with the bass drum in jazz bands. To the phonograph was attached a cymbal. I had demonstrated it to the Maharajah by putting on a record, accompanying it with the improvised battery. No doubt I had gotten the idea from my first visit to Cocteau' (*Self Portrait*, p. 172).

139-41. Self portraits.

142. Untitled.
One of Man Ray's favourite photographs: 'photograph of a broken chair carried home from Griffith Park, Hollywood; at one of its broken legs, the slippers of Anna Pavlova'. This still life was taken from several different angles. A photograph very close to this one was published on the cover of *View* (No. 2, series III).

143. *The Magnet*, rayograph, 192 × 3.

144. Rayograph, 1922.
Project for the cover of *Photographs by Man Ray 1920-1934* published in 1934 in Paris by *Les cahiers d'art* and in America by James Thrall Soby of Hartford, Connecticut.

145. *Ships*, rayograph, 1924.

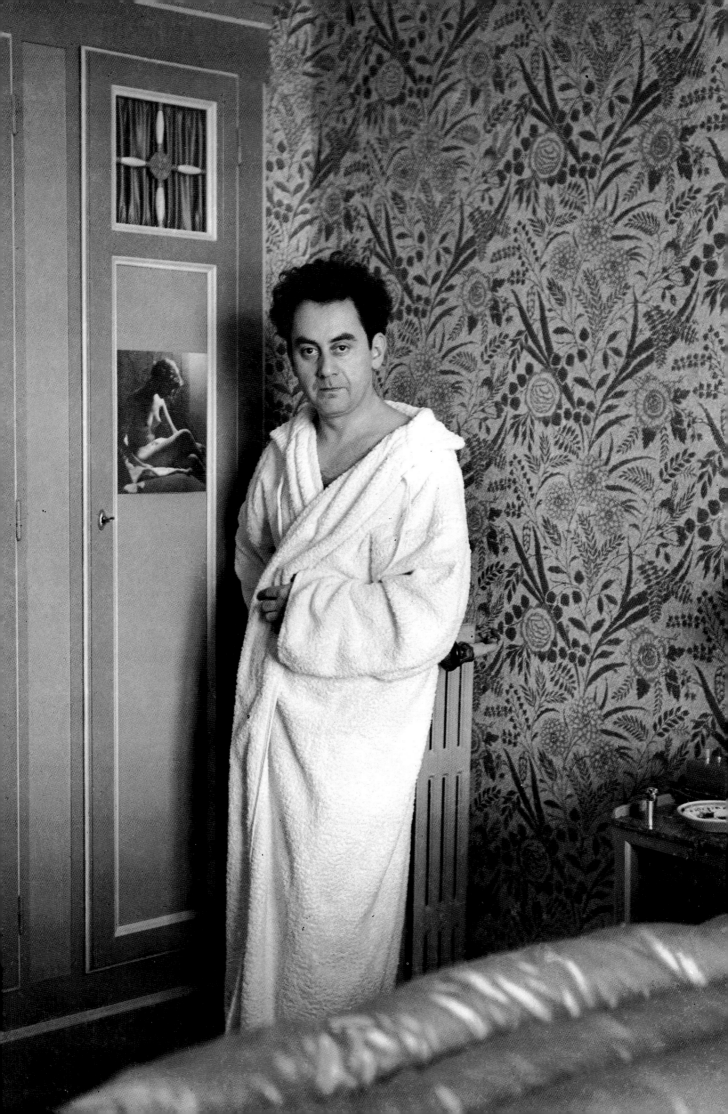

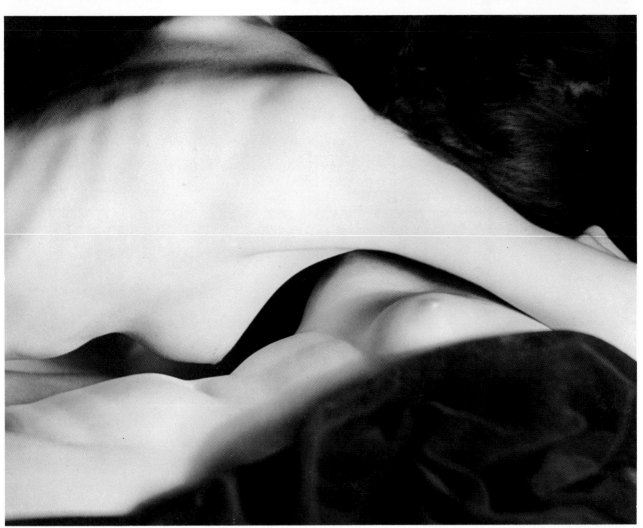

87 Sans titre / Untitled.

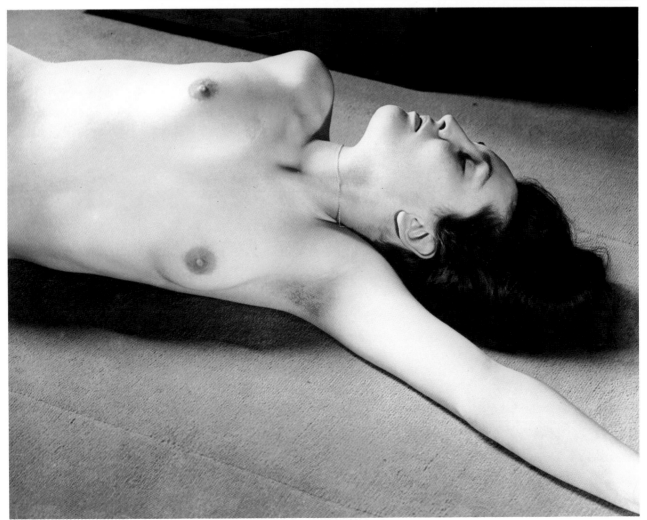

88 Meret Oppenheim.

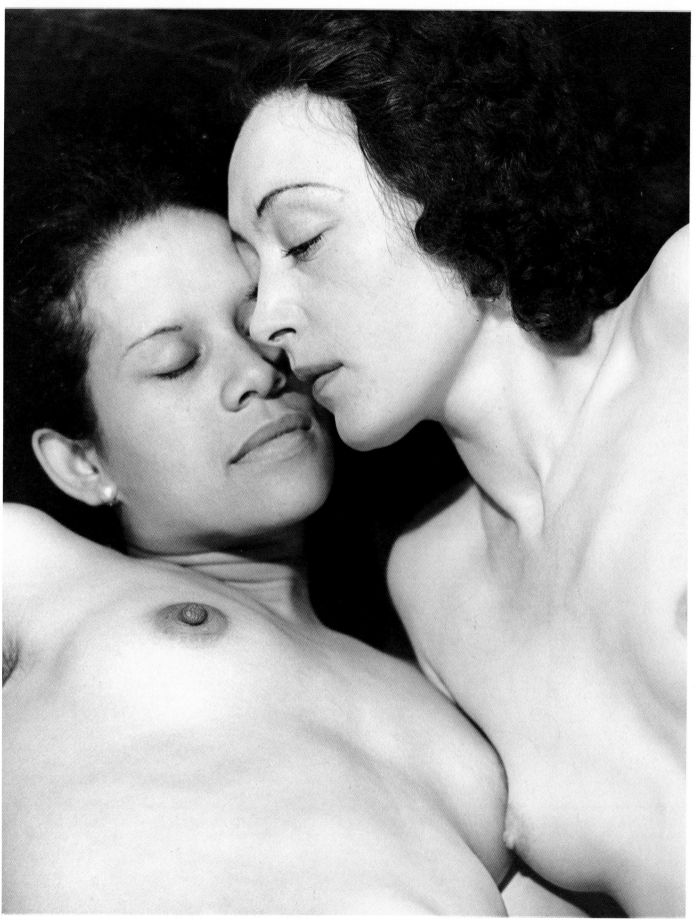

89 Nusch Eluard, Ady.

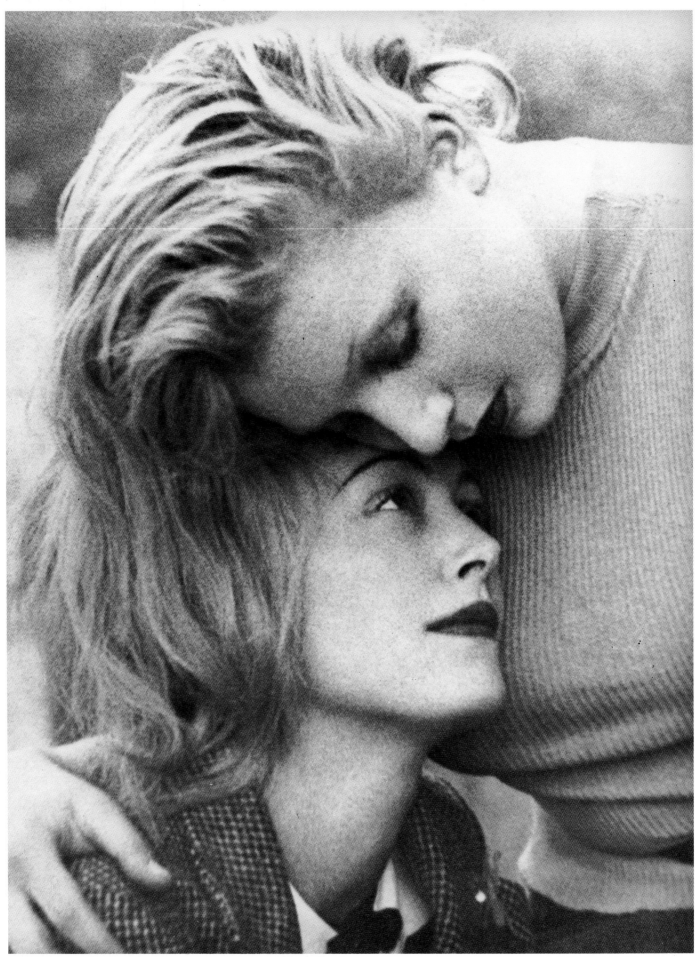

90 Nusch Eluard, Sonia Mossé, 1936.

91 Nusch Eluard, 1935.

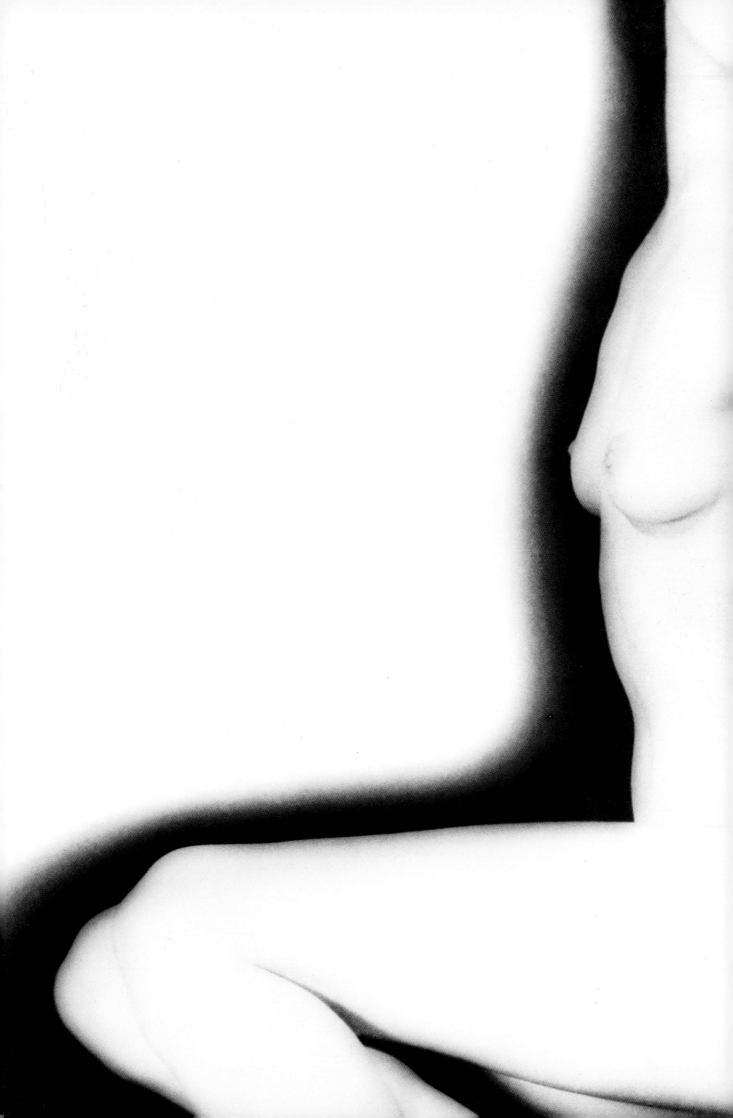

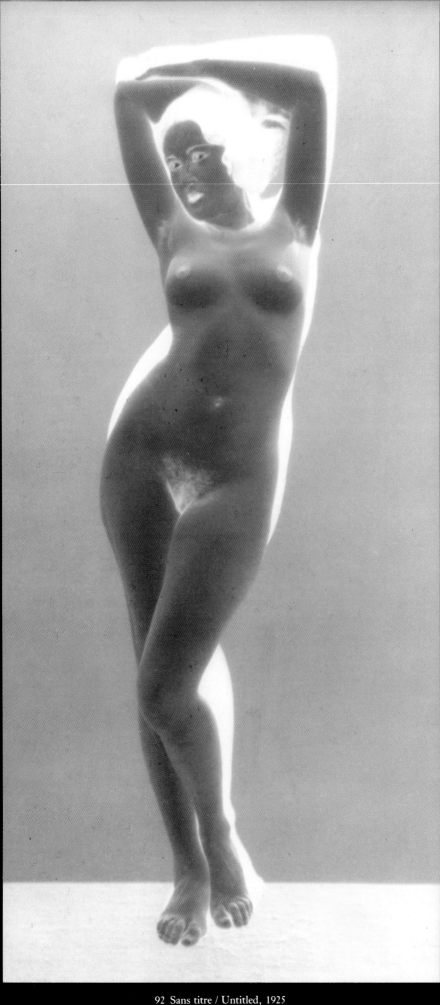

92 Sans titre / Untitled, 1925

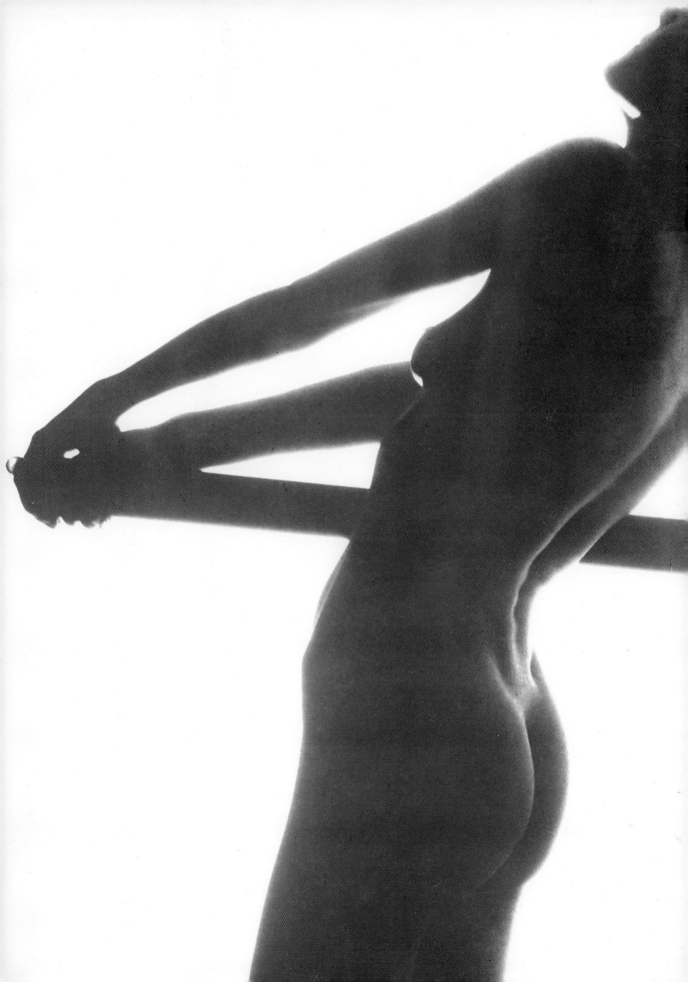

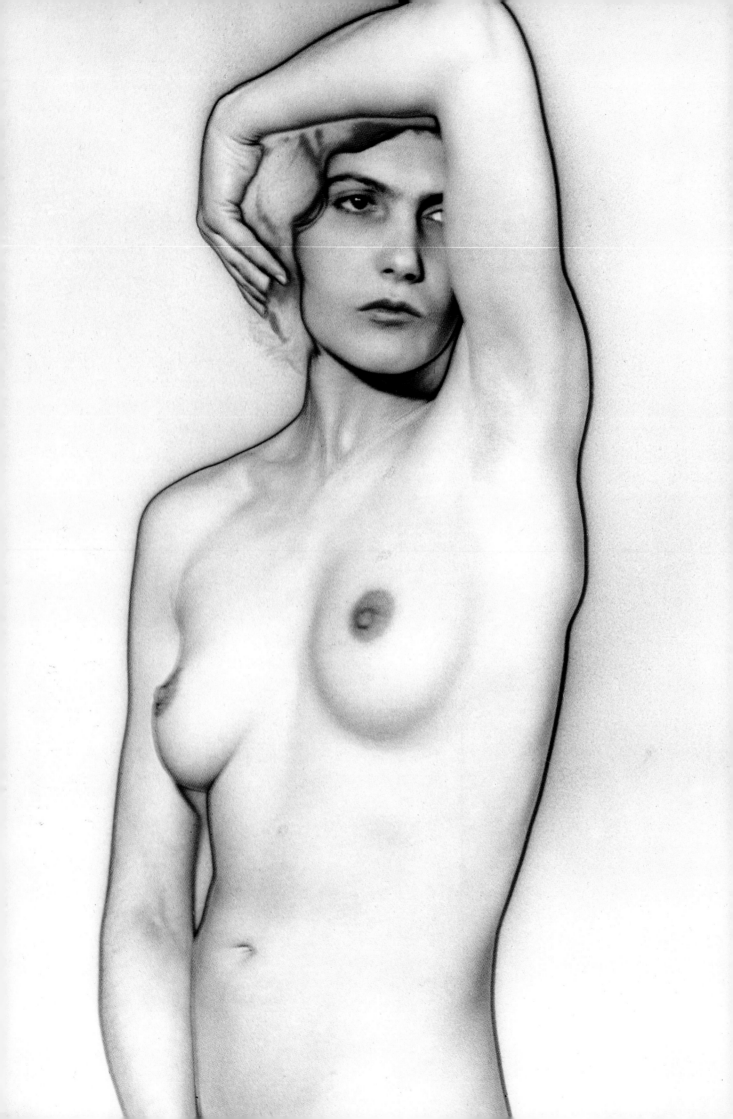

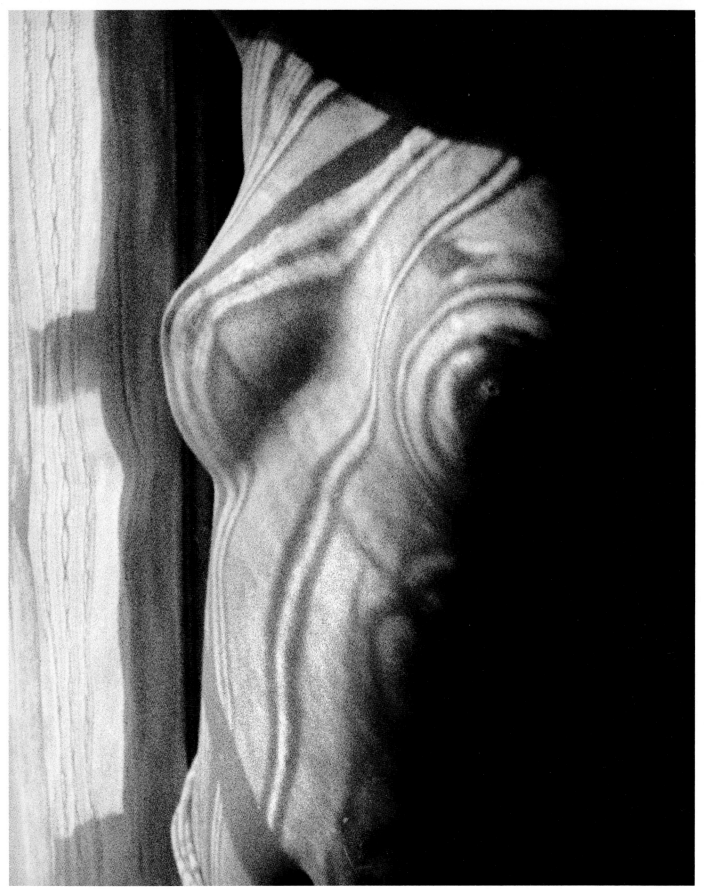

95 *Retour à la raison*, 1923.

94 Sans titre / Untitled.

Pages 98 & 99 :
96 Sans titre / Untitled, 1927.
97 Sans titre / Untitled, 1927.

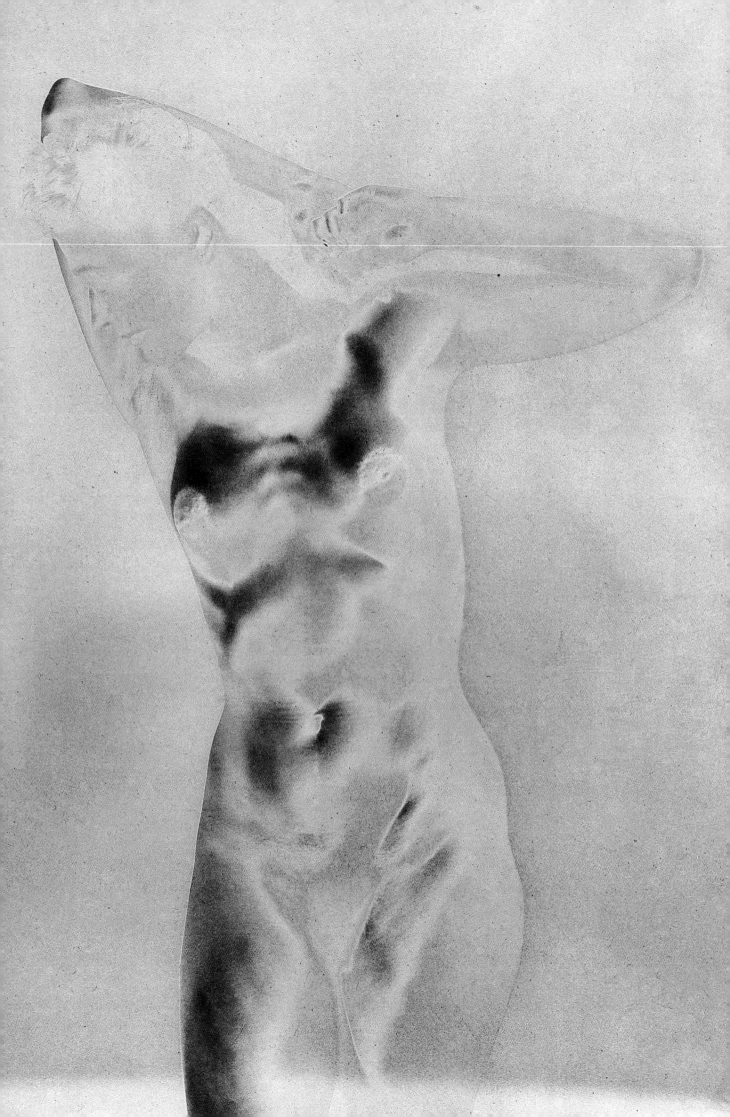

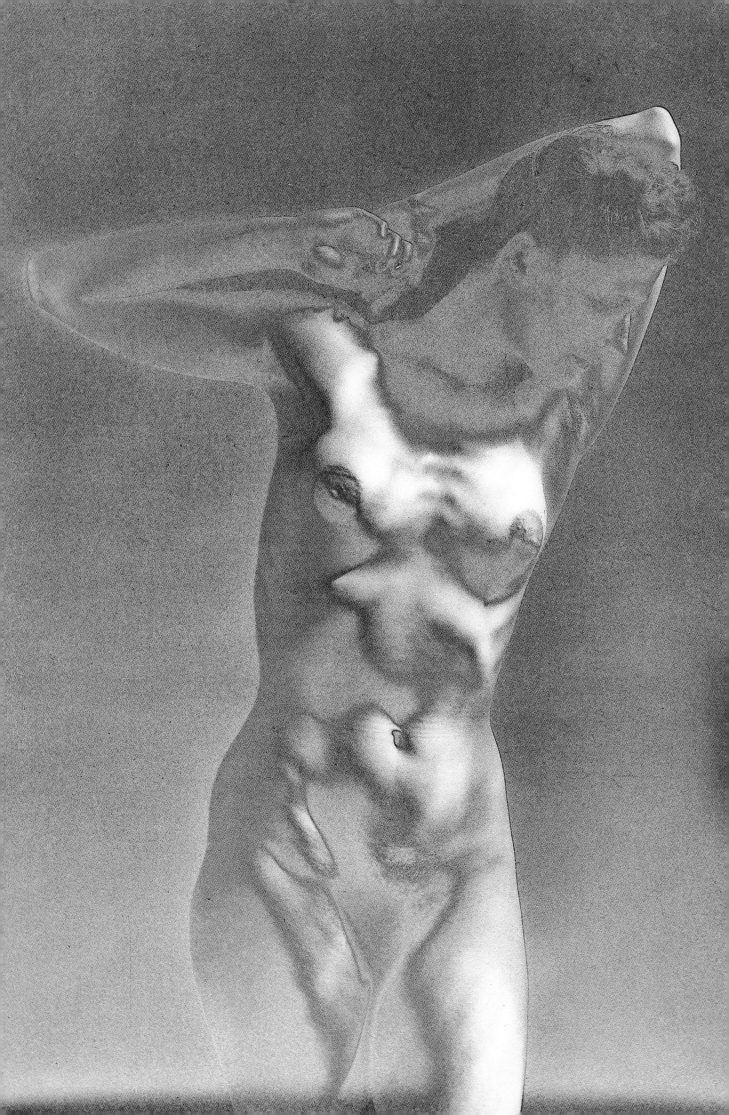

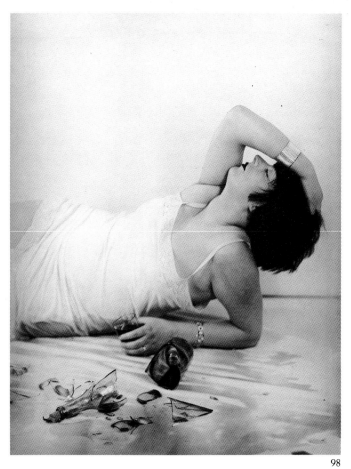

98

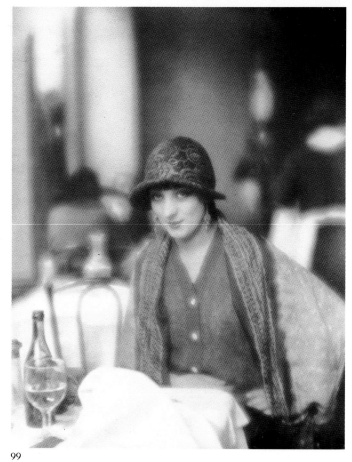

99

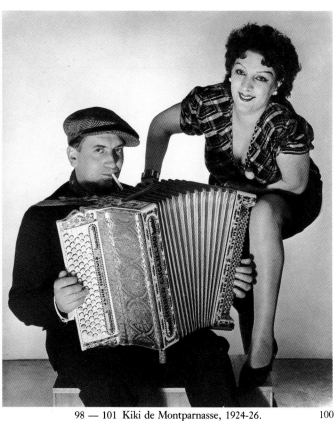

98 — 101 Kiki de Montparnasse, 1924-26. 100

101

102 Kiki de Montparnasse, 1922.

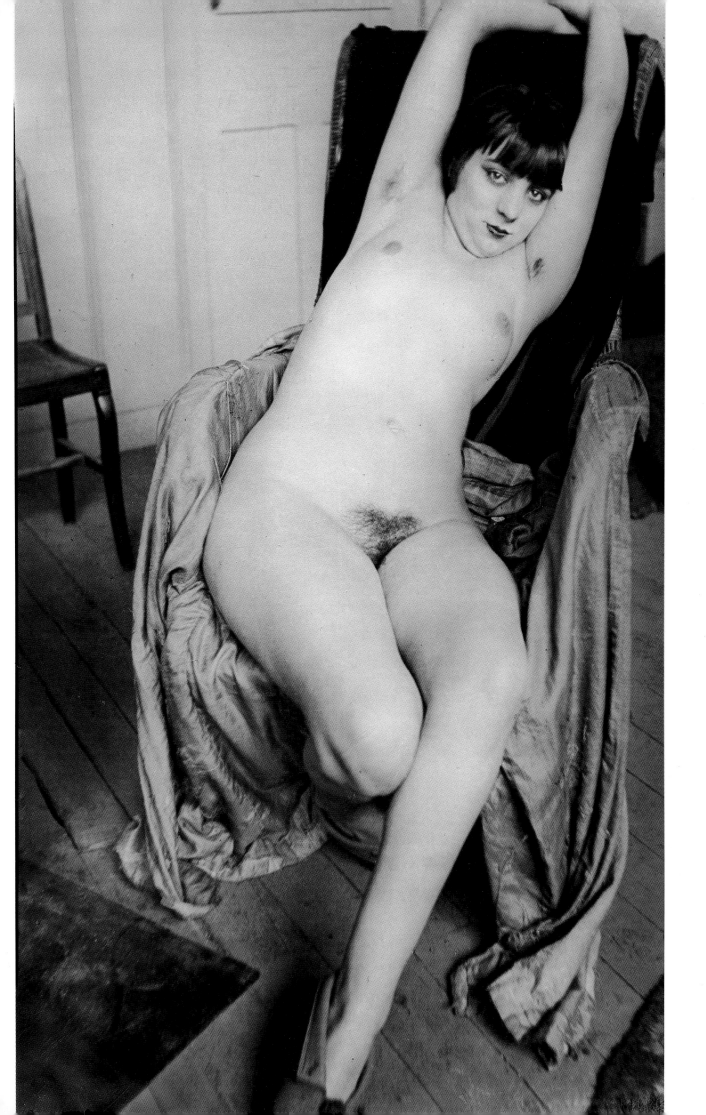

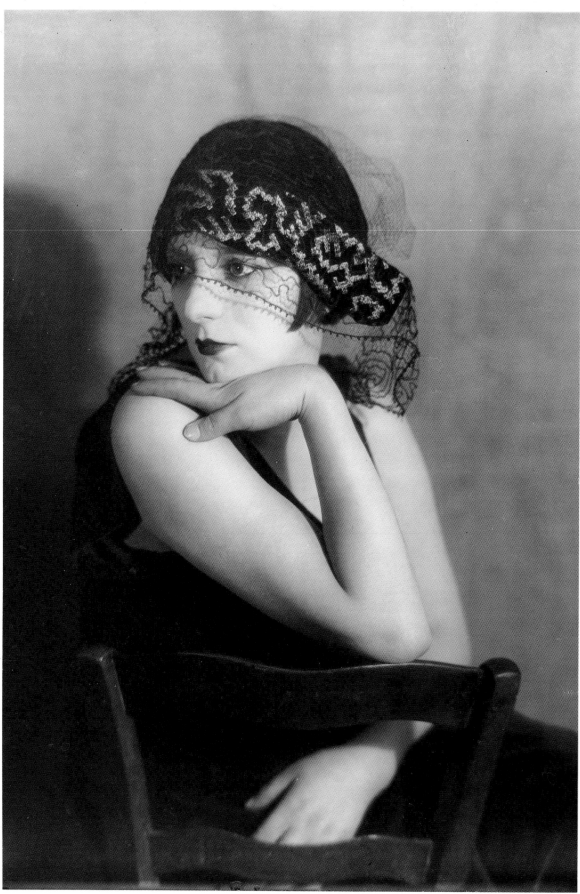

103 Kiki de Montparnasse, 1922.

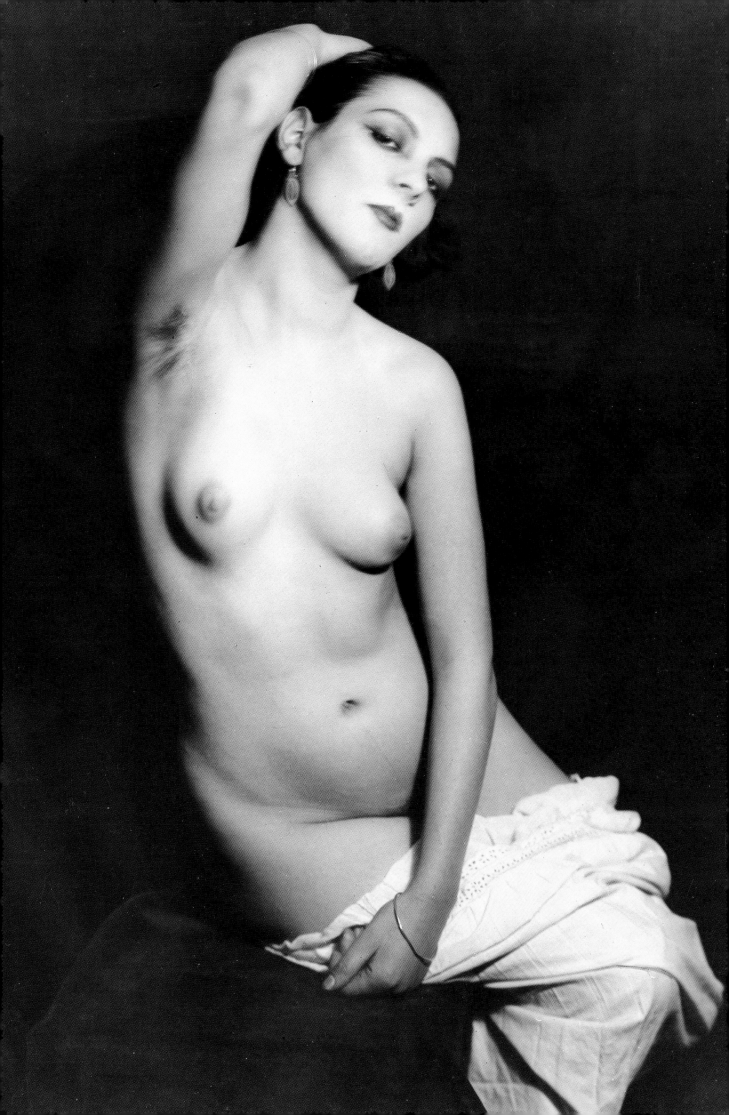

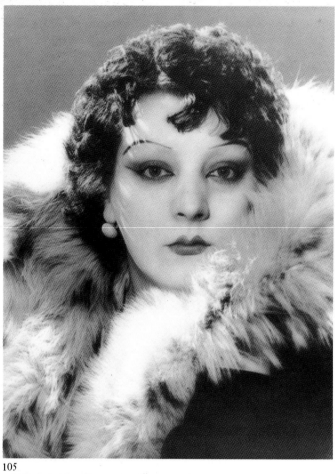

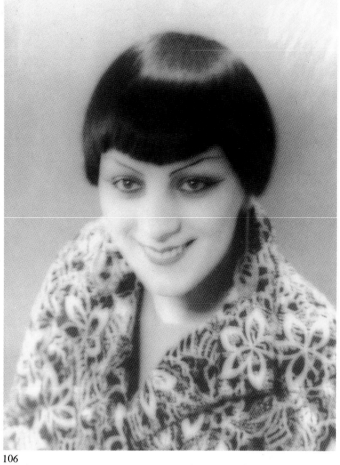

105

106

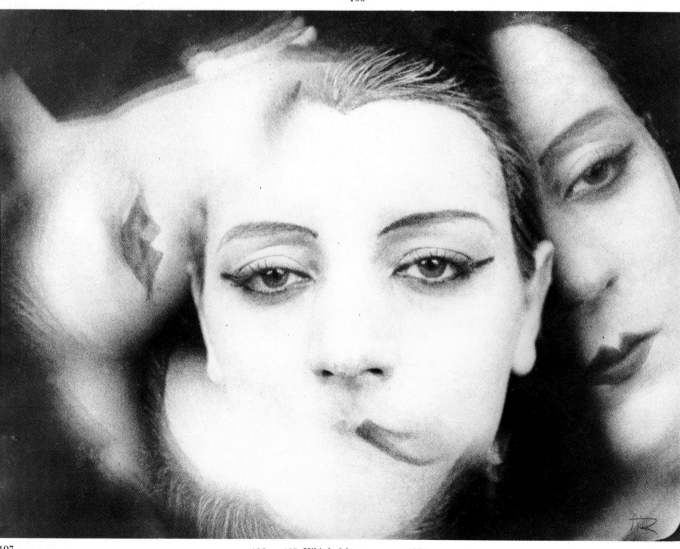

107

105 — 107 Kiki de Montparnasse, 1924.

108 Kiki de Montparnasse, 1922.

104

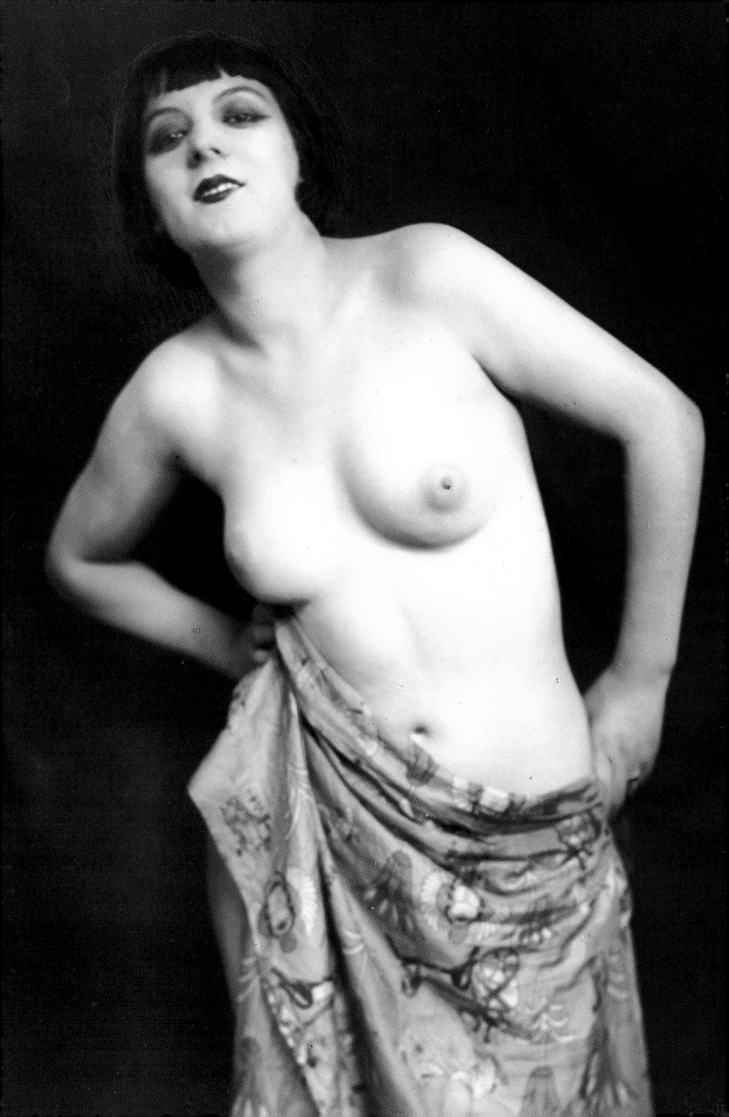

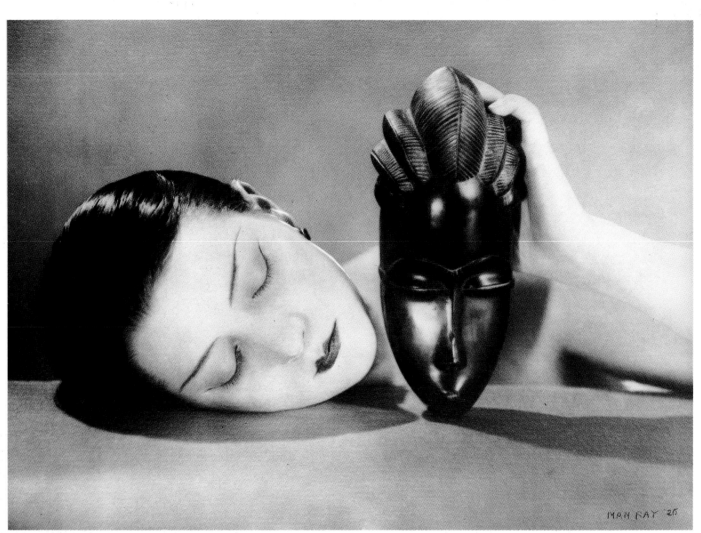

109 *Noire et blanche*, 1926.

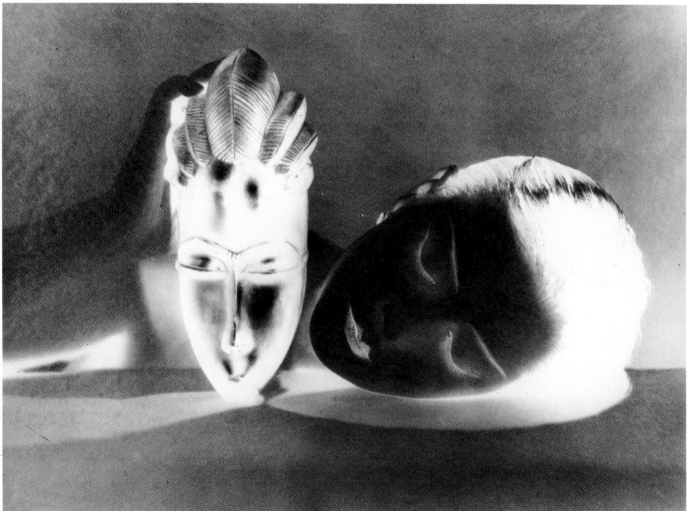

110 *Noire et blanche*, 1926.

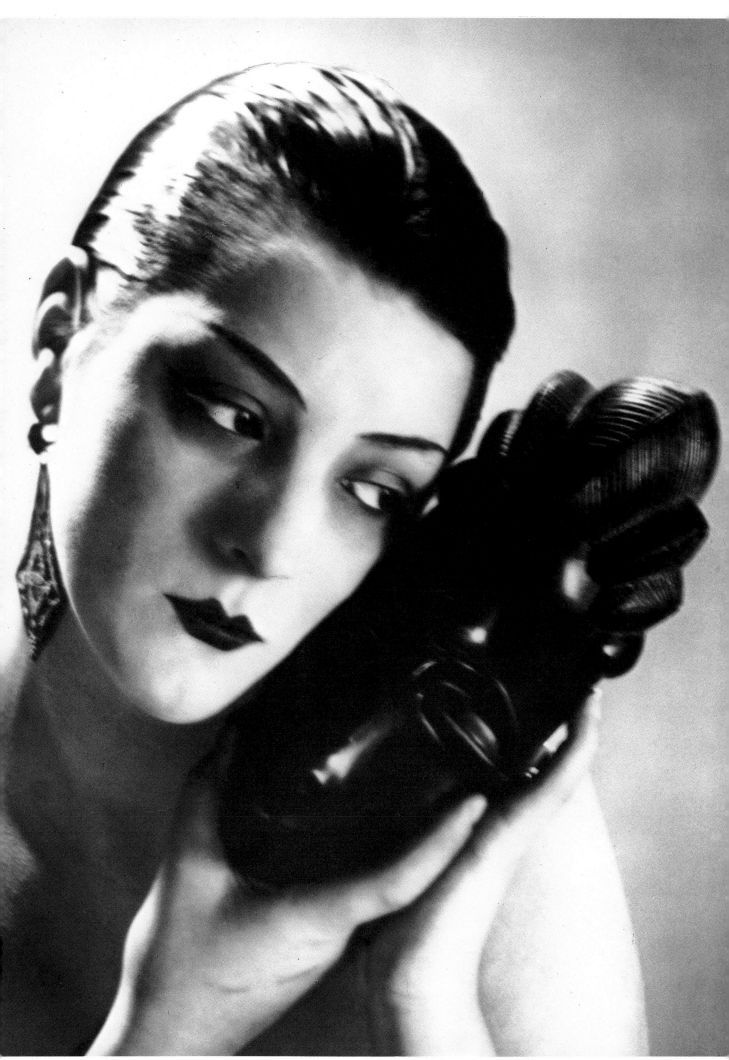

111 *Noire et blanche*, 1926.

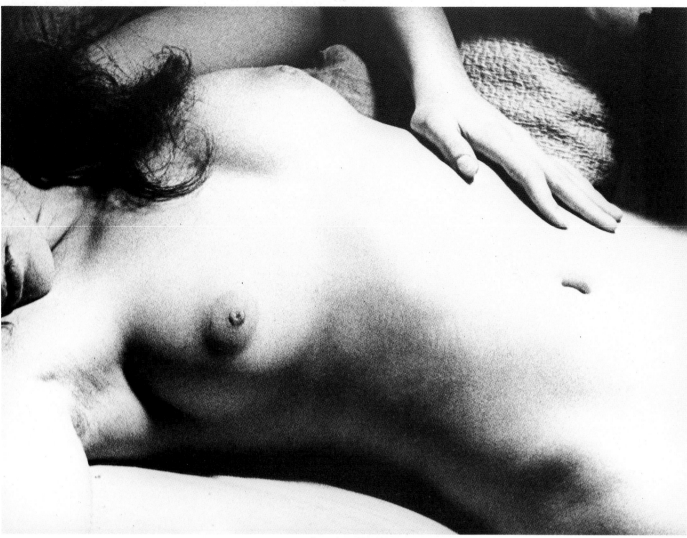

112 Sans titre / Untitled.

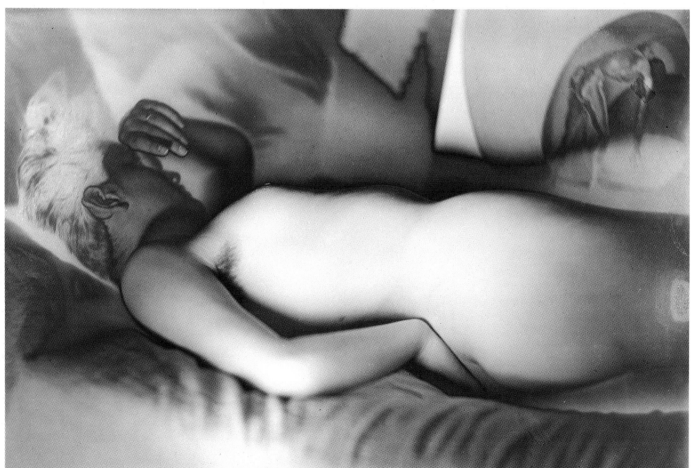

113 Meret Oppenheim, 1933.

114 Sans titre / Untitled.

115 Sans titre / Untitled.

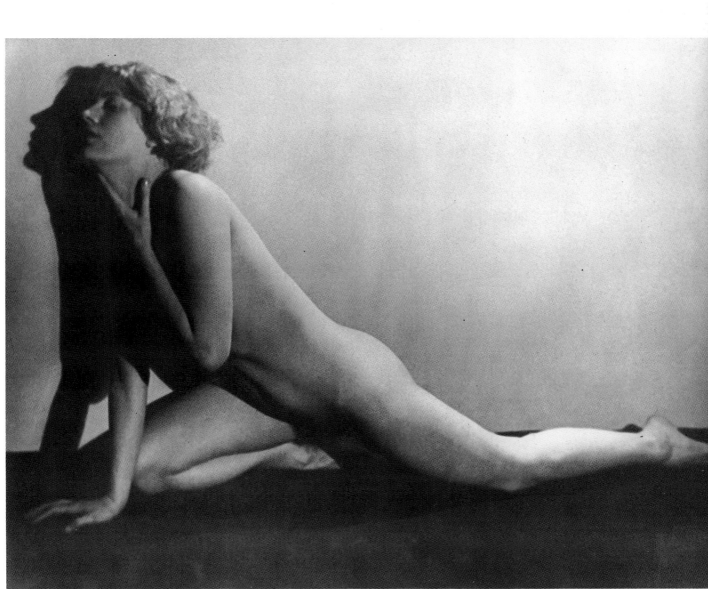

116 *Suicide*, 1930.

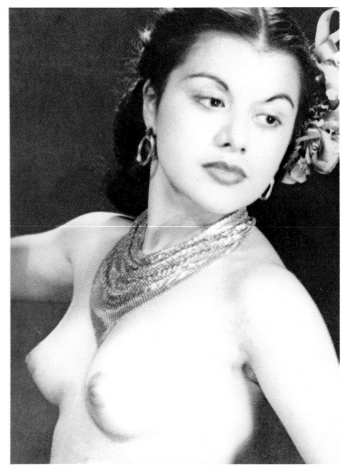

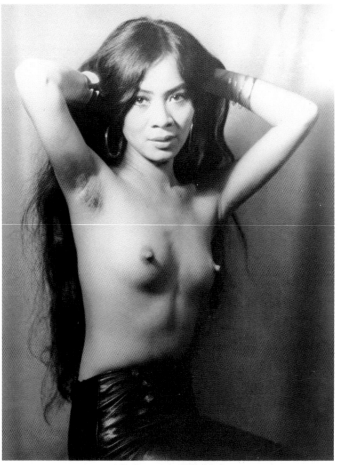

117 Sans titre / Untitled.

118 Sans titre / Untitled.

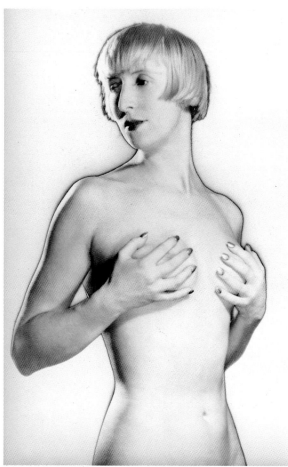

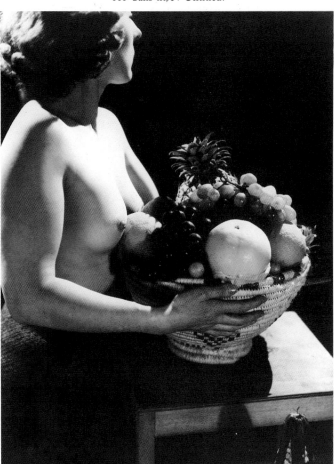

119 Suzy Solidor, 1929.

120 Sans titre / Untitled.

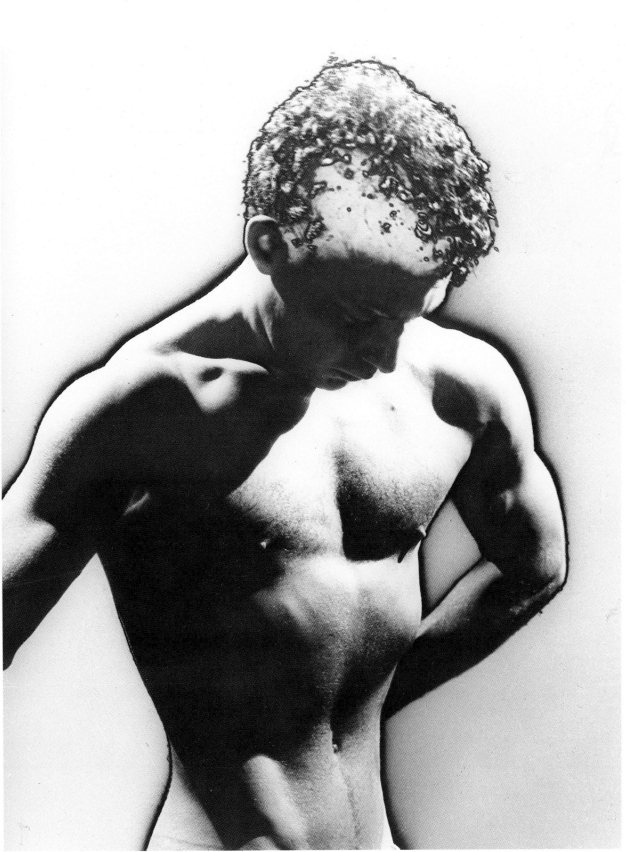

121 Sans titre / Untitled.

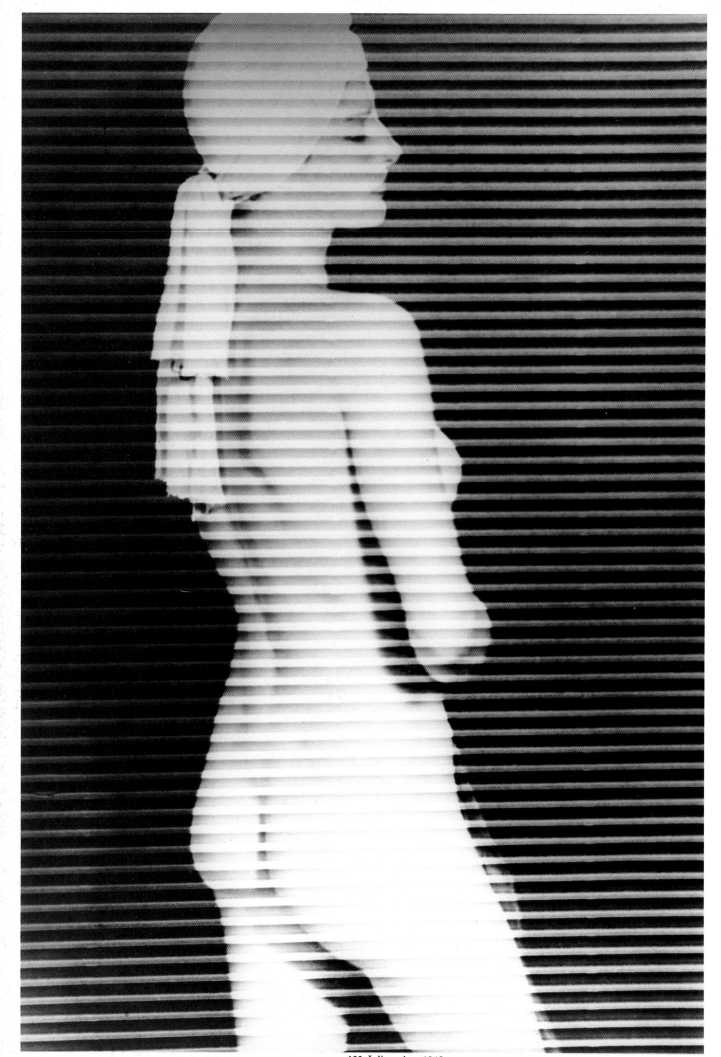

122 Juliet, circa 1945.

123 Juliet, circa 1945.

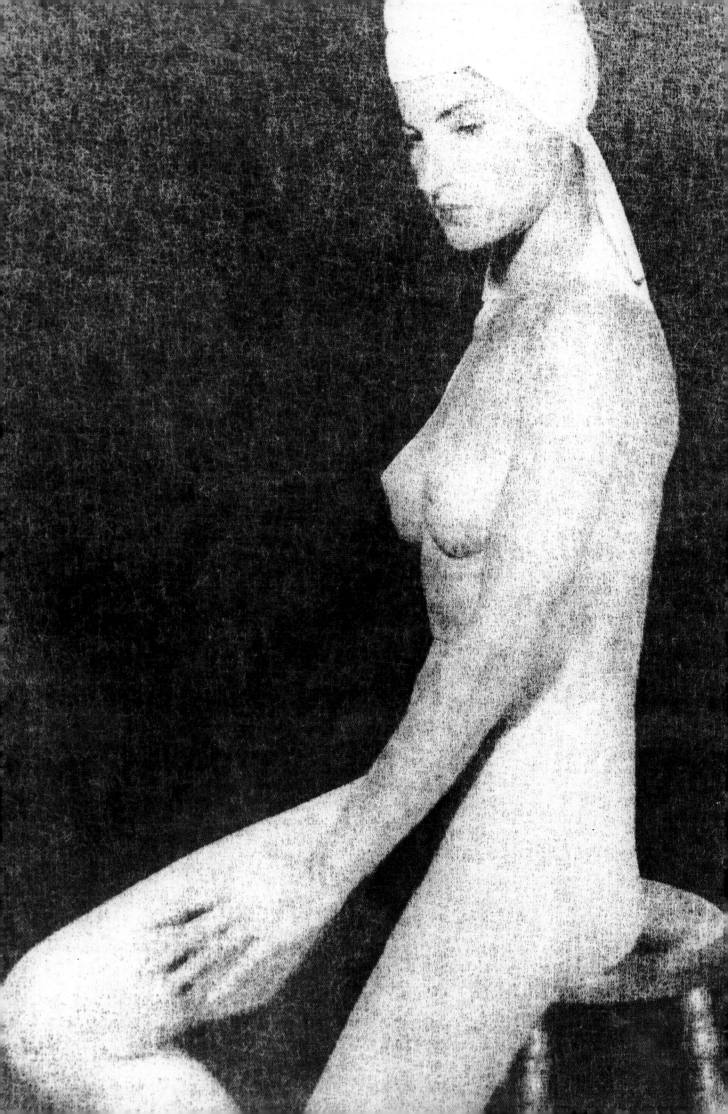

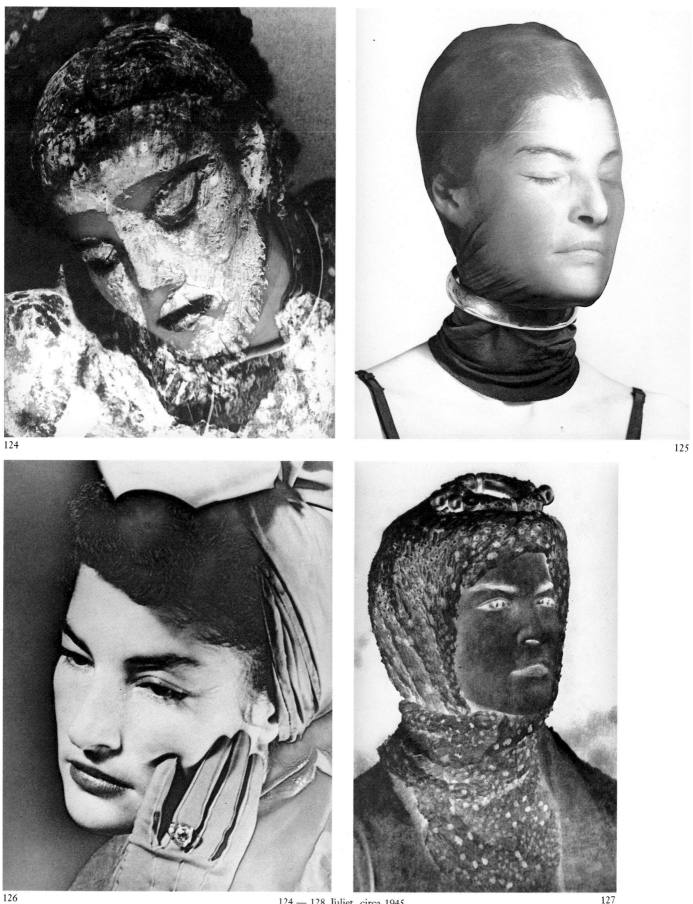

124

125

126

124 — 128 Juliet, circa 1945.

127

128

Pages 118 & 119 :
129 Juliet, circa 1945.
130 Juliet, circa 1945.

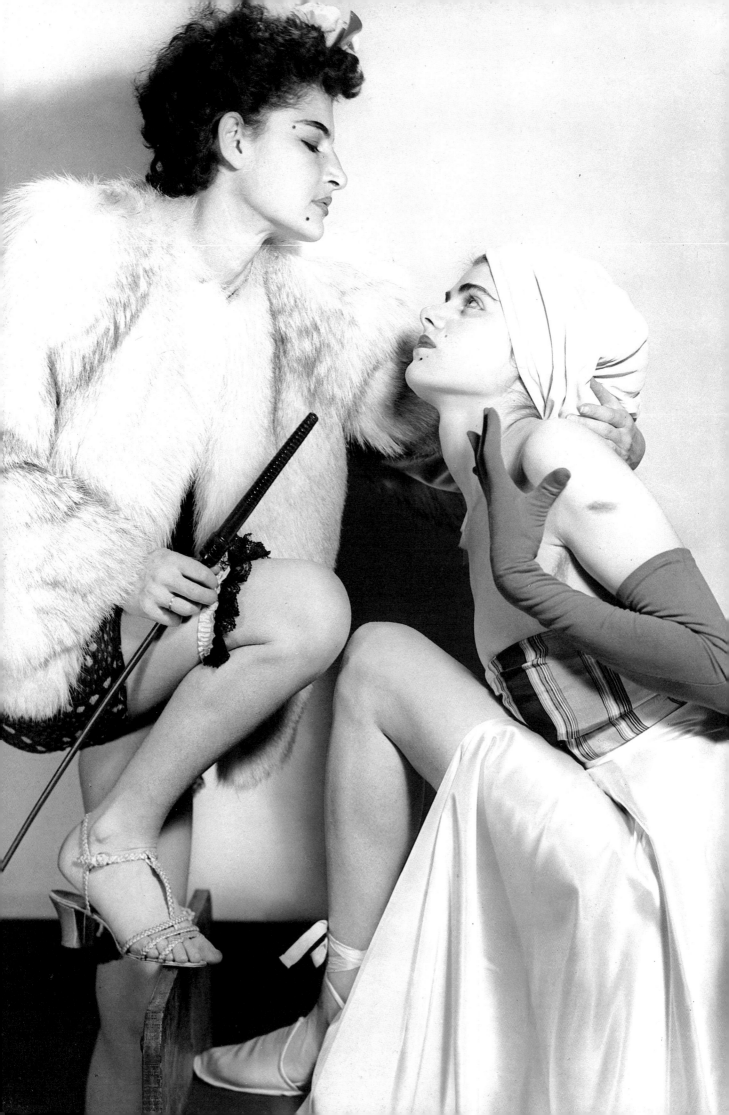

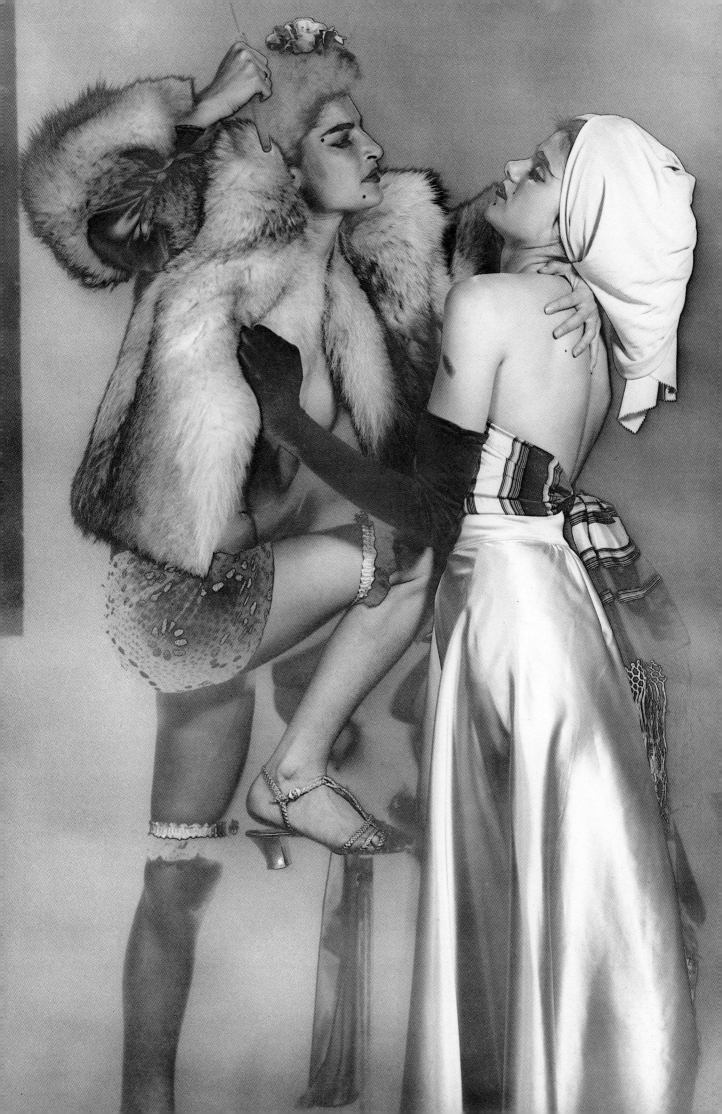

131 Max Ernst, Juliet, Dorothea Tanning, Man Ray.

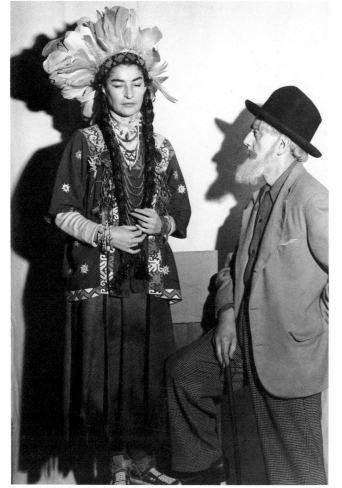

132 Man Ray, Juliet.

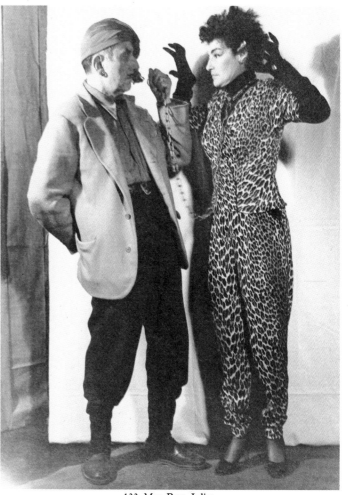

133 Man Ray, Juliet.

134 Autoportrait / Self-Portrait.

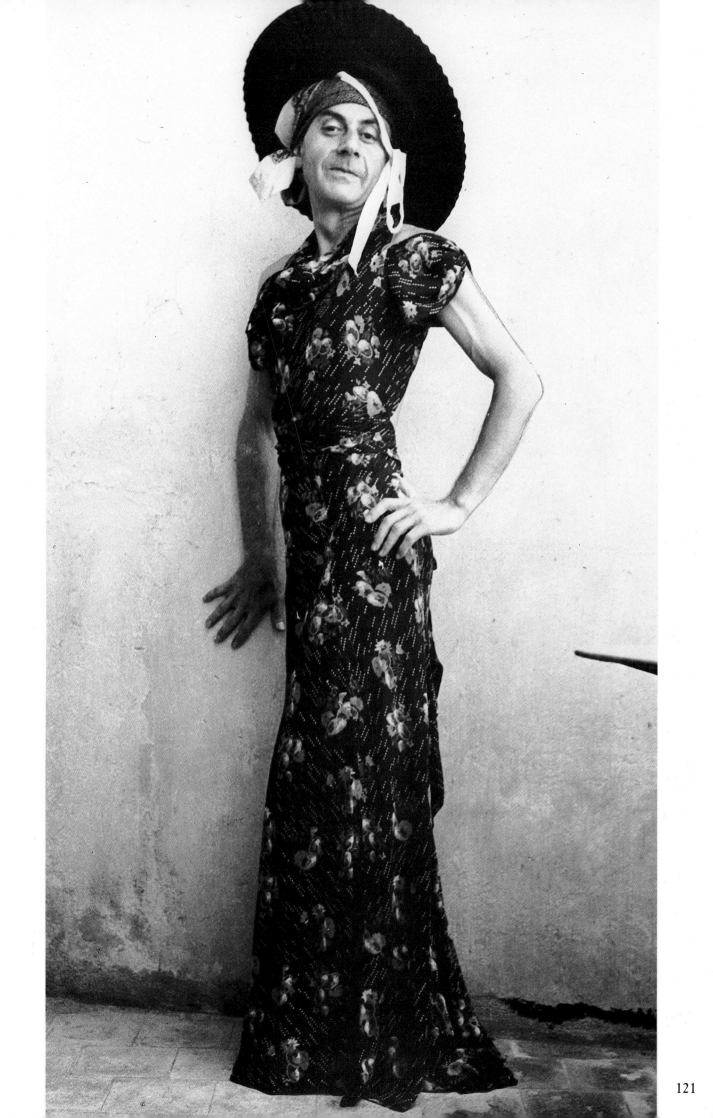

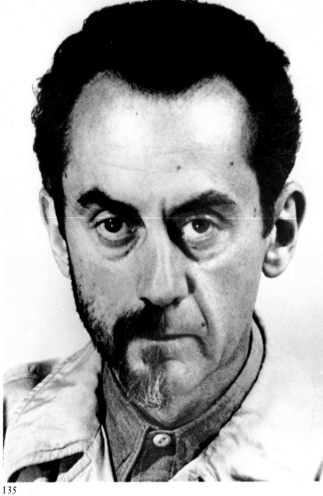

135

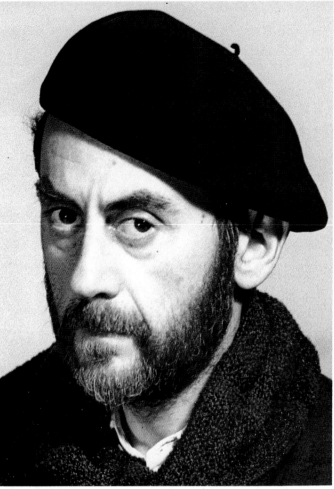

136

137

138

135 - 139 Autoportraits / Self-Portraits.

122

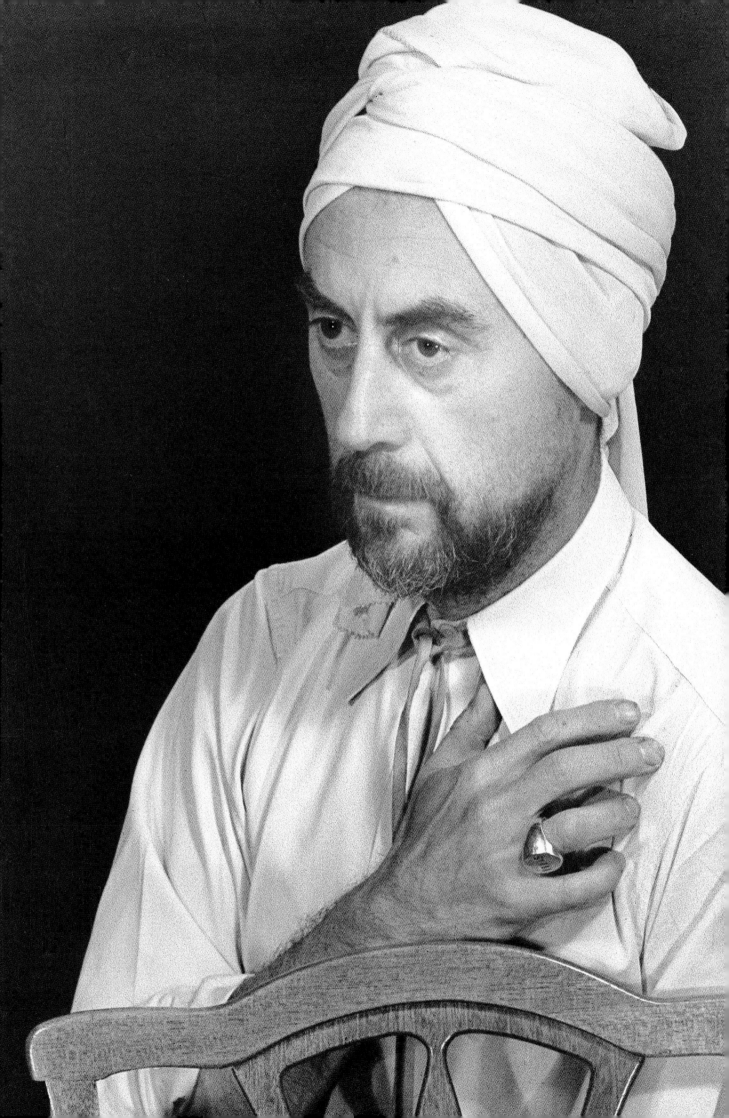

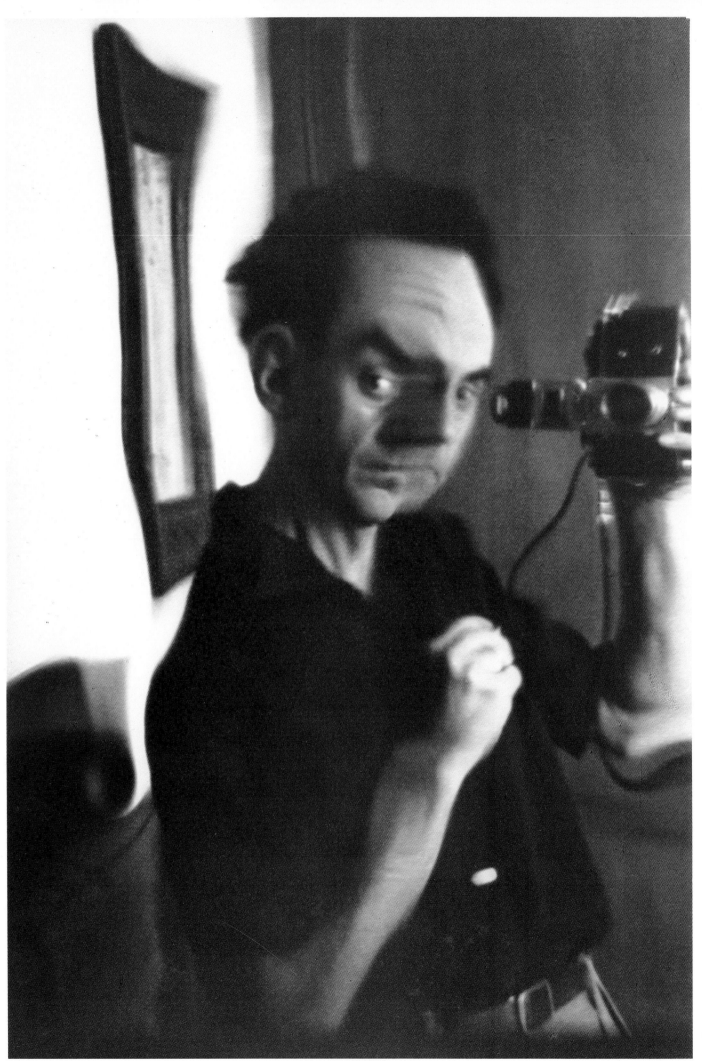

140 Autoportrait / Self-Portrait.

141 Autoportrait / Self-Portrait.

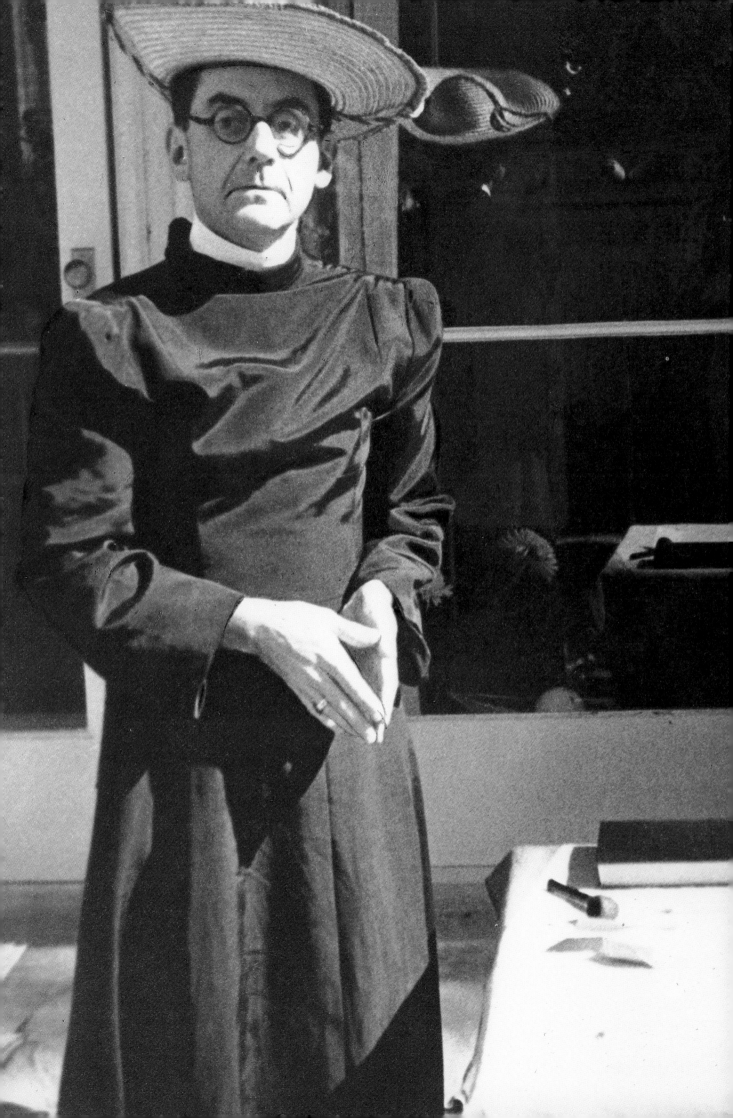

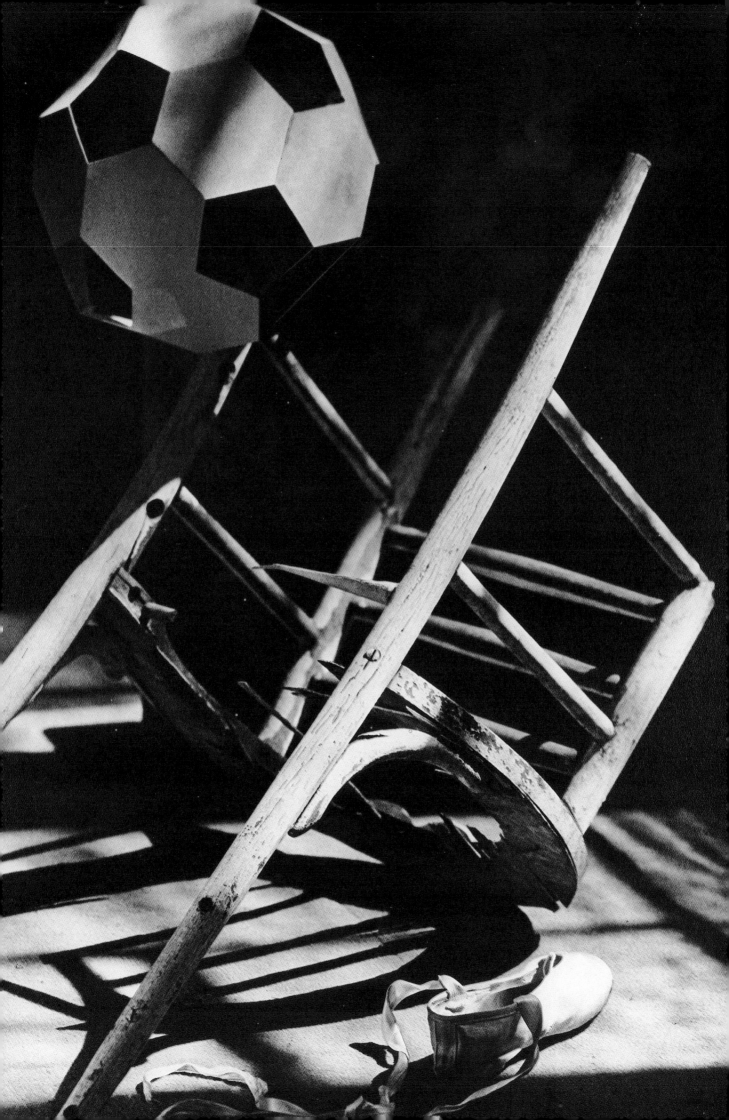

143 *The Magnet*, rayographie / Rayograph, 1923.

144 Rayographie / Rayograph, 1922

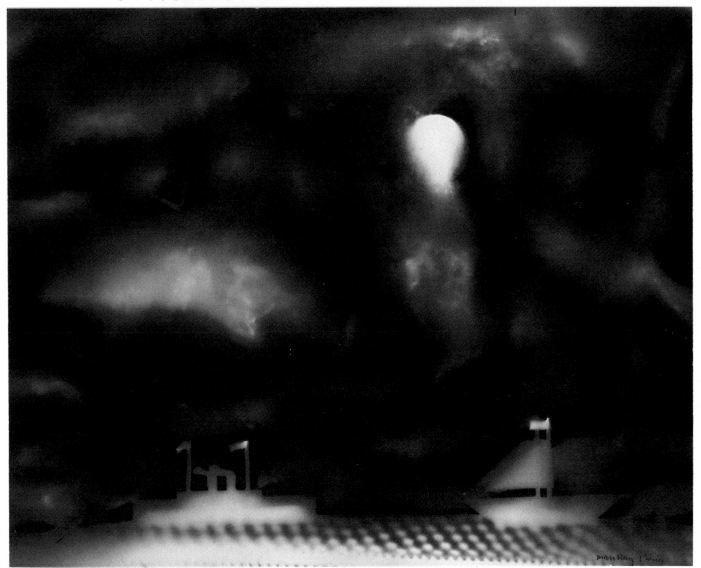

145 *Ships*, rayographie / Rayograph, 1924.

142 Sans titre / Untitled.

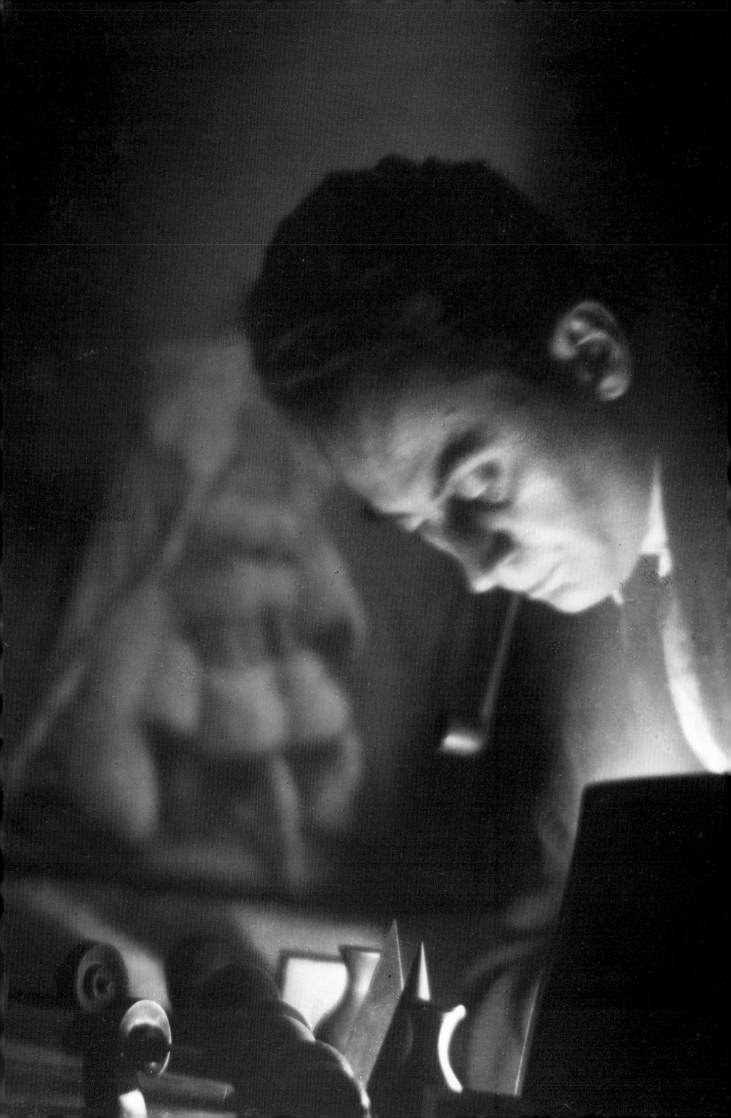

The enigma
of things

I like to think of the two old Chinese sages who have ceased all activity and proselytism, who speak as little as necessary between themselves. They do go down to the river bank every morning to catch a fish for their dinner. Sitting one morning alongside one another, silently holding their lines, one feels a tug on his and begins gently to pull in his line, evidently a large catch, with the other watching. Presently a beautiful girl's head appears above the water, expressing fright, but she is hooked and cannot get away. The fisherman motions reassuringly to her to come nearer, bends down and lifts her out of the water. A long tail covered with fish scales terminates the body. Taking the mermaid on his lap, the sage gently disengages the hook, while she docilely holds on to him. Then he lifts her and places her back in the water. Meanwhile, the other sage has been quietly watching the operation; after a minute, he utters one word : WHY ? To which his companion, after a minute's reflection, replies : HOW ? People are always asking how certain results are obtained, seldom why. The first query stems from the wish to do likewise, a feeling of necessity, a wish to emulate; the second wishes to understand the motive that has prompted the act — the desire behind it. If the desire is strong enough, it will find a way. In other words, inspiration, not information, is the force behind all creative acts.

146. Self portrait.
Man Ray is leaning over one of the many chess sets he designed (he had already made several before he left New York). He often played with Marcel Duchamp and Duchamp's wife, Teeny. The light is reflected from a mirror, below right.

147. *A l'heure de l'observatoire - Les amoureaux.*
A print of the nude in this picture belonging to the Museum of Modern Art in New York is dated 1934.

148. Untitled, 1933.
A trial version for the cover of *Photographs by Man Ray 1920-1934.* A colour photograph, reproduced on the cover of this book, takes up the same elements: the upstretched wooden mannequin's hand (cf. **217**), the cupped plaster hand, the coloured polyhedron which is also found in many other compositions (cf. **142**) the *Indestructible Object* (the metronome with a photograph of Lee Miller's eye), the light-bulb, the cup and ball game, and the head that Man Ray had just had done of himself in the same year.

149. *L'enigme d'Isidore Ducasse*, 1920.
This tribute to the Comte de Lautréamont (Isidore Ducasse) was published in *La révolution surréaliste* (No. 1, 1 December 1924). The object, a sewing machine wrapped in an army blanket and tied up with string, was probably made just for the photograph. Ten copies of it were published by Arturo Schwarz in 1971.

150. Untitled.
The spiral, to which Man Ray was particularly attached, appeared as his emblem in *Almanach surréaliste du demi-siècle* (La Nef, 1950).

151. *Beau comme la rencontre fortuite, sur une table de dissection, d'une machine à coudre et d'un parapluie*, 1933.
This appeared in *Minotaure* (Nos. 3-4, October-December 1933, p. 101), as an illustration for an 'enquiry'. There is also a drawing of it.

152. *Enigme II*, 1935.

153. *Space-writing*, 1937.
The negative showed the setting of the studio in the rue Denfert-Rochereau with, at the back on the left, the large painting *Le retour à la raison* (Cologne, Ludwig Collection) and, on the right, a work by Alberto Giacometti, *Courrounou V-Animal* (1932).

154. *Space-writing.*

155. *Kiki Drinking*, rayograph, 1922.
'Besides the trays and chemical solutions in bottles, a glass graduate [a measuring flask] and thermometer, a box of photographic paper, my laboratory equipment was nil. Fortunately, I had to make only contact prints from my large plates. I simply laid a glass negative on a sheet of light-sensitive paper on the table, by the light of my little red lantern, turned on the bulb that hung from the ceiling, for a few seconds, and developed the prints. It was while making these prints that I hit on my Rayograph process, or cameraless photographs. One sheet of photo paper got into the developing tray - a sheet unexposed that had been mixed with those already exposed under the negatives - I made my several exposures first, developing them together later - and as I waited in vain a couple of minutes for an image to appear, regretting the waste of paper, I mechanically placed a small glass funnel, the graduate and the thermometer in the tray on the wetted paper. I turned on the light; before my eyes an image began to form, not quite a simple silhouette of the objects as in a straight photograph, but distorted and refracted by the glass more or less in contact with the paper and standing out against a black background, the part directly exposed to the light. I remembered when I was a boy, placing fern leaves in a printing frame with proof paper, exposing it to sunlight, and obtaining a white negative of the leaves. This was the same idea, but with an added three-dimensional quality and tone graduation. I made a few more prints, setting aside the more serious work for Poiret, using up my precious paper. Taking whatever objects came to hand; my hotel-room key, a handkerchief, some pencils, a brush, a candle, a piece of twine - it wasn't necessary to put them in the liquid

but on the dry paper first, exposing it to the light for a few seconds as with the negatives - I made a few more prints, excitedly, enjoying myself immensely. In the morning I examined the results, pinning a couple of the rayographs - as I decided to call them - on the wall. They looked startlingly new and mysterious.' (*Self Portrait*, pp. 128-29).

156. Rayograph, 1922.

157. Rayograph, 1925.

158. Rayograph, 1923.

159. Rayograph, 1922.
A rayograph that Man Ray re-photographed, as he often did, in a negative version.

160. Rayograph, 1922.
Cover for the catalogue of the exhibition *Fantastic Art, Dada and Surrealism*, held at the Museum of Modern Art in New York in 1936.

161. Rayograph, 1959.

Note: Illustrations 162-64 are incorrectly captioned 163, 162 and 163 respectively.

162. Rayograph, 1923.

163. Rayograph, 1926.

164. Rayograph, 1921-22.
Man Ray used one of his *Lampshades* (cf. **27**) in this picture.

165. Rayograph, 1927.

166. Rayograph.

167. Rayograph, 1922.

168. Rayograph, 1921.
The gyroscope was probably in motion when the rayograph was made.

169. Rayograph.

170. Rayograph, 1922.

171. Untitled.
Rayograph with illuminations (perhaps for Christmas) on the Eiffel tower in the background. They can also be seen in the photograph *Electricité* of 1931.

172. *Photo de mode 'Collection d'hiver'* ('Fashion Photo, "Winter collection"'), 1936.
The subject is a pear tree on which the fruit has been protected with paper bags. This photograph was used as an illustration to Man Ray's 'Photography is not Art' in *Cahiers G.L.M.* (November 1936, p. 25).

173. *Course d'autos*, 1925.
This appeared in *La révolution surréaliste* (No. 7, 15 June 1926).

174. *Moving Sculpture*, 1920.
This photograph was reproduced on the cover of *La révolution surréaliste* (No. 6, 1 March 1926). The ephemeral and moving forms are in opposition to traditional static sculpture, and bring to mind the *Sculpture de voyage* (1918) by Marcel Duchamp. This photograph formed the basis of a painting which is now in a private collection in the United States.

175. *Le minotaure*, c. 1935.
This photograph appeared as an illustration to the contents list in *Le minotaure* (No. 7, June 1935).

176. Untitled, c. 1924.
Two photographs superimposed. The hands are Marcel Duchamp's as they appeared in a portrait in New York. This photograph was published in *La révolution surréaliste* (1 December 1924, p. 12).

177. *Le bateau ivre*, 1924.
This rayograph was a study for a poster advertising the café 'Le Bateau Ivre' (Paris, Galerie Seroussi) in 1928. The café, at 3 place de l'Odéon, Paris, which took its name from a poem by Apollinaire, offered its clients 'the best cocktail at six o'clock, the best music at ten o'clock'. Man Ray conceived the decor.

178. Rayograph, 1922-24.

179. *L'inquiétude*, 1920.
This is probably the object *Inquiétude* (1920), one of Man Ray's 'objects of my affection', a sort of clock mechanism that was shut up in a glass box and, here, set in motion.

180. Portrait, 1920.

181. *Insultor*.
A contact print of the whole object is stuck onto the photograph in the bottom right hand corner. The title is a play on the word 'insulator'.

182-183. *Anatomies*, c. 1930.
This pair illustrates the way Man Ray often cropped his photographs.

184. *Femme aux longs cheveux*, 1929.

185. Untitled.

186. Portrait, 1932.

187. *Saddle*, 1934.

188. *Ostrich Egg*, 1944.
Man Ray wrote on the mount 'Of course, nature provides all the elements for creative inventiveness, including anal techniques.'

189. Untitled, 1931.
Published in *Les cahiers d'art* (Nos. 8-10, 1932, p. 356).

90. Untitled, 1931.

191. *La prière*, 1930.
Eight numbered prints were made of this photograph (1930-60).

192. *L'œuf et le coquillage* ('The Egg and the Shell'), 1931.
These two white and apparently anodyne objects are full of metaphysical symbolism of the kind that the Surrealists were especially fond of: life and death, finite and infinite. Spiral objects appealed particularly.

193. *Dora Maar*, 1936.
'...a beautiful girl and an accomplished photographer, some of whose work showed originality and a Surrealist approach. Picasso fell in love with her. One day in my studio he saw a portrait I had made of her and begged to have the print, saying he would give me something in exchange.' (*Self Portrait*, p. 226.) The promised gift was a print of *La tauromachie*.

194. Untitled, 1946.

195. *Mains* ('Hands'), 1936.

196. *La resille* ('The Hairnet'), 1931.
'A solution, not to hide, but to highlight the model's beauty.'

197. *Mesure pour mesure* ('Measure for Measure'), 1936.
This photograph appeared in *Les cahiers d'art* (Nos. 1-2, 1936, p. 7). Here, as for **199**, Man Ray photographed mathematical objects at the Institut Poincaré in Paris. He also used them in paintings to which he gave the titles of Shakespeare plays, in the series *Shakespearean Equations* (1948). Illustration **199** was taken up under the title *A Comedy of Errors*. There is a dummy of an unpublished book including all these photographs of mathematical objects. The objects were first brought to Man Ray's attention by Max Ernst.

198. Untitled, c. 1927.
Photograph of a part of the object *Mire universelle* (1933), including the arm and hand of a mannequin. A photograph

of the entire object was published in *La révolution surréaliste* (Nos. 9-10, 1 October 1927, p. 42).

199. *Perspective d'un cube, d'une sphère, d'un cône et d'un cylindre*, 1936. See **197**.

200-04. *Mr and Mrs Woodman*, 1927-45.
The twenty-seven photographs of Mr and Mrs Woodman were reprinted in an edition of fifty copies by Editions Unida (The Hague) in 1970.

205. Untitled, *c*. 1938.
Project for a tapestry to illustrate 'La photographie qui console' in *XXᵉ siècle* (Nos. 1-4, 1938, p. 16).

206. *L'aurore des objects*, 1937.
Published in *Minotaure* (No. 10, 1937, p. 41).

207. Untitled, *c*. 1945.
A collage of two photographs: a spider's web and a piece of material thrown on the ground and photographed as it lay, as in the *Stoppages-étalons* by Marcel Duchamp (1913-14).

208. *Origine de l'espèce* ('The Origin of the Species'), *c*. 1956.
A cork from a champagne bottle, like those seen hanging from Meret Oppenheim's ears (**56**), and a shape similar to that in *Lampshade*. The photograph was reproduced in *Le surréalisme même* (1, 1956, p. 35).

209. *Ombre II* ('Shadow II'), 1944.
Another, fully-lit version appears in the dummy of an unpublished book, 'Objets de mon affection' (Stockholm, Aronowitsch Gallery).

210. Untitled.

211-15. *La télévision*, 1975.
The mannequins are posed in front of a television showing a programme by Jacques Soustelle about Maya architecture; Uxmal can be seen in **212** and **215**. Nine prints of these photographs were made.

216. Untitled, *c*. 1926.
This photograph was used for the painting *Aline et Valcour* (1950), whose title was drawn from the book by the Marquis de Sade. It illustrates 'L'enclume des forces' by Antonin Artaud in *La révolution surréaliste* (No. 7, 15 June 1926, p. 1).

217. *Moi, elle* ('Me, Her'), 1934.
This photograph reflects the Surrealist taste for divination and clairvoyance. It appeared in *Minotaure* (No. 5, 1934-35, p. 8) and was used to illustrate *L'amour fou* by André Breton in 1937.

218. *La lune brille sur l'île Nias* ('The Moon shines on the Island of Nias'), 1926.
Cover for the catalogue of the Galerie Surréaliste, 16 rue Jacques Callot in Paris, which opened on 26 March 1926 at midnight with *Tableaux de Man Ray et objets des îles*.

219. *Transatlantic*, 1920.

220. *Frozen Fireworks*, *c*. 1931.
Man Ray took several photographs of firework displays. This one, also called *Le bouquet*, was published in *Minotaure* (No. 7, June 1935).

221. *Integration of Shadows*, 1919.
This photograph has had several titles: *Shadows, Integration of Shadows, Object, La femme* and *Construction* (as it was called in *The Little Review*, Spring 1925).

222. *La voie lactée* ('The Milky Way'), 1973.
This photograph was included in a portfolio of eleven photographs, *Les voies lactées*, published by Luciano Anselmino of Turin for the Il Fauno gallery in 1974. *La voie lactée* was the title of a book, printed in white, on the importance of the white tones in photography - a topic of great interest to Man Ray.

223. Untitled.
'A dying leaf, its curled ends desperately clawing the air'. One of the ten photographs Man Ray considered to be his best.
'Why should I, amidst all the luxurience of the plants around me, pick out this dying leaf as the preferred subject for my lens? Perhaps, at first, for no other reason than that it was different, being the only one of its kind on the hardy plant. But, thinking back, it seems that I was motivated more by its poignant quality, its greater fragility; that I could get the others any time, but that the dying leaf would be completely gone tomorrow, and now its expressiveness mattered more than the monotonous health of the other leaves.'

224. *Compass*, 1920.
The magnet, by its force of attraction, restrains the pistol of death, with its force of expulsion and rejection.

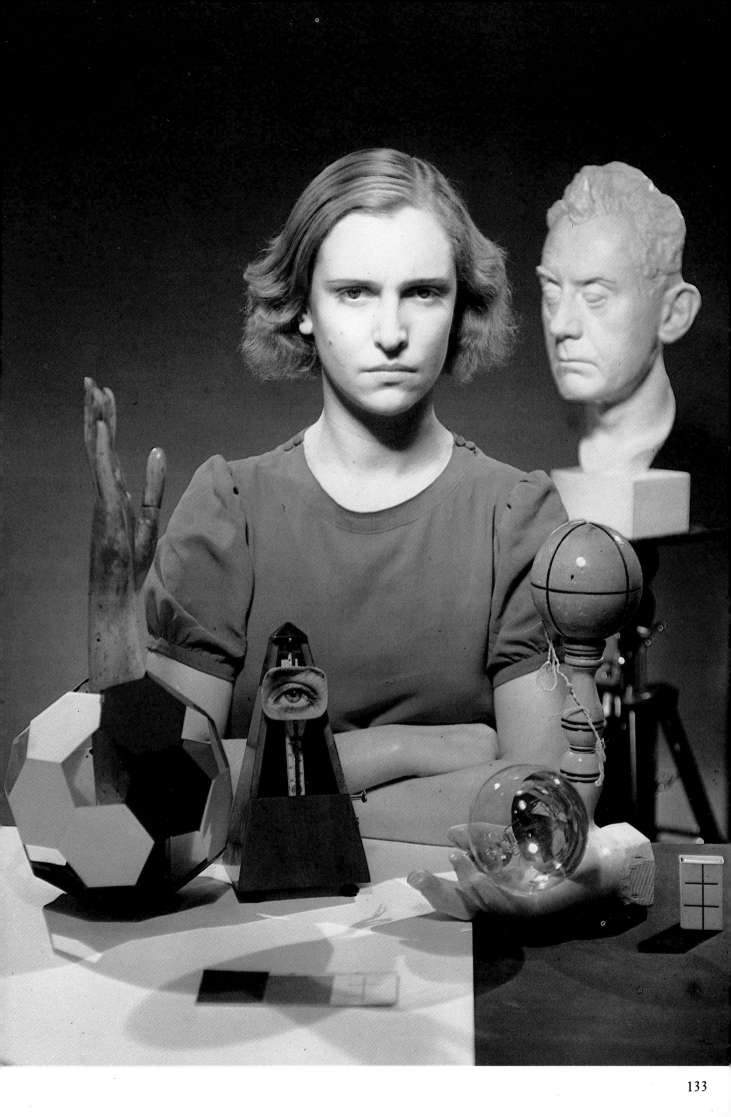

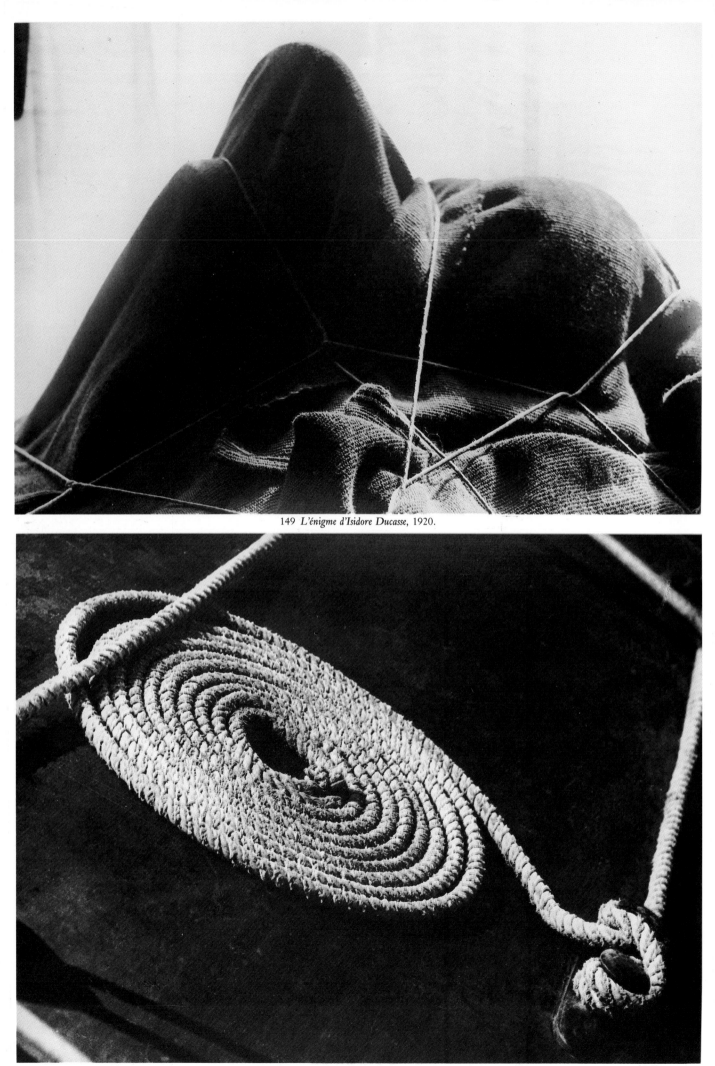

149 *L'énigme d'Isidore Ducasse,* 1920.

150 Sans titre / Untitled.

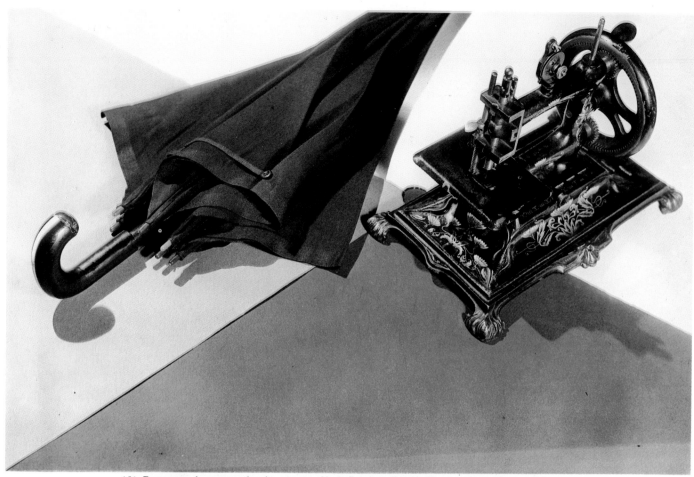

151 *Beau comme la rencontre fortuite, sur une table de dissection, d'une machine à coudre et d'un parapluie*, 1933.

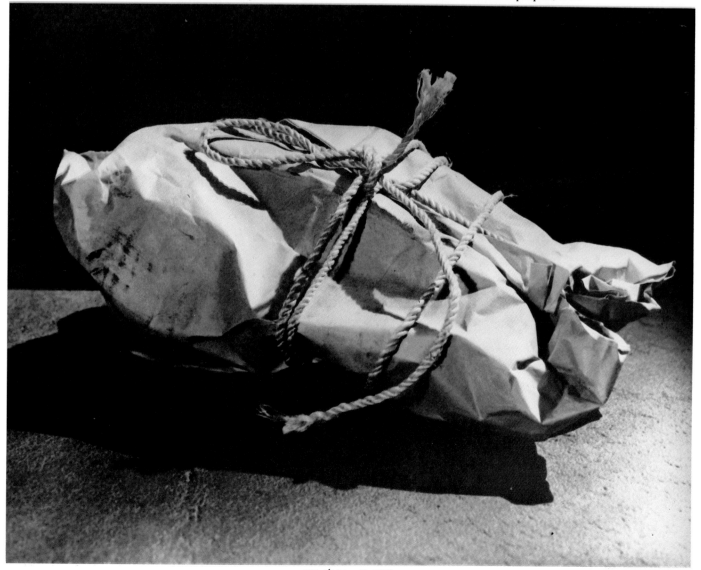

152 *Énigme II*, 1935.

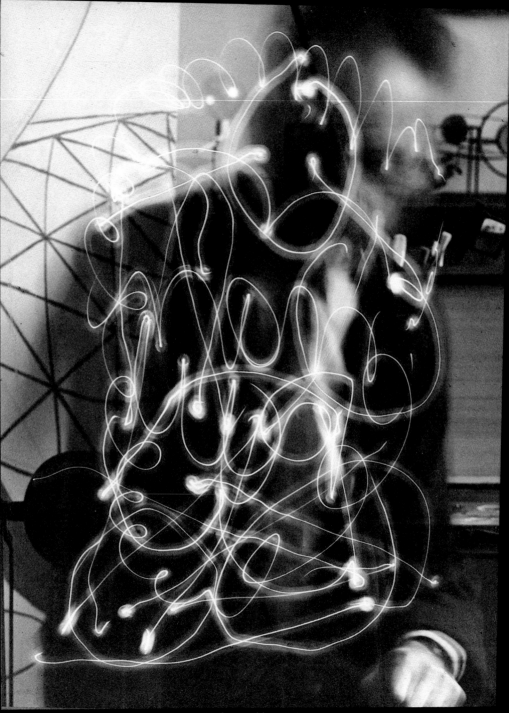

153 *Space-writing, 1937.*

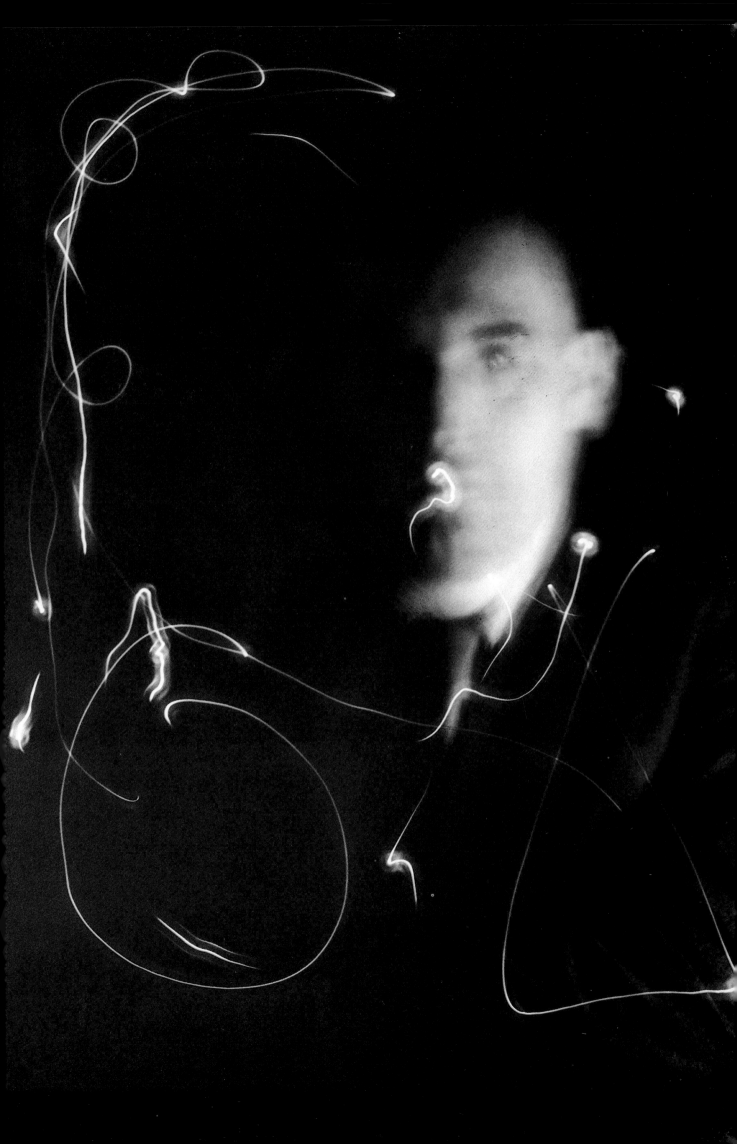

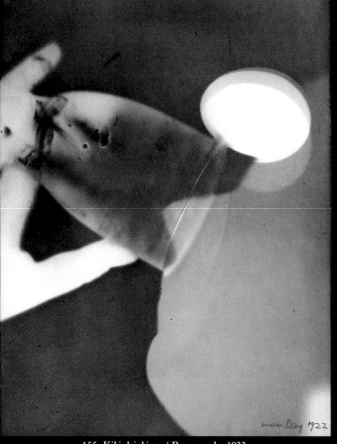

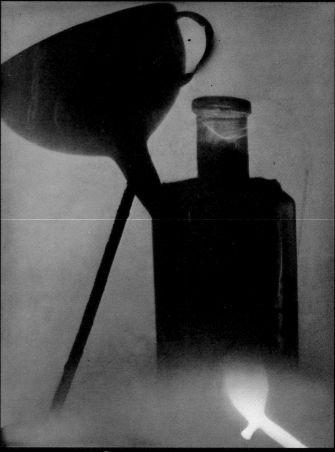

155 *Kiki drinking,* / Rayograph, 1922.

156 Rayographie / Rayograph, 1922.

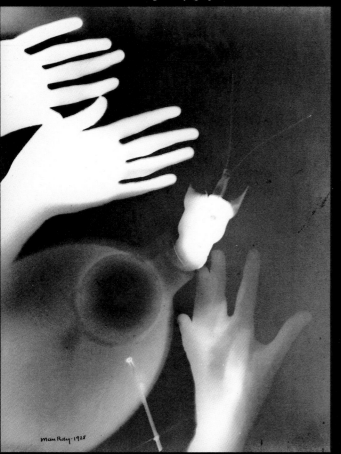

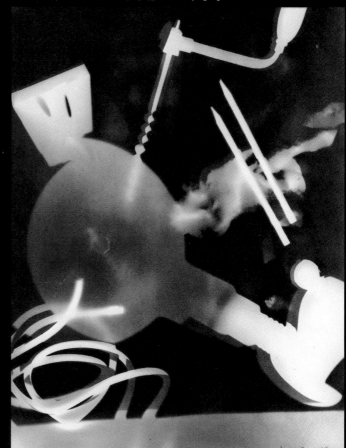

157 Rayographie / Rayograph, 1925.

158 Rayographie / Rayograph, 1923.

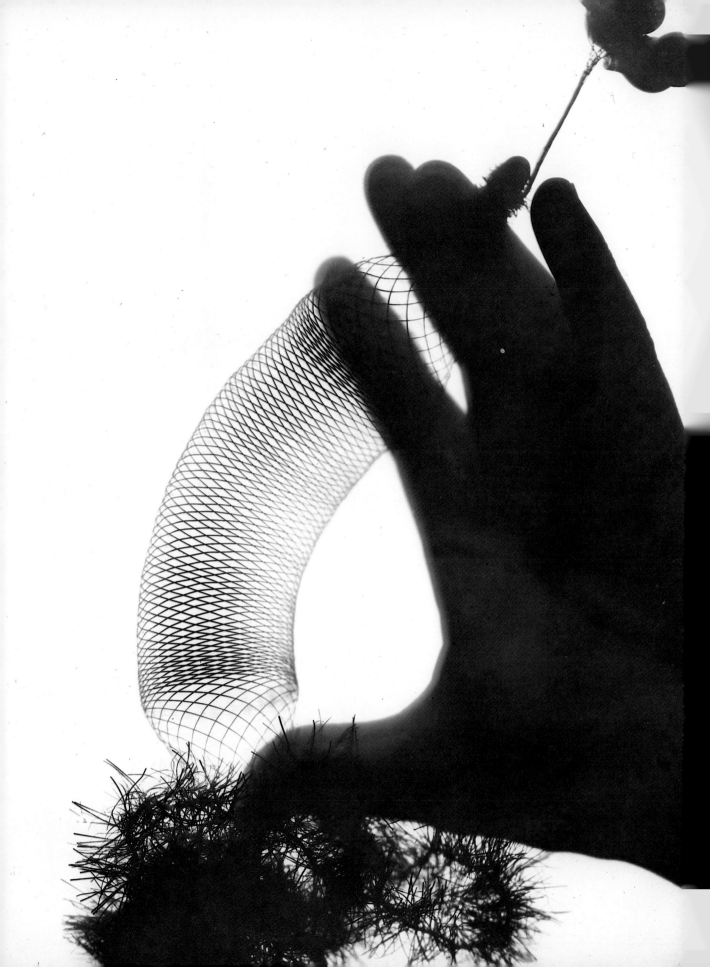

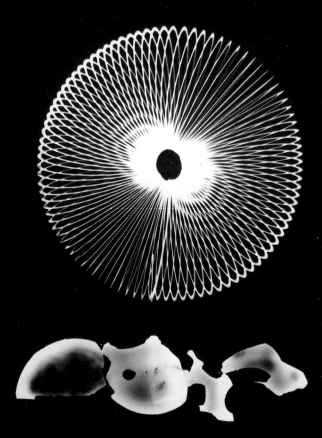

160 Rayographie / Rayograph, 1922.

161 Rayographie / Rayograph, 1959.

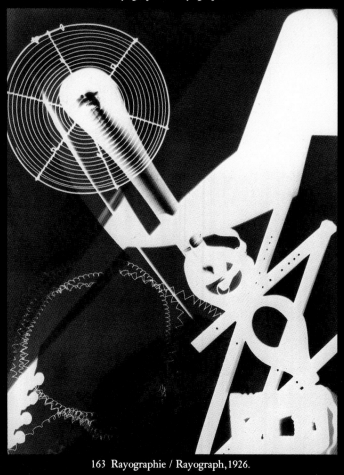

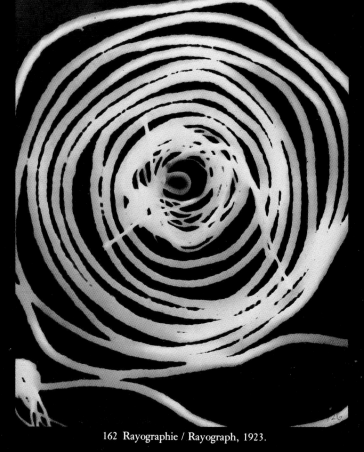

163 Rayographie / Rayograph, 1926.

162 Rayographie / Rayograph, 1923.

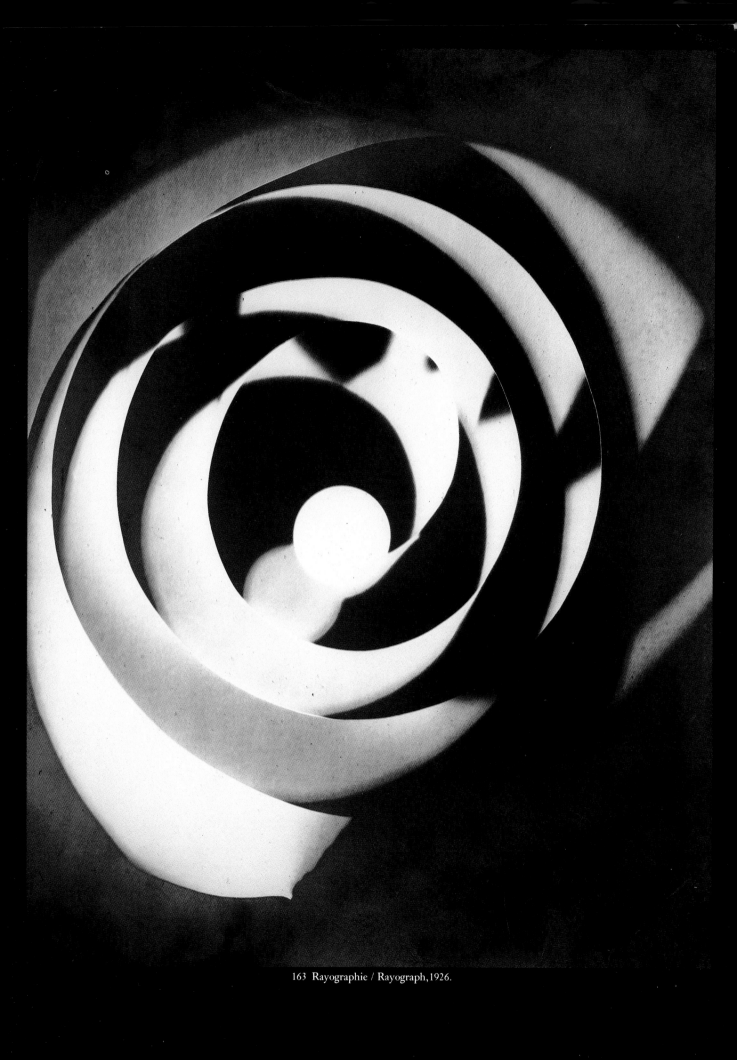

163 Rayographie / Rayograph, 1926.

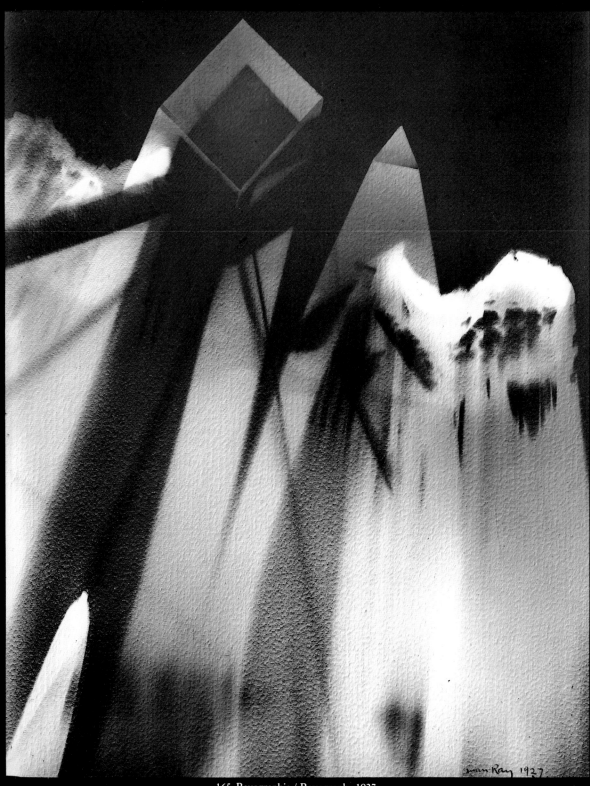

165 Rayographie / Rayograph, 1927.

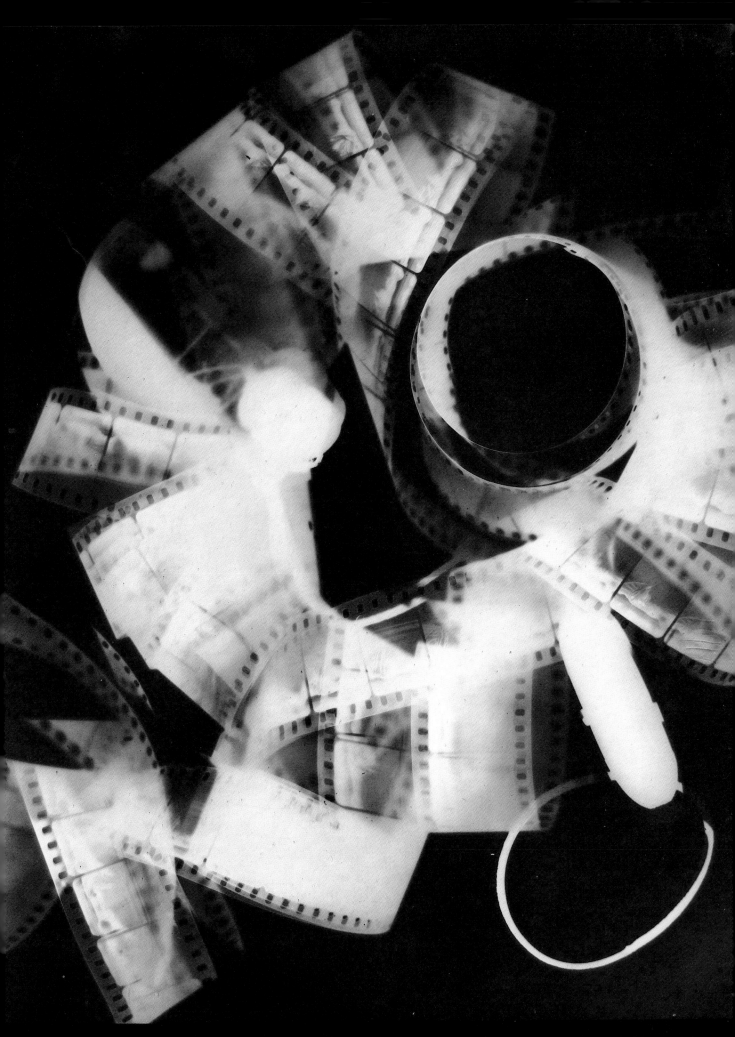

166 Rayographie / Rayograph.

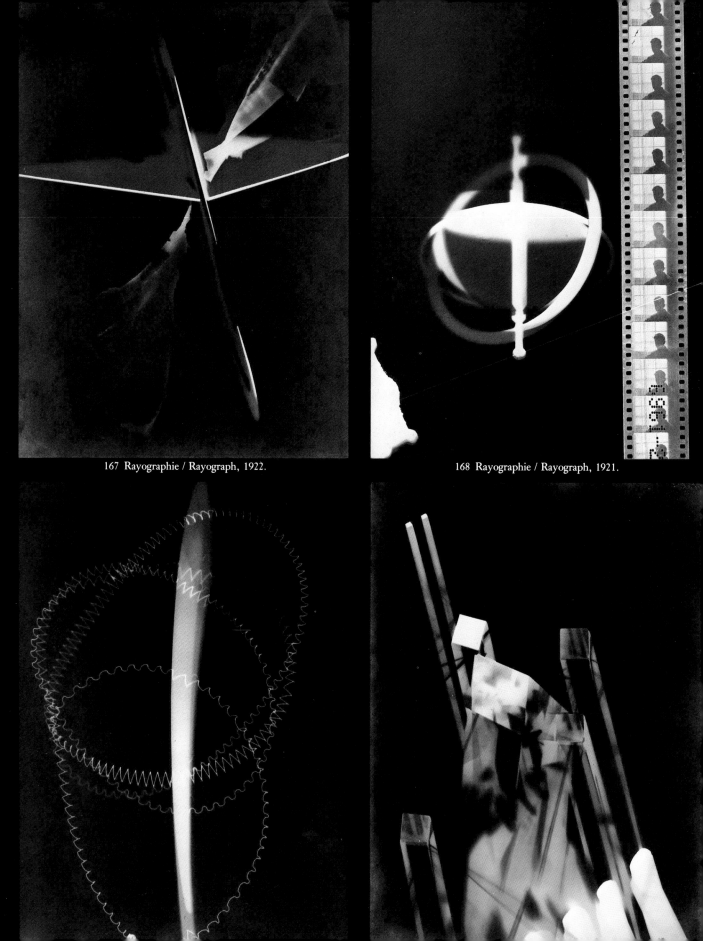

167 Rayographie / Rayograph, 1922.

168 Rayographie / Rayograph, 1921.

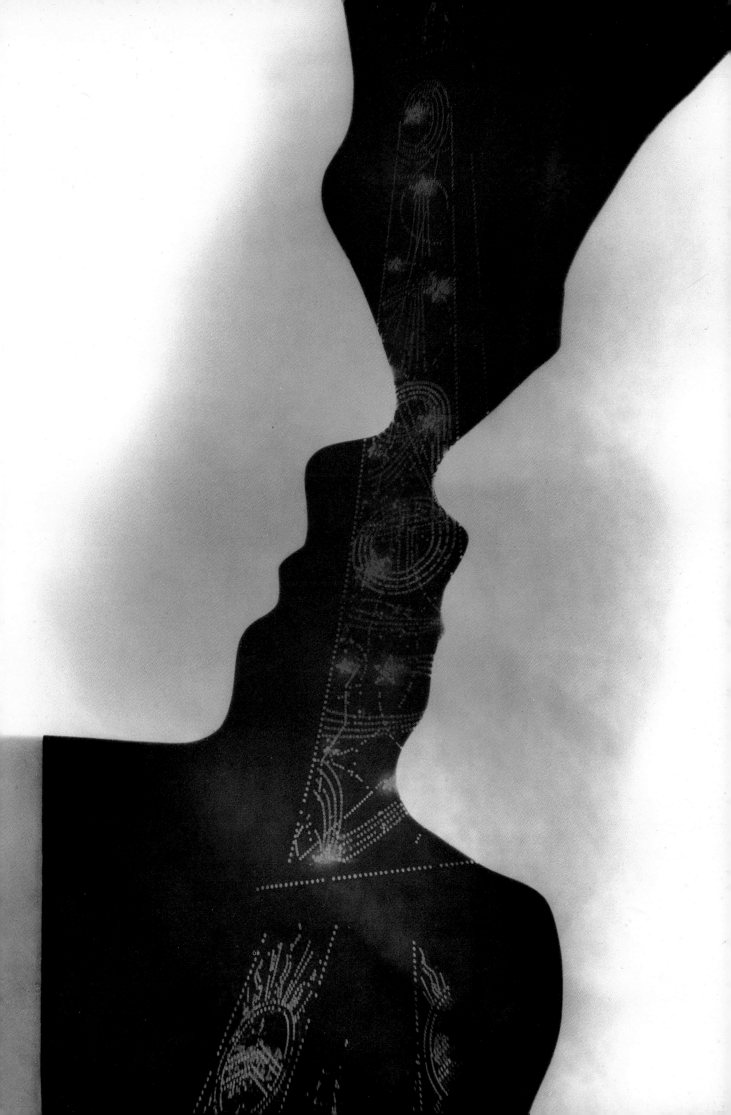

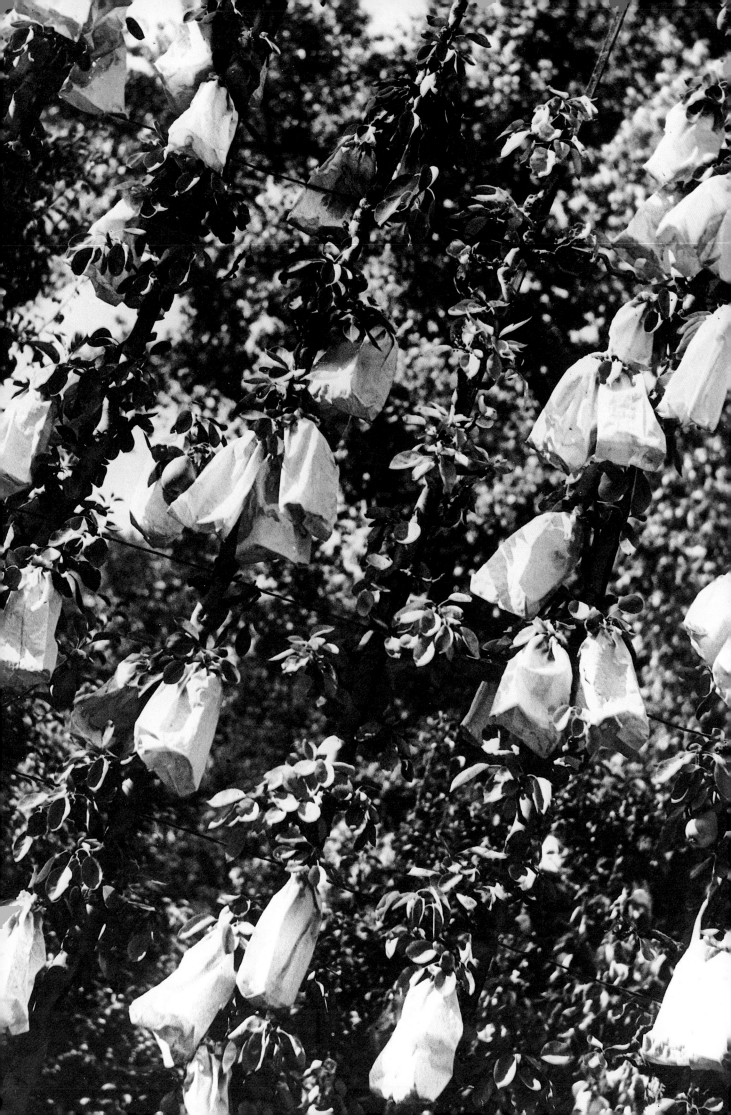

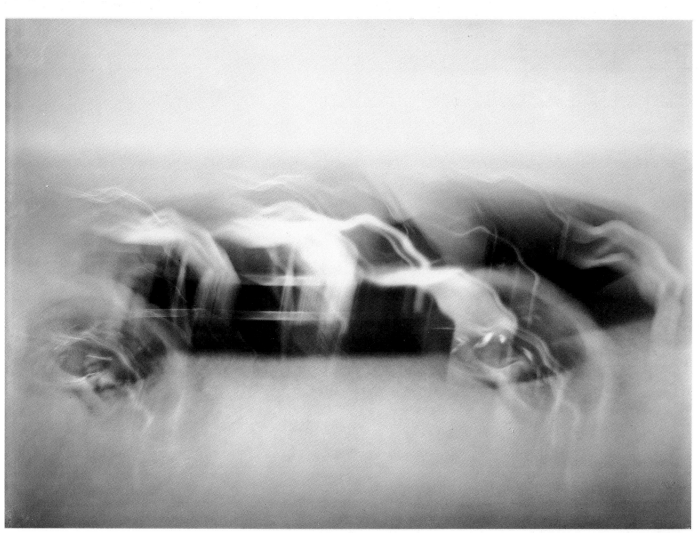

173 *Course d'autos*, 1925.

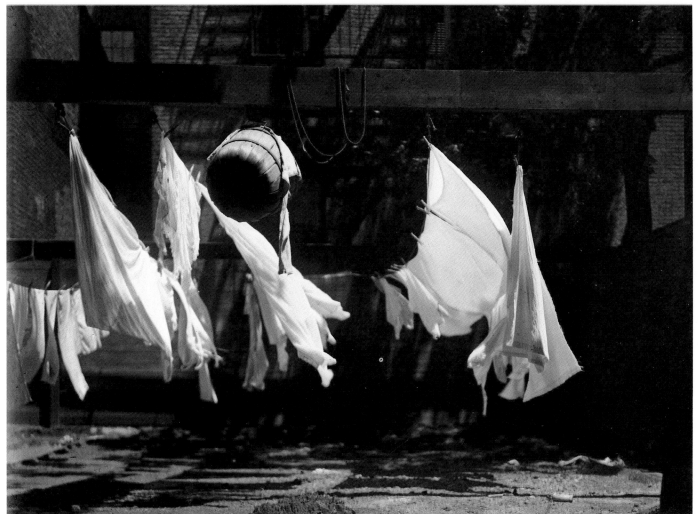

174 *Moving sculpture*, 1920.

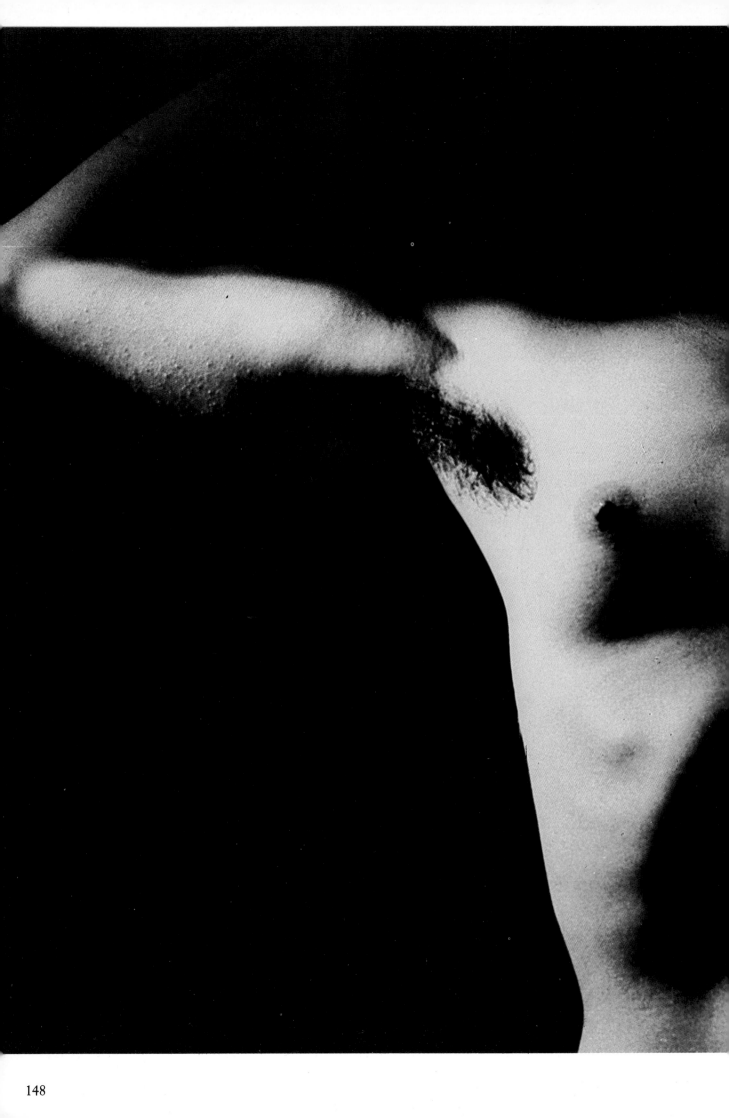

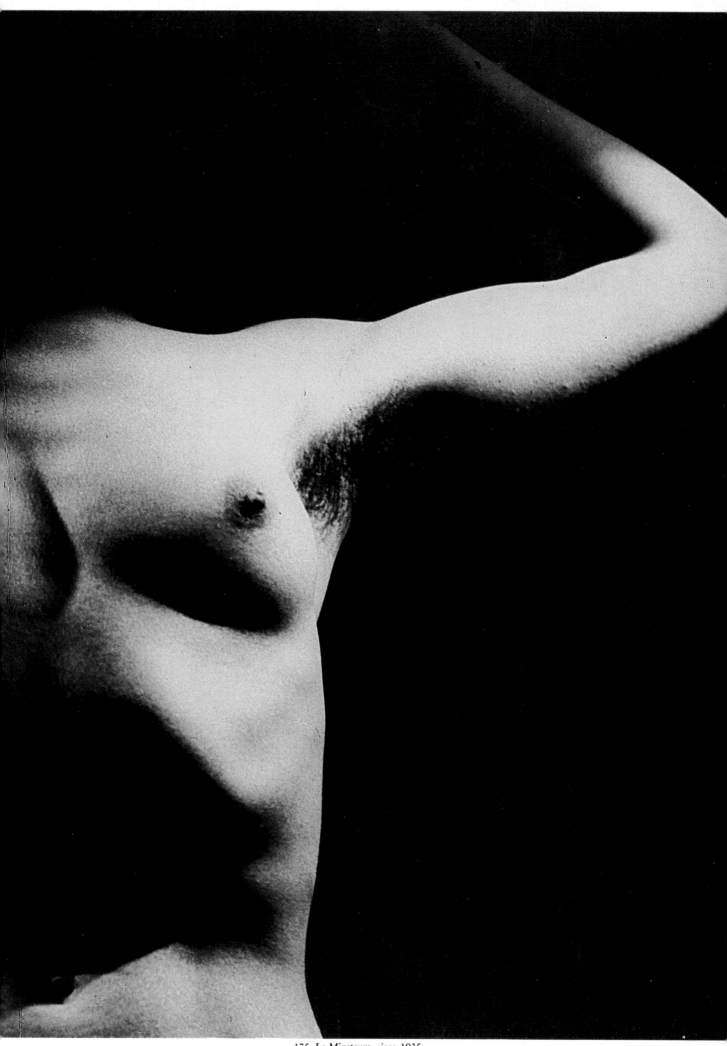

175 *Le Minotaure*, circa 1935.

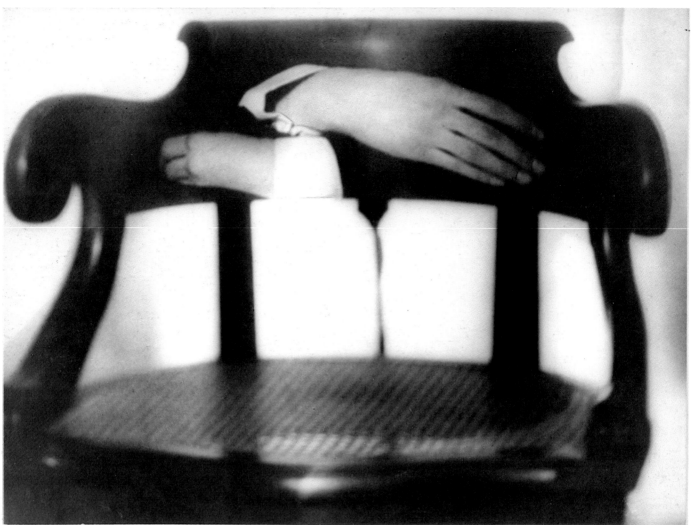

176 Sans titre / Untitled, circa 1924.

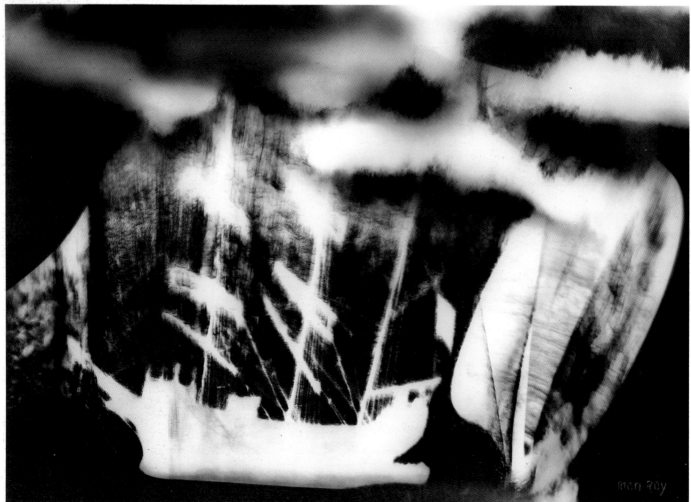

177 *Le bateau ivre*, 1924.

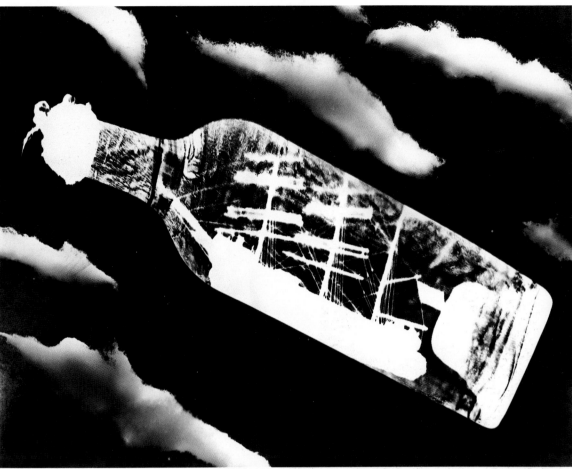

178 Rayographie / Rayograph, 1922-24.

179 *L'inquiétude,* 1920.

180 Portrait, 1920.

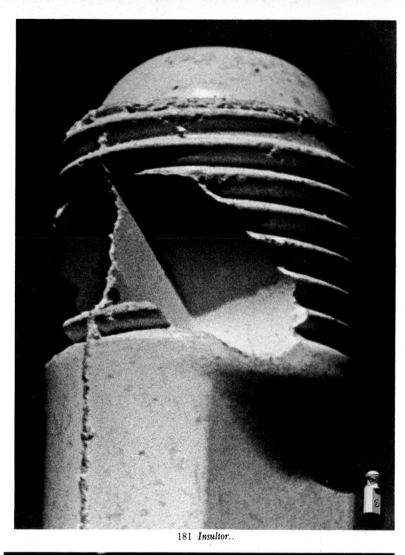

181 *Insultor.*.

182 *Anatomies,* circa 1930.

183 *Anatomies,* circa 1930.

184 *Femme aux longs cheveux,* 1929.

185 Sans titre / Untitled.

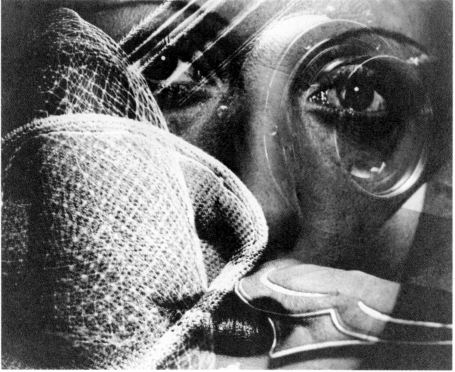

186 Portrait, 1932.

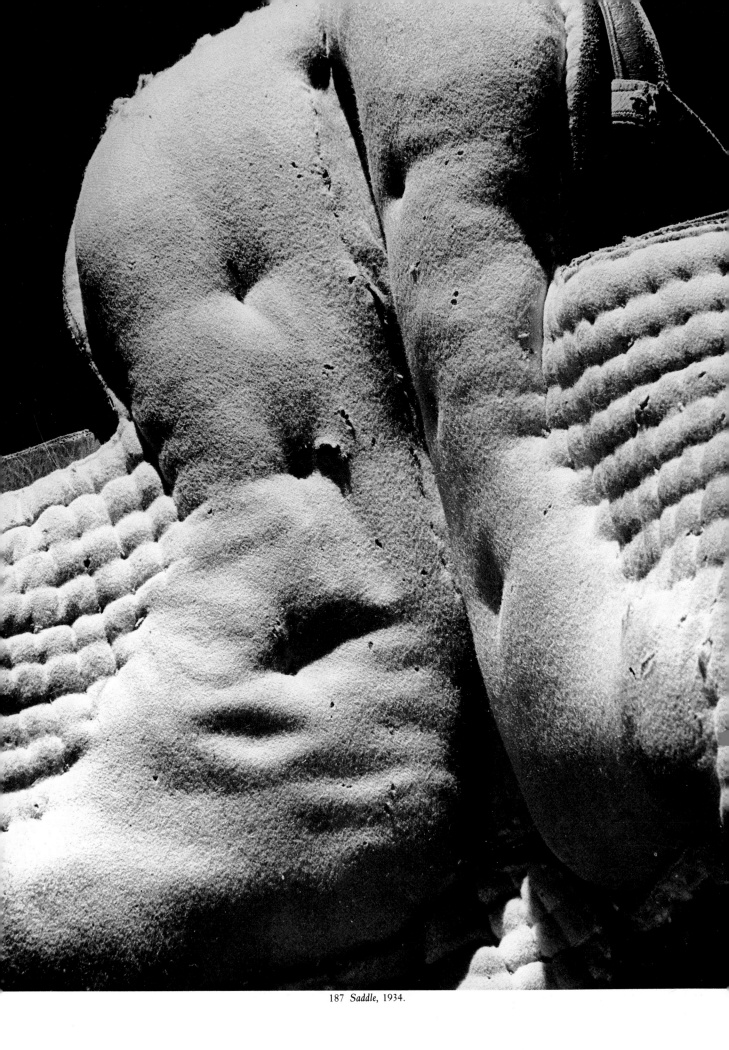

187 *Saddle*, 1934.

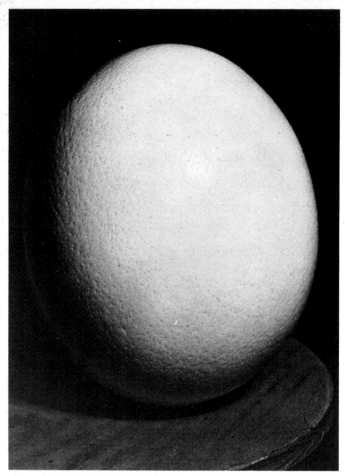

188 *Ostrich egg*, 1944.

189 Sans titre / Untitled, 1931.

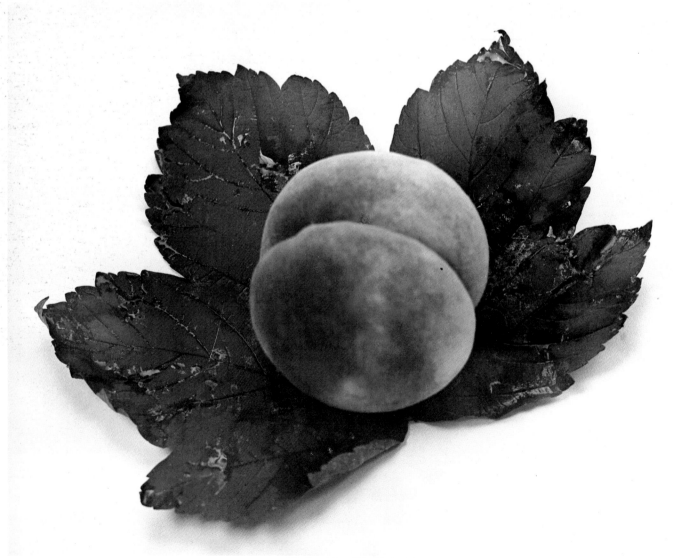

190 Sans titre / Untitled, 1931.

191 *La prière*, 1930.

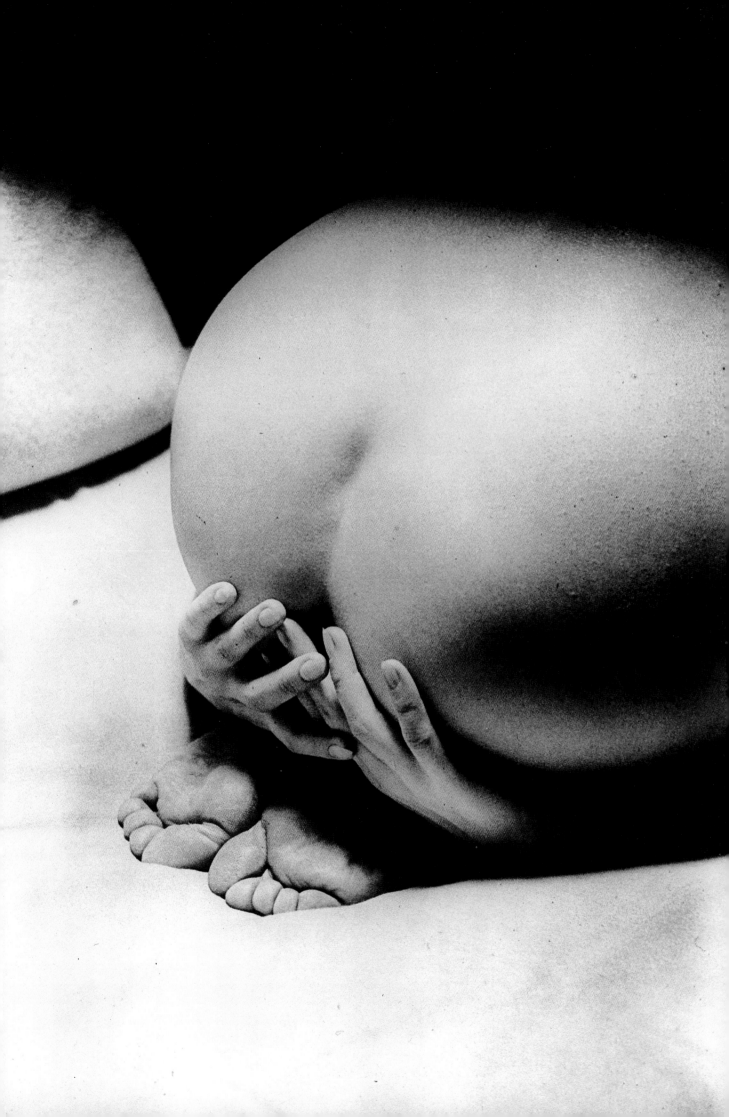

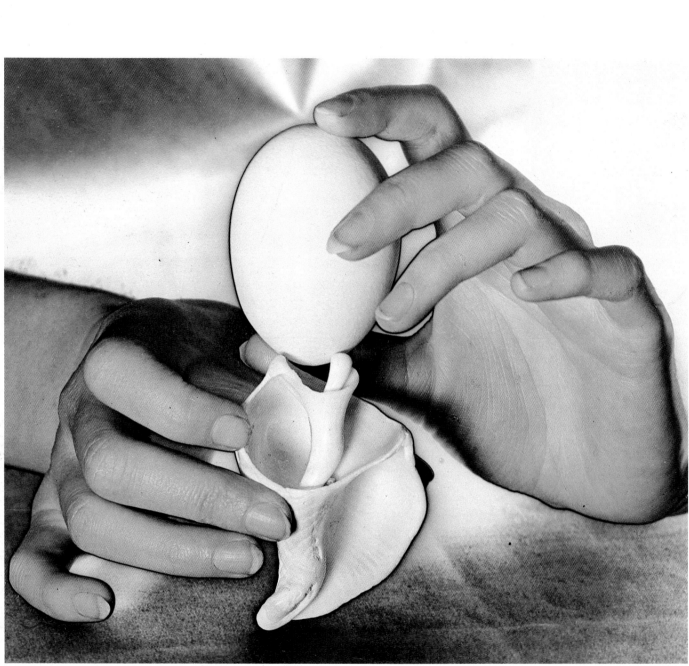

192 *L'œuf et le coquillage*, 1931.

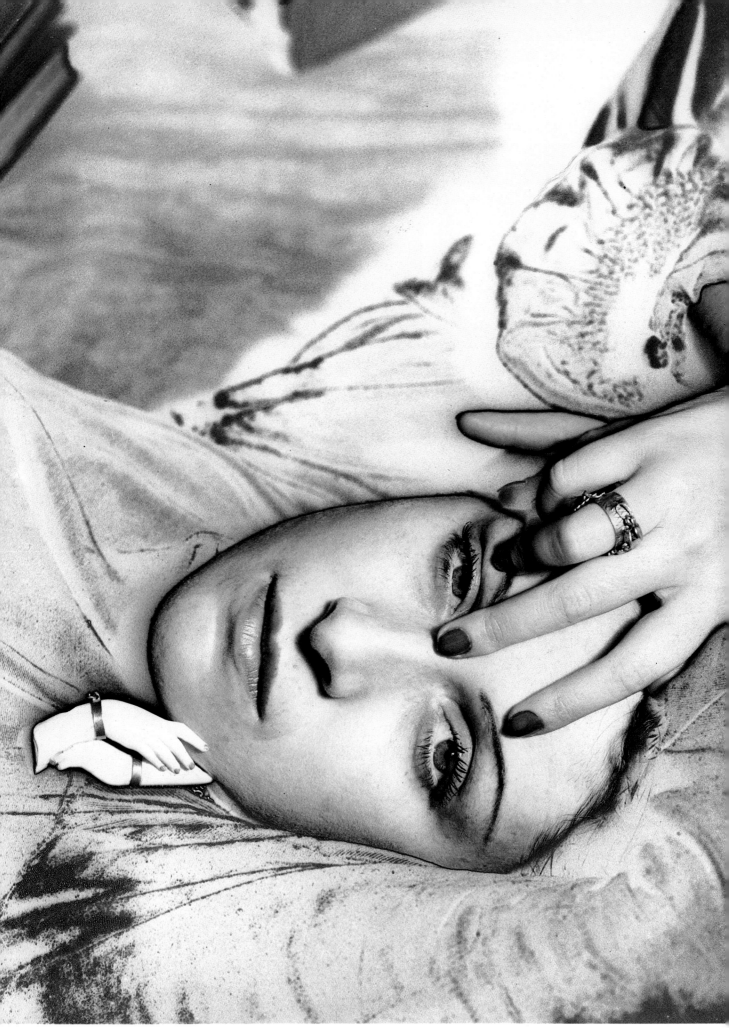

193 Dora Maar, 1936.

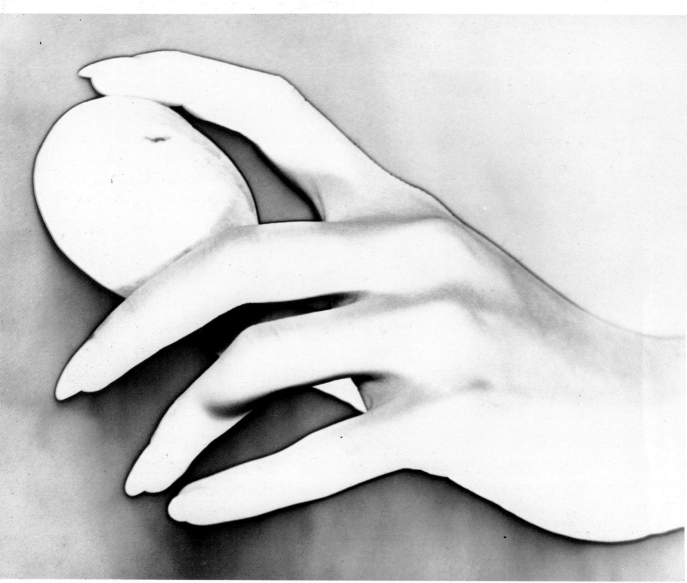

194 Sans titre / Untitled, 1946.

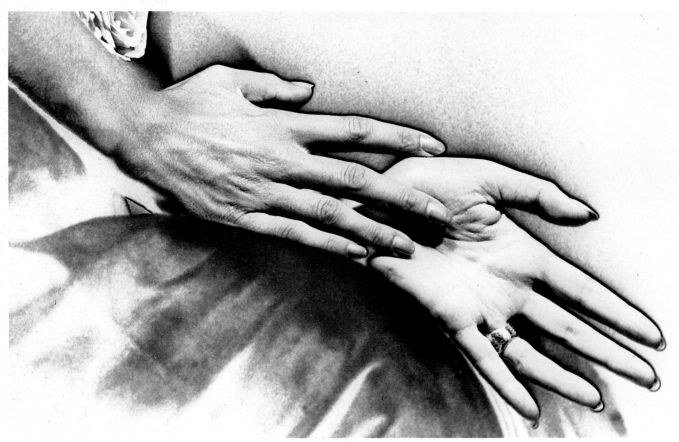

195 *Mains*, 1936.

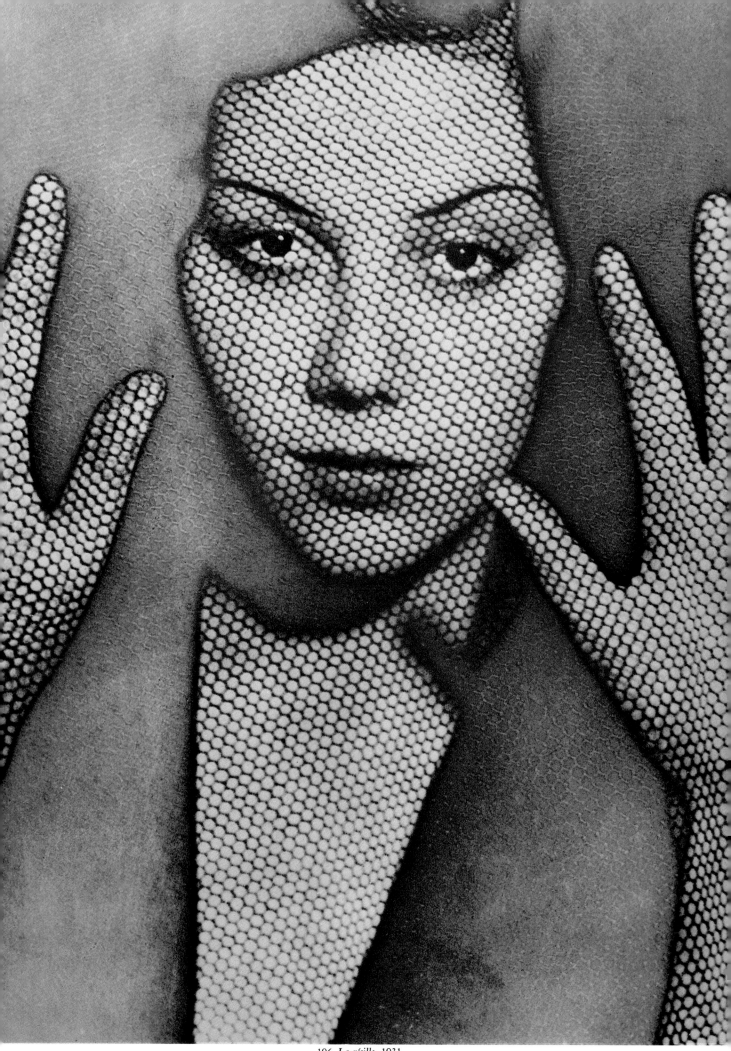

196 *La résille*, 1931.

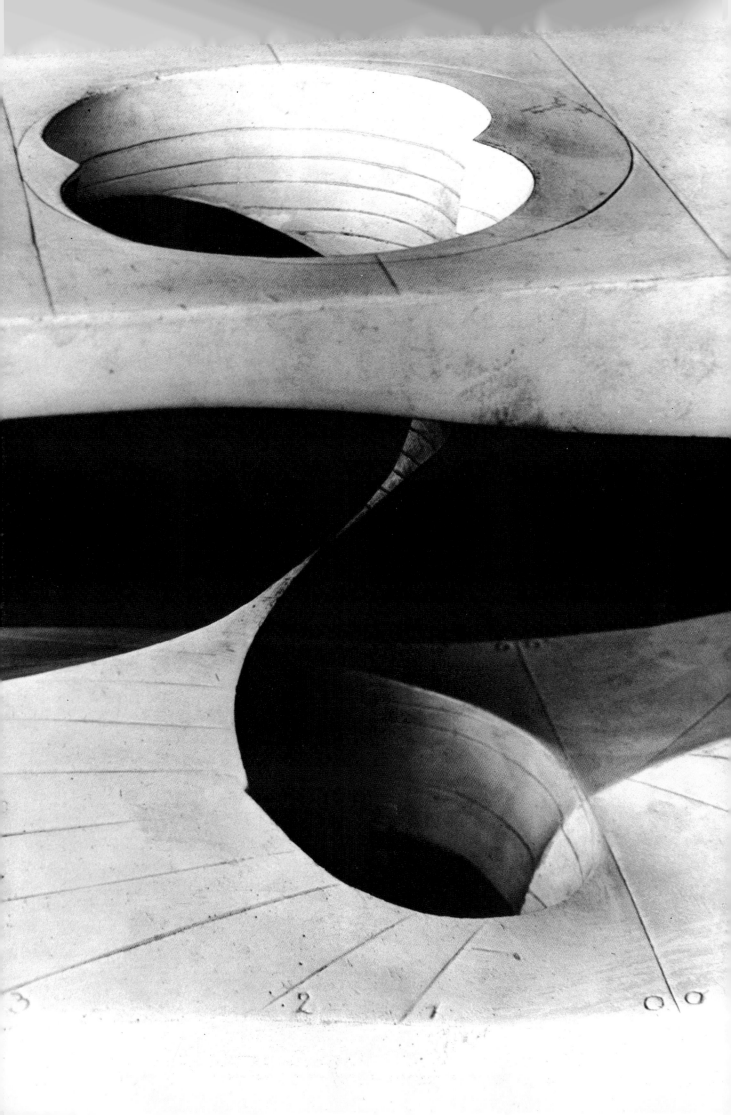

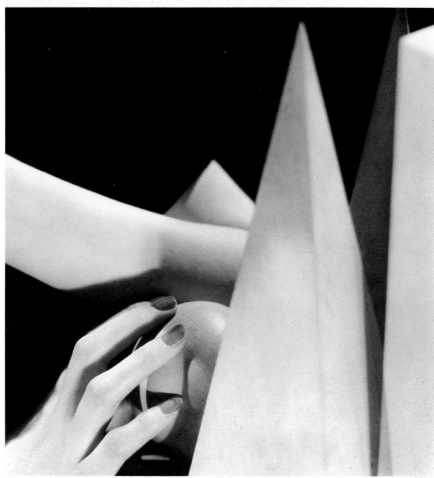

198 Sans titre / Untitled, circa 1927.

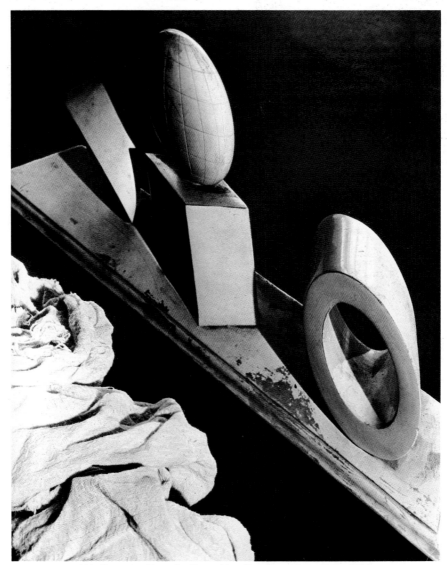

199 *Perspective d'un cube, d'une sphère, d'un cône et d'un cylindre*, 1936.

197 *Mesure pour mesure*, 1936.

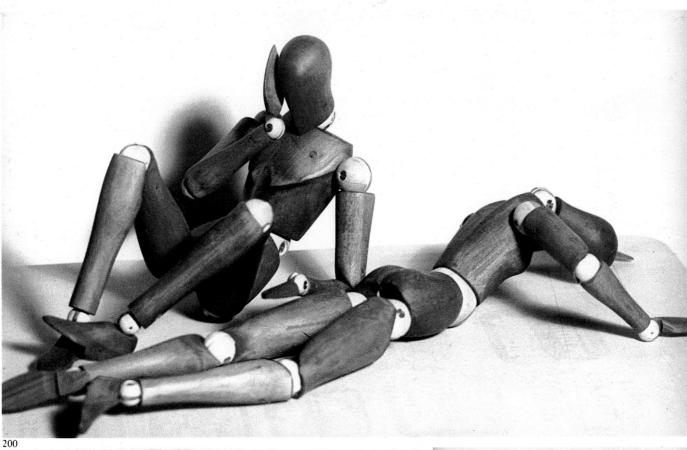

200

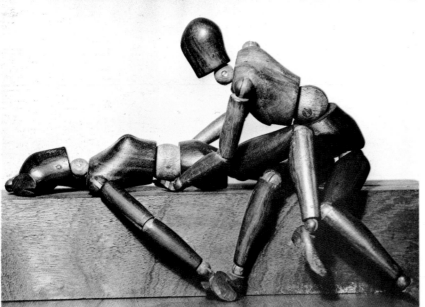

201

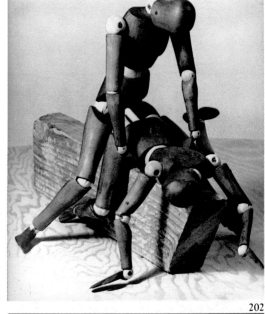

202

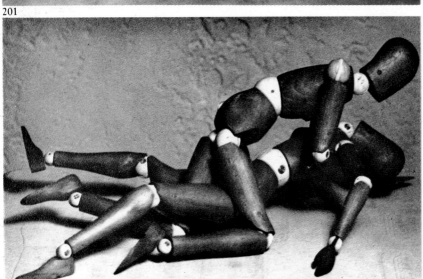

203

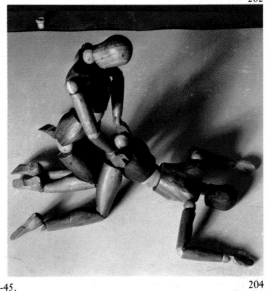

204

200 — 204 *Mr and Mrs Woodman*, 1927-45.

205 Sans titre / Untitled, circa 19

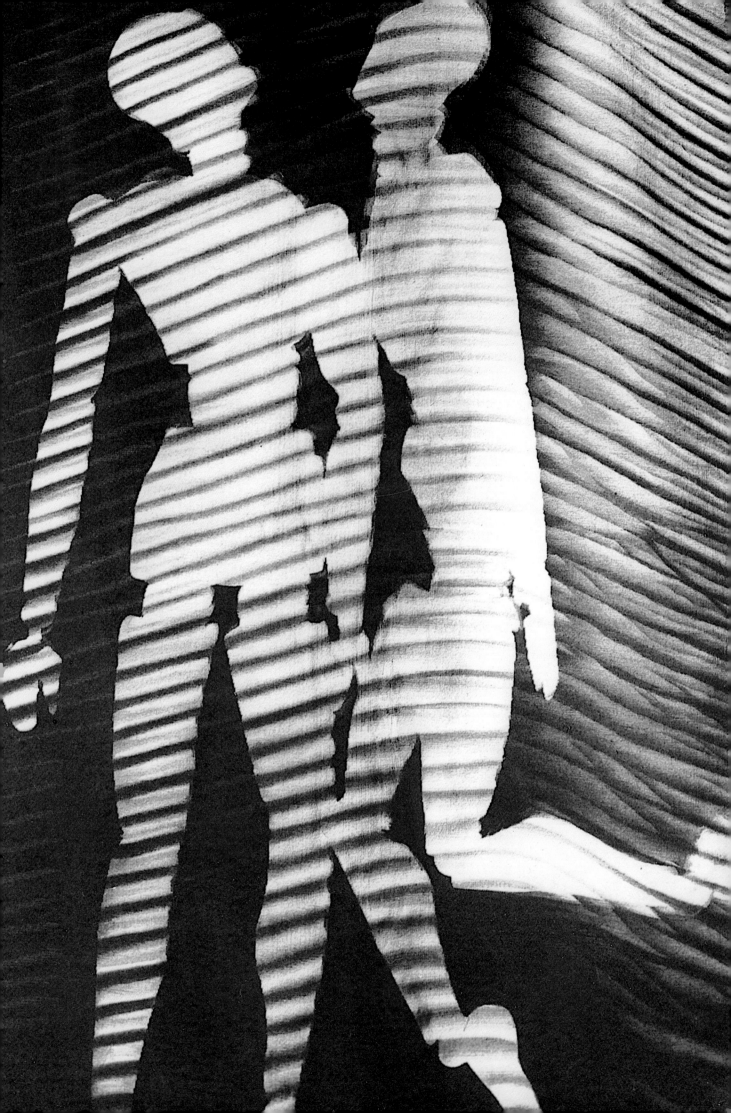

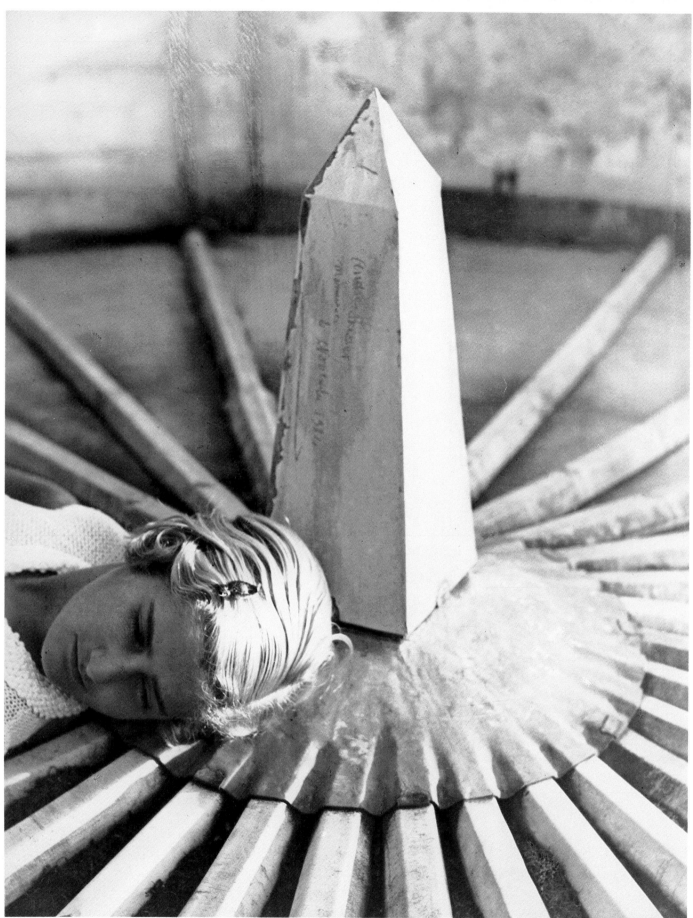

206 *L'aurore des objets*, 1937.

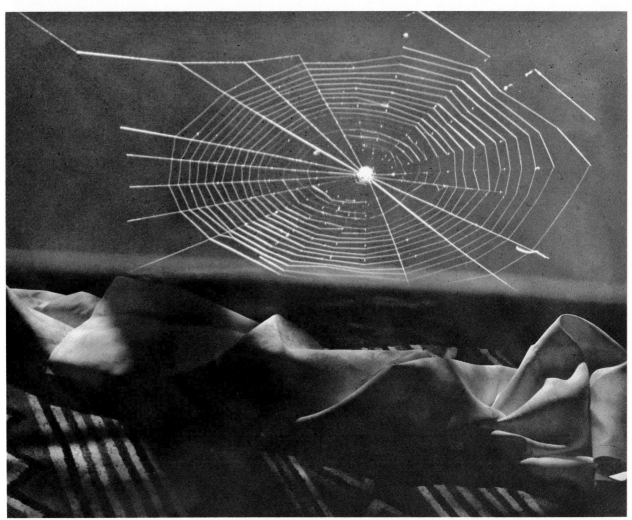

207 Sans titre / Untitled, circa 1945.

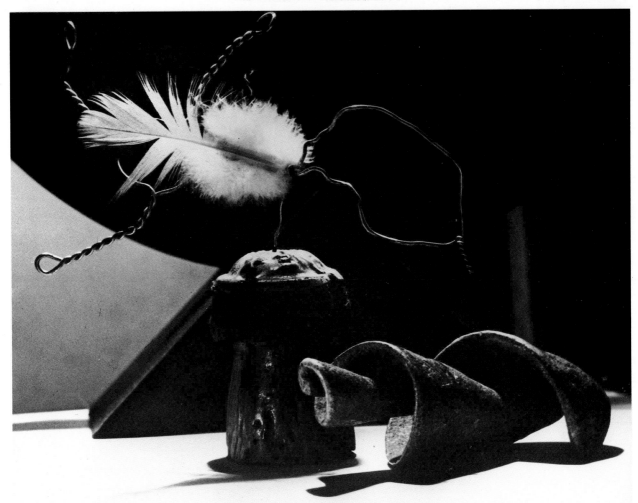

208 *Origine de l'espèce*, circa 1956.

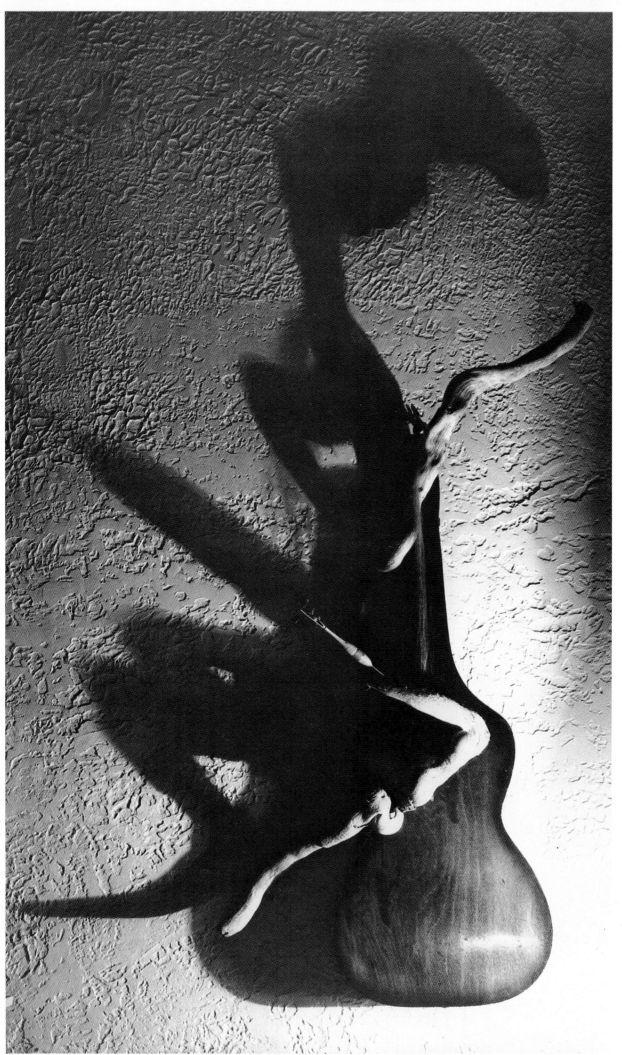

209 *Ombre II*, 1944.

210 Sans titre / Untitled.

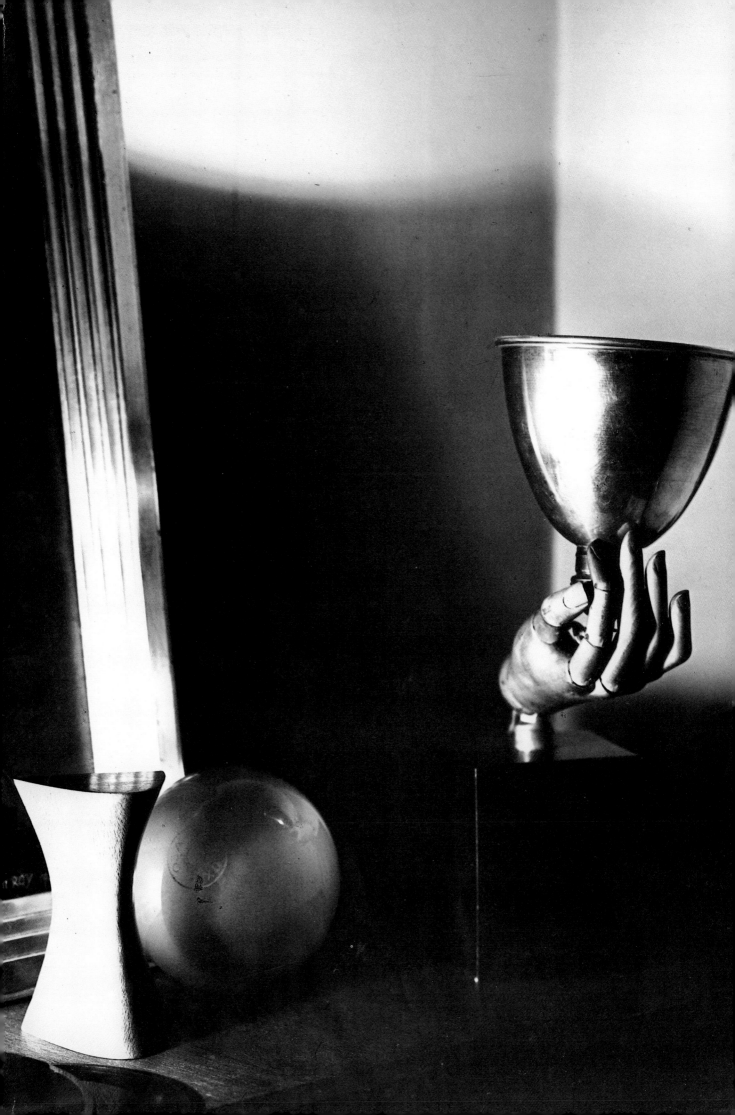

211

212

213

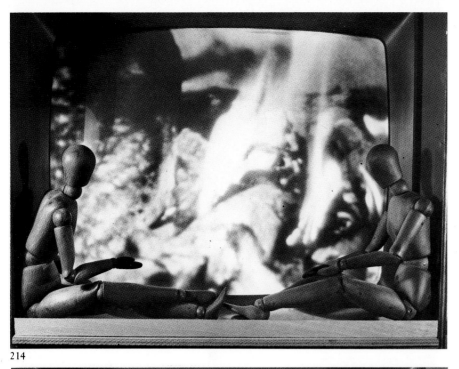

214

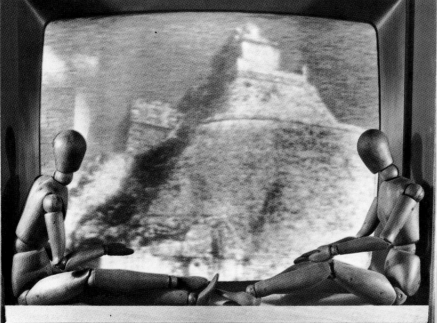

211 — 215 *La télévision*, 1975.

215

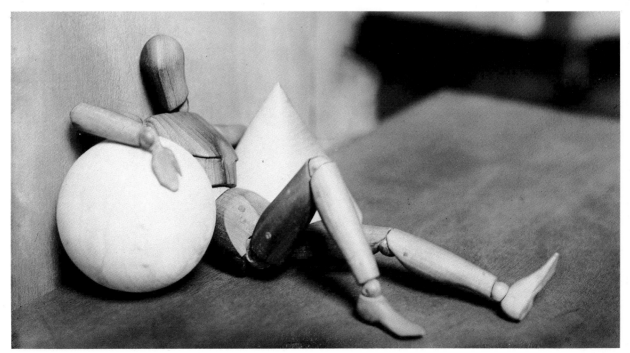

216 Sans titre / Untitled, circa 1926.

171

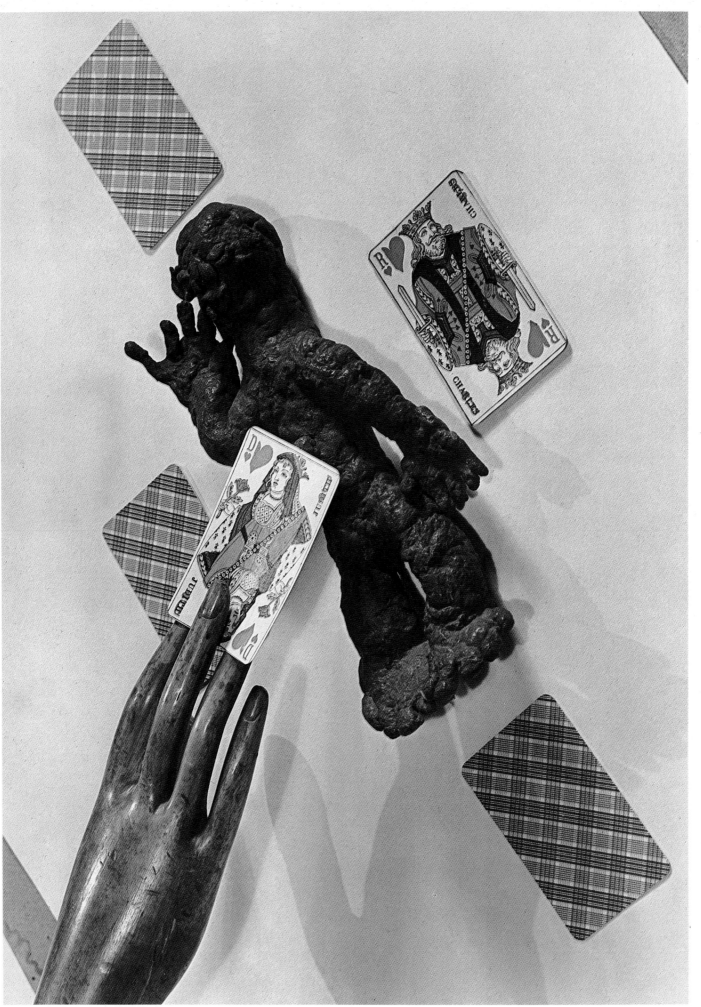

217 *Moi, elle,* 1934.

218 *La lune brille sur l'île Nias,* 1926.

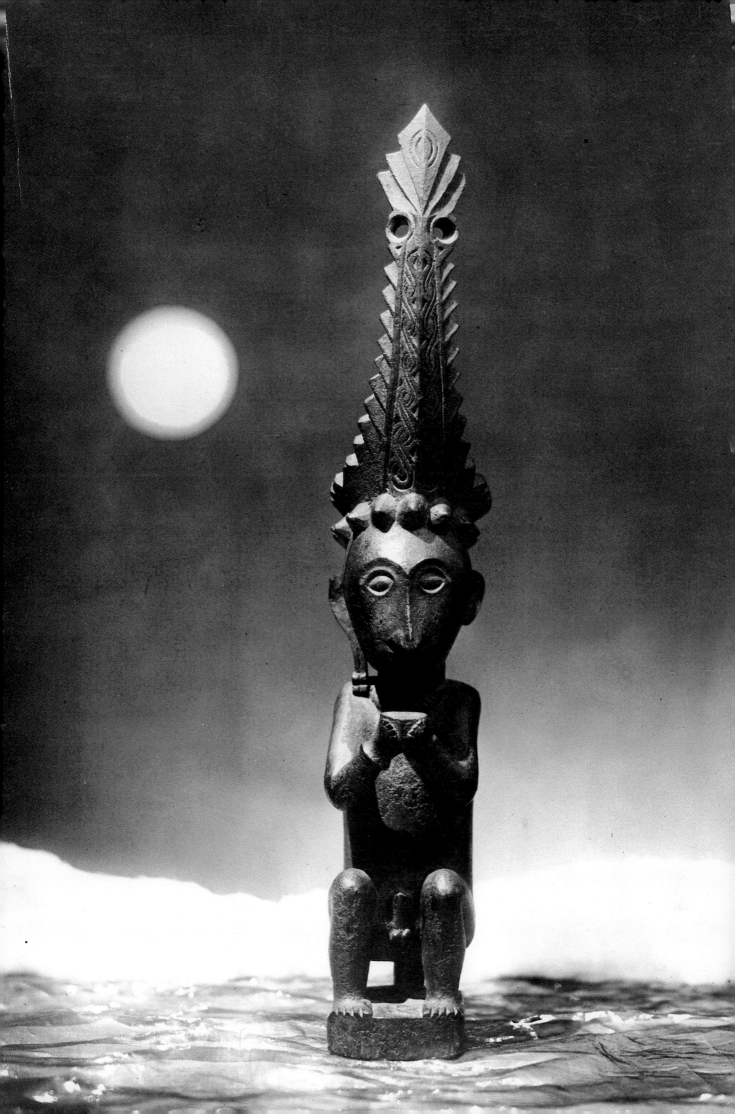

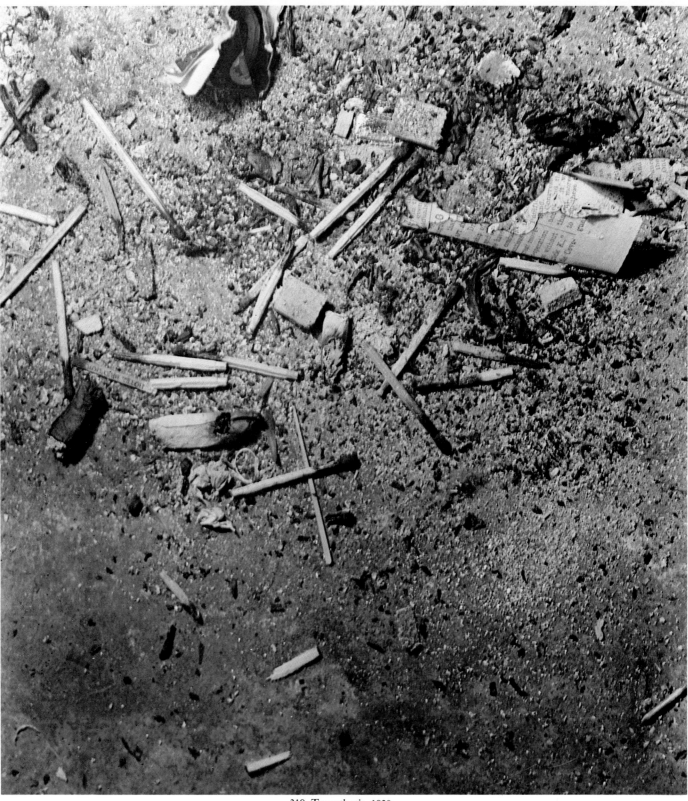

219 *Transatlantic*, 1920.

220 *Frozen fireworks*, circa 1931.

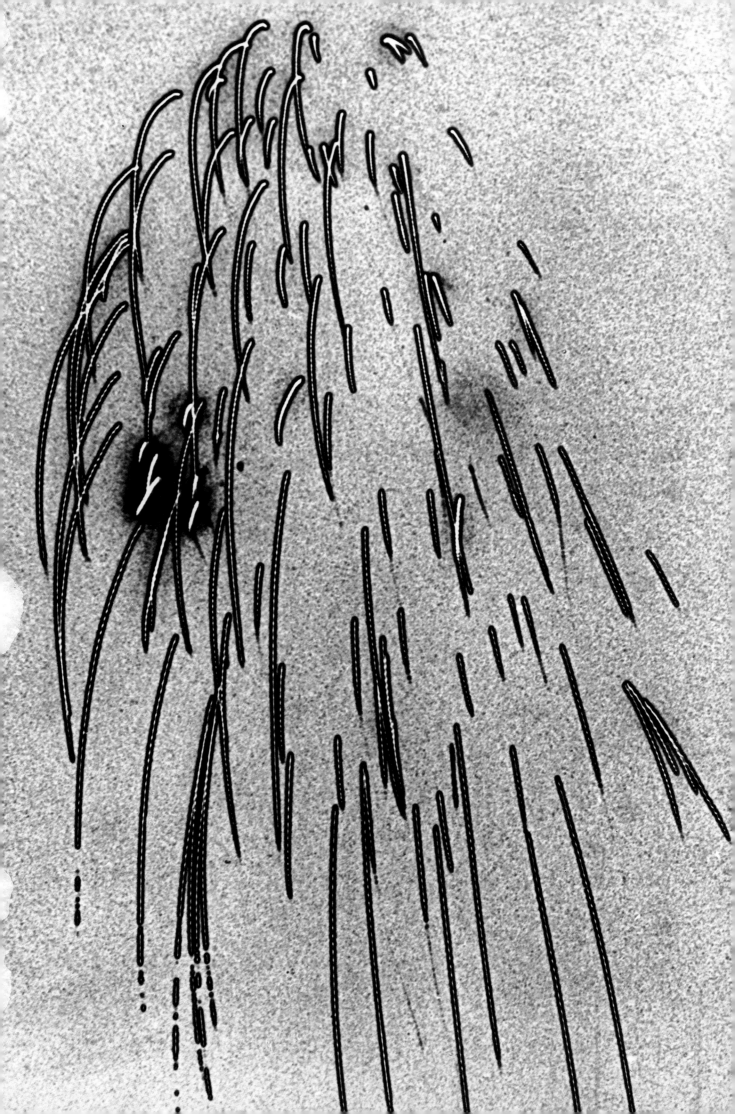

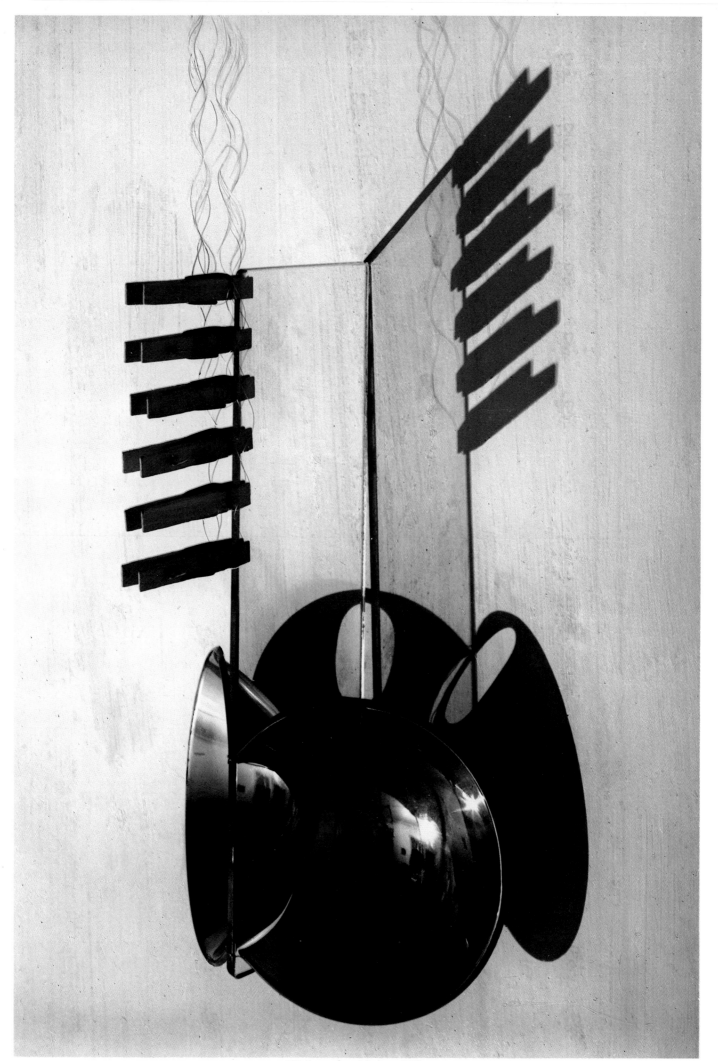

221 *Integration of shadows*, 1919.

222 *La voie lactée*, 1973.

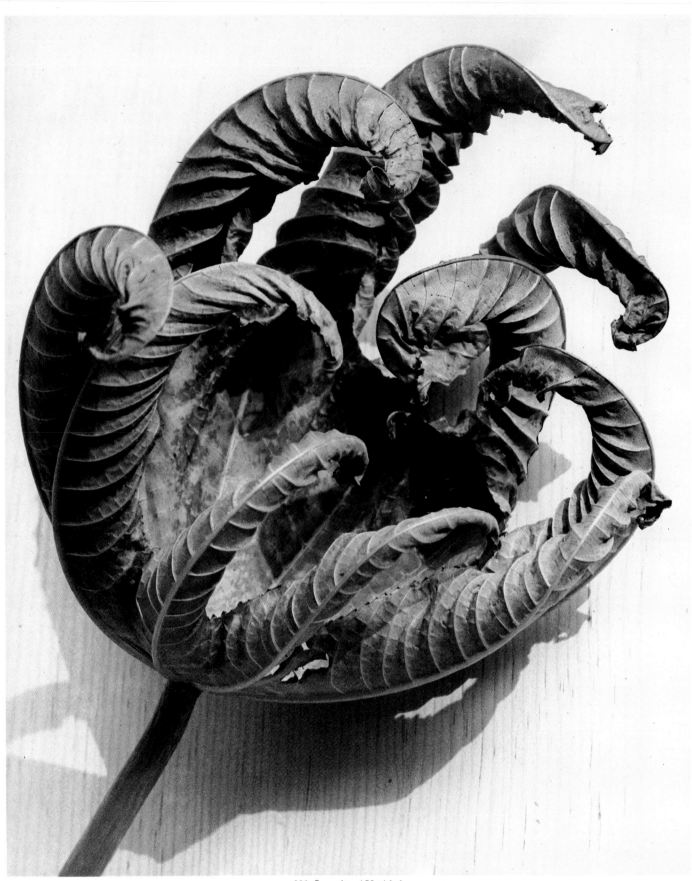

223 Sans titre / Untitled.

224 *Compass*, 1920.

Behind
the façade

Drawing and painting for me were a relief from my photography, but I had no intention of substitution. It irked me when I was asked, according to my activity at the moment, whether I had given up the one for the other. There was no conflict between the two — why couldn't people accept the idea that one might engage in two activities in his lifetime, alternately or simultaneously? The implication, no doubt, was that photography was not on a level with painting — it was not art. This has been a moot question since the invention of photography, in which I had never been interested, and to avoid discussion, I had declared flatly that photography is not art, publishing a pamphlet with this statement as the title, to the dismay and reprobation of photographers. When asked more recently if I still held to my opinion, I declared that I had revised my attitude somewhat : for me, art is not photography.

NOTES ON PLATES 225-264

225. Untitled, 1928.
229 boulevard Raspail, Paris.

226. *A l'heure de l'observatoire - Les amoureux*, 1935-1938.
See **12**.

227. Self portrait, Ridgefield, 1919.
Man Ray lived with Adon Lacroix in a little house made of wood in Ridgefield, New Jersey. It was there that he started his life as a painter.

228-29. Untitled, 1935.
These rocks on the Catalonian coast near Cadaqués formed the setting for the opening scene of Luis Buñuel's film *L'age d'or*, where skeletons dressed in bishops' robes are seen sitting on them.

230. *La super-nevrose mammouth* ('The Mammoth Super-neurosis'), *c.* 1933.
This photograph of Gaudi's Parc Guell, which appeared in *Minotaure* (No. 1, 1933, p. 69), was an illustration for an article by Salvador Dali, 'De la beauté terrifiante et comestible de l'architecture modern style' ('On the terrifying and edible beauty of "modern style" architecture'). Its title is also by Dali.

231. Paris, 1926-27.
A view of the rue de la Paix and, in the background, the Vendôme column.

232. Paris, 1926-27.
This photograph of a courtyard, taken from a porch, recalls those of Eugène Atget. Man Ray had helped to make him known in artistic circles at the time.

233. Paris, 1926-27.
The Moulin de la Galette, seen from the rue Tholozé. Many of these photographs of Paris, and several landscapes, were printed by Man Ray in the form of postcards for his personal use.

234. Paris, 1926-27.
An elegant woman with the fashionable dog of the Roaring Twenties in France, the fox terrier.

235. Paris, 1926-27.
The Bullier dance hall, since demolished, opposite the Closerie des Lilas in the continuation of the avenue de l'Observatoire. Man Ray was named as an artist on the poster for a 'Fête de nuit à Montparnasse' at the Bullier on 30 June 1922.

236. Paris, *c.* 1930.

237. *La Loire à Orléans à Pâques* ('The Loire at Orléans on Easter Day'), 1938.

238. Saint-Germain-l'Auxerrois, Paris, 1930.
In the background are the colonnades of the Louvre.

239-42. Paris, *c.* 1930.
The exposed party wall parapets attracted the attention of several painters and photographers. Raoul Hausmann also photographed them.

243. The Seine, Paris, *c.* 1930.

245. Untitled.

246. Untitled, 1926.

247. Paris, *c.* 1926.
The Cheval de Marly statue in the place de la Concorde. The obelisk in the background alludes to Man Ray's short poem *Temps révolu*.

248. Untitled, 1926.
Place de la Concorde.

249. *Boulevard Edgar-Quinet, a minuit* ('Boulevard Edgar Quinet, Midnight'), 1924.
A similar photograph was published in *La révolution surréaliste* (15 January 1925, p. 22), under the same title.

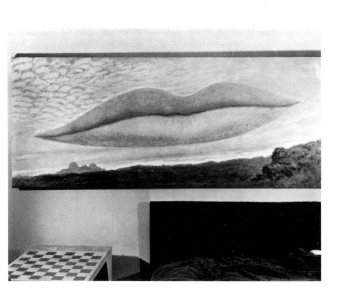

250. Paris, *c.* 1930.

251. Paris, *c.* 1930.

252. Boulevard du Montparnasse, Paris, *c.* 1930.

253. *Au château tremblant*, Paris, *c.* 1930.

254. Rue Sade, Antibes, 1936.

255. Studio, Paris, *c.* 1935.
Studio in the rue Campagne-Première where Man Ray moved in 1921, and where he stayed till 1930-33. Some of his works can be seen on the wall: rayographs, *Sequidilla*, *Study for Promenade*.

256. Studio, 2 bis rue Férou, Paris, *c.* 1950.
The entrance hall of the studio in the rue Férou as it was in 1951 when Man Ray moved in, before he had rearranged it.

257. *Tu me retrouverais toujours, dit le sphynx* ('You Will Always Find Me Again, Said the Sphinx'), 1935.

258. *Rien dans le puits du nord*, 1935.

259. *A la suite d'une vision sinistre, Don Juan...*, 1935.
During the summer of 1935, while they were staying with Lise Deharme in the Landes in Aquitaine, André Breton, Paul Eluard and their wives attempted to make a Surrealist film. But Man Ray's small ciné camera broke down. Only seven images are left, which were published in *Les cahiers d'art* (Nos. 5-6, 1935, p. 107), under the title 'Essai de simulation du délire cinématographique, scénario d'André Breton et Paul Eluard, réalisation de Man Ray'. 'I... had renounced making films... My curiosity had been satisfied - surfeited... I prefer the permanent immobility of a static work which allows me to make my deductions at my leisure, without being distracted by circumstances'. (*Self Portrait*, pp. 286-87.) The subjects in **257** and **258** are Nusch Benz and Gala, at the time Paul Eluard's wife, later Salvador Dali's lover.

260. Studio, 8 rue du Val-de-Grâce, Paris, *c.* 1935.
'By the middle of the Thirties I had re-established myself as a photographer, moving about more in social circles and being solicited by advertising agencies and fashion magazines. It was more irregular work, but better paying than portraits, leaving me more time for painting. I found a large studio with an apartment, which I fixed up again according to my ideas. Here I could live and work. I gave up the other places, reducing my double life to a single one, still remaining single as far as amorous adventures were concerned. The studio was full of photographic paraphernalia, to impress my clients, but the walls were covered with paintings and a couple of easels stood among the lights. None except the Surrealists and some friends noticed the painting. I was casual with my more commercial clients, getting all I could out of them.' (*Self Portrait*, pp. 292-93.)
The furniture was designed by Man Ray. The painting on the easel is entitled *Maisons ennemies* (1933). Man Ray advertised his change of address for his portraits in *Minotaure*, June 1935.

261. Studio, New York, *c.* 1918.
This photograph was reprinted, with eight others, in a portfolio, *First Steps in 1920* (Turin, Luciano Anselmino, 1971), of which there were eight numbered copies.

262. Studio, rue Denfert-Rochereau, Paris, 1939.
Man Ray painted *Le retour à la raison* here, and worked on elements in the painting *Trois parasols pour dames et cavaliers délicats* (Cologne, Ludwig Collection).

263. New York, 1919.
Man Ray dedicated this photograph to Yvonne Chastel (the first wife of Jean Crotti, the painter, and later Marcel Duchamp's lover) - with the inscription 'Follies of 21' - in thanks to her for having put him up at 22 rue de la Condamine when he first arrived in Paris. Several of the objects reappear in other photographs, for example the small step-ladder, the banjo (**80**), and the alarm clock (**11**). *Narcisse* (former collection of Van Doesburg) can be seen against the wall, and *Sculpture By Itself II* is lying on the shelf.

264. New York, 1918.
Objects belonging to Man Ray: *Sculpture By Itself I* and *New York* (jar containing marbles); a cap that Duchamp used to wear; *Williams Varnishes* (a record of Duchamp's); and a work by Duchamp propped up against the mirror, a photograph called *A regarder d'un œil de près pendant presque une heure* (1918).

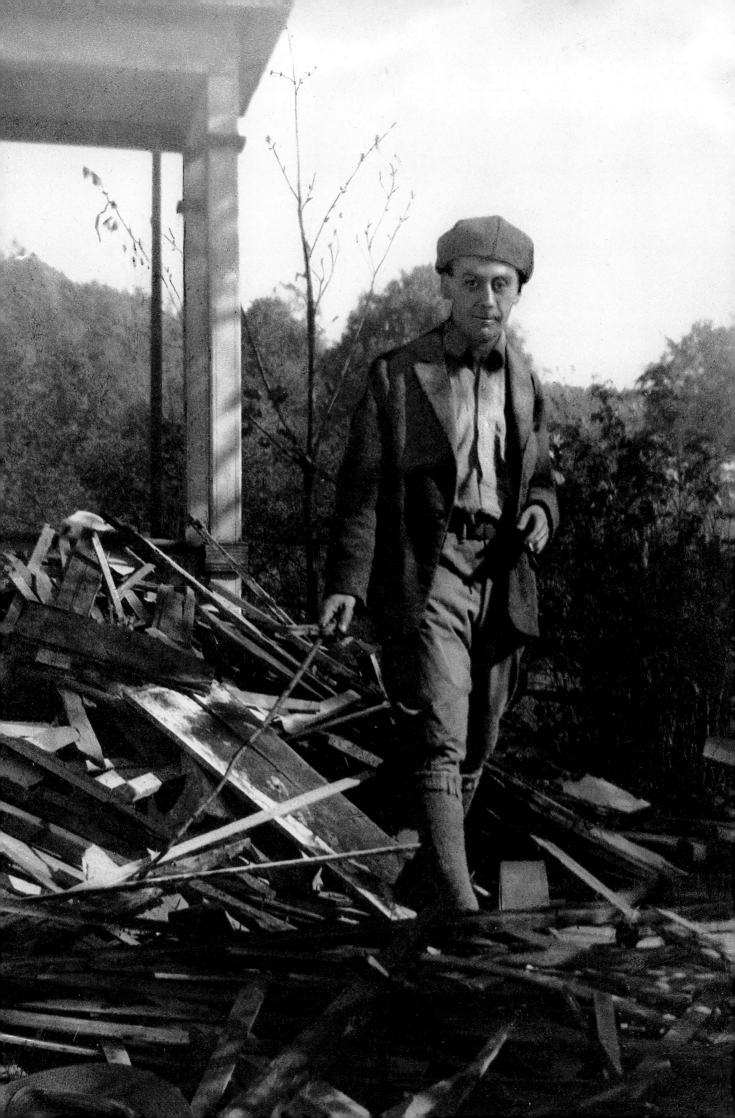

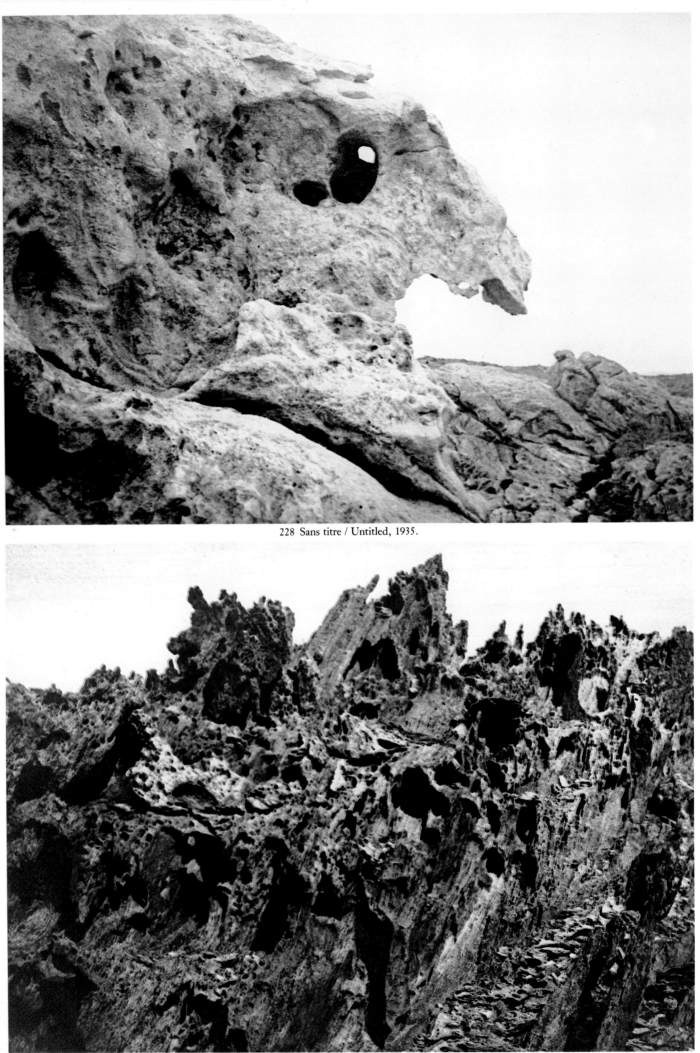

228 Sans titre / Untitled, 1935.

229 Sans titre / Untitled, 1935.

230 *La super-névrose mammouth*, circa 1933.

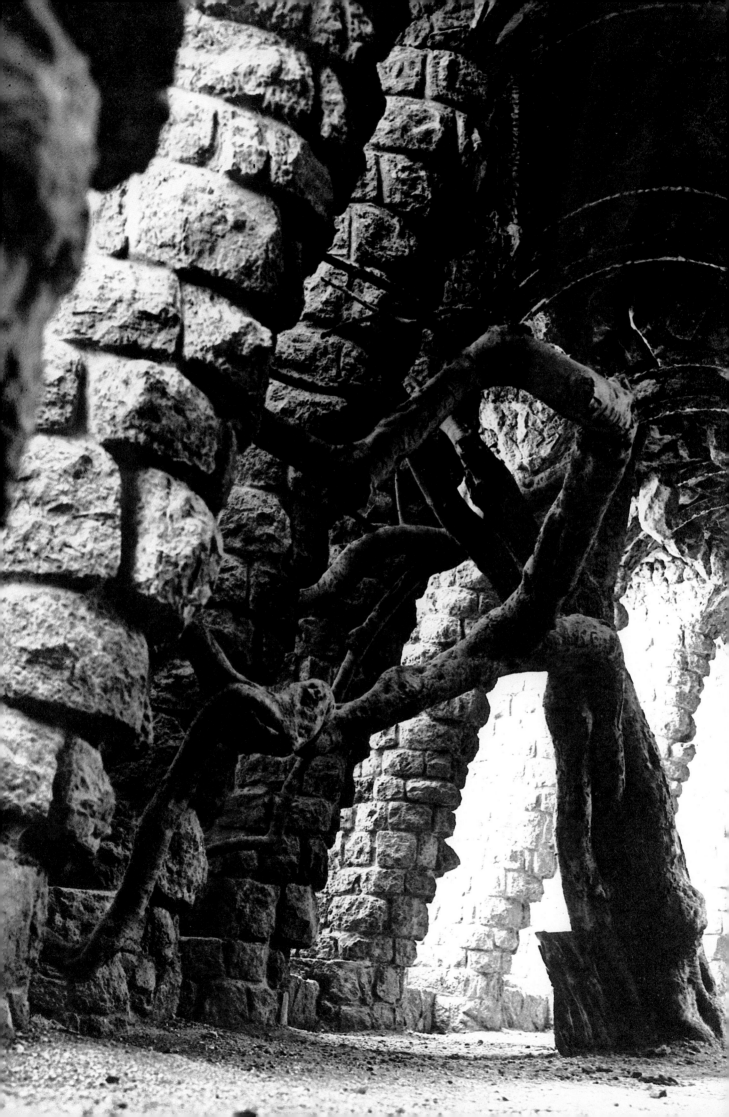

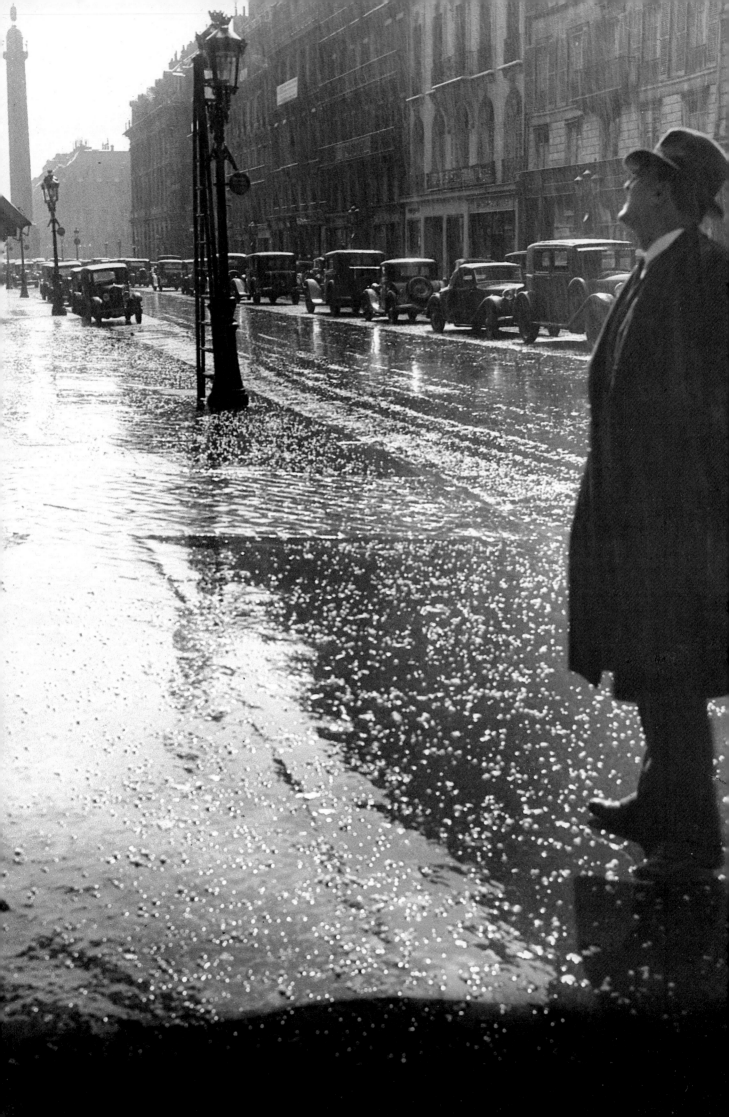

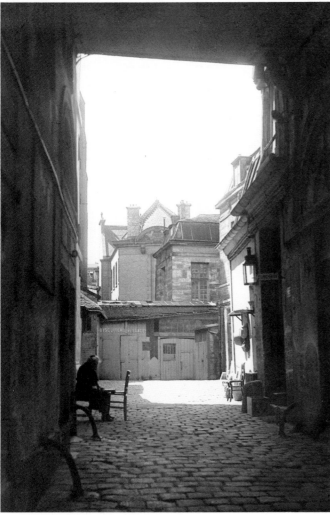

232 Paris, 1926-27.

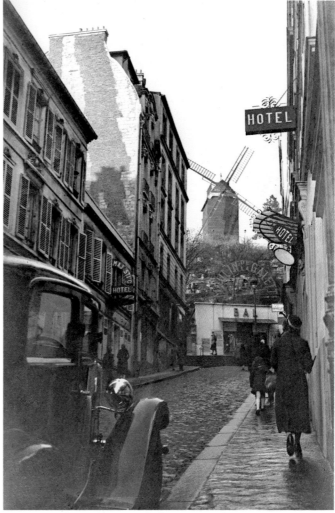

233 Paris, 1926-27.

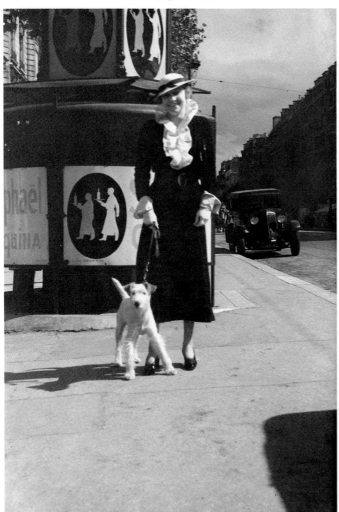

235 Paris, 1926-27.

234 Paris, 1926-27.

231 Paris, 1926-27.

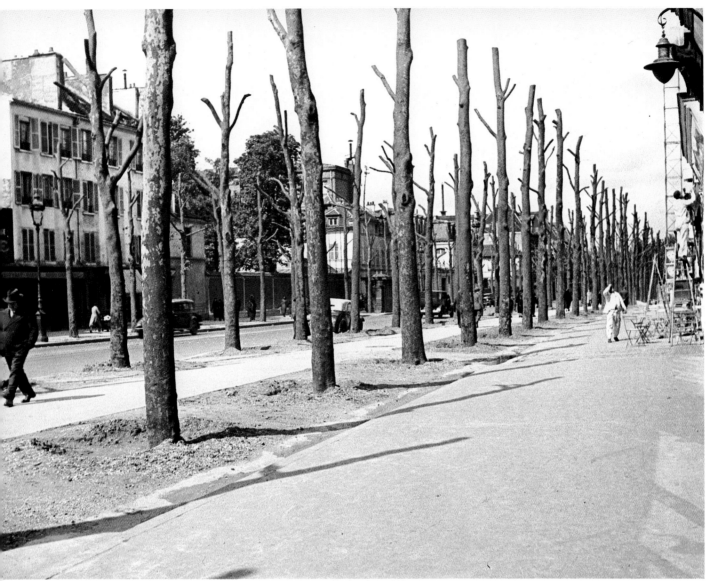

236 Paris, circa 1930.

238 St-Germain-l'Auxerrois, Paris 1930.

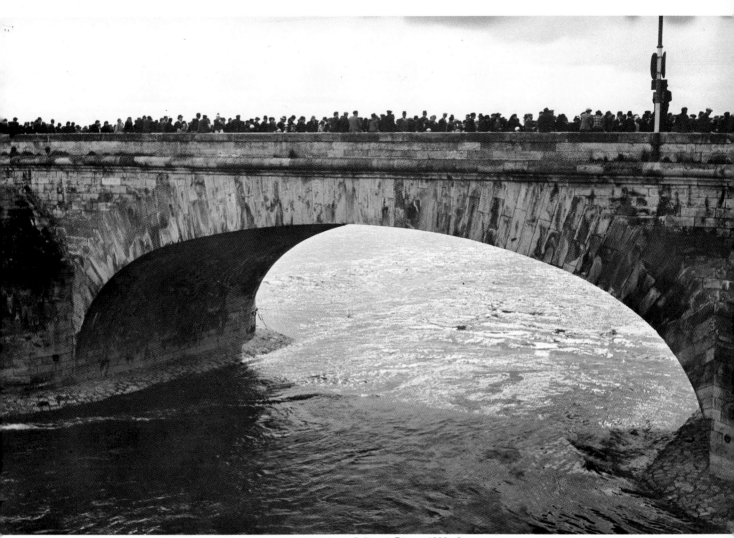

237 *La Loire à Orléans à Pâques,* 1938.

239 Paris, circa 1930.

240 Paris, circa 1930.

241 Paris, circa 1930.

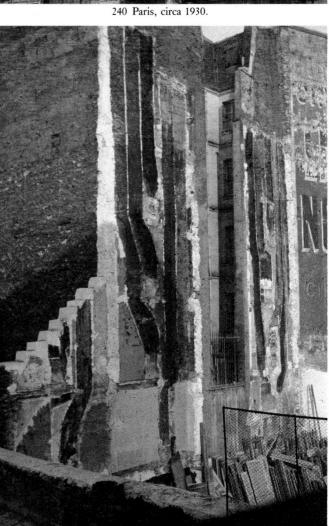

242 Paris, circa 1930.

192

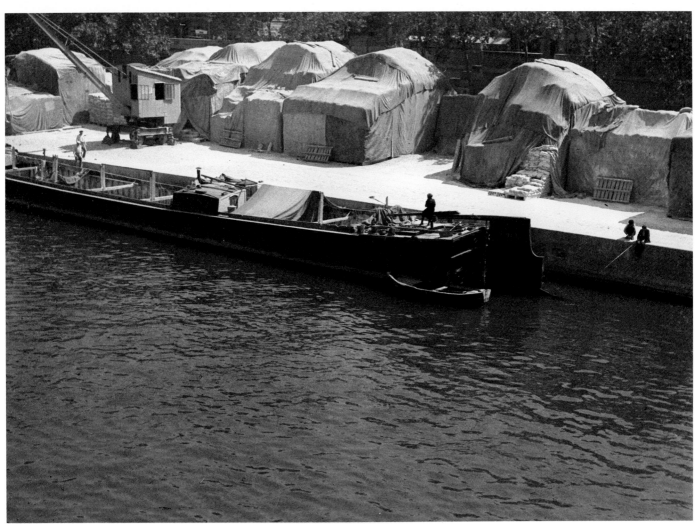

243 La Seine, Paris, circa 1930.

244 La Seine, Paris, circa 1930.

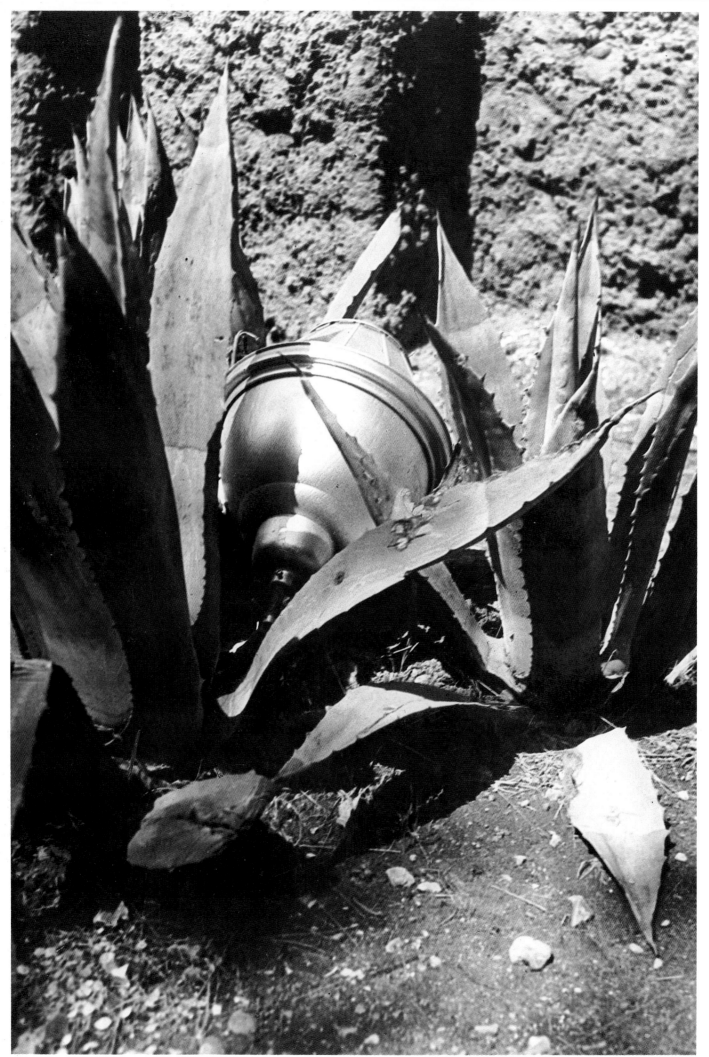

245 Sans titre / Untitled.

246 Sans titre / Untitled, 1926.

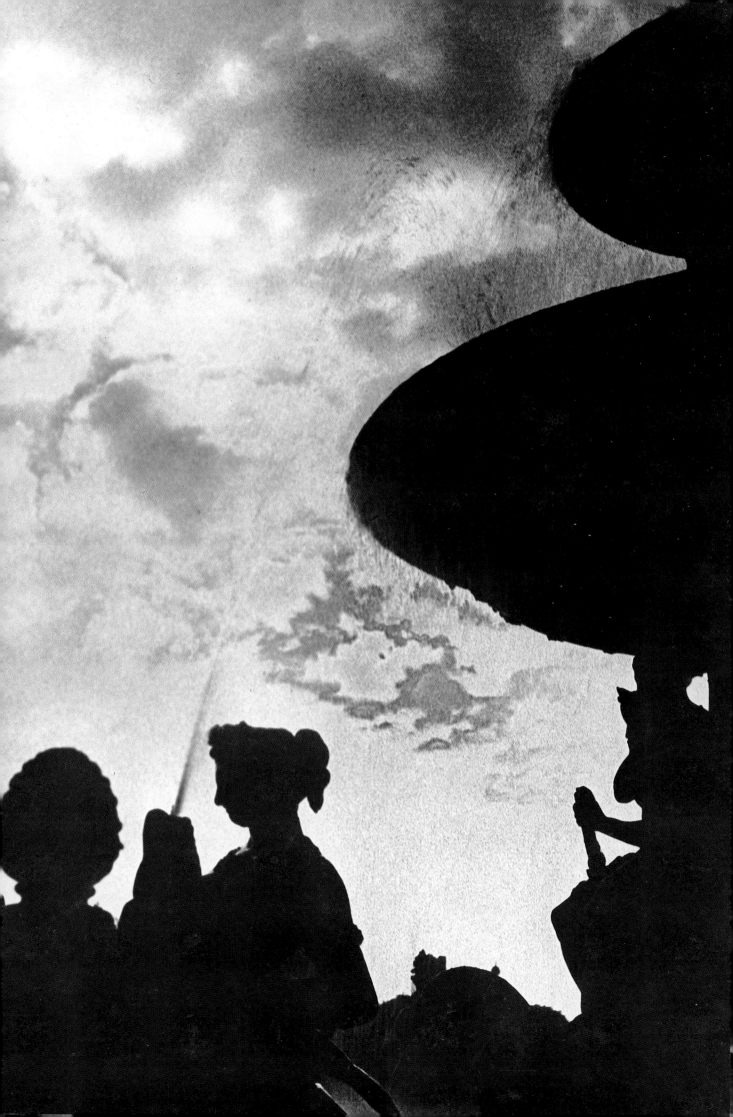

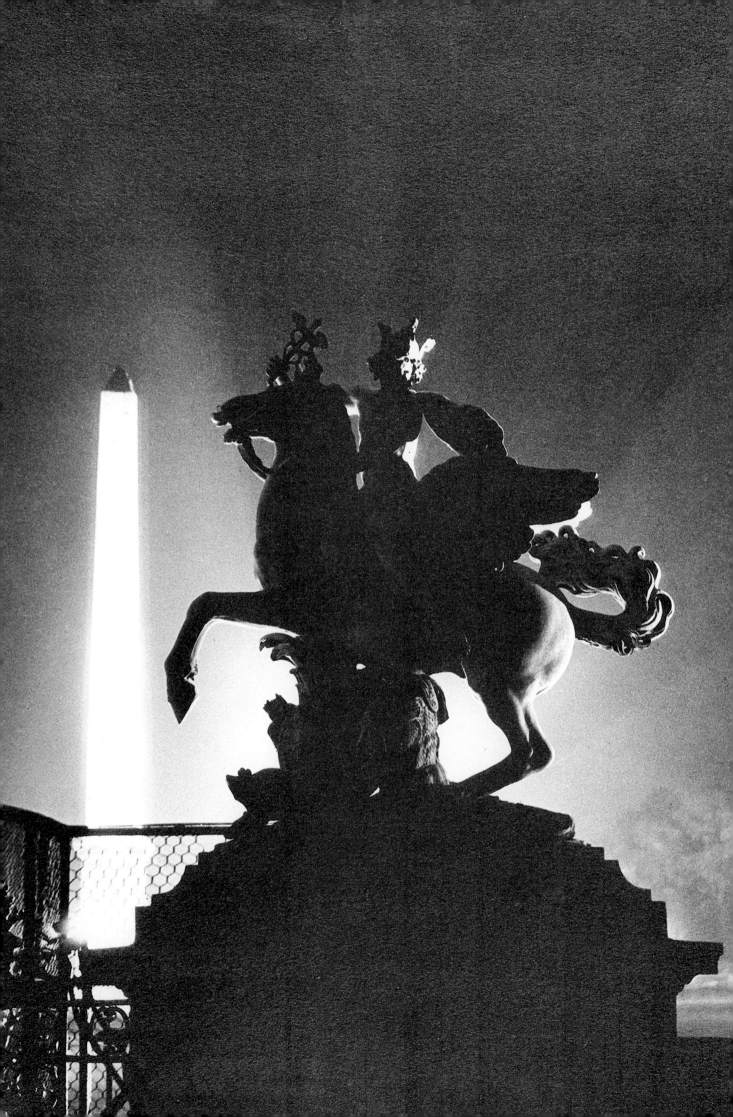

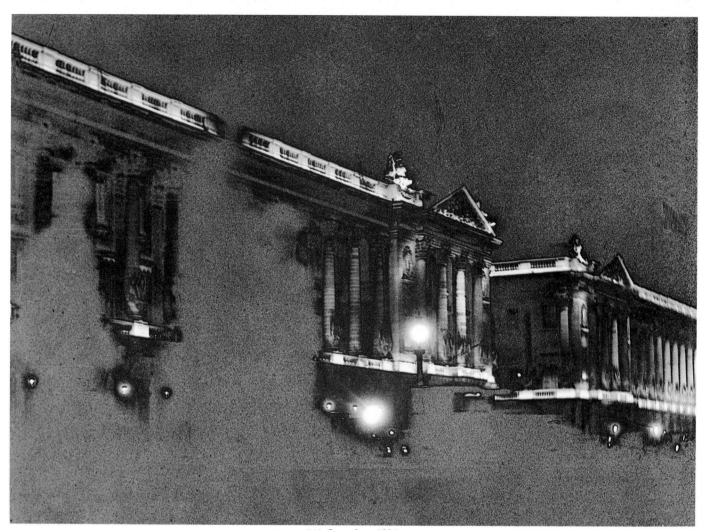

248 Sans titre, 1926.

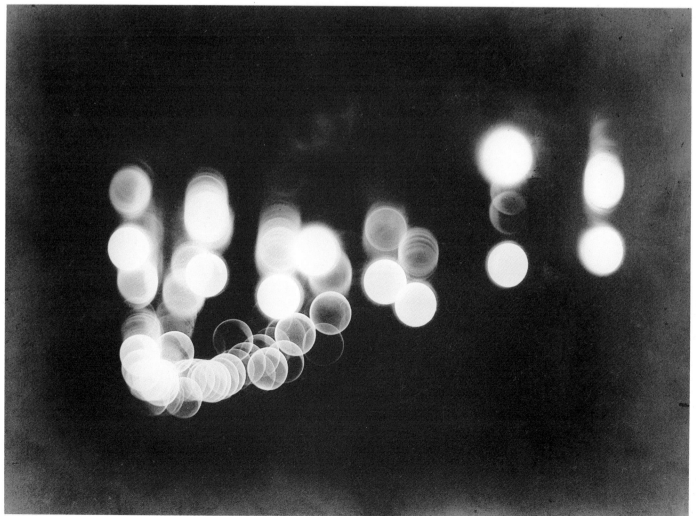

249 *Bd Edgar-Quinet, à minuit*, 1924.

247 Paris, circa 1926.

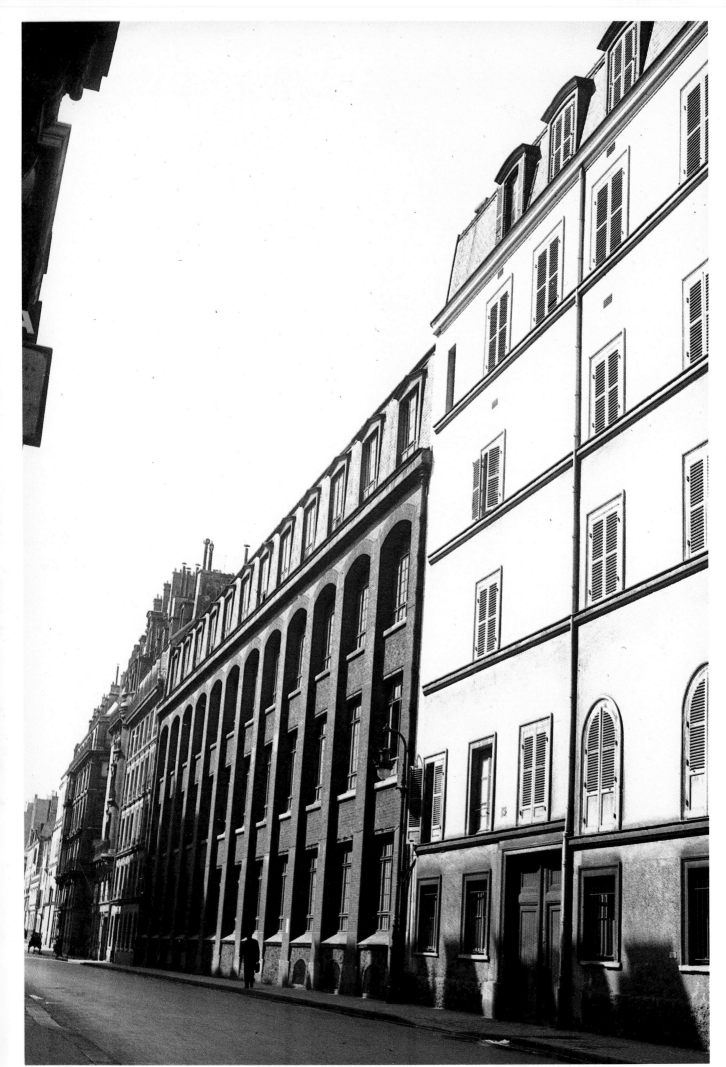

250 Paris, circa 1930.

251 Paris, circa 1930.

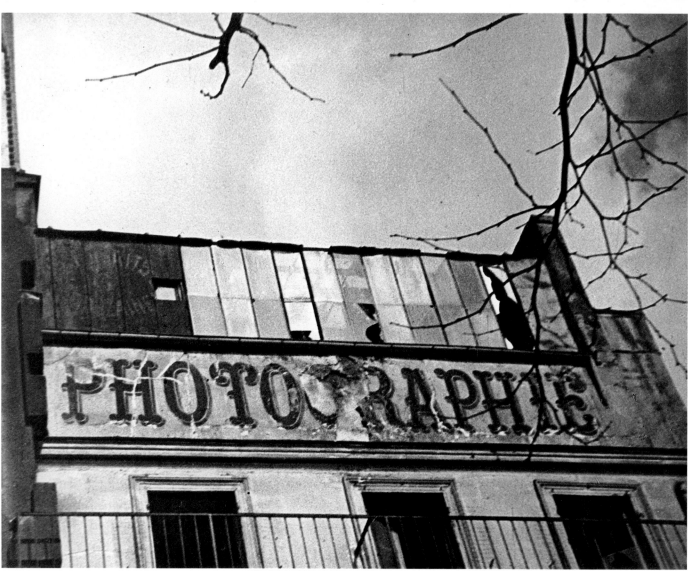

252 Bd du Montparnasse, Paris, circa 1930.

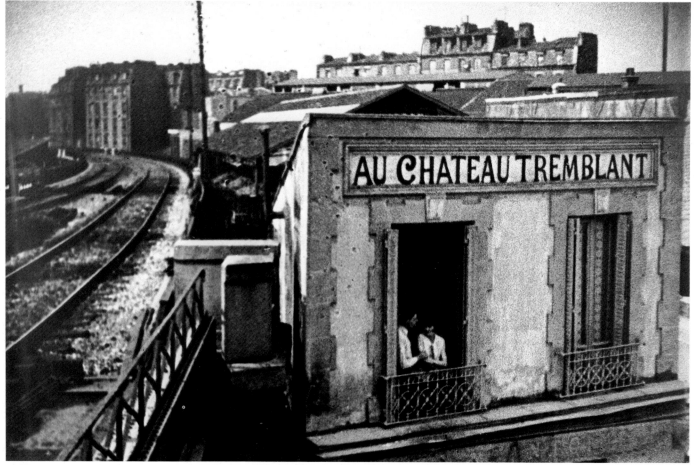

253 *Au château tremblant*, Paris, circa 1930.

254 Rue Sade, Antibes 1936.

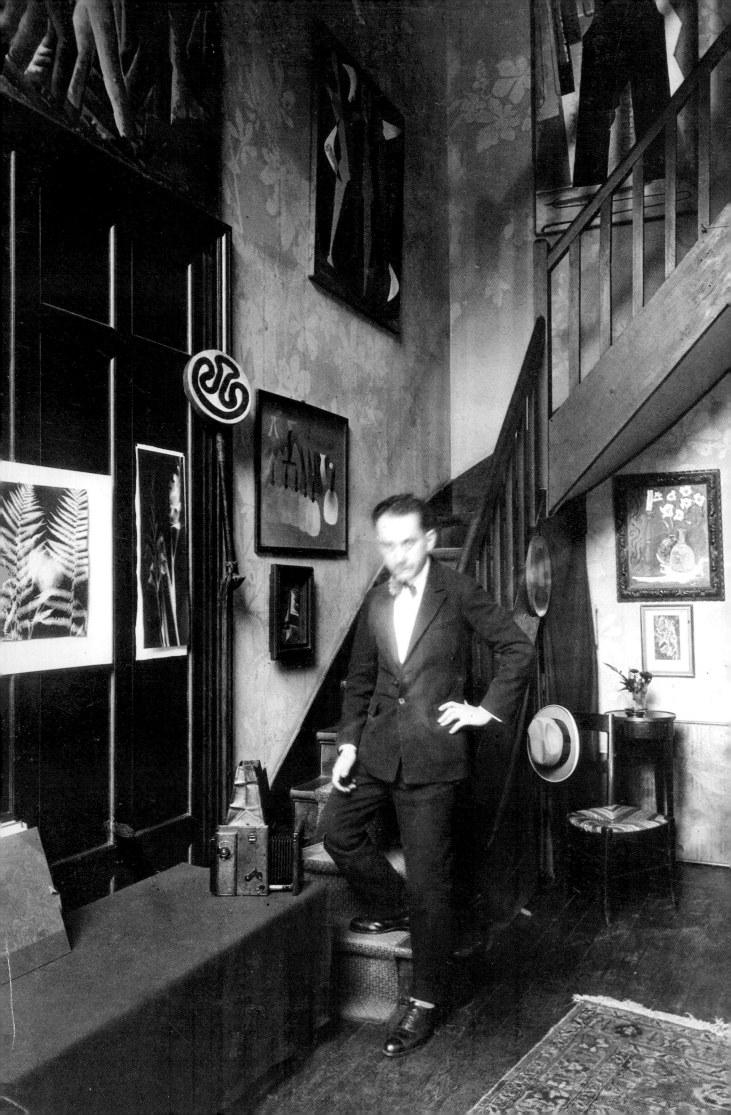

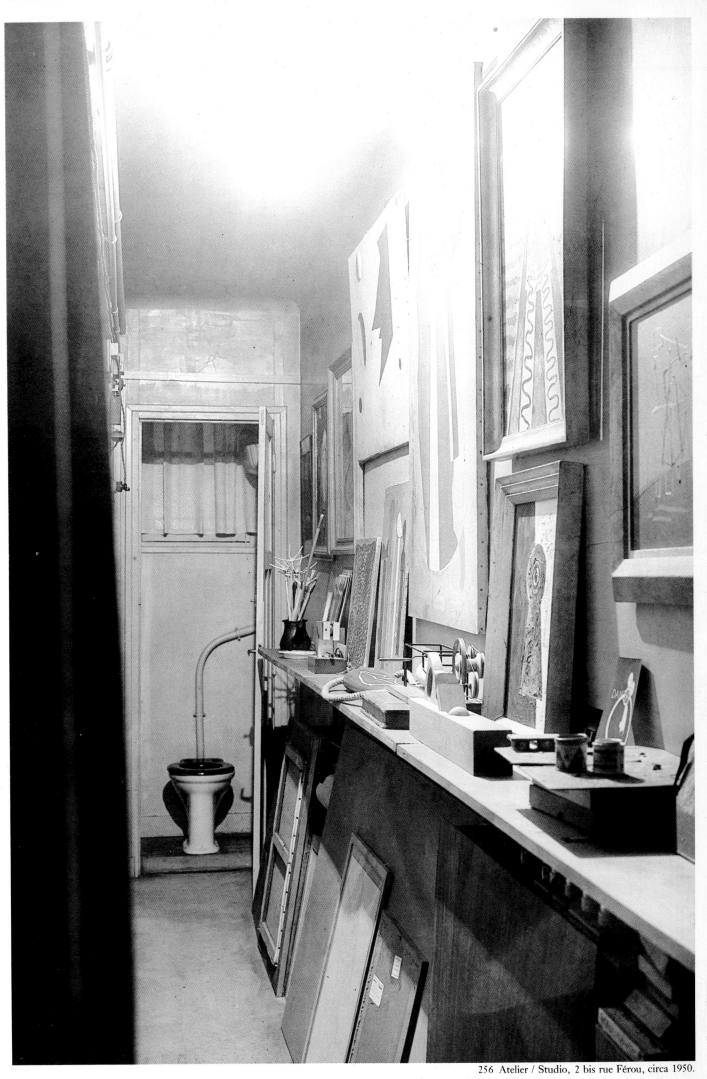

255 Atelier / Studio, Paris, circa 1935.

256 Atelier / Studio, 2 bis rue Férou, circa 1950.

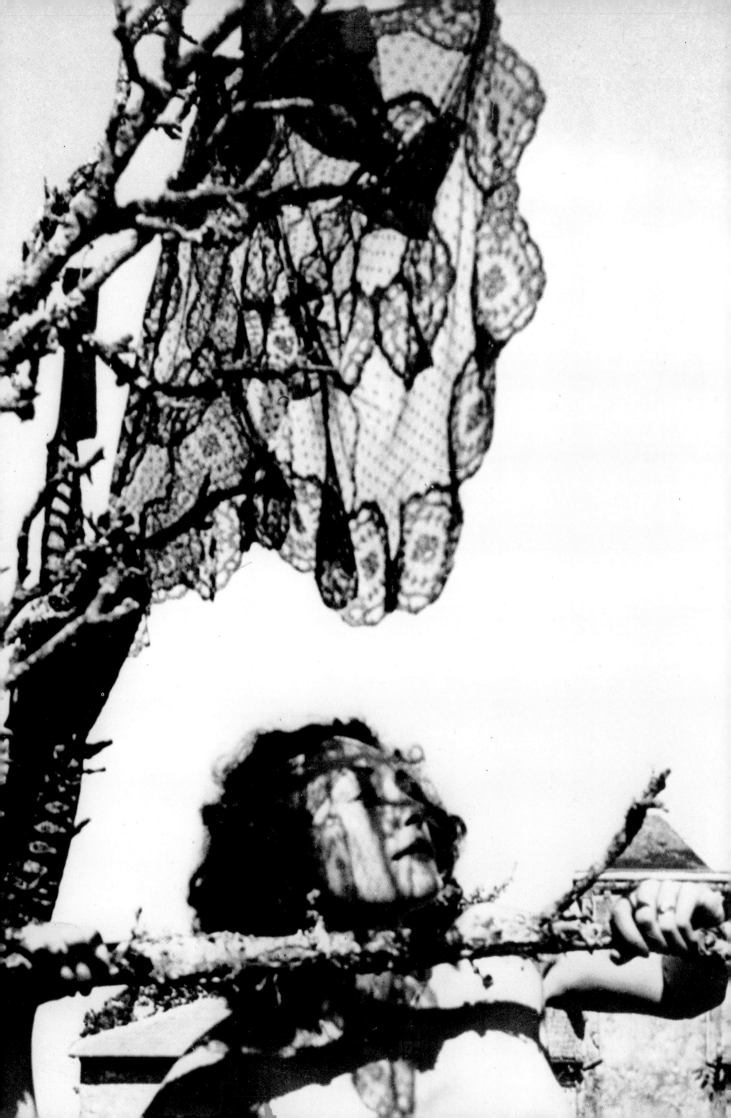

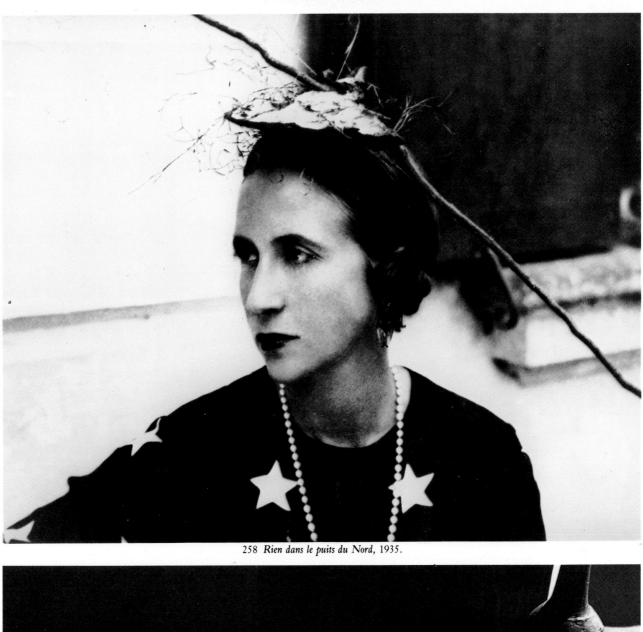

258 *Rien dans le puits du Nord*, 1935.

259 *A la suite d'une vision sinistre, Don Juan...*, 1935.

257 *Tu me retrouverais toujours, dit le sphynx*, 1935.

260 Atelier / Studio, 8 rue du Val-de-Grâce, Paris, circa 1935.

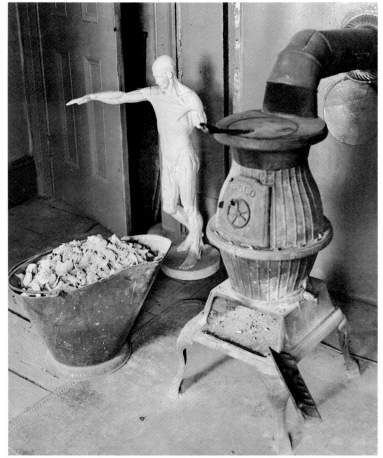

261 Atelier / Studio, New York, circa 1918.

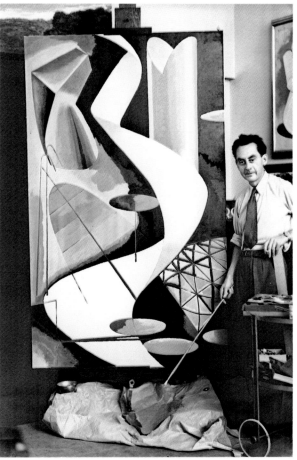

262 Atelier / Studio, Paris, 1939.

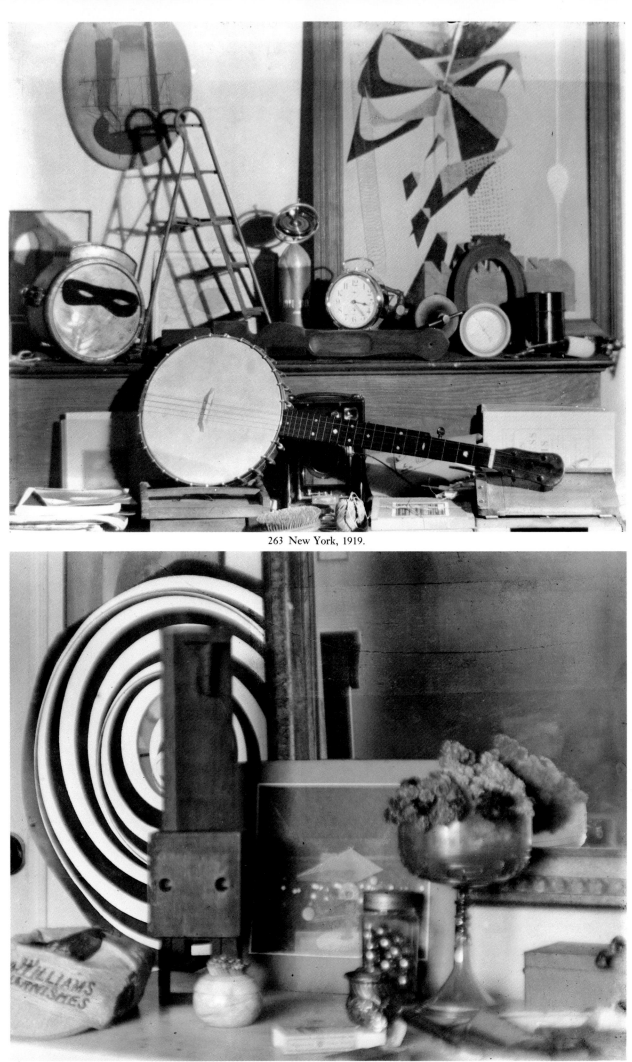

263 New York, 1919.

264 New York, 1918.

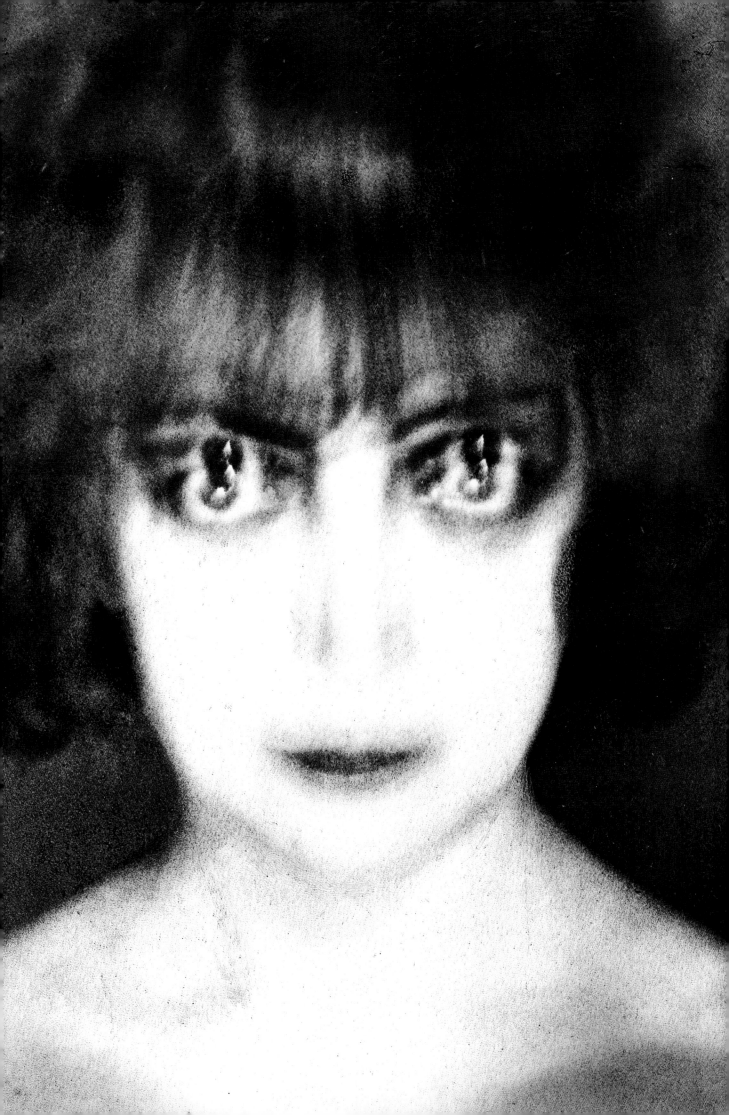

A fashionable photographer

That night when I developed my negatives, they were all blurred : I put them aside and considered the sitting a failure. Not hearing from me, [the Marquise] phoned me some time later; when I informed her that the negatives were worthless, she insisted on seeing some prints, bad as they were. I printed up a couple on which there was a semblance of a face — one with three pairs of eyes. It might have passed for a Surrealist version of the Medusa. She was enchanted with this one — said I had portrayed her soul, and ordered dozens of prints. I wished other sitters were as easy to please. The picture of the Marquise went all over Paris; sitters began coming in — people from the more exclusive circles, all expecting miracles from me. I had to get out of my hotel room — find a real studio.

265. The marquise Casati, 1922.

266. *A l'heure de l'observatoire - Les amoureux*, 1935-38.

267. *Un photographe de mode* ('Fashion photographer'), 1936.

268-69. Lee Miller, *c.* 1930.
Man Ray's 'favourite student', who became a great photographer. She married Sir Roland Penrose (**70**) and often posed for Man Ray.

270. Barbette, 1926.
'Barbette is a young, twenty-four-year-old American, hunched like a bird, his gait a little infirm (no doubt because of his small hands and feet). Having fallen from a trapeze, he was left with a scar curling his upper lip thereby revealing his crooked teeth. Only the surprising arch of his eyebrows set over inhuman eyes singles him out as a presence, otherwise as anonymous as an offstage Nijinsky... Even when his make-up is completed, as precious as a new box of paints, his jaw highlighted with enamel brilliance, and his body strangely plastered, this peculiar little devil, a self-styled Saint-Just, death's coachman, is yet still a man, bound to his double by a hair's thread. It is only as he dons his blonde wig, which is held in place by a simple elastic round his ears, that he takes on the gestures of a woman doing her hair, down to the minutest detail, a cluster of snow-white hairpirs in his mouth. He gets up, he walks, he puts on his rings. The metamorphosis is complete.' (Jean Cocteau.)
It was through Jean Cocteau that Man Ray met Barbette, a trapeze artist. All of Paris and the Surrealists in particular flocked to see him. (He would take his wig off at the end of his act.)

271. Iris Tree, 1923.
'Portrait of an actress well-suited to soft-focus effects.'

272-76. Virginia Woolf, 1935.
Photographs probably taken during the writer's travels on the continent of Europe at the beginning of the summer of 1935. She had already completed most of ther important works. Man Ray recounted that he put lipstick on her before taking her photograph.

277. Henri Matisse, *c.* 1926-27.
'I visited Matisse in his studio in Nice in the Thirties. The room was filled with bird cages and a continual chirping.' (*Self Portrait*, p. 216.) The studio is the one in the place Charles-Félix, in the old quarter of Ponchettes.

278. André Derain, *c.* 1930.
'André Derain, the painter, was entirely different from his contemporaries. Large and heavy, he sat at the bar of the Coupole consuming innumerable glasses of beer. His conversation was brilliant, tough and pungent.' (*Self Portrait*, p. 220.) Man Ray also photographed Derain at the wheel of his sports car.

279. Gertrude Stein, 1926.
This is not the most celebrated portrait of Gertrude Stein. There is another one, in particular, where she can be seen sitting in front of her portrait by Picasso. She wrote to Man Ray 'Kindly remember that I have always refused to sit for anyone who wishes to photograph me, in order to give you the exclusive rights. Kindly remember that you have never been asked to give any return for your sale of my photos. My dear Man Ray, we are all hard up, but don't be silly about it. Pleasant trip.' (Undated.)

280. Coco Chanel, *c.* 1935.
Dressed in the 'little black dress', adorned with the strings of pearls and the imitation jewelry for which she was renowned, and defiantly smoking a cigarette, Coco Chanel appears here as the prototype of the New Woman.

281. Elsa Schiaparelli, *c.* 1934.
Man Ray had met Elsa Schiaparelli a few years before, in New York: 'She was unhappy, separated from her husband, and looking for something to do. She soon left for France with some knitting that was different from the usual sort of thing, and became the well-known couturier.' (*Self Portrait*, p. 98.)

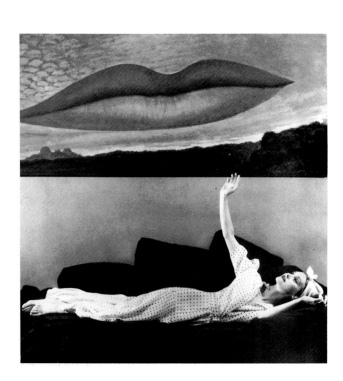

282. *Danses horizons*, 1934.
This photograph appeared in *Minotaure* (No. 5, 1934-35, pp. 27-29), with the caption 'The marvellous, the fantastic, fall short of our expectations. The real marvellous resides in a norm; reason, for example, or common sense. It is not illness that is so surprising, but rather good health.' (Jacques Rigaut.)

283. Fashion photograph.

284. Fashion photograph, 1936.

285-89. Fashion photographs, 1925.
The scene is an exhibition of the Musée des Arts Décoratifs in Paris, at the Pavillon de l'Elégance, the dress section of the Grand Palais. The exhibition was presented by Monsieur André Vigneau of the Siegel mannequin company. Contemporary woman was stylized in each of her favourite poses in wooden or wax figures. The dresses in **285** are by Yvonne Davidson, those in **288** and **289** by Lanvin. **286** was reproduced on the cover of *La révolution surréaliste* (5 July 1925).

290. Fashion photograph.
The dress is by Lucien Lelong, the wheelbarrow by Oscar Dominguez: a picture taken at the Surrealist exhibition in 1937. The photograph was published in *Minotaure* (III, No. 10, p. 44).

291. Fashion photograph.

292. Fashion photograph, *c.* 1930.

293. Fashion photograph.
In their transparent effects and viewpoint, these two photographs are similar to *Le sex-appeal*, one of Man Ray's favourite photographs, which appeared in *Cahiers G.L.M.* (November 1936, p. 30).

295. Raymond Radiguet, 1921.
A friend of Jean Cocteau's and Max Jacob's, 'the new Rimbaud' of the 1920s became an overnight success with two short novels: *Le bal du comte d'Orgel* and *Le diable au corps*. Man Ray photographed him at the age of eighteen, two years before he killed himself.

296. Untitled.
The 'Chanel suit' transformed into an evening dress.

297. Ball at the Chateau of the Vicomte de Noailles, 1929.
This was a ball given during the shooting of the film *Mystères du château de Dés* at the chateau, which was built by Robert Mallet-Stevens (**315**). The Comte de Beaumont, who appeared at all the fashionable parties in the 1920s, can be seen in the centre.

298. Serge Lifar.

299. Helen Tamiris.
Helen Tamiris (Becker), an American dancer and choreographer (1905-66) worked with Max Reinhardt.

300. Genica Athanasiou, 1922.
Her real name was Eugénie Tanase; she was born in Bucharest in 1897 and died in 1966. An actress in the theatre and in films, she was Artaud's first girlfriend from 1922 to 1927. She played in *L'avare* with him in 1922. In this photograph she is playing in *Antigone*, Jean Cocteau's one-act tragedy based on the play by Sophocles. The play was staged by Charles Dullin at L'atelier on 20 December 1922, with costumes by Gabrielle Chanel.

301. Portrait.

302. Portrait.

303. Germaine Tailleferre.
She was the only woman member of the group of composers known as the 'Groupe des six'. According to Darius Milhaud, her music was the music of 'a sweet-smelling young woman'.

304. Madame Pignet, 1925.
She was one of the Pignet Furs family.

305. Portrait.
The subject is Miss Chase.

306. Juliette Gréco.
This photograph was published in *Le surréalisme même* (No. 1, 1956).

307. Kay Boyle.

308. Jacques Doucet, 1926.
A famous couturier, he was also a collector of ancient art who subsequently became interested in modern art, and particularly in Dada and Surrealism. His collections of books and manuscripts were left to two institutions, the Institut d'Art et d'Archéologie and the Bibliothèque Sainte-Geneviève.

309. Catherine Deneuve, 1956.
Behind her is the screen entitled *Les vingt nuits et jours de Juliet* and *Lampshade*, of which she is wearing two miniature versions as earrings.

310. The Marquise Casati, *c.* 1930.
The photograph was taken against a backcloth at a ball at the Beaumont's.

311. Yvonne George.
She was one of the star attractions at the 'Boeuf sur le toit'.

312. Marie Laurencin, 1923.
A friend of Apollinaire's, and a painter 'in a modernized eighteenth-century style', she is photographed here with the soft-focus effect typical of Man Ray's early work in Paris (he used it most in the years 1921-23).

313. Clément Doucet, Jean Wiéner, 1926.
Wiéner played the piano at the 'Boeuf sur le toit'. The concerts he organized were well known in musical circles of the time. He brought Schönberg and Stravinsky to notice in Paris and contributed to the recognition of jazz as a style in its own right.

314. Jacqueline.
A prototype of the New Woman, who took the place of Kiki de Montparnasse, though her appearance and behaviour were very different.

315. Robert Mallet-Stevens.
The architect is photographed in front of one of his buildings.

316. Dr Lotte Wolf.
Wolf was a German doctor who had emigrated from Berlin. She was particularly interested in hands, and practised palmistry.

317. Edgar Varese.
One of the first of Man Ray's male models, whom he met in New York. Man Ray made an effort to highlight his bushy eyebrows and blazing eyes.

318. Henri Cartier-Bresson.

319. Ànna de Noailles, 1927.
'The technique of this portrait gives the flavour of a *fin de siècle* academic writer.'

320. Maurice de Vlaminck, 1930.
A painter 'who spread his colours like butter on bread.'

321. Francis Poulenc, 1922.

322. Léon Blum, *c.* 1930.
Man Ray dedicated several drawings to Léon Blum, who was a friend of his.

323. Jean Paulhan.

324. Arnold Schönberg, 1926.
There are striking similarities between this portrait by Man Ray and the self portraits that Schönberg painted (he had exhibited with Kandinsky at the time of the Blaue Reiter). His paintings showed heads looming up out of the night like spectres.

325. Igor Stravinsky, *c.* 1925.
According to Man Ray, there was little resemblance between Stravinsky and his music. Man Ray made several exposures during the same sitting, despairing of such an unrewarding sitter. This is a snapshot - rare in Man Ray's work - and was probably taken between two poses.

326. Georges Braque, 1933.
Man Ray made two series of portraits of Georges Braque ('He might be considered the real classic of today's painting', *Self Portrait*, p. 217). The first series shows the painter in his shirt-sleeves, the second series is solarized. One photograph of the second series was reproduced in *Les cahiers d'art* (Nos. 1-2, 1933, p. 9).

327. Jean Cocteau, *c.* 1924.
Man Ray took many photographs of Jean Cocteau. This one, in which he is wearing woollen gloves, is little known.

328. Max Jacob, 1922.

329. Djuna Barnes, 1926.
An artist and writer, author of a moderately successful book entitled *Nightwood*, she and Mina Loy were among Man Ray's first models in Greenwich Village, and later in Paris. She was one of Edgar Varèse's circle of friends.

330. Saint-Pol Roux, 1925.
Saint-Pol Roux, of whom Nadar also made a portrait, was a symbolist poet who patronized the artists' cabaret 'Le chat noir' in Montmartre. He was known as 'the Magnificent'. He lived a secluded life in Brittany, with his daughter Divine (her portrait appeared in *La révolution surréaliste*). A banquet at the Closerie des Lilas was organized in his honour by the Surrealists, under the inspiration of André Breton, who was an admirer of his. During the banquet the Surrealists settled their scores with 'all the conformist elements of the time' (André Breton).

331. Berenice Abbott, 1922.
Man Ray met Berenice Abbott while she was a sculptor in New York. He won a $10 prize with Honours at the Wanamaker Exhibition in New York for his *Portrait of a Sculptor*, another photograph of her. He met her again in Paris 'dying of hunger' and took her on as an assistant. She subsequently became a photographer, making portraits of many of the personalities that Man Ray also photographed: Jean Cocteau, Marcel Duchamp, James Joyce, Peggy Guggenheim, Max Ernst, Marie Laurencin, Djuna Barnes. 'We became unwitting competitors, which was ridiculous because his work was so different from mine. His portraits of men were good, but he always made the women look like pretty objects. He never let them be strong characters in themselves.' (Berenice Abbott.)

332. Roberto Rossellini, Henri Langlois, Jean Renoir.

333. T.S. Eliot, *c.* 1930.

334. Henry Miller, 1945.
This photograph was taken at Big Sur, at Miller's Californian retreat. Man Ray visited him there several times during his stay in Hollywood.

335. André Derain, 1923.
This photograph was published in *Vu* on 6 March 1929, with the caption 'Who can claim to have seen Derain painting ? His art is returning to classicism'. This photograph was an illustration for an article by Florent Fels.

336. Fernand Léger, 1922.
'...heavy, and striving to be understood by the public' (*Self Portrait*, p. 253).

337. Constantin Brancusi, 1930.
Photographing him with his little dog, Man Ray made an affectionate portrait of Constantin Brancusi which follows on from his tender description of the sculptor's quasi-monastic life in his studio (*Self Portrait*). Man Ray taught him how to take photographs.

338. Robert Delaunay, *c.* 1930.

339. Pablo Picasso, 1932.
Man Ray was asked to photograph Picasso's works and he also made several portraits. At the end of the 1930s he often spent the summer with him, near Mougins. This photograph appeared in *Les cahiers d'art* (Nos. 7-10, 1935), with a little 'Dictionnaire panoramique de Pablo Picasso' by Man Ray.

340. James Joyce, 1922.
This photograph was commissioned by Sylvia Beach's bookshop 'Shakespeare and Company' for the occasion of the publication of *Ulysses*. Other photographs were taken of Joyce at the same sitting, where he can be seen shielding his tired eyes from the glare of the lights.

341. Ezra Pound, *c.* 1923.
This photograph could be seen alongside that of Hemingway, also taken by Man Ray, on the wall at 'Shakespeare and Company', the bookshop frequented by the pre-War French, American and English literary circles.

342. Jules Pascin, 1923.
This photograph was reproduced on the cover of *Paris-Montparnasse* (15 July 1929). 'He could have been someone who had stepped out of a Toulouse-Lautrec poster; his tight-fitting black suit on a spare figure, topped jauntily with a bowler hat from which a lock of hair escaped, a cigarette butt in the corner of his mouth, and a spotless white silk scarf around his neck, indicated the tough guy at the turn of the century. He painted small women with short legs, in nervous delicate strokes: his young girls also looked like little women' (*Self Portrait*, p. 248).

343. Michael Larionov, *c.* 1930.

344. S.M. Eisenstein, 1929.
See **81**.

345. Self portrait, 1934.
The lamp-object has disappeared. Man Ray used the neck of a violin or of a cello several times. Here, the strings are replaced by electric wires that light up two lamps which replace the keys.

346. (Front endpaper) Man Ray's studio in New York.

347. (Back endpaper) Rue Jacques-Callot, 1926.
The Galerie Surréaliste. In the window is a painting by Francis Picabia, *Femme à l'ombrelle*.

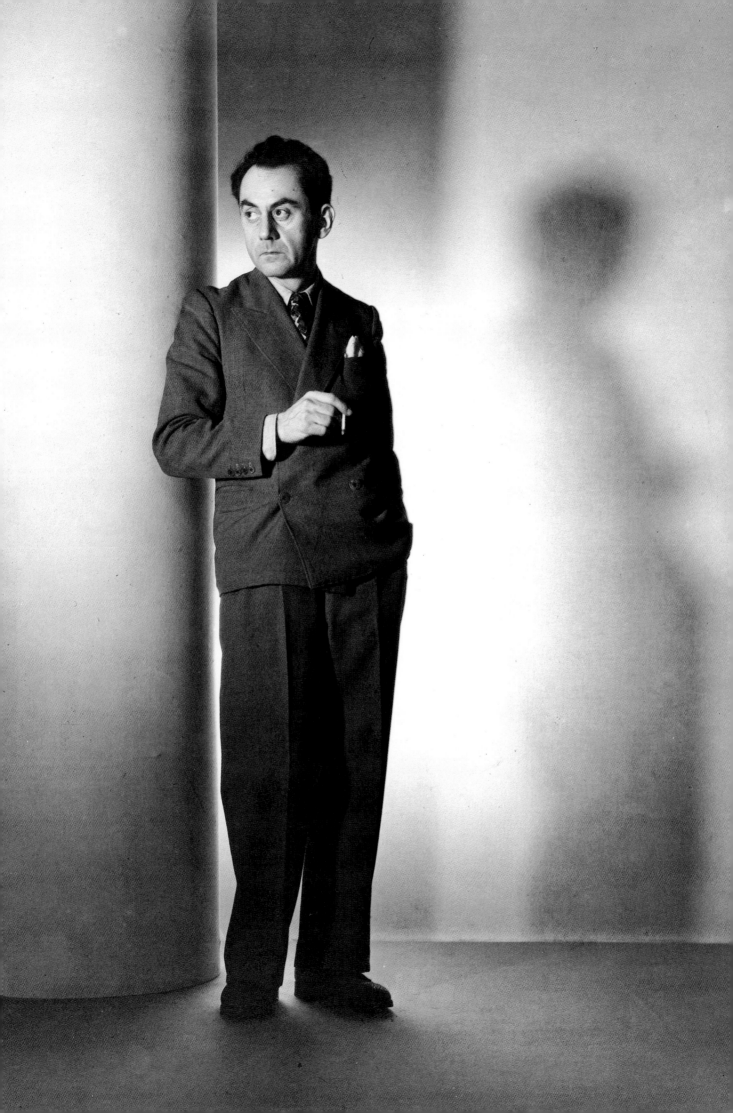

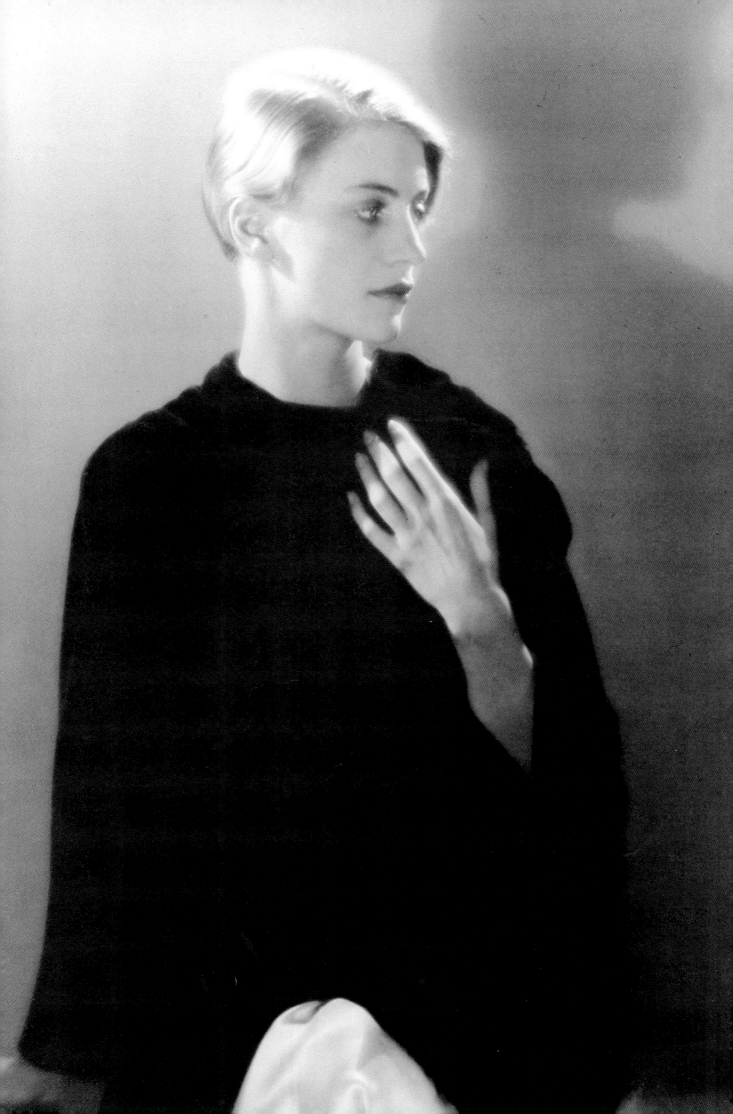

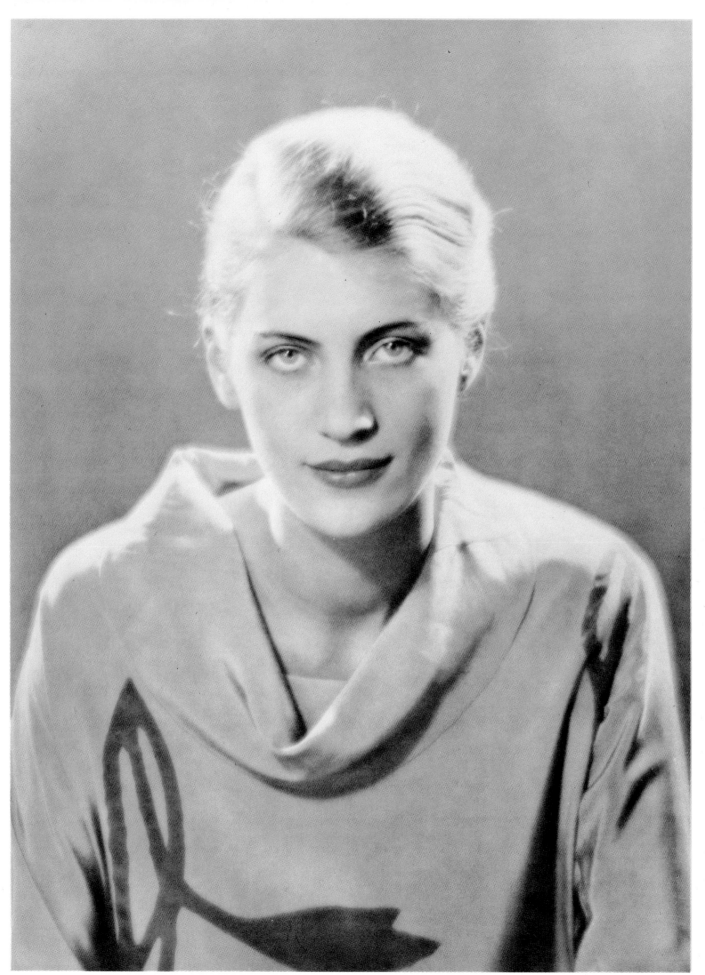

269 Lee Miller, circa 1930.

268 Lee Miller, circa 1930.

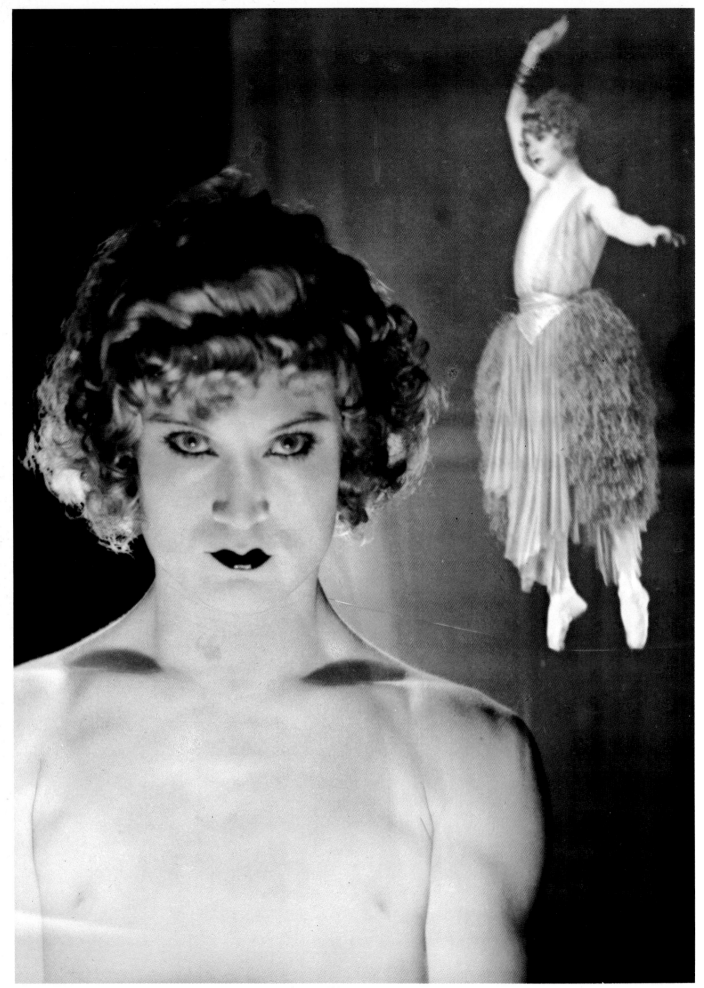

270 Barbette, 1926.

271 Iris Tree, 1923.

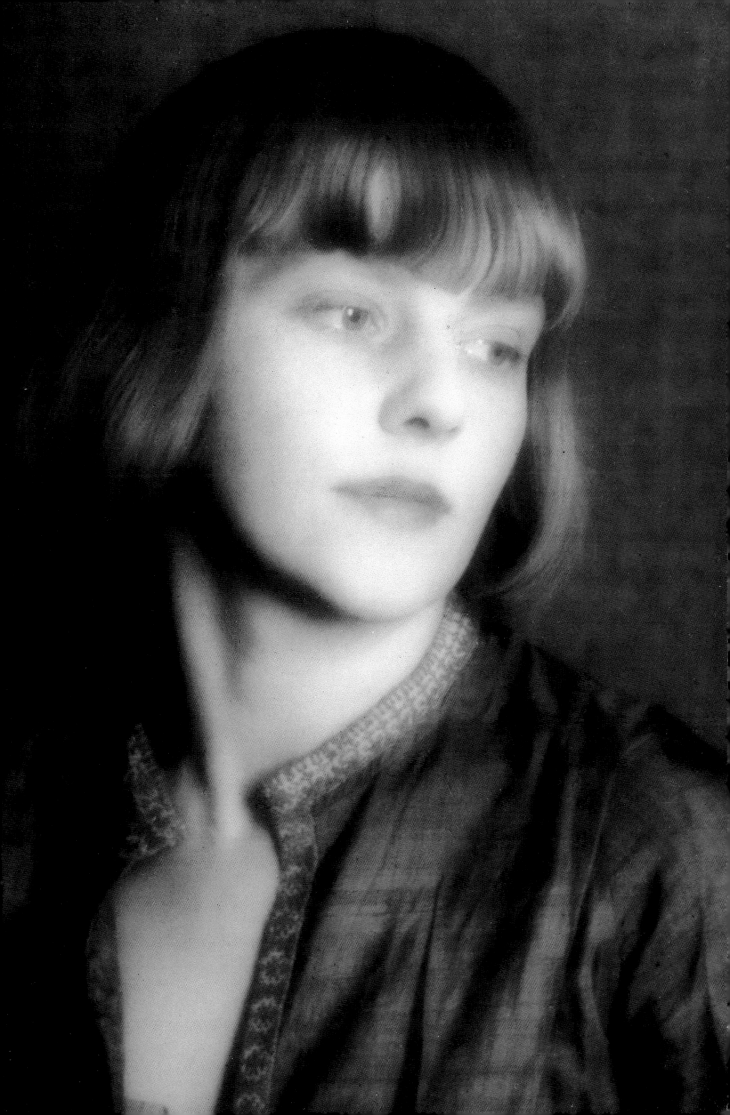

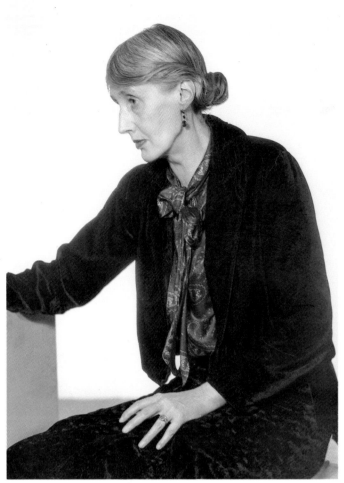

273 274

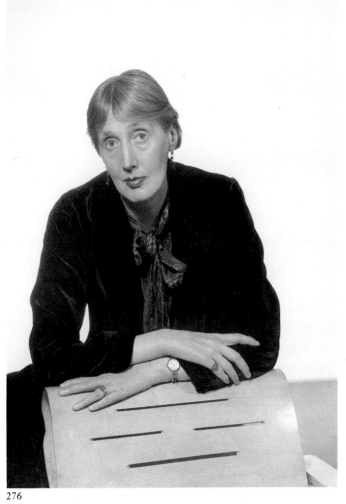

275 276

272 — 276 Virginia Woolf, 1935.

Page 220: 277 Henri Matisse, circa 1926.

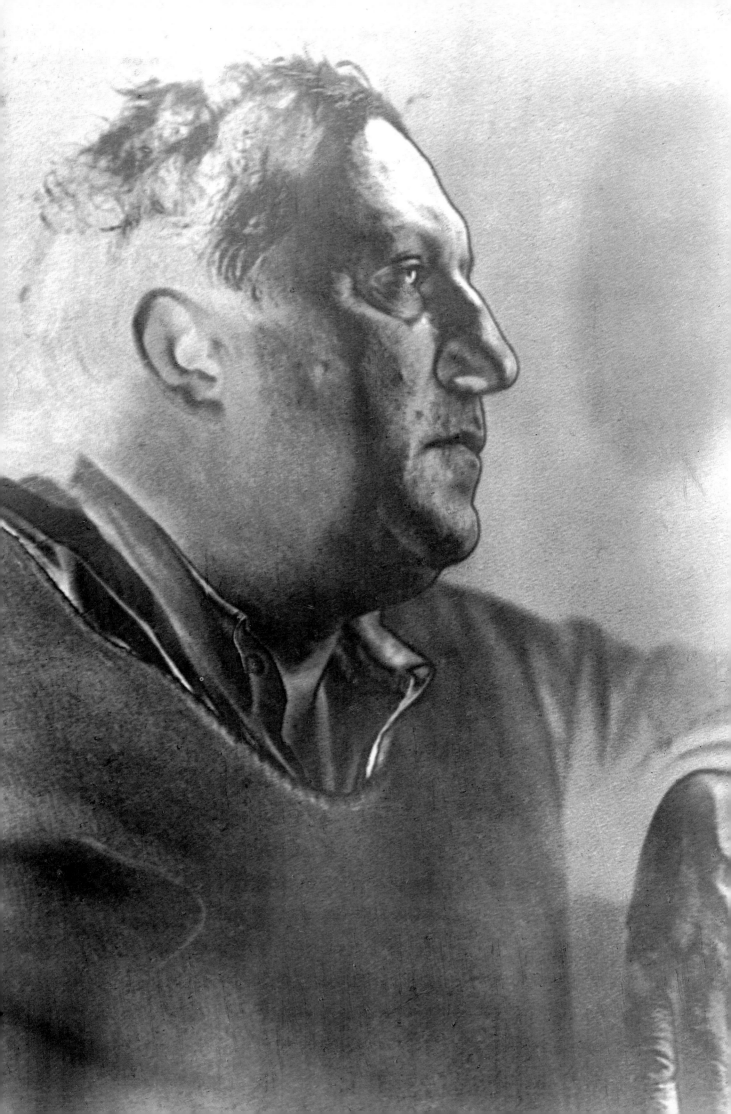

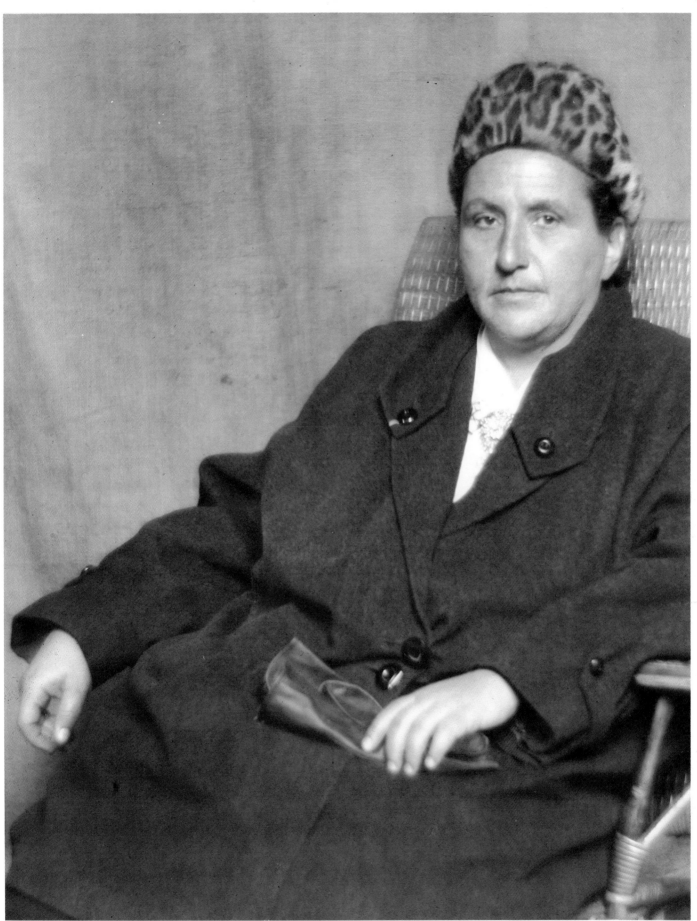

279 Gertrude Stein, 1926.

278 André Derain, circa 1930.

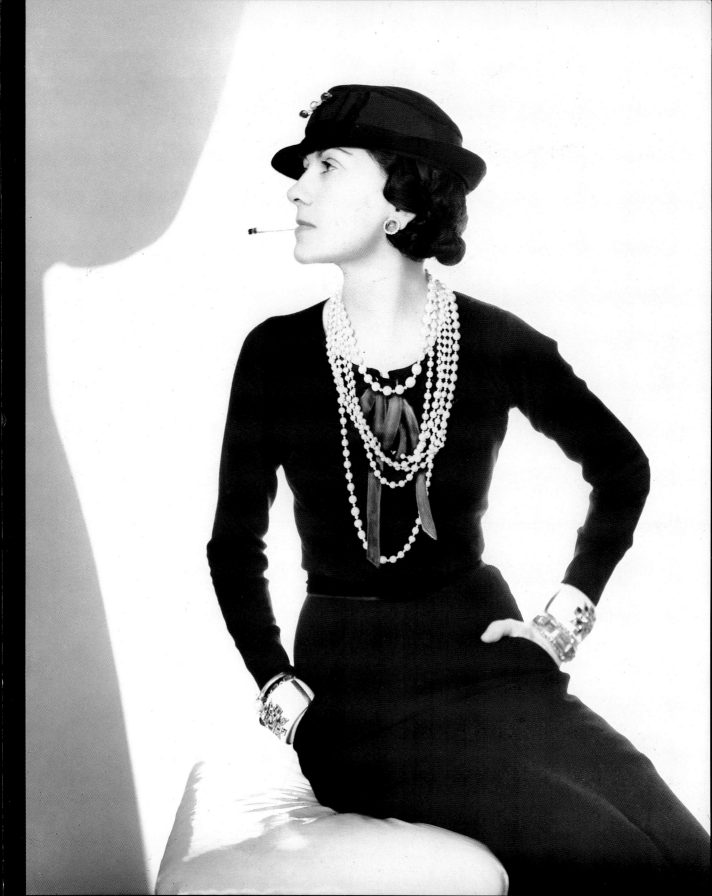

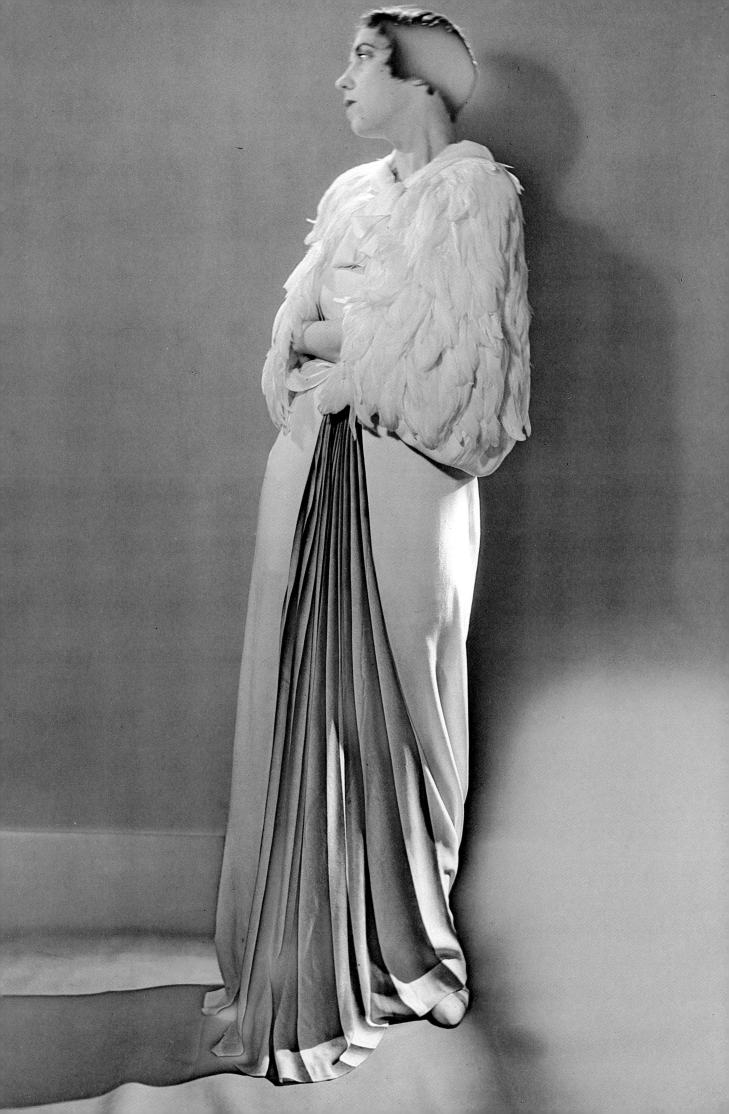

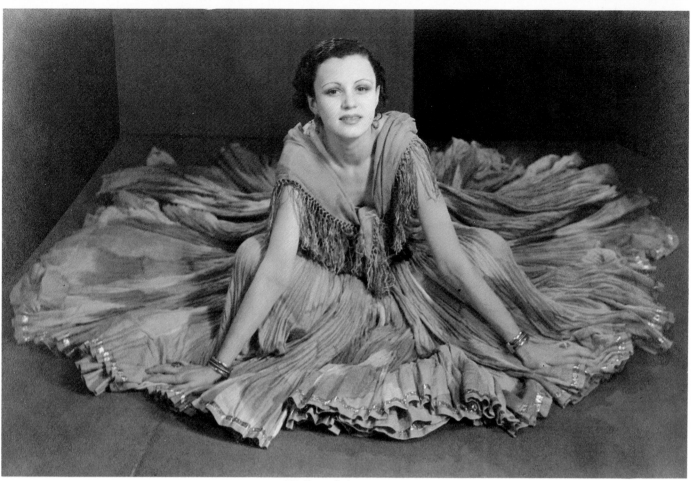

282 *Danses horizons*, 1934.

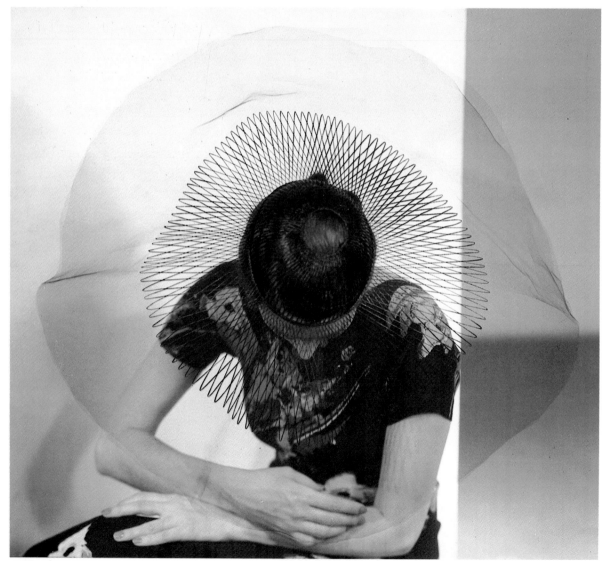

283 Mode / Fashion photograph.

284 Mode / Fashion photograph, 1936.

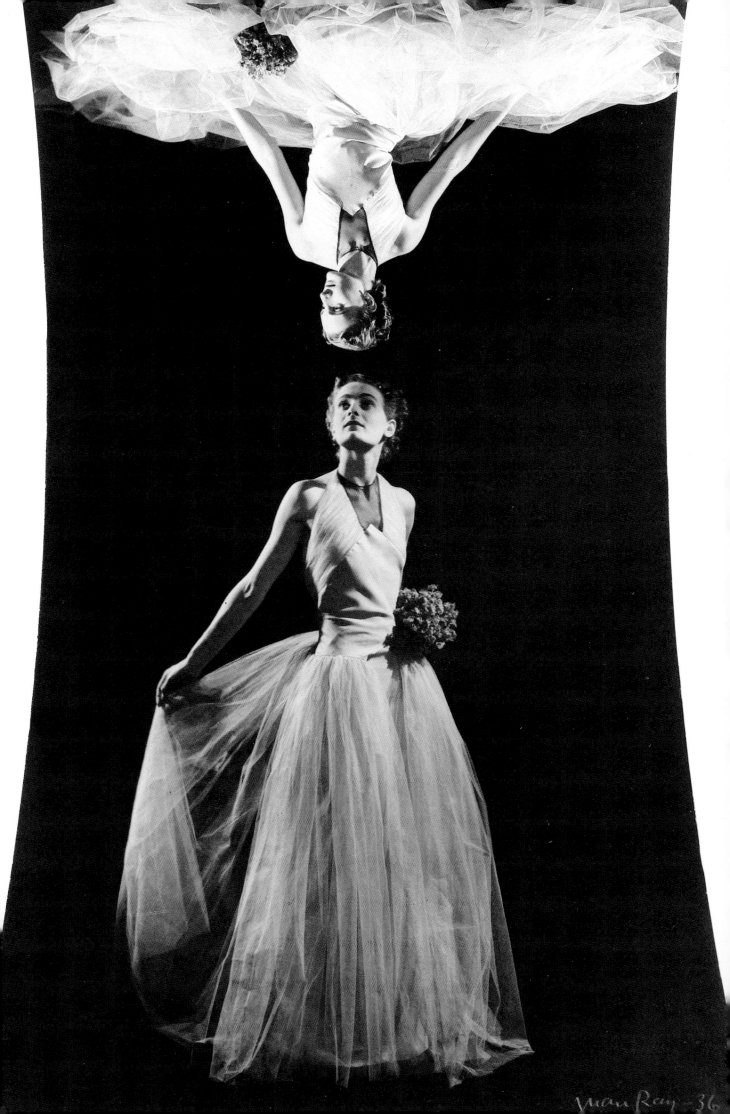

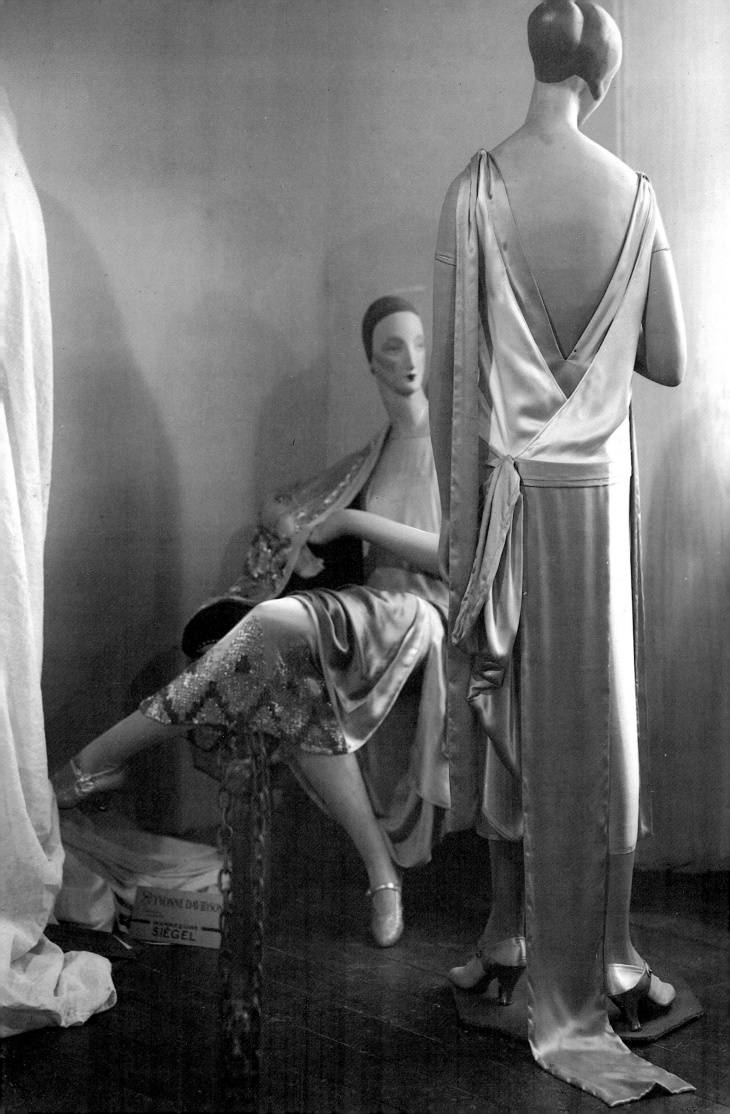

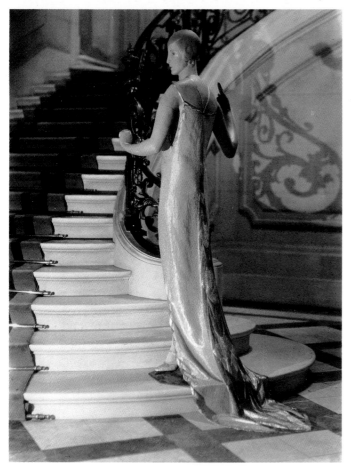

286 Mode / Fashion photograph, 1925.

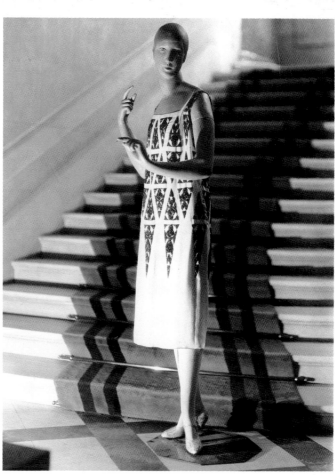

287 Mode / Fashion photograph, 1925.

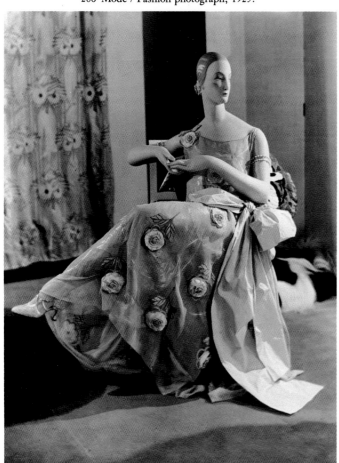

288 Mode / Fashion photograph.

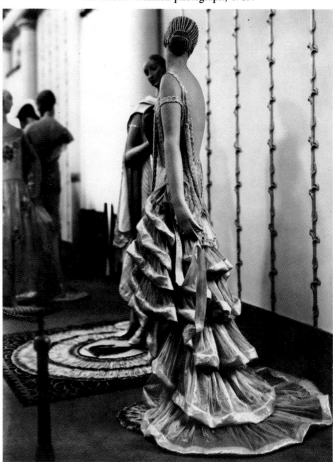

289 Mode / Fashion photograph, 1925.

285 Mode / Fashion photograph, 1925.

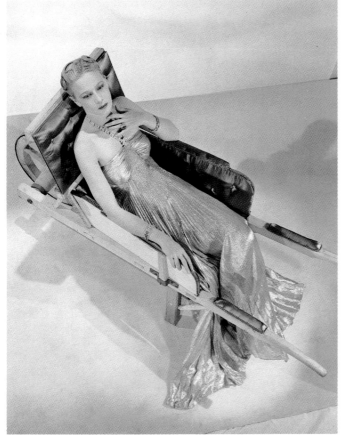

290 Mode / Fashion photograph.

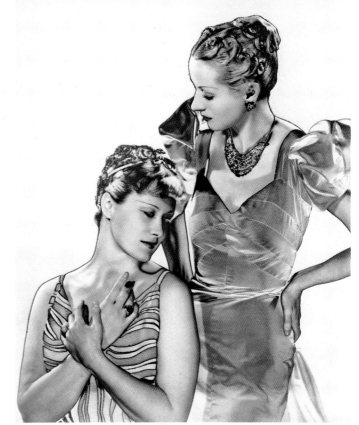

291 Mode / Fashion photograph.

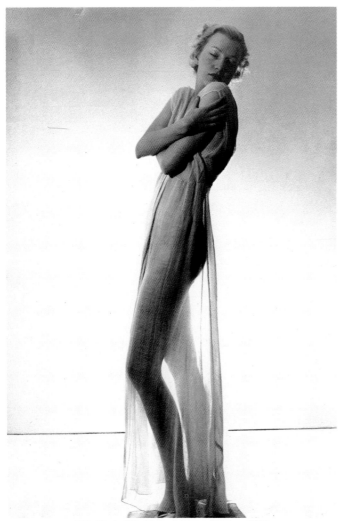

292 Mode / Fashion photograph, circa 1930.

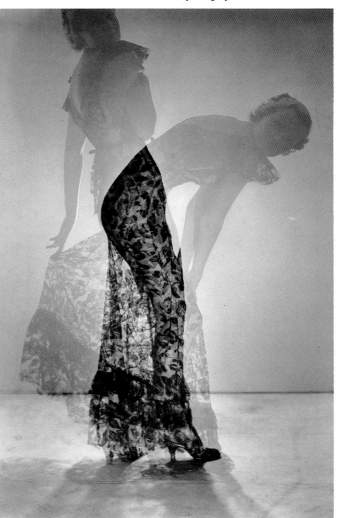

293 Mode / Fashion photograph.

294 Mode / Fashion photograph, circa 1930.

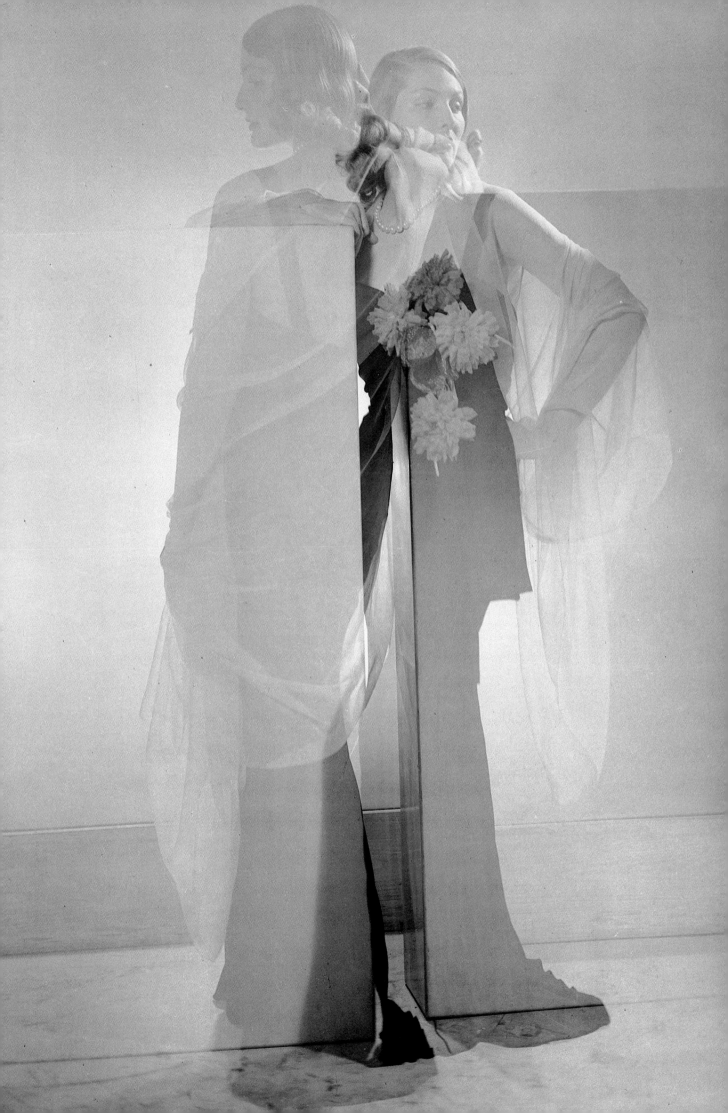

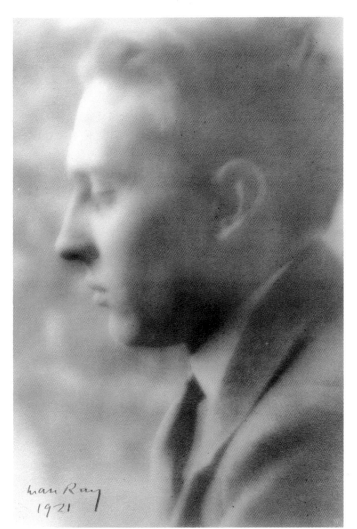

295 Raymond Radiguet, 1921.

296 Sans titre / Untitled.

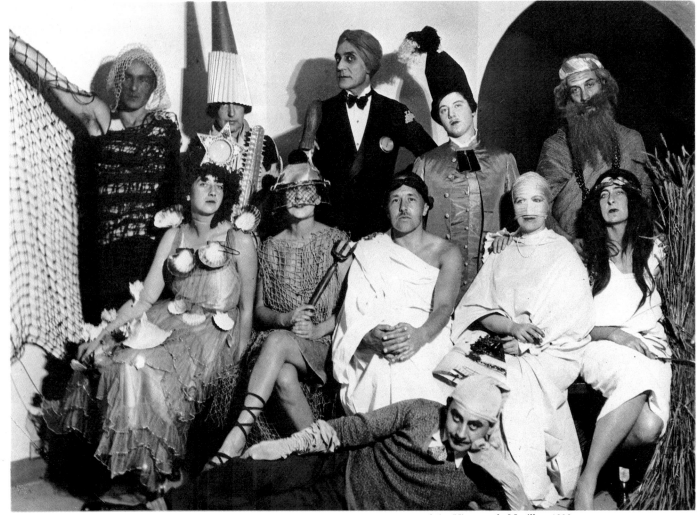

297 Bal au château du Vicomte de Noailles / Ball at the Château of the Vicomte de Noailles, 1929.

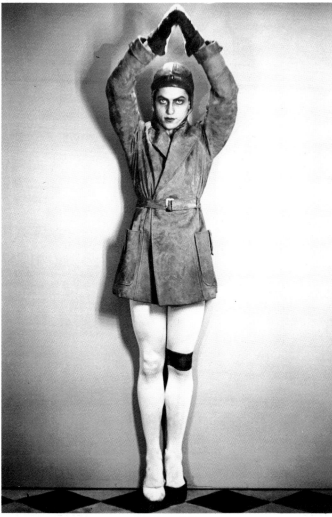

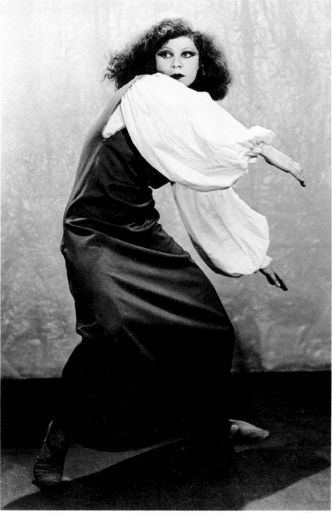

298 Serge Lifar.

299 Helen Tamiris.

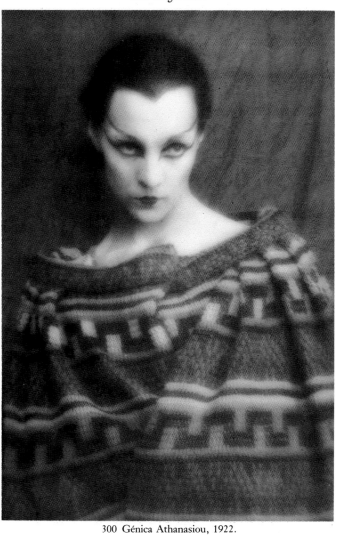

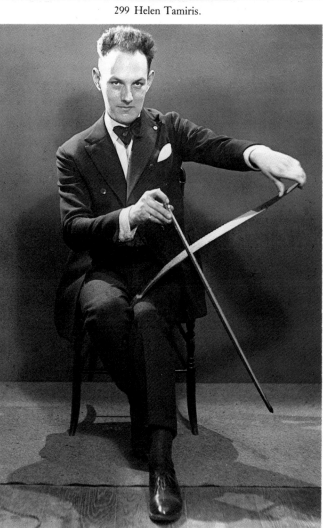

300 Génica Athanasiou, 1922.

301 Portrait.

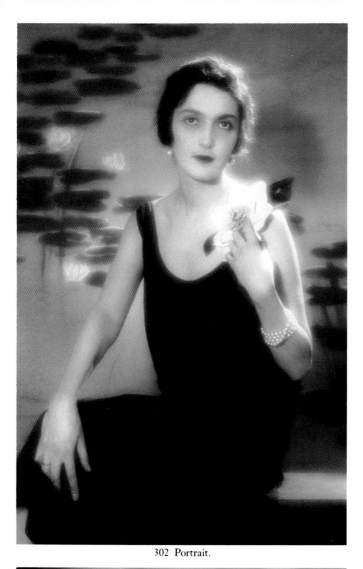

302 Portrait.

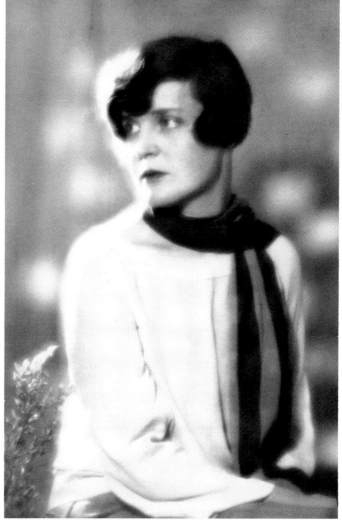

303 Germaine Tailleferre.

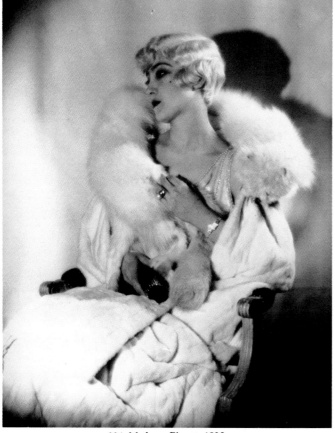

304 Madame Pignet, 1925.

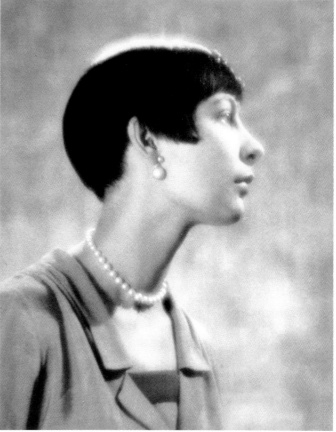

305 Portrait.

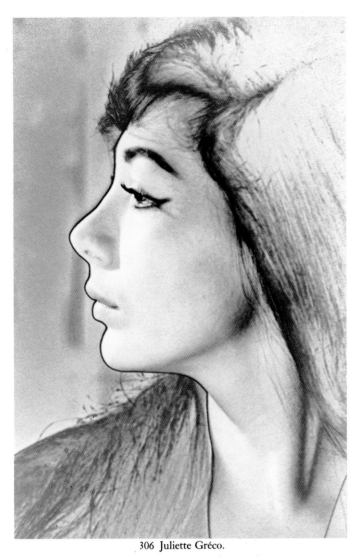

306 Juliette Gréco.

307 Kay Boyle.

308 Jacques Doucet, 1926.

309 Catherine Deneuve, 1966.

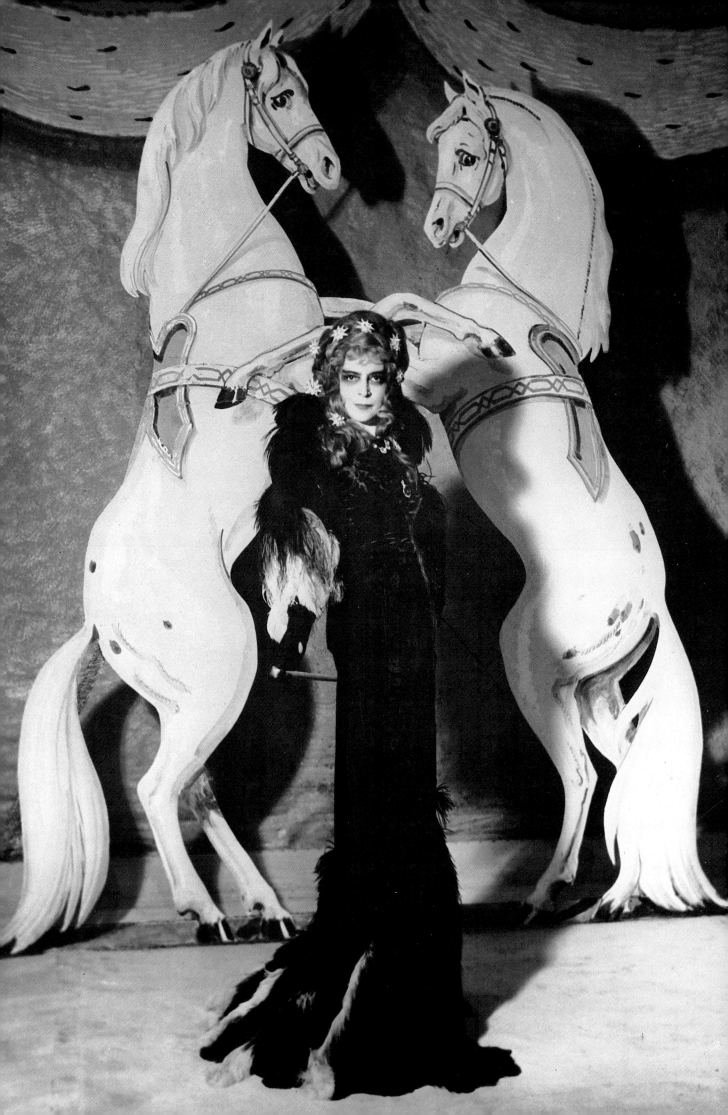

311 Yvonne George.

310 La marquise Casati, circa 1930.

312 Marie Laurencin, 1923.

313 Clément Doucet, Jean Wiéner, 1926.

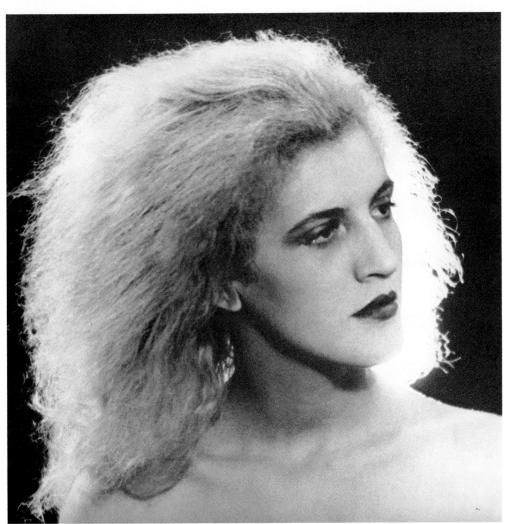

314 Jacqueline, 1930.

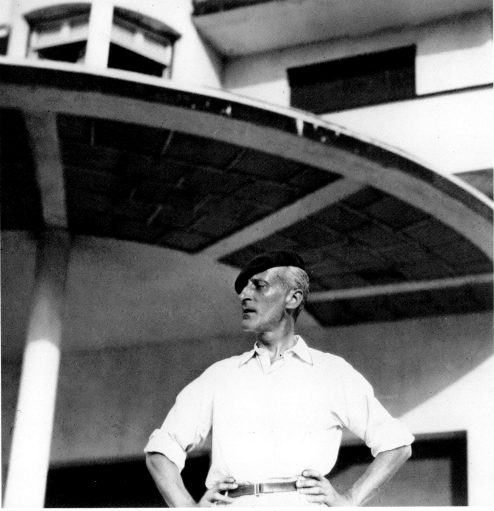

315 Robert Mallet-Stevens.

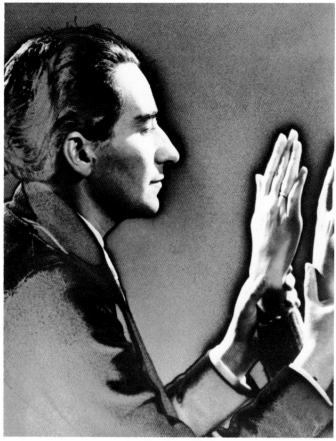

316 Dr. Lotte Wolf.

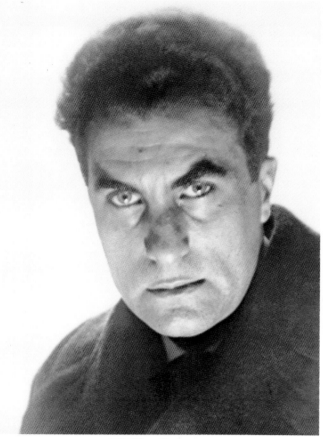

317 Edgar Varèse.

318 Henri Cartier-Bresson.

319 Anna de Noailles, 1927.

320 Maurice de Vlaminck, 1930.

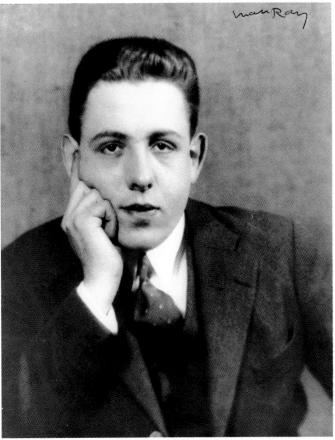

321 Francis Poulenc, 1922.

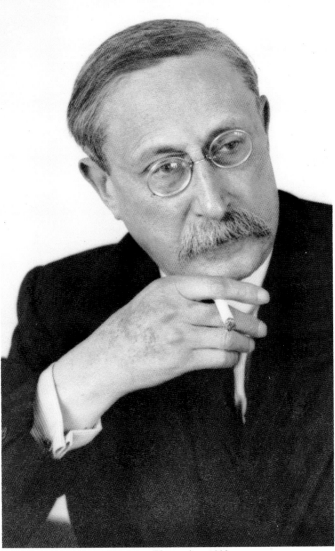

322 Léon Blum, circa 1930.

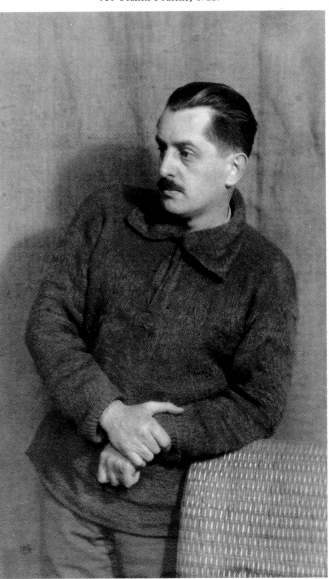

323 Jean Paulhan.

325 Igor Stravinsky, circa 1925.

324 Arnold Schönberg, 1926.

326 Georges Braque, 1933.

327 Jean Cocteau, circa 1924.

328 Max Jacob, 1922.

329 Djuna Barnes, 1926.

330 Saint-Pol Roux, 1925.

331 Berenice Abbott, 1922.

332 Roberto Rossellini, Henri Langlois, Jean Renoir.

333 T.S. Eliot, circa 1930.

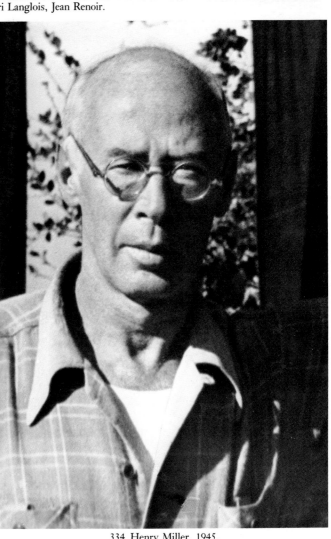

334 Henry Miller, 1945.

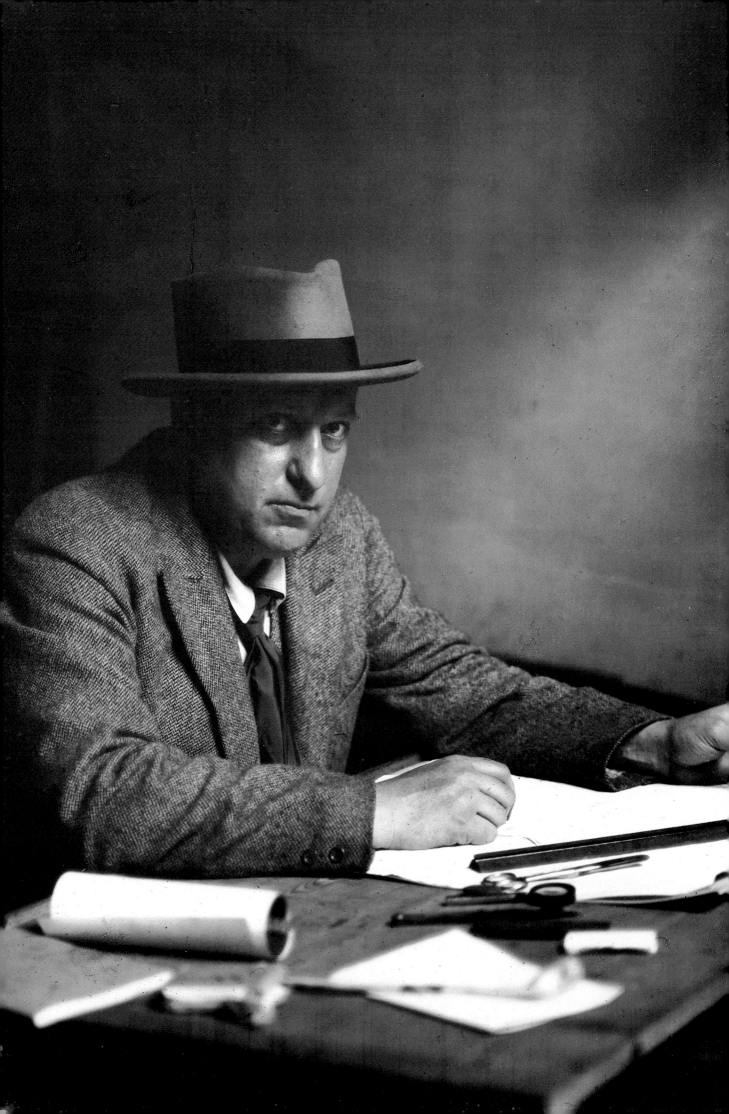

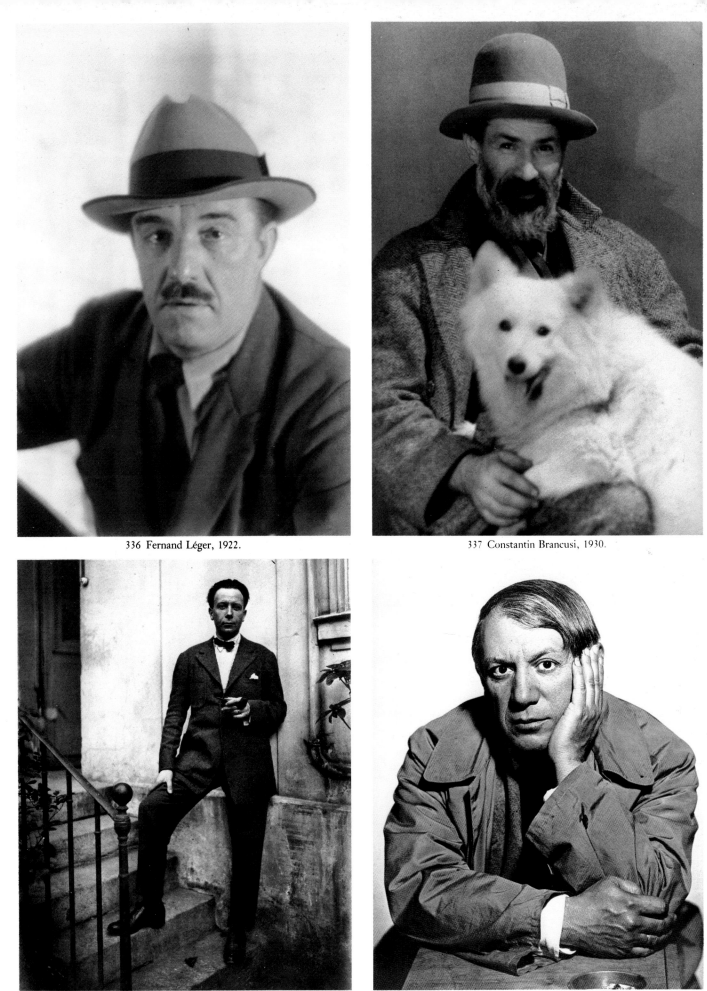

336 Fernand Léger, 1922.

337 Constantin Brancusi, 1930.

338 Robert Delaunay, circa 1930.

339 Pablo Picasso, 1932.

335 André Derain, 1923.

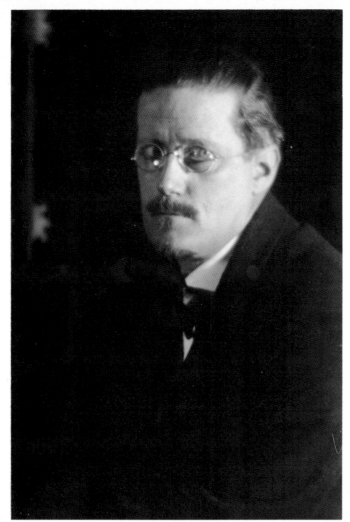

340 James Joyce, 1922.

341 Ezra Pound, circa 1923.

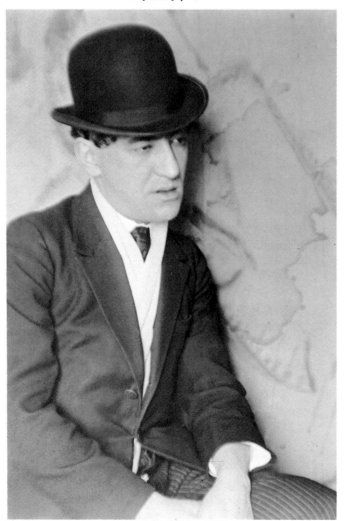

342 Jules Pascin, 1923.

343 Michael Larionov, circa 1930.

344 S.M. Eisenstein, 1929.

Chronology

1890. Born in Philadelphia, Pennsylvania.
1897. His family moves to Brooklyn, New York.
1903. Bar Mitzvah.
1904. Enters High School, and has lessons in free drawing and industrial draughtsmanship.
1908. Graduates High School.
Is offered grant to study architecture, which he turns down.
September. Begins working in New York, while living in Brooklyn with his family.
1910-11. Begins going to Ferrer Center, where he participates in art classes and social life.
Begins to visit Stieglitz's 'Gallery of the Photo-Secession', 291 Fifth Avenue, New York, where he is introduced to European Art and to American artists. Man Ray never had an exhibition at the 291 Gallery, but his work could sometimes be seen there casually hung by Stieglitz for people to see.
1911. Moves to New York, begins contact with artists.
1912. Spring. Moves to Ridgefield, New Jersey.
1913-19. Works as draughtsman for publisher of maps and atlases.
1913. 17 February - 15 March. Sees Armory Show, after which he makes first Cubist painting, *Portrait of Alfred Stieglitz*.
1913. Through Stieglitz, sells painting for $150 to a publisher.
3 May. Marries Adon Lacroix.
By now has evidently changed his name to 'Man Ray', as it appears thus in the Marriage Register.
Begins photography.
1914-15. Buys a camera to take photographs of his paintings.
1914. Meets Alison Hartpence and Charles Daniel, of the Daniel Gallery, New York.
Summer. Writes 'Impressions of 291' for *Camera Work*, to be published in January 1915 issue.
August. War breaks out in Europe. Has to postpone his plans to go to France with Adon Lacroix.
August and September issues of *Mother Earth News* published with covers by Man Ray.
By the end of the year finishes working on *A Book of Diverse Writings*, with Adon Lacroix (to be published the following year).
1915. January. 'Impressions of 291' published in *Camera Work*.
16 February - 7 March. Work shown in 'An Exhibition of Paintings by Elmer Scholfield and An Exhibition of Paintings Representative of the Modern Movement in American Art', Memorial Art Gallery, Rochester, New York.
23 March - 24 April. Work shown in 'A Group Exhibition of Paintings, Drawings and Sculpture,' Montross Gallery, 550 Fifth Avenue, New York.
14 March. Article by Kreymbourg about Man Ray's life in Ridgefield, 'Artist lives on $ 25 a Week', appears in a New York newspaper.
31 March. Publication of *The Ridgefield Gazook*. Hand-written with drawings by Man Ray.
April. Publication of *A Book of Diverse Writings*, co-author Adon Lacroix.
June. Marcel Duchamp arrives in New York.
September/October. First meeting with Marcel Duchamp in Ridgefield, New Jersey.
October - 3 November. First exhibition at Daniel Gallery, after which Arthur J. Eddy buy 6 paintings for $2000.
Before winter. Moves back to New York into studio on Lexington Avenue across from Grand Central Station.
December. Publication of 'Three Dimensions' in *Others* (founded by Kreymbourg, with financial assistance from Walter Arensberg, in July 1915).
1915-16. Attends soirées at Arensbergs.
1916. 13-25 March. Work shown in Synchronists' 'Forum Exhibition of Modern Painters,' Anderson Galleries, New York.
Summer. Meets Edgar Varèse.
Before winter. Moves to 26th Street, near Broadway.
November. Henri-Pierre Roché arrives in New York.
Paints *The Rope Dancer Accompanies Herself with her Shadows*.
End of year. Begins to plan 'Indépendants' show with Duchamp and others.
1916-17. December 1916 - 16 January 1917. Second Exhibition at Daniel Gallery.
1917-20. Makes photographs for John Quinn (and Roché ?) of art works Quinn owns or is interested in buying.
1917. 10 April - 6 May. Society of Independant Artists (New York) exhibition. Man Ray enters *The Rope Dancer*, 'which he withdraws when Duchamps' *Fountain* is rejected. (Man Ray, Duchamp and Arensberg resign from Society of Independant Artists.)
14 April. Stieglitz's 291 Gallery closes.
19 April. Attends Arthur Cravan's lecture at Waldorf Astoria Hotel.
April-May. Contribute to 2 issues of the review *The Blind Man*.
Paints *Suicide*, one of his first aerographs.

Moves to 147 West 8th Street, between 5th and 6th Avenues.
Nakes first cliché-verre.
1918. Ferdinand Howald begins to collect Man Ray's work, through Daniel Gallery.
1919. March. Publication of only issue of the anarchist review *TNT*.
Illustrates Adon Lacroix's poem, *La logique assassinée*.
Breaks with Adon Lacroix. Moves from apartment into a basement where he finds the dress dummies and paints *La volière*.
Frequents Breevoort Bar.
17 November - 1 December. Third exhibition at Daniel Gallery.
1920. Corresponds with Tristan Tzara.
Designs his first chess set.
Collaborates with Duchamp in photography.
Photographs Duchamp tonsured.
1-29 February. Work shown in 'Exhibition of Painting by American Modernists', Museum of History, Science and Art, Los Angeles.
29 April. With Duchamp and Katherine Dreier, signs the constitution of 'Société Anonyme'.
30 April-15 June. First exhibition of Société Anonyme. *Lampshade* removed by janitor the day before opening.
Late in year. Photographs Duchamp as Rrose Sélavy.
1921. 7-26 March. Wins $10 for photograph *Portrait of a Sculptor* (Berenice Abbott) in John Wanamaker's competition '15th Annual Exhibition of Photographs', Philadelphia, Pennsylvania.
April. Publication of *New York Dada*, co-author Marcel Duchamp.
Before 21 June. Makes film with Duchamp, *Elsa, Baroness von Freytag-Loringhoven, Shaves her Pubic Hair*.
21 June. Duchamp leaves for Paris.
Late June - early July. Holidays in Provencetown, Cape Cod, Massachusetts.
July. Gets $500 from Ferdinand Howald and money from family to go to Paris.
14 July. Arrives in Paris. Duchamp introduces him to Dadaists.
By 18 August. Living in room on top floor of 22 rue de la Condamine. Has begun planning exhibition at Librairie Six.
c. September. Sees Picabia, signs 'L'Œil Cacodylate'. Introduced by Gabrielle Buffet Picabia to Paul Poiret.
October. Cocteau returns to Paris.
Between October 1921 and January 1922. Meets Jean Cocteau.
October. Talking to two galleries about exhibitions. Leonce Rosenberg has taken some of his work to sell, but after a month Man Ray takes it back.
November. Very busy photographing people. Librairie Six exhibition is settled. Planning to go to Germany to arrange exhibition there.
After 14 November. Leaves 22 rue de la Condamine.
Between 14 November 1921 and 11 July 1922. Meets and photographs Gertrude Stein.
c. November. Makes first rayograph.
Goes with Duchamp to his brother's country house to work on rotary discs.
Photographs Duchamp with star tonsure.
3-31 December. Exhibition at Librairie Six. Meets Eric Satie at the opening, with whom he crates *Gift*, an iron bristling with nails.
By 27 December. Has moved to Hôtel des Ecoles, rue Delambre.
Before Christmas. Meets Kiki.
1922. Does many photographic portraits, among them Braque and Joyce. Paris publishers of books in English use him as a photographer.
Employed by Pam Poiret as fashion photographer.
Knows Fernand Léger and Beatrice Hastings.
January. Tzara moves into Hôtel des Ecoles.
10 January. Opening of the café 'Bœuf sur le Toit', where photographs of 'the Cocteau gang' are displayed.
28 January. Duchamp leaves Paris.
28 January - 28 February. Shows 3 works at Salon des Indépendants.
5 February. Picabia goes to Saint-Raphael. Man Ray probably goes with him, and returns by 17 February.
17 February. Signs resolution of no confidence in Breton's *Congrès de Paris*.
20 March. Robert Desnos begins associations with artists and Dadaists.
April-May issue of *Les feuilles libres* contains rayograph, with article by Cocteau.
By 28 May. Has photographed Picasso and Braque. Becoming very successful and active as photographer, has sold 4 rayographs to *Vanity Fair*. Has begun working on *Champs délicieux*.
After 28 May. Leaves Hôtel des Ecoles.
30 June. Listed as artist on poster for 'Fête de Nuit de Montparnasse', a ball at the Bullier dance hall.
By 11 July. Moves to 31 bis rue Campagne-Première.
July/August. Duchamp back in Paris.
August. Tzara writes Preface for *Champs délicieux*.
Mid-October - late November. Ill in bed.
18 November. Death of Marcel Proust. Takes photograph of him at Cocteau's request.
December. Publication of *Champs délicieux*, with 12 rayographs.
1923-26 Berenice Abbott assistant to Man Ray. Although Duchamp makes frequent excursions elsewhere, Paris is now his base.
1923. Photographs Nancy Cunard and her mother.
Photographs Jules Pascin.
Desnos writes about Man Ray's rayographs (see Schwarz, *Man Ray*, London, New York, 1977, pp. 237-38).

By March. Has decided to stay in Paris. In a letter to his family says that if he came to New York, he would keep on Paris studio.

6/7 July. Man Ray's film *Retour à la raison* is shown at the 'Cœur à barbe' soirée at the Théâtre Michel.

Between 14 July and end of August. With Kiki, visits Peggy Guggenheim at her house in Normandy.

Approached by Dudley Murphy to make a film. When the project turns out to be a failure, Murphy goes to Léger and makes *Ballet mécanique*, for which Man Ray does some of the photography.

Autumn-winter issue of *The Little Review* contains Ribemont-Dessaignes' article 'Dada Painting or the Oil-eye', which includes Man Ray.

1 November. Shows portrait at Salon d'Automne.

December. Duchamp living at Hôtel Istria, 29 rue Campagne-Première, next door to Man Ray. They are together frequently, including daily appointment for supper at midnight or 1 a.m. at the Dôme with Treize and Kiki. Paints portraits of Duchamp and Kiki.

1924. Very successful as photographer. By this time has his own printed stationery and telephone. Visits Nancy Cunard at her flat on the Ile Saint-Louis.

Spring or summer. May have gone on trip to south of France, perhaps with Picabia, and painted *Regatta*.

13 June. *Le violon d'Ingres* published in *Littérature*.

c. autumn. Acts in *Entr'acte*, film directed by Picabia and René Clair.

4 December. *Relâche*, performed at Théâtre des Champs Elysées, with a showing of *Entr'acte*. A reviewer for Paris-Journal lists Man Ray among the 'celebrities' present.

End of year. Much activity around Hôtel Istria, partly in preparation for *Relâche*. Picabia lives there, Germaine Everling, Elsa Triolet, Jeanne Léger, Mayakovsky and others being often present, or living in the hotel.

1925. Publication of Cocteau's *L'ange heurtebise*, with a rayograph. Begins to use the word 'rayograph'.

25 April. Opening of 'Exposition des Arts Décoratifs'. Man Ray commissioned to photograph couture section.

May issue of French *Vogue* and 15 May issue of American *Vogue* contain fashion photographs by Man Ray.

May-June issue of *Les feuilles libres* contains article 'Man Ray' by Ribemont-Dessaignes.

14-25 November. Participates in Surrealist exhibition at Galerie Pierre.

1926. Publication of *Revolving Doors* (collages).

Goes on outing to Duclair in Normandy with Kiki and several Surrealists. Fight breaks out between the group and locals.

March. Kiki arrested and jailed at Villefranche.

26 March. Man Ray exhibition at opening of Galerie Surréaliste.

April. Attends Kiki's trial in Nice.

May. Starts 'in earnest' on his film *Emak Bakia*, which he plans to finish by autumn.

August. Filming of *Emak Bakia* at Arthur Wheeler's house in Biarritz. Duchamp finishes *Anémic Cinéma* with Man Ray and Marc Allegret.

September. Finishes *Emak Bakia*.

19 November 1926 - 1 January 1927. Work included in Société Anonyme exhibition at Brooklyn Museum.

23 November. Première of *Emak Bakia* at the Vieux Colombier.

1927. End February. Julien Levy and Marcel Duchamp, en route from New York to Paris, hear that Man Ray has gone to New York.

26 March. Exhibition, 'Man Ray: Recent Paintings and Photographic Compositions', at Daniel Gallery, New York.

By 28 April. Back in Paris.

8 June. Duchamp's marriage. Man Ray films the wedding.

September. Publication of Surrealists' 'Hands off Love', in *La révolution surréaliste*, a defence of Charlie Chaplin in his divorce scandal. Man Ray among signers.

20 December. Man Ray attends opening of the Coupole.

c. **1928-29.** Attends party in Paris suburbs with many American writers. Talks to US Internal Revenue Service official who tries to find out how much money he makes and if he pays his taxes.

1928. February. Hears Desnos' poem 'Etoile de mer' and plans to use it as scenario for film. Begins *Etoile de mer*.

25 April. In Marseille.

13 May. Première of *Etoile de mer* at Studio des Ursulines; it continues to be shown in same programme as *The Blue Angel* until at least December 1929.

1929-32. Lee Miller assistant to Man Ray.

1929. Publication of 'The Work of Man Ray' by Desnos in *Transition* (No. 15). Publication of pornographic photographs, *Printemps, été, automne, hiver*, in *1929*, with poems by Aragon and Péret. Censored and seized by customs officials.

5-19 February. 'Photographic Compositions', exhibition of Man Ray's work at Art Club of Chicago.

Early summer. Meets Lee Miller and goes with her to Biarritz.

June. Publication of French edition of Kiki's *Souvenirs*. Preview of *Mystères du Château de Dés*.

c. autumn. Acquires Val-de-Grace Studio.

October. Showing of *Mystères du Château de Dés* at Studio des Ursulines.

2-14 November. Exhibition of paintings and recent rayographs at Galerie des Quatre Chemins.

6-30 November. Exhibition of paintings Chez Van Leer, 41 rue de Seine.

c. **1930-31.** Visits Picabia and Olga on their houseboat at Cannes.

1930. Summer. Ball given by Count and Countess Pecci-Blunt: with Lee Miller as assistant, projects hand-coloured films onto guests dressed in white.

1931. 13-19 April. 'Photographies de Man Ray', exhibition at Galerie Alexandre III, Cannes, arranged with the help of Picabia, who also wrote the Preface to the catalogue.

1932. Takes part in the 'Surrealist Exhibition' (Julien Levy Gallery, New York), in the 'Mosta della cinégrafica' (Florence) as well as the 'Exposition internationale de la photographie' (Palais des Beaux-Arts, Brussels).

Three one-man exhibitions, one in New York at Julien Levy's (photographs) and two others in Paris, one at Dacharry's (works 1919-32) and another at the Galerie Vignon (recent works).

1933-34. *A l'heure de l'observatoire - Les amoureux.* Exhibits at the 'Salon du nu photographique' (Galerie de la Renaissance, Paris), in 'An Exhibition of Foreign Photography' (Art Center, New York), in the 'Exposition des surréalistes' (Galerie Pierre Colle, Paris) and at the 'Salon des Surindépendants' (Paris).

1933. Makes a trip to Hamburg.

During the summer he meets up with Marcel Duchamp and Mary Reynolds in Cadaquès. They later go to Barcelona together. In Cadaquès he meets Salvador Dali and Gala again.

1934. Exhibition of his photographs at Lund, Humphries and Co., London.

He gives works to the exhibition sale organized by the Committee for the Liberation of Thaëlman and imprisoned antifascists (Galerie Vignon).

1935. One-man show at Wadsworth Atheneum, Hartford, Connecticut (rayographs and photographs), as well as at the Art Center School, Los Angeles (drawings and photographs), the Galeria Adlan, in Barcelona (paintings and rayographs) and at the Galerie des Cahiers d'Art (objects and paintings, including *The Lovers*).

1936. Moves to the rue Denfert-Rochereau. Also buys a small house at Saint-Germain-en-Laye.

Liaison with Adrienne (Ady).

He and Adrienne spend their summers in the south at Mougins, with Paul Eluard and Nusch, Roland Penrose and Lee Miller, Pablo Picasso and Dora Maar, along with Kasleck, the Afghan hound.

Exhibition, 'Objets surréalistes', at the Galerie Charles Ratton in Paris, which includes several of Man Ray's objects: *Lanterne sourde et muette, Boardwalk, Ce qui nous manque à nous tous* and *Mon rêve*.

June. Takes part in the 'International Surrealist Exhibition' at the New Burlington Gallery in London:

At the end of the year, makes three trips to New York for a fashion magazine. One-man show at the Valentine Gallery in New York. 36 drawings. Catalogue Preface by Eluard.

December. Goes to the opening night of the exhibition, 'Fantastic Art, Dada, Surrealism', at the Museum of Modern Art in New York.

1937. Takes part in the exhibition 'Trois peintres surréalistes' (Tanguy, Ernst, Man Ray), at the Palais des Beaux-Arts in Brussels, with 33 of his works.

One-man exhibition at Jeanne Bucher's in Paris. Early drawings (1908-17) and 36 drawings for *Les mains libres* as well as photographic enlargements of details from his drawings. Catalogue Preface by Paul Eluard.

Shoots his last film (in colour) near Antibes, with Picasso and Eluard.

Rents a flat in Antibes, 'so as to devote himself as much as possible to painting'.

La photographie n'est pas l'art (G.L.M., Paris). 12 photographs, illustrated by André Breton.

1938. 'Exposition Internationale du Surréalisme' at the Galerie des Beaux-Arts, Paris. Man Ray is the 'master of lighting'. As a result, on the opening day, the rooms are plunged into darkness and each visitor, equipped with a torch, sets off to discover the paintings. Sixteen display mannequins are put at the painter's disposal. 'I left my mannequin naked, with glass tears on her face and glass soap-bubbles in her hair', wrote Man Ray.

Takes part in the exhibition, 'Surrealist Paintings, Drawings, Object', at the London Gallery, London.

Paints his *Portrait imaginaire de D.A.F. de Sade*.

1939. One-man exhibitions in London (London Gallery) and in Paris (Galerie de Beaune; the catalogue introduction is an essay by Sade on imagination).

1940. May-June. Man Ray leaves Paris with Adrienne.

End of June - beginning of July. Returns to Paris. Leaves for New York, via Lisbon. Arrives in Hollywood. Meets Juliet Browner. Takes part in the 'Exposition Internationale du Surréalisme', Galeria de Arte Mexicana in Mexico.

1941. Settles down, first in the Château aux Fleurs and soon afterwards in a large studio on Vine Street.

Re-makes some of his works (*La Fortune II, The Woman and Her Fish II*) including very old ones, such as *Revolving Doors*.

One-man shows at the Frank Perls Gallery in Los Angeles and at the M.H. de Young Museum in San Francisco.

1943. One-man exhibition of drawings and rayographs at the Art Museum in Santa Barbara, California.

1944-46. Hans Richter makes *Dreams That Money Can Buy*, six 'dreams' with scenarios by Calder, Duchamp, Ernst, Léger, Man Ray and Richter and with music by Varèse, Cage, Bowles, Latouche and Milhaud.

Richter asks Man Ray to shoot one of the film's scenes. Man Ray refuses, but sends him a scenario, *Ruth, Roses and Revolvers*.

1944. Takes part in the exhibition, 'The Imagery of Chess', at Julien Levy's in New York.

One-man exhibition at the Pasadena Art Institute, California.

1945. One-man shows at the Los Angeles County Museum and at Julien Levy's in New York.

1946. One-man exhibition of objects at the Circle Gallery, Los Angeles.

Takes part in the exhibition *Pioneers of Modern Art in America* at the Whitney Museum in New York.

Man Ray gives a lecture on Surrealism. 'The only preparation I made for this was to construct an object that would demonstrate a Surrealist act'. At the end of the lecture he organizes a lottery and gives the object to the winner.

Double wedding in Beverly Hills of Man Ray and Juliet Browner and of Max Ernst and Dorothea Tanning.

Meets Bill Copley.

1947. Takes part in the 58th annual painting and sculpture exhibition, 'Abstract and Surrealist American Art', at the Art Institute in Chicago.

Summer. Lightning visit to Paris with Juliet.

Beginning of autumn, returns to America.

1948. Takes part in two exhibitions: 'Paintings and Sculpture by the Directors of the Société Anonyme 1920-48' (Yale Art Gallery, Yale), and 'School of Twentieth Century Art' (Modern Institute of Art, Beverly Hills). For the latter's catalogue he wrote an essay entitled 'Dadaism'.

Alphabet For Adults, an album of drawings (Copley Gallery, Beverly Hills).

Paints his series *Shakespearean Equations*, based on photographs of mathematical objects which he took in the 1930s and which he brought back with him on his trip to Paris.

December, 1948. Exhibits these in Bill Copley's gallery in Beverly Hills.

1950. Takes Ava Gardner's photograph.

1951. At the beginning of the year. Returns to New York. Takes part in the exhibition, 'Abstract Painting and Sculpture in America', at the Museum of Modern Art.

March. Leaves for Paris with Juliet.

May. Moves into a studio in the rue Férou.

Summer-winter. Takes up painting again. Experiments with colour photography.

One-man exhibition at the Galerie Berggruen, Paris.

1953. One-man show at the Paul Kantor Gallery, Los Angeles. Paintings.

1954. One-man exhibition at the Galerie Furstenberg, Paris, with 15 *Shakespearean Equations*, 14 paintings, and objects.

1956. 'Non Abstractions', personal exhibition at the Galerie de l'Etoile Scellée, Paris, with paintings, including *Mythologies modernes*, and a selection of objects. Catalogue preface by André Breton.

'Man Ray, Max Ernst, Dorothea Tanning', exhibition at the Musée des Beaux-Arts in Tours, France.

1957. Takes part in the Dada Exhibition at the Galerie de l'Institut, Paris. Presents *Boardwalk* and *Objet à détruire*.

1958. Series of *Natural Paintings*.

Takes part in two Dada exhibitions, at the Stedelijk Museum in Amsterdam and at the Kunsthalle in Dusseldorf (*Dada, Dokumente einer Bewegung*). For the latter, he wrote an essay entitled 'Dadamade'. Among the objects was *Pain peint*.

1959. Five one-man exhibitions: in Paris (Galerie Larcade and Galerie Rive Droite), in New York (Mayer Gallery, drawings; and Alexander Iolas Gallery, works 1912-59, with a text by Marcel Duchamp), in London (Institute of Contemporary Art, organized by his friend, Roland Penrose: 71 works 1928-59, with texts by Marcel Duchamp and Man Ray 'What I Am').

Takes part in the 'Exposition internationale du surréalisme (Eros)' at the Galerie Daniel Cordier, Paris. Catalogue text entitled 'Inventaire d'une tête de femme'.

1960. One-man exhibition at the Esther Robles Gallery, Los Angeles: works 1912-46.

Takes part in 'Photokina' in Cologne.

1961. Receives gold medal for photography at the Venice Biennale. Takes part in 'The Art of Assemblage', an exhibition at the Museum of Modern Art in New York.

1962. Two one-man exhibitions in Paris, one at the Galerie Rive Droite (recent works), the other at the Bibliothèque Nationale.

1963. Five one-man exhibitions: in Stuttgart (*LGA Ausstellung*, rayographs), in Princeton (University Art Gallery, 53 paintings, along with drawings, watercolours, rayographs, objects, books, chess pieces, and an essay by Man Ray), in New York (Cordier and Ekstrom, paintings before 1950, with a text by Marcel Duchamp), at the Museum in Amiens (photographs and rayographs) and in London (Cavendish Gallery, paintings).

Publication of his autobiography, *Self Portrait* (Little Brown and Co., Boston; André Deutsch, London).

1964. '31 Objects of my Affection, 1920-1964', first one-man exhibition in Italy, Galleria Schwarz, Milan. Essays by Man Ray and Tristan Tzara.

Takes part in the exhibition, 'Le surréalisme: sources, histoire, affinités', Galerie Charpentier, Paris.

1965. One-man exhibition at Corder and Elkstrom's in New York: 'Objects of My Affection'. Collages.

Takes part in two exhibitions: 'Aspects du surréalisme' (Galerie d'Art Moderne, Basle) and 'L'écart absolu' (L'Œil, Paris).

1966. Fiftieth anniversary of Dada. Man Ray takes part in several retrospectives in Paris (Musée National d'Art Moderne), in Zürich (Kunsthaus), in Milan (Padiglione Civico d'Arte Contemporanea).

Takes part in the travelling exhibition of the Goethe Institute, 'Dada 1916-1966'. (Cities visited include Copenhagen, Rome and Tokyo.) First big retrospective exhibition at the Los Angeles County Museum of Art. Takes part in 'Le surréalisme' exhibition at the Museum of Tel-Aviv.

1967. Takes part in the exhibition, 'Le Muse Inquietanti, Maestri del Surrealismo', Galleria Civica d'Arte Moderna, Turin. 'Salute to Man Ray' exhibition at the American Center, Paris.

1968. Takes part in two exhibitions at the Museum of Modern Art in New York: 'Dada, Surrealism and their Heritage' and 'The Machine as Seen at the End of the Mechanical Age'.

Two personal exhibitions, in New York (Martha Jackson Gallery) and in Cologne (Galerie Der Spiegel).

Marcel Zerbib makes multiples of 13 of Man Ray's works (1918-67).

1969. Four one-man exhibitions: Vence (Galerie Alphone Chave, catalogue text by Man Ray, 'Les invendables'), London (Hanover Gallery, catalogue text by Man Ray), Milan (Studio Marconi, works 1919-69) and Turin (Galleria Il Fauno, catalogue text by Janus).

Exhibition with his niece, Naomi Savage, at the New Jersey State Museum, Trenton.

1970. One-man exhibitions: New York (Cordier and Ekstrom), Padua (Galleria La Chicciola, catalogue text by Man Ray), Paris (Galerie XX Siècle, 'La ballade des temps hors du temps'), Venice (Galleria del Cavallino, etchings), Ghent (Galerie Richard Foncke, lithographs) and New York (Noah Goldowsky Gallery).

Takes part in several exhibitions: 'The Poetic Image' (Hanover Gallery, London), 'Surrealism ?' (Galerie Rive Gauche, Rome).

1971. One-man exhibitions: Paris (Galerie Visat, 'Obstruction'), Turin (Galleria Il Fauno, catalogue text by Hans Richter), Geneva (Galerie Pourquoi Pas ?) and Washington (Lunn Gallery)

Shows *Le Violon d'Ingres* at the presentation 'Autour du Bain Turc d'Ingres', (Louvre, Paris).

Two retrospectives, at the Boymans van Beuningen Museum (Rotterdam), and at the Galleria Schwarz (Milan): 225 works 1912-71.

1972. Musée National d'Art Moderne, Paris; Louisiana Museum, Humlebaek (Denmark): presentation of the Boymans van Beuningen Museum retrospective.

One-man exhibitions at Ferrara (Galleria Civica d'Arte Moderna, 119 works, catalogue text by Janus), Turin (Galleria il Fauno, 'Revolving Doors', catalogue text by Roland Penrose), Paris (Galerie Françoise Tournier), Rome (Galleria-libreria Pictogramma) and in Paris (Galerie des Quatre Mouvements, 40 rayographs).

Takes part in commemorative Surrealism exhibition (Musée des Arts Décoratifs, Paris; Haus der Kunst, Munich), catalogue text by Patrick Waldberg.

1973. One-man exhibitions in Milan (Galleria Iolas), Florence (Galleria Michaud), Tokyo (Natenshi Gallery) and New York (Metropolitan Museum of Art, photographs).

Takes part in exhibition, 'Combattimento per un' immagine', Museo Civico, Turin.

1974. One-man exhibitions in Rome (Galleria Il Collezionista, 124 works; Palazzo delle Esposizioni, his entire graphic work), Madrid (Galeria Iolas), Paris (Galerie Iolas, catalogue text by Janus), Turin (Galleria Il Fauno), New York (Timothy Baum Gallery, 69 photographs, 1917-74).

Takes part in 'New York Dada' exhibition - works by Marcel Duchamp, Francis Picabia, Man Ray; catalogue by A. Schwarz (Städtische Galerie, Munich; Kunsthalle, Tübingen).

85th-birthday exhibition in New York, 'Man Ray, Inventor, Painter, Poet', at the Cultural Center, organized by Roland Penrose and Mario Amaya (224 works).

Andy Warhol devotes a series of paintings and seriographs to Man Ray. The image of the metronome (*Objet à détruire ? Objet indestructible ?*) is used by the Social Democrat Party of Hamburg during its election campaign 'as an emblem of vigilance and discernment' (R. Penrose, *Man Ray*).

1975. Personal exhibitions in London (Mayor Gallery), Athens (Iolas Gallery) and Milan (Studio Marconi).

The New York exhibition is presented in London (Institute of Contemporary Art) and then, modified, in Rome (Palazzo delle Esposizioni, 'Man Ray - l'occhio e il suo doppio', catalogue by M. Fagiolo dell'Arco.

1976. 18 November, Man Ray dies in Paris.

Index

Numbers in italics refer to plates and notes on the plates